His Other Half

Wendy Lesser

HIS OTHER HALF

*Men Looking at Women
through Art*

*Harvard University Press
Cambridge, Massachusetts
London, England · 1991*

Publication of this book has been aided by a grant from the
Andrew W. Mellon Foundation.

This book is printed on acid-free paper, and its binding materials
have been chosen for strength and durability.

Library of Congress Cataloging-in-Publication Data

Lesser, Wendy.
 His other half : men looking at women through art / Wendy Lesser.
 p. xx cm.
 Includes bibliographical references and index.
 ISBN 0-674-39210-8
 1. Women in art. 2. Arts, Modern—19th century. 3. Arts,
Modern—20th century. 4. Artists—Relations with women. 5. Women—
Public opinion. I. Title.
NX652.W6L4 1991
700—dc20

90-37165
CIP

For Richard

Contents

Illustrations

His Other Half

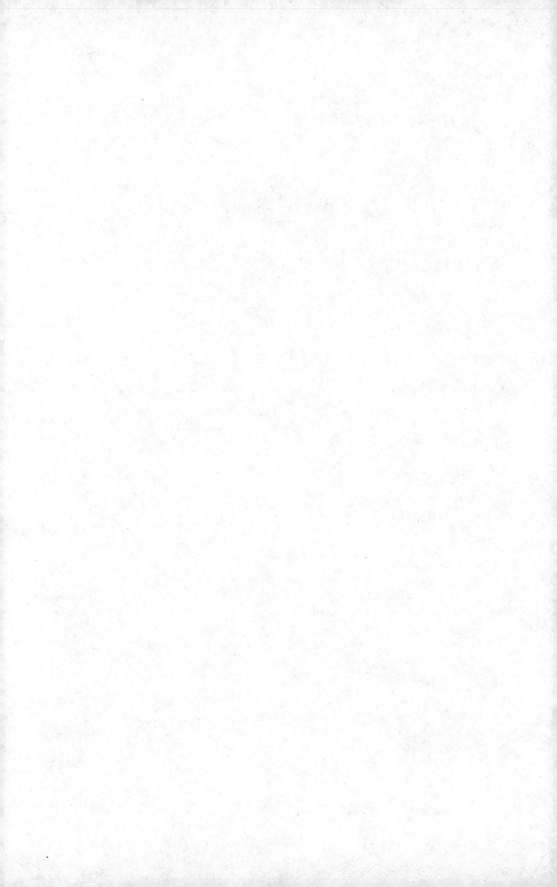

Divided Selves

1 I find myself caught in a contradiction: I am saying that gender both does and does not matter. I dislike what I see as the rigid separatism of "women's studies," and yet I choose here to examine the work of male artists and writers only. If art transcends gender, as I think it does, why would men's artworks be any different from those of their female counterparts? One way out of the dilemma might be to say that gender matters for the creator but not for the reader or viewer; that the artist inevitably produces work from within his own sex, while we, in absorbing it, can cross boundaries and become either male or female. But this certainly isn't true in all cases. Shakespeare, for instance: his writing stems from a self which seems composed equally of male and female parts, of Antony and Cleopatra, of Romeo and Juliet. Vermeer, on the other hand, is an artist who directly addresses us as male or as female. Who we are affects how we view his paintings. I discovered this when I tried to hang a poster of *Head of a Young Girl* over my desk to supervise the writing of this book. I have loved the painting in museums, where I was part of a mixed-gender public, and in books, where the reproduction was small enough to reduce the power of the girl's glance. But when she looked over her shoulder at me from my own wall, larger than life, with her intense brown gaze and her softly parted lips, I felt I was sitting at the wrong desk. She was definitely looking at a man.

I feel as if I've been arguing about the relationship between men and women for most of my adult life—but then, I think most Americans my age probably feel that. At college in the late Sixties and early Seventies I was cavalierly anti-feminist. It was not that I didn't want women to have all the good things men had. I believed in equal pay, shared childcare, adequate birth control, and all the other unarguable benefits. But it seemed to me that the so-called movement was weaving

a straitjacket for its members. I felt no natural affinity with fifty percent of the human race; I was as likely to be friends with a man as a woman; and even on a political level, I thought that other factors (class, for instance) were more significant than gender. What's more, I saw the women around me channeling themselves toward high-status, high-pay, high-tension careers, while my male friends (benefiting, no doubt, from an extra thirty centuries of cultural self-confidence) felt able to pursue more artistically satisfying work as photographers, philosophers, writers, actors, critics, and journalists. Why, I thought, should I be condemned to relive the tedious history of male advance and retreat, of office-life domination and subsequent flight to the world of the imagination? Why couldn't I just leap directly into the arts? My mind, I felt, was not particularly female, having been composed partly by the male writers (Orwell, Dostoevsky, Henry James, among others) who had been most important to me. On the other hand, I realized even then that my mental atmosphere was also formed by my having grown up in an all-female household, where it never occurred to me that women couldn't do all the same things men did.

After college, I lived for two years in England. At that time—the mid-Seventies—the English attitude toward women brought to mind the American 1950s. If you asked a man to help you with the vacuuming, he immediately responded that he couldn't be expected to bear children. There was no room in this scenario for the niceties of subtle resistance, the minority opinion within the rebellious movement. Feminism was viewed, purely and simply, as an extension of American Momism: a crackpot provincial ideology designed to expand the empire of the female battleaxe from the domestic front out into the world at large. I remember my relief on casually picking up, one day on the train to London, an already out-of-date copy of the *New York Review of Books,* in which Susan Sontag's critique of Leni Riefenstahl was being attacked on the grounds of its insufficiently feminist position, and then defended on the wider grounds of its moral probity. Out there, I realized, the real discussion was still going on; it was only here in England that we were hopelessly out of touch.

Toward the end of the decade, having re-settled in America, I returned to England for a visit. During the intervening period, feminism—of a particularly virulent variety—had swept the country like an influenza epidemic. No playwright or novelist worth his salt would

now write anything that didn't come down firmly on the side of women's rights. Even the anti-nuclear movement had become feminist property: the entrenched female demonstrators at Greenham Common were deciding, grudgingly, whether or not to allow men into their camp. In America, meanwhile, the fray had been joined by the feminist literary theorists, the most extreme of whom seemed to be insisting that gender was the *sole* determining factor in the way we read or wrote. And while the argument has modulated a great deal since then, with "women's studies" gradually eliding into "gender studies," there is still a tendency among certain feminist critics to view with suspicion any work of art or criticism produced by a man.

I want to resist such tendencies for a number of reasons, some of which are merely practical. If the gender separatists prevail, both men and women will suffer the consequences: women because they will forfeit a vast portion of their artistic inheritance, and men because they will lose a large and sensitive segment of their potential audience. If women can listen only to female critics and men speak only to male audiences, then the possibilities for conversational exchange become sadly limited. I am not, by the way, positing a hypothetical stance; a number of feminist critics have already adopted this separatist approach. In her relatively middle-of-the-road feminist study of Hitchcock, *The Women Who Knew Too Much*, Tania Modleski quotes one of the more extreme critics:

> Some feminists . . . have recently argued that we should altogether dispense with analysis of masculinity and of patriarchal systems of thought in order to devote full time to exploring female subjectivity. Teresa de Lauretis, for example, has declared that the "project of women's cinema [by which she also means feminist film theory] is no longer that of destroying or disrupting man-centered vision by representing its blind spots, its gaps or its repressed"; rather, she argues, we should be attending to the creation of another—feminine or feminist—vision. Although I fully share de Lauretis's primary concern . . .

And Modleski then goes on to defend herself for being so retrograde as to look at the work of a male filmmaker. I gather there are even some female critics who would go so far as to ban men entirely from the depiction of female experience. This is biological determinism of the most pernicious sort: such critics are refusing to acknowledge the degree to which their own imaginations and attitudes (perhaps even

their own desire to ban things) have been shaped by men. At the same time, they are misunderstanding the true implications of sexual difference. Any woman who has ever loved a book or a painting or a film by a man takes a part of him into her. Yet that does not mean she has become a man: one can absorb the loved one without turning into him. And the reverse is true for men: they can venture into women and still remain male. To go inside the opposite does not necessarily mean to give up the self—though it may involve risking a temporary loss of some degree of self, or, alternatively, escaping temporarily from oneself.

On a practical level, the gender-separatist stance is self-defeating. But I also think it is wrong. The rich world of men's artistic visions of women cannot be summarized with a mere reference to the artists' sex. No overarching theory of gender can simultaneously explain Shakespeare and Vermeer, Henry James and D. H. Lawrence, Edgar Degas and Cecil Beaton, *Some Like It Hot* and *Vertigo*. There is no single meaning that women have for men, no single manner in which men use the feminine in their art. There may, as Wittgenstein might say, be a "family resemblance" among the various masculine visions of women, but that resemblance goes almost no way toward achieving an explanatory theory. All it gives us—all it may give me, in this particular book—is a way of organizing details and observations. All I'm after, finally, is a collection of true remarks about a subject that, in addition to interesting me personally, seems to have importance in the world at large.

That subject is men's relationship to the feminine—and, in this case, the way that relationship comes out in works of art. The subject is gigantic, so the selection is necessarily idiosyncratic. If I look at the artists I've selected—from Dickens, Gissing, Degas, Lawrence, and James to Randall Jarrell, Alfred Hitchcock, Harold Brodkey, and Preston Sturges—I find that I'm drawn to the points at which most pressure is brought to bear, to the places where the artist risks (and one often hears) the charge of misogyny. Sometimes what draws me is my own struggle with the material: why do I love Hitchcock's movies, for instance, when the women appear to be so weak? But sometimes my attraction to the material has been entirely separate from any conscious awareness of conflict. I loved Degas's nudes, immediately and unashamedly, long before hearing of his "misogynist"

streak, and it never occurred to me that Henry James could be seen as an anti-female writer until I began to encounter feminist attacks on *The Bostonians*.

In defending these artists from the putative charge of misogyny, I'm hoping also to make some larger discoveries about how art functions. All art, I think, must contain both conflict and resolution, not necessarily in balancing quantities. Harold Brodkey expressed a similar idea when he said: "The essence of art is that it does not ever consist of a single voice without some evidence beyond that voice: art involves at least one convincing voice plus at least one other genuinely existent thing." With men's art about women, part of the conflict will be between the male artist and his own feminine side, and part of the resolution will involve a truce between that male artist and his real or imagined female audience (by which I mean the female part of his androgynous audience, for it is in the nature of most audiences to be androgynous—to consist, literally, of both male and female).

On the other hand, I'm not denying that there can be such a thing as misogyny in art produced by men. I can even acknowledge that a work of art might be misogynist—might violate the female, or its own relationship to the female—and still be a great work of art. This is probably true, for instance, of some of Picasso's late pictures. I have left Picasso out of this book, not only because I am afraid to grapple with a subject so vast, but also because he is still too much of a force in our time. The man as well as the work is still too present to us— too difficult, changeable, luridly fascinating, and vision-altering—for me to get an accurate fix on him. But to the extent I am able to understand Picasso, through trusted critics and through the evidence of my own eyes, I can see that something disturbing is happening in the sex-obsessed engravings, drawings, and paintings of his last years. John Berger movingly describes those works in this way:

> An old man's frenzy about the beauty of what he can no longer do. A farce. A fury. And how does the frenzy express itself? . . . The frenzy expresses itself by going directly back to the mysterious link between pigment and flesh and the signs they share. It is the frenzy of paint as a boundless erogenous zone. Yet the shared signs, instead of indicating mutual desire, now display the sexual mechanism. Crudely. With anger. With blasphemy. This is painting swearing at its own power and at its own mother. Painting insulting what it had once celebrated as sacred.

Nobody before imagined how painting could be obscene about its own
origin, as distinct from illustrating obscenities. Picasso discovered how
it could be.

As Berger suggests, the pathos of Picasso's late art comes from its
revulsion against its own history—not just the overall history of paint-
ing, but the very specific history of Picasso's previous art. His late
"misogyny" is moving and powerful because one sees it against the
background of Picasso's deep love of women (Picasso the painter, I
mean—the man is irrelevant). Those frenzied, obsessional works stand
in stark contrast to the 1904 *Frugal Repast,* where the man, in profile,
looks merely starved, while the woman, who nearly faces us, looks
thoughtful; or the 1906 portrait of Gertrude Stein, where the artist
has given her his own deep, inscrutable Spanish eyes; or the 1932 *Girl
before a Mirror,* in which the obviously female figure on the left has as
her reflection a figure so abstract—and at the same time so character-
istically Picasso—as to be androgynous. Such pictures, and uncount-
able others, have not only presented us with specific women whom
Picasso taught us to love; they have also helped to define, for both
men and women, what it has meant to be female in this century. With
that achievement behind him, Picasso can persuasively take us into
the frightening terrain of his final sexual anxiety. Those late works
may be misogynist, but Picasso the artist is not.

There are certain male artists—Milan Kundera, for instance, and
John Updike—who do strike me as being thorough misogynists. But
if pressed I would probably say that the offense lies in their insuffi-
ciency as artists rather than just in their attitudes toward women. I
don't want to get sidetracked into a full-scale attack here, but I will
take a moment to show what I mean in the case of Kundera's best-
known book, *The Unbearable Lightness of Being.* This is a bad novel, I
think, but it is a bad novel on a high level—extremely intelligent,
quite witty, and very certain about its meanings. In fact, Kundera's
novel is bad partly because its author knows too clearly and powerfully
what he wants to say. Nobody else—in particular, none of the char-
acters—has a chance to say otherwise. The prose has a coy way of
suggesting that the novel is partly the product of accident, as when
Kundera remarks about an earlier section: "There is something I failed
to mention at the time." But this author defers to no power beyond
himself, and the novel's "accidental" deaths—of one character in a

political demonstration, of two others under a truck—all feel excessively contrived. You get the sense that it is easy, too easy, for Kundera to kill off his characters because they were never very much alive in the first place.

Kundera is well guarded against such criticism, in that he builds the answers to it into his novel. This is self-aware fiction of the latest variety, parrying with its right just where the critic is about to throw a left. He counters the comments I've just made by saying in the midst of the novel: "But isn't it true that an author can write only about himself? . . . The characters in my novels are my own unrealized possibilities. That is why I am equally fond of them all and equally horrified by them." Certainly this is egotism of a high order: can one only be fond of one's own faults?

It is also a lie. Kundera does not love all his characters equally, at least to the extent of giving them independent being. The only character in the novel who seems at all substantial is Tomas, a Czech doctor-turned-window-washer. The central fact about Tomas is that he is a tremendous womanizer (in a manner that is much more evocative of writers than doctors), and this promiscuity is clearly an object of intense enjoyment and delight for the author. Any gestures toward condemning Tomas that occur in the course of the novel are purely ritual ones. Kundera tells us that Tomas's wife Tereza is made desperately jealous by his behavior, and we are shown her jealousy and her pain in all its detail. But we can't really feel it. Even when we hear stories about Tereza's dreams or childhood anxieties, the stories have the ring of something told *to* the author, not something experienced *by* him. And this failure of empathy occasionally causes Kundera to misjudge the reader's reaction. In one case, following a tale of Tomas's affair with Sabina and Tereza's discovery of that affair through a hidden letter, Kundera says:

> Anyone who has failed to benefit from the Devil's gift of compassion (co-feeling) will condemn Tereza coldly for her deed, because privacy is sacred and drawers containing intimate correspondence are not to be opened. But because compassion was Tomas's fate (or curse), he felt that he himself had knelt before the open desk drawer, unable to tear his eyes from Sabina's letter.

Who is kidding whom here? While we're in the process of coldly condemning, perhaps we might cast a brief glance at Tomas's own

behavior—but no. Tomas's infidelities, like his desk drawers, are apparently sacred.

An important character in the novel is a female dog named Karenin. As Russian scholars and readers of Tolstoy will know, Karenin is a man's name. But for various reasons Tomas and Tereza do not want to name their dog Karenina, and she therefore becomes Karenin, after which point in the novel she is invariably referred to as "he." Somehow this is indicative of Kundera's attitude toward his human characters, but in reverse: his female characters are just outpourings of a masculine imagination, the results of his determination to give them female names. What they are in themselves does not interest him (though he would have us believe that it does, for this novelist wants full credit for empathy, for "compassion").

There is a great deal of discussion about love in *The Unbearable Lightness of Being:* love of a betraying husband for his betrayed wife, of a lover for his mistress, of an author for his character, of a master for his dog. Finally, the novel seems to assert that the latter is the only form of "unselfish" love, because a dog can't give us anything back. But as anyone who has lived with an animal knows, the love you bear your pets is likely to be the most selfish love of all, for an animal depends on you utterly and reveals its personality in response to yours. Because an animal can't talk, you give it language and thought; because it uncomplicatedly accepts your affection, it makes you feel both powerful and unselfish, both loving and beloved. The mistake Kundera makes is to treat his characters like pets. He thinks what he feels for them is love, whereas it's merely an excess of self. If it were really love, we would be able to push aside that gigantic authorial face that looms out of the pages of Kundera's novel, and find behind it the tiny, human, flawed faces of real novelistic characters. But they aren't there. Behind that leering, all-obliterating mask is nothing.

The artists I've chosen to look at in this book, on the other hand, are men for whom the female face, the fictional self, is not just a mask. For all of them, the feminine represents a mode of access into the fictional, but "the fictional" is by no means seen as simply the opposite of "the real." In fact, these writers, visual artists, and filmmakers frequently use the fictional world they create as a way of commenting on, negotiating with, and possibly even altering that "other" world which is, indeed, part of the same world—that is, the world of our everyday reality.

I would like to do something similar in my criticism. Like the critics I most admire (I'm thinking of Orwell and Empson, among others), I would like to say things about art that matter outside the walls of the academy. I want to talk about subjects—not just men's and women's feelings about each other, but also my feelings about works of art, my sense of the relationship between evasion and directness, my concerns and convictions about the roles of will and chance—that are not, these days, seen as proper subjects for academic literary criticism. And yet, in order to develop this discussion from the raw material of novels, memoirs, poems, photographs, paintings, and films, I have to rely on a density of expression—in terms of both description and analysis—that is not part of everyday speech. I cannot get at the truths I want unless I work with a very heavy pick; but I'm afraid that, in doing so, I may dig myself in deeper than most readers care to follow. This is the inescapable irony for the critic who tries to write general literary criticism in an age when this kind of writing reportedly has no general readers. Between such a critic and her (or his) imagined audience, there may well be a gap that is even wider than the gap between the sexes.

The current climate of gender-theory obsession is the context in which this book appears, but it is not the initial stimulus that gave rise to it. Rather, I am responding in each of these essays to specific conflicts in the work of writers and artists I have cared about—to the presence of Brodkey's "one other genuinely existent thing." In this case, that other thing is often but not always the artist's awareness of the feminine. As a whole, the essays try to go beyond simply describing male artists' attitudes toward women: they end up portraying the attempt to acknowledge yet reach across difference, the search for one's own lost half, and the perception and understanding of divisions within the self.

When I first began to think about this collection of essays, I thought of the myth recited by Aristophanes in Plato's *Symposium,* the one about how certain men and women used to be part of a single body. "The sexes were not two as they are now, but originally three in number," runs Jowett's translation; "there was man, woman, and the union of the two . . ." According to Aristophanes, these four-legged, two-headed people were powerful enough to pose a threat to the

gods. Zeus was the one who came up with the practical solution: "Methinks I have a plan which will enfeeble their strength and so extinguish their turbulence; men shall continue to exist, but I will cut them in two and then they will be diminished in strength and increased in numbers; this will have the advantage of making them more profitable to us."

The gods followed his advice, and the indirect result was human love: "After the division the two parts of man, each desiring his other half, came together, and throwing their arms about one another, entwined in mutual embraces, longing to grow into one . . . Each of us when separated, having one side only, like a flat fish, is but the tally-half of a man, and he is always looking for his other half." When I found the exact passage, I was surprised and also pleased to discover its combination of humor and pathos, for both were aspects of what I wanted to talk about. The search for one's missing half is bound to include ludicrous elements, even as one grants the enterprise all the seriousness in the world.

My topic, then, began as an exploration of the *Symposium* story— at least, that part of it dealing with sundered male-female pairs—in men's art about women. "Art" included, in my definition, not only novels, poetry, and painting, but also film, photography, and other "technology-produced" works. There was something both compelling and moving, I felt, in the way certain male artists portrayed women: a kind of longing that was not just an expression of the erotic (it's not, certainly, erotic attraction as we usually think of it, since one thing these artists do not share is sexual preference); a desire to *be* the other as well as to view her, and at the same time an acknowledgment of irrevocable separation.

Yet as I pursued the topic, the nature of the division inevitably broadened. The sundered pair no longer simply referred to men and women. The selves who had been divided were also the onlooker and the participant, the writing self and the written-about self, the willed creature of mind and the less conscious soul of being; they were the public character, located in history, and the private character, defined psychologically and individually; they were, moreover, the high arts and the popular arts, the priceless and the commercial; and, along with that, they represented the divided nature of the audience itself, which expects and explicitly wants one thing while secretly wishing for another. All of these divisions involved an internal self-contradic-

tion, an apparent confusion of intention. Yet it was a confusion that might, if I pursued it faithfully enough, come to be more significant and more expressive than most clarities.

Over and over, as I thought about these essays, one image kept returning to me: the image of a mirror. It is a mirror, however, in which the portrait one gets back is not the self one expects, but the lost self for which one searches. Thus Randall Jarrell, looking into the mirror, sees his stupid Girl in a Library; Peter Handke sees his suicidal mother; Hitchcock sees his frightened blonde heroines; Degas sees his soft, oblivious nudes; and I—the female critic, looking in—find the male artist peering out at me.

The idea of the divided self or the mirrored self is already familiar to us from the work of psychoanalysts. D. W. Winnicott's "true" and "false" selves, R. D. Laing's schizoid or schizophrenic "divided self," Heinz Kohut's theory of "mirror transference," and Jacques Lacan's notion of the "mirror stage" are all versions of this idea. All of these practitioners are, to one degree or another, inheritors of Freud, and their theories of self-division stem directly or indirectly from Freud's concept of narcissism. I want to take some time now to discuss these mirroring theories and compare them to one another, not only because they are of interest in any definition of "divided selves," but also because I will want to draw on some of these ideas later in the book. And though my summary of narcissistic theory may at first take us some distance from issues of gender, it should be apparent by the end of this chapter how the two concerns intersect.

I do not propose to defend Freud from feminist attacks. That would be a task beyond my means and scope, and I already have my hands full with Degas, Lawrence, and Hitchcock. My allegiance to Freud, in any case, is not premised on what he did or did not say about women. I am much more interested in him as both a literary critic and a cultural phenomenon—that is, at the sentence level and the social level, viewed in terms of the details and the general outline. As a cultural phenomenon, Freud underlies a surprising number of the artists I examine in this book. His influence (sometimes in the form of a resisted influence) on the novels of D. H. Lawrence, the poems of Randall Jarrell, the films directed by Alfred Hitchcock and Preston Sturges, and the films *about* Marilyn Monroe, is direct and explicitly acknowledged. While it's less explicit, one can also see his influence— or at least his culturally transmitted effect—in the self-scrutinizing

work of Cecil Beaton, Peter Handke, and Harold Brodkey. And though James and Degas are too early to be influenced by him, one has the sense that their very contemporaneity with Freud shows through in their work. Freud's and Breuer's *Studies in Hysteria,* James's *The Spoils of Poynton,* and a number of Degas's most luxuriant bathers (for instance, *Seated Nude Drying Herself* and *Breakfast after the Bath*) all appeared within a year of one another. If it's a coincidence, then it's a socially significant coincidence that these three artists, working in three such different forms, arrived simultaneously at an interest in the secrets of women.

But even aside from his pertinence to my particular subjects of study, Freud would be an influence on my work as a literary critic (under which role I subsume, for the moment, art and film criticism as well). For the techniques and theories discovered by Freud are, as William Empson has shown, among the crucial underpinnings of responsive literary criticism. I don't mean that specific Freudian principles should be applied, in some complex-seeking fashion, to the characters, plots, and scenery of literature. The analogy is rather between the central beliefs underlying the two endeavors. Literary criticism of the sort I try to practice (the sort nowadays deprecated by semioticians and post-structuralists as "intuitive" or "impressionistic") shares with Freudian theory a belief in unconscious meaning: the sense that things created by an artist can have significance and even intention without being consciously thought out by the waking self, and the sense that the artist is drawing, for his wit and inventiveness, on a far larger share of memory, association, and deep feeling than one consciously has access to. Primo Levi lucidly describes this underlying source of art when he remarks that writers (like other people) "are made up of ego and id, spirit and flesh and furthermore, nucleic acids, traditions, hormones, remote and recent experiences, and traumas; therefore we are condemned to carry from crib to grave a doppelganger, a mute and faceless brother who nevertheless is co-responsible for our actions, and so for all of our pages." A corollary of this belief, in both literary criticism and Freudian theory, is that things can be "overdetermined"—that is, they can have a variety of meanings which converge on one another in unexpected but significant ways. And a third important analogy between the two endeavors is that they both recognize the relationship—problematic, far from obviously identical, but all we have to go on—between events in the world and the language that expresses them.

Perhaps the analyst who has been most explicit about this connection, and therefore most obviously useful to literary critics, is Jacques Lacan. I sense, on the part of certain of my readers, a heavy sigh and a glazing of the eyes at the introduction of the name Lacan. I sympathize with that reaction; I have frequently felt it myself. But I am not going to burden you here with the Lacan of bizarre charts and diagrams, "subjects" rather than plain old selves, a capitalized "Other," and untranslatable French obscurities. The Lacan I have discovered and learned a great deal from is the practicing psychoanalyst who from 1953 to 1955 presided over a seminar on Freud, the transcript of which is now available to English readers in a relatively accessible two-volume translation. Reading Lacan in seminar—as the sometimes unbuttoned, often joking, but always intellectually committed teacher—is appealingly like reading Plato's dialogues. And like the *Symposium*, *The Seminar of Jacques Lacan* gives us the sense that what we are getting at one remove—in the mere reconstructed transcript of a spoken event, rather than a word-on-the-page direct statement—is actually closer to the heart of things than "real" writing might be. Perhaps this is because in both cases the dialogue format of the symposium mirrors and recreates the "divided self" about which both Lacan and Plato are speaking.

In his talk on "The Topic of the Imaginary," Lacan says:

> Commenting on a text is like doing an analysis. How many times have I said to those under my supervision, when they say to me—*I had the impression he meant this or that*—that one of the things we must guard most against is to understand too much, to understand more than what is in the discourse of the subject. To interpret and to imagine one understands are not at all the same things. It is precisely the opposite. I would go as far as to say that it is on the basis of a kind of refusal of understanding that we push open the door to analytic understanding.

One could take that as the best possible hint on how to do literary criticism: analysis and interpretation are to be performed, but not at the expense of the work's impenetrable mystery. On the contrary, good criticism should further our sense of that mystery, that inaccessibility. Like Freud, Lacan is a great believer in the fundamental importance of language ("Before speech, nothing either is or isn't," says Lacan; ". . . it is only with speech that there are things which are—which are true or false, that is to say which are—and things which are not"), but he is also fully aware of its limitations. "By

definition," he asserts, "speech always has its ambiguous backdrops, which attain the moment of the ineffable, in which it can no longer be spoken, can no longer provide its own foundations as speech."

It is Lacan's Kafkaesque perception of the divided nature of language (both all there is and insufficient) that opens him up, I think, to a perception of inevitable division in the self. He is famous for his theory of the mirror stage, at which the human being first sees himself—whole, unfragmented, neither a bundle of body parts nor a continuation of another being—yet sees himself as *other,* as *not-himself.* This is what Lacan calls the formation of an "imaginary" self, a self that corresponds in some ways (perhaps in all ways—on this he's not too clear) to Freud's idea of the *ideal-Ich,* the ideal ego—that which later took form in Freud's thought as the superego. For both Lacan and Freud, the sense of being a separate, worthy person in the world— the sense of "self-regard"—is thus intimately connected with a sense of "being watched," of having one's life supervised by a self-within-the-self. Both those quoted terms come from Freud's 1914 essay "On Narcissism: An Introduction," the work to which Lacan explicitly attributes his theory of the mirror stage.

Freud's notion of the two selves—the one experiencing and the other watching, the one inside and the other somehow more external—can be seen as crucial to all subsequent psychoanalytic work on narcissism and mirroring. Thus R. D. Laing says in *The Divided Self:* "Self-consciousness, as the term is ordinarily used, implies two things: an awareness of oneself by oneself, and *an awareness of oneself as an object of someone else's observation*" (his italics). Heinz Kohut points out that "what I call the mirror transference in its various phases of development is an expression of the fact that others are experienced and needed in the sense of being *agents for self-confirmation,* for self-approval" (again, his italics). And D. W. Winnicott, in his typically clear and humane manner, remarks in an essay called "The Mirror-role of Mother and Family in Child Development":

> This glimpse of the infant's and child's seeing the self in the mother's face, and afterwards in a mirror, gives a way of looking at analysis and at the psychotherapeutic task. Psychotherapy is not making clever and apt interpretations; by and large it is a long-term giving the patient back what the patient brings . . . I like to think of my work this way, and to think that if I do this well enough the patient will find his or her own self, and will be able to exist and to feel real.

Winnicott warns us toward the end of this essay that though "the actual mirrors that exist in the house" may contribute somewhat to a child's developing sense of self, "the actual mirror has significance mainly in its figurative sense." This seemingly casual remark is a subtle but direct hit at Lacan, who is mentioned as an influence at the start of Winnicott's essay but who "does not think of the mirror in terms of the mother's face in the way that I wish to do here." For Lacan, the importance of the actual mirror is enormous. It would not be going too far, I think, to say that he builds his entire theory of the mirror stage on the literal, visual effects created by mirrors. In the setting of the seminar, he even describes a physical gadget (a burnished cauldron, functioning as a concave/convex mirror, with a vase of flowers placed within it) that is intended to symbolize the problematic notion of the "imaginary" and "real" mirrored selves. As always with Lacan, it is not entirely clear where the symbol trails off into the imaginary, on the one hand, and the real, on the other.

In Lacan's version, the Freudian self often seems the equivalent of one of Philip Guston's late paintings: a single gigantic eye accompanied by a cigar. Lacan's dependence on the visual aspect of understanding is overwhelming, and words like *reflection, imagination,* and *speculation* are crucial to his sense of the way the mind works. "The eye is here, as so often, symbolic of the subject," he says at one point. One can see how his notions are reflected (so to speak) in everyday speech: we say "I see" when we mean "I understand," and we refer sometimes to "the mind's eye" as a way of describing the imagination. Yet one can't help feeling that Lacan is overdoing it. In place of Lacan's "imaginary" (with its connections to the idea of "image"), Freud himself was much more likely to use the adjective "ideal," which has wider and more abstract applications. And we do, in fact, apprehend the world, other people, and our own emotions and perceptions through all five senses, not just sight. "I hear you" is colloquial American for "I understand what you're saying"; "Reach out and touch someone" and "Keep in touch" are, respectively, the commercially exploited and idiomatically common ways of telling people to maintain emotional contact; Catholic communion and Winnicott's idea of analysis as "a good meal" both stress the spiritual aspect of our sense of taste; and "That stinks!" is our slangy way of saying that something is rotten in the moral sphere. Lacan's oversights in this realm are best illustrated by an anecdote Heinz Kohut tells, when he is describing a film about some blind children:

There was a beautiful scene in which one of the children, with some musical talent, played the piano and received acclaim, the normal mirroring of adults' saying it was beautiful or applauding. But the height of the experience came when the playing, which was tape recorded, was replayed. The child suddenly recognized "That's me!" There was this narcissistic bliss that you could see suddenly in this blind child.

That is, mirroring can be aural as well as visual. As Winnicott says, and as Lacan repeatedly seems to overlook, the importance of the mirror is *figurative:* it is not just something that literally gives back the child's reflection, but something that reflects and reinforces the child's sense of self in any number of ways.

For both Winnicott and Kohut, it is the mother (or some substitute for the mother) who offers the mirroring function that Lacan attributes to the mirror itself. I find their theory more appealing than his on a number of levels. For one thing, not all children are exposed to real mirrors—either because of physical constraints (blindness, for instance) or cultural ones. The Japanese, I've heard, explicitly discourage the use of mirrors in the child-raising setting, and there must be many isolated peoples who do not have the technology to make mirrors. Are we to presume that individuals from these cultures do not develop proper selves?

I also have an innate aversion to tracing any crucial development in the self to such a chance encounter with a cold, inanimate object. Thus I find Kohut persuasive when he says:

> What is called the mirror transference is of course very clear. Why do schizophrenics stare into the mirror? What are they trying to do? The answer is obvious. They feel themselves crumbling and disappearing. By vision they are trying to see "No, I'm still there. I can see myself." But a mirror is cold; it is only a mirror visually. The mother is not just such a mirror. She is a responding mirror, which is a very different kind of mirror.

Winnicott explains exactly how that responding mirror works: "What does the baby see when he or she looks at the mother's face? I am suggesting that, ordinarily, what the baby sees is himself or herself. In other words the mother is looking at the baby and *what she looks like is related to what she sees there*" (his italics).

It is ironic that Lacan missed this possibility, this particular version of human mirroring, for in his Freud seminar he singled out, from

Poe's story "The Purloined Letter," a moment that acutely resembles Winnicott's image. Lacan quotes the detective Dupin: "When I wish to find out how wise, or how stupid, or how good, or how wicked is any one, or what are his thoughts at the moment, I fashion the expression of my face, as accurately as possible, in accordance with the expression of his, and then wait to see what thoughts or sentiments arise in my mind or heart, as if to match or correspond with the expression." Given Winnicott's perspective, and the bridge provided by Lacan's quoting of Poe, it's easy to see how empathy—the identification with another's feelings—develops out of the mirroring that has been labeled narcissism. Kohut makes this explicit: "Empathy does develop originally out of a narcissistic relationship to another human being. The likeness of the mother-child relationship, their feeling the same thing at the same time—this is how empathy originates." But this conclusion is possible only if one abandons Lacan's literal notion of the mirror and defines narcissistic love in relation to an extension of oneself, a being other than oneself.

That feeling of mutuality, of another person perceived and responded to, is what I miss in Lacan, and what I find in Winnicott and Kohut. Winnicott, as befits his strong practical bent, eschews labels entirely; Kohut and Lacan both call the focus of their interest "narcissism." Yet the two kinds of narcissism—oneself as seen in a mirror, and oneself as perceived in the reflection given back by another self—aren't exactly the same. This misleading vagueness of definition is, in a way, Freud's own fault. It is he who, in the original essay "On Narcissism," defines the narcissistic type as loving "a) What he is himself (actually himself). b) What he once was. c) What he would like to be. d) Someone who was once part of himself." Lacan, it seems to me, has staked out points (a) and (c), the real self and his "imaginary" or ideal counterpart, whereas Winnicott and Kohut have leaned more heavily toward (b) and (d). For what is the mother, that "responsive mirror," but a combination for the child of "what he once was" and "someone who was once part of himself"?

Throughout the essay "On Narcissism," Freud never once refers to the actual myth of Narcissus, the story that gave his theory its name. This is unlike him: he usually starts with the literary or mythical material—the story of Oedipus or Faust—and moves from there to the abstract. I think that in this case he omitted the myth because it was inappropriate in many ways to the phenomenon he was trying to

describe. All the mirror terminology, from Lacan and others, derives from the myth itself, in which Narcissus falls in love with his own mirror image and never moves beyond that stage. But there are no mirrors in Freud's essay. Even when he uses phrases like "self-regard" or "the delusion of being watched," he does not call on the image or even the idea of a mirror. I want to suggest that Freud's definition of narcissism, especially in its points (b) and (d), is more consistent with another myth—that is, the myth of the divided selves expounded by Aristophanes in the *Symposium*.

Once upon a time, all human beings were unified with a fellow being, were part of the same body with that fellow being. Then came the separation—birth—and the more drawn-out psychological separation following birth. Yet each human being retains a memory, however intangible, of that initial closeness, and each seeks to recapitulate something like that closeness in its intimate relations with other human beings. "To the child the mother is himself," says Kohut. Freud's narcissist seeks to join with "what he once was," "someone who was once part of himself." "Love," says Lacan, "the love of the person who desires to be loved, is essentially an attempt to capture the other in oneself, in oneself as object." "After the division the two parts of man, each desiring his other half, came together, and throwing their arms about one another, entwined in mutual embraces, longing to grow into one . . . So ancient is the desire of one another which is implanted in us, reuniting our original nature, seeking to make one of two, and to heal the state of man," says Aristophanes in the *Symposium*.

What do we gain, other than the loss of the useful mirror, by replacing Narcissus with the *Symposium?* For one thing, I think we gain a sense of the universality of what Freud called "narcissism," a sense that everybody's love possesses it to one degree or another. Lacan has been explicit about this universality, and Kohut has taken pains to distinguish between "good" and "bad," "adaptive" and "non-adaptive," "mature" and "regressive" narcissism; he has even gone so far as to deplore the "value judgments" that automatically accrue to such concepts. But as long as the originating myth remains that of Narcissus, that negative judgment is bound to remain. There is something despicable, and despicably particular, about the idea of that beautiful youth glued fatally to the image of his own static perfection. It is an entirely closed circle, with a certain moral airlessness, a certain

aesthetic sterility. And, on the contrary, there is something admirable, or at least sympathetic, about the thought of a whole race of human beings, a whole species, voyaging out into the unknown to find their severed halves. By opening out the myth we give it air and light, and we also make it apply to ourselves. In that sense, the theory remains mirror-like, showing us our own images. But if there is a mirror in this version of the story, it is a mirror that gives back an image of the self as contained in another self: Winnicott's child looking up into its mother's face, Cecil Beaton twinned with his sister's image, Randall Jarrell finding imaginary women in his looking glass.

When R. D. Laing talks about a "divided self," the term is inevitably pejorative, for it implies an inability to be whole in a world where other people have managed to achieve coherence. But I doubt that such untroubled wholeness is actually possible, or even desirable. To be a divided self is not necessarily to lack anything, except insofar as we all lack something, and are indeed defined by that lack. We are all "like a flat fish, . . . but the tally-half of a man," as Aristophanes says, and it is tragic but it is also funny; it's the human condition. If we can accept the idea that life entails death—that what we mean by life, as opposed to eternity, is defined by death—then can we not also accept the idea that to be a "whole" individual inevitably entails division, separation, and unappeasable longing? These two kinds of doubleness—life entwined in death, and the self seeking its mirror image in other selves—may even be tied to each other, as Shakespeare suggests when he has a character say in *Pericles:*

> For death remembered should be like a mirror,
> Who tells us life's but breath, to trust it error.

For Shakespeare, the mirror has moved so far beyond a purely visual function that it can be used to catch the slight motion of breath. Its literal coldness is the thing that enables it to measure human warmth—just as the feminine, once rendered immortal in art, may be what enables male artists to gauge both their own masculinity and their own mortality.

Before embarking on the chapters about specific male artists, I'd like to take a moment to explain why these chapters appear in the order they do—which is also a way of explaining (to the extent that is

possible) why these artists and not others have ended up shaping this work. A book that begins by mixing together Dickens, Lawrence, Brodkey, Handke, and Berger on the subject of mothers; rockets from Degas through Gissing and James to Hitchcock; backs up a bit for Jarrell and Beaton; and finally puts Stanwyck (a Thirties and Forties star) after Monroe (a Fifties star)—such a book does not, obviously, have an overriding concern with chronology. In fact, the critical technique which nowadays goes under the name of "historicism" is not especially useful in the kind of impressionistic, audience-based criticism I do. Regardless of when artworks were created, we respond to them (to the extent they have not dated) from our own position in time. I have chosen to look at these particular artworks because they have *not* dated—by which I mean that, as artworks, they function as powerfully now as they ever did: we do not have to make any allowances for them. For this reason, I have felt free to abandon chronological order. As I end up saying in the Barbara Stanwyck chapter (where I talk about Preston Sturges's *The Lady Eve*), certain works piercingly comment on other works made after as well as before them. My non-chronological sequence enables me to acknowledge such visionary qualities. For I believe, with something akin to naive faith, that real artworks transcend their time even as they are of it—just as they simultaneously transcend gender and partake of it.

In keeping with the psychoanalytic (or, to be more accurate, Winnicott-based) underpinnings of the book, I have tried to find a sequence that is developmental rather than historical, in the sense that the "history" it mirrors is that of the individual life. I see the book as moving from the artist-as-child to the artist-as-adult, from the "primitive ruthlessness" of infant passion to the more civilized and mutual forms of adult love. (I hope I can use such words without seeming to elevate civilization over infancy, or vice versa. Whereas we like our companions to grow up, this may not necessarily be something we want in our artists.) Along with this development goes a progression in the view of women: from woman as mother (the first chapter), to woman alone (the Degas and Gissing chapters), through woman as opponent in the sexual battle (James, Hitchcock), and finally to woman as the artist's mirror (Jarrell, Beaton, Monroe)—which brings us rather circuitously back to the beginning, if we recall Winnicott's idea of "the mother as mirror." The chapter on Barbara Stanwyck then recapitulates all of the phases of the book. Needless to say, the

various artists I examine refuse to sit neatly in their assigned categories, and are forever popping out of mirroring to say something about infancy, or out of women alone to say something about the battle of the sexes, or whatever. It is in the nature of such a topic to have its various aspects connected in more than one way: that very overdetermination is what makes it a fruitful topic.

Somebody is bound to point out that I am comparing apples and oranges here—that a commercial film by Billy Wilder can't usefully be set against a novel by Henry James, or a commissioned fashion photo by Cecil Beaton be compared to a self-generated masterpiece like one of Degas's nudes. I grant that the book has even less respect for disciplinary boundaries than it does for chronological order. On the other hand, I don't think that what I'm doing here falls under the rubric of "comparing." I'm not interested in determining, in some bizarre *Animal Farm*–ish fashion, whether all these artworks are equal. Their relative values will vary, not only from person to person, but even for me from one day or year to the next. I don't, however, want to let go of the idea of value, or evaluation. All of the artworks I focus on in this book are here because they are good. They are even comparably good: Beaton's photo of Coco Chanel is better than most other fashion photography, James's *The Golden Bowl* is better than most other novels, Vidor's *Stella Dallas* is better than most other Thirties melodramas, and so on. But these exemplary works needn't then be ranked against one another to establish their value; that value is already presumed in their inclusion here.

Combining disciplines has led me into one linguistic snarl which I should at least acknowledge, since I can't untangle it. The problem has to do with how I discuss intentionality in film. I have no anxiety about attributing intentions to writers or painters, since I don't really care to what extent the conscious mind or the unconscious produced the work. I have only minimal concerns about attributing intentions to a photographer (who does, after all, control both initial shot and final selection), and in any case these concerns prove helpful in focusing my ideas about Cecil Beaton. But I do feel uncomfortable referring to a movie as if it were the product solely of a director's mind, when so much else—screenwriter's words, cameraman's technique, producer's restrictions, not to mention what is perhaps the most important factor of all, actors' performances—goes into making a film. In this book I use the director's name to represent all of these people, and

their contributions unfortunately get subsumed under his. Yet I don't see any way around it. Not only is this the convention; it also describes, at least to some degree, a reality. With directors like Alfred Hitchcock and Preston Sturges (and, to a lesser degree, Billy Wilder, John Huston, and King Vidor), there *is* such a thing as a recognizable film style. Theirs may not be the only signature on a movie, but it is certainly the largest.

Still, the book acknowledges the way in which, as we move from writing and painting through photography to film, the artwork begins to get away from its creator. Thus the final two chapters on movies refer in their titles, not to the male directors who are looking at women, but to the women who are looked at. Monroe and Stanwyck, rather than Hathaway, Wilder, Huston, Vidor, and Sturges, are the determining forces in our experience of their films. This is not to say that the director is helpless. A Billy Wilder movie with Marilyn Monroe can be (and is) better than a Jean Negulesco movie with Marilyn Monroe, or even than a previous Billy Wilder film with her (as the superiority of *Some Like It Hot* to *The Seven Year Itch* demonstrates). Nor is the situation that prevails in film entirely unconnected to what takes place in novels or poems or paintings. The actress dominates— but is that so different from what happens with a male author's female character, or a painter's imaginary woman? It becomes impossible to draw the line between discovery and creation, between the woman who inspires an artwork and the artwork she inspires. Winnicott expresses this idea in psychoanalytic terms when he says:

> I should like to put in a reminder here that the essential feature in the concept of transitional objects and phenomena (according to my presentation of the subject) is *the paradox, and the acceptance of the paradox:* the baby creates the object, but the object was there waiting to be created and to become a cathected object. I tried to draw attention to this aspect of transitional phenomena by claiming that in the rules of the game we all know that we will never challenge the baby to elicit an answer to the question: did you create that or did you find it?

The same rules, I should think, prevent us from so challenging the artists at whom I'll now proceed to look.

Mothers

2 Whenever a man sets out to write a story about a mother (or *his* mother, for it comes to the same thing), it is also, inevitably, a story about the extortion of sympathy. Two kinds of sympathy are extorted: the reader's and the male author's. That is to say, it becomes a story both about the sympathy the author had to feel for his mother and about the sympathy we have to feel for him because that other sympathy was forced from him.

This story about extorted sympathy also becomes a story about how that man came to be a writer. For in feeling another's pain, he begins to learn how to create characters beyond himself; and in extracting sympathy from us without making us resentful, he learns the skill of mediating between himself and an audience of readers. It's possible that something comparable takes place in the genesis of female writers, but in their case I do not think the origin of authorship hinges so heavily on the mother. Only a man can envy, with a futility and frustration that eventually prove fruitful in fictional terms, the power to give birth to a creature other than oneself. Only a man can play Pygmalion to his mother's Galatea, Orpheus to her Eurydice. Only with a man does the attempt to portray his mother—to create her anew, or to bring her back from the land of the shades—involve such a conscious overcoming of difference, such a pained acknowledgment of similarity within that difference.

A chapter on "Mothers" is thus an obvious starting point for a book about male artists looking at women, for the mother is the initial woman from whom the male artist has literally to sever himself in order to become both a man and an artist. The mother may, in some disguised form, be the female figure animating the work of all male artists; of that I can't be sure, nor do I care to make such broad pronouncements. What I *can* say about the five authors I consider in

this chapter—Charles Dickens, D. H. Lawrence, Peter Handke, Harold Brodkey, and John Berger—is that they had to retrieve, refashion, and finally let go of their mothers, in memory and in writing, before they could embark on their own lives as writers. For some of them, this process itself became their primary work as writers.

It is to Charles Dickens that one must look for the initial item in the series, the initial book about a mother remembered, retrieved, and forgiven through literature. *David Copperfield* is not, of course, the first literary work about a mother; for that one would have to go back at least as far as the *Oresteia*. But it is the first novel, to my knowledge, that harps on the dualities so self-consciously displayed in the work of more recent writers like Handke, Brodkey, and Berger. As a work of fiction that bears some relation to autobiography, it brings together adult self and child self, remembering writer and experiencing character, the real C.D. and his fictionalized self D.C. And it demonstrates (as does, for that matter, *Remembrance of Things Past*), that a story about memory retrieved must be, to begin with, a story about one's mother.

One might put it the opposite way as well: a story about one's mother is bound to be a story about the duality of memory (oneself seen simultaneously as small child and remembering adult) and about the duplicity of memory ("Is this *really* the way it happened?" the remembering adult asks the remembered child, and gets no answer). The doubleness inherent in the transcribing of childhood memories is central to these stories about mothers, and it is particularly central to *David Copperfield*. Time and again in the early scenes of the novel, where David is remembering both his long-dead mother and his own small self, we get references to the discrepancies between the child's perceptions and the adult's. There is the message about "Barkis is willing" that little David must transmit uncomprehendingly, though *we* know (and the adult writer Copperfield knows) that it means Barkis wants to marry Peggotty. There is Mr. Murdstone's joke to his cronies about "Brooks of Sheffield"—his way of referring to David without David's knowledge, so that only the adults in the conversation (Murdstone, his friends, ourselves, the grown-up Copperfield) will be in on the joke. There is the portrait of David's mother herself: a beloved and frightened fellow-child in his eyes, a weak and somewhat vain woman in ours. For the child David, Murdstone is the uninvited oppressor, and his sister, Miss Murdstone, takes on all the evil that

womanhood need bear. But for us, as adults, it seems reasonable that David's mother bear some of the blame for introducing Murdstone to the household (she did, after all, marry him) and for allowing him to take charge of David's life.

We might be tempted, in some moods, to banish our awareness of the mother's flaws by saying that Dickens didn't know any better, that he felt women were mere victims of society—and there *is* some truth to that, represented here in the tales not only of Clara Copperfield Murdstone, but also of Martha and Little Em'ly. But *David Copperfield* is also the novel which contains Betsey Trotwood—that good, strong, effective woman who herself considers David's mother a weak child. And this is the novel which asks us to choose between Dora, David's first wife—a weak, pretty, brainless little thing who tremendously resembles his mother—and Agnes, his strong, intelligent second wife. The novel clearly chooses Agnes. If David cannot acknowledge the unhappiness his mother caused him, he can at any rate begin to understand the unhappiness he brought upon himself through marrying a woman exactly like her.

That Dickens has set out to write a novel *about* memory as much as through memory is clear from his numerous references to that mental capacity. As early as the second chapter of the novel, which is titled (with Lacanian acuity) "I Observe," David says of his mother and his beloved nurse Peggotty:

> I believe I can remember these two at a little distance apart, dwarfed to my sight by stooping down or kneeling on the floor . . . This may be fancy, though I think the memory of most of us can go farther back into such times than most of us suppose; just as I believe the power of observation in numbers of very young children to be quite wonderful for its closeness and accuracy.

Halfway through the novel, when he first revisits Yarmouth with Steerforth, he comments: "The streets looked small, of course. The streets that we have only seen as children always do, I believe, when we go back to them. But I had forgotten nothing in them . . ." Memory is simultaneously false and true: it reduces the scale but preserves all the details. Might this not also be an accurate description of Dickens's novels? They compress a lifetime or an entire society into the span of six hundred pages, so that everything is miniaturized, doll-like—except, that is, for the details, which, retaining the vitality and

power of memory's first impression, grow hugely disproportionate to their setting.

My own first exposure to Dickens was having *David Copperfield* read to me by my mother when I was seven or eight. That single reading planted the book so firmly in my memory that I was able to pass university exams about it and discuss it in college seminars without ever perusing it again until I was thirty-six (when I read it to write about it in this chapter). All the details remained absolutely as I had remembered them: Peggotty's red face, Little Em'ly's blue eyes, Steerforth's handsome good looks, Mr. Micawber's syntactical convolutions, and so on. But what I only saw for the first time during this adult reading was the way the novel is actually constructed around the idea of an adult re-encountering childhood memory. It was quite a disconcerting experience, and I might have suspected myself of confusing the book's intentions with my own idiosyncratic response if I had not had George Orwell to back me up. In his essay "Charles Dickens" Orwell says:

> I must have been about nine years old when I first read *David Copperfield*. The mental atmosphere of the opening chapters was so immediately intelligible to me that I vaguely imagined they had been written *by a child*. And yet when one re-reads the book as an adult and sees the Murdstones, for instance, dwindle from gigantic figures of doom into semi-comic monsters, these passages lose nothing. Dickens has been able to stand both inside and outside the child's mind, in such a way that the same scene can be wild burlesque or sinister reality, according to the age at which one reads it.

What isn't made explicit here is that Dickens constructed this particular book precisely around the capacity Orwell describes: the capacity of the mind to revert to childhood memory as truthful observation while at the same time altering its interpretation of events to fit an adult point of view.

This duality of vision is so important in *David Copperfield* that it even invades the hateful Mr. Murdstone. "He had that kind of shallow black eye—I want a better word to express an eye that has no depth in it to be looked into—which, when it is abstracted, seems, from some peculiarity of light, to be disfigured, for a moment at a time, by a cast"—to be looking, that is, in two directions at once. Later David says of his stepfather: "That old, double look was on me for a moment; and then his eyes darkened with a frown as it turned, in its aversion,

elsewhere." Here there is even the grammatical duality of the singular "look" and the plural "eyes" to stress the doubleness. Murdstone's dislike of David, "*its* aversion," belongs grammatically to his "look," just as Murdstone's looks are what David is looking at—and disliking—here. To see and to be seen are the two gestures central to this novel, and they are most powerful when performed simultaneously by the same person. "I Observe": David looks at himself as a child from the outside, becomes a character in his own memory. His sense of self-regard, of being a real and valuable person in the world, is intimately and sometimes conversely linked to his sense of being a self regarded. "More solitary than Robinson Crusoe, who had nobody to look at him and see that he was solitary, I went into the booking-office," he says of his first lonely trip to school; and once at the school, where he is forced to wear a shaming placard on his back: "Whether it was possible for people to see me or not, I always fancied that somebody was reading it. It was no relief to turn round and find nobody; for wherever my back was, there I imagined somebody always to be." The verb "imagined" stresses the visual nature of Dickens's procedure: it is the "I" who represents, or substitutes for, the "eye" of others looking at the pathetic self.

That this self-regarding behavior is closely connected with a passion for literature is demonstrated elsewhere in the novel. About his life with Mr. Micawber, David remarks: "I set down this remembrance here, because it is an instance to myself of the manner in which I fitted my old books to my altered life, and made stories for myself, out of the streets, and out of men and women; and how some main points in the character I shall unconsciously develop, I suppose, in writing my life, were gradually forming all this while." The child David converts his real surroundings into stories resembling the books he read in earlier childhood, and the adult David, "in writing my life," converts his child self into a "character." Against a background of such deep and complex authorial intentions, the word "unconsciously" itself begins to seem duplicitous, or at least only half-true.

At the very end of the novel, David comments for the last time on one of the "old books" he read as a child. "There is something bulky in Peggotty's pocket," he says in the present-tense chapter called "A Last Retrospect."

It is nothing smaller than the Crocodile-Book, which is in rather a dilapidated condition by this time, with divers of the leaves torn and

stitched across, but which Peggotty exhibits to the children as a precious relic. I find it very curious to see my own infant face, looking up at me from the Crocodile stories; and to be reminded by it of my old acquaintance Brooks of Sheffield.

This is Orwell's experience recapitulated—or mine, for that matter: we find our childhood selves, and our present differences from those selves, in the pages of the books we long ago read as children. "Unconsciously" or not, Dickens is very carefully underlining the parallel between our experience and his: he is able to create that experience for us because he understands it so well himself. At this moment of re-reading, he is both intimately connected with his child self ("I see my own infant face," which in turn is "looking up at me"—the double vision, the mutual glance, both selves seeing and seen) and completely separate from that outsider, that mere "acquaintance," Brooks of Sheffield. At his most plangent in this chapter (as he always is when using the present tense, as if that intense degree of grammatical involvement made ironic distance impossible), Dickens nonetheless retains a shred of biting humor in the reference to Brooks of Sheffield—for that was originally a joke at his own expense, one perpetrated by his worst enemy (Murdstone), and one that we could share only by joining with that enemy against the oblivious child. My conspiratorial "we" includes both the novel's readers and its adult narrator. David Copperfield, by becoming a character in his own book, has also become a potential victim of his author's curious combination of sentimentality and wit, for Dickens, as much as Murdstone, is the man with that "old, double look." He has the ability to make us weep and snigger almost simultaneously (as Oscar Wilde astutely suggested in his remark about its taking a heart of stone to read of the death of Little Nell without laughing).

Even this cruel sentimentality, this signature Dickensian technique, is acknowledged and to some degree explained in *David Copperfield*. The crucial memory-producing book, the stand-in for all childhood reading and for *David Copperfield* itself, is called, significantly, "the Crocodile-Book." D. W. Winnicott—whom I will rely on repeatedly throughout the ensuing chapters as the most lucid and humane representative of the Freudian viewpoint—has something interesting to say about crocodiles. In a footnote to an essay called "Primitive Emotional Development," Winnicott remarks: "Crocodiles not only shed

tears when they do not feel sad—pre-concern tears; they also readily stand for the ruthless primitive self." Are our tears for Dickens's characters—in particular, our tears at the deaths in this novel of David's mother and his wife Dora—merely crocodile tears? If Winnicott is right, the adverb "merely" is wrong, for crocodile tears go even deeper than our mature, "post-concern" tears. Crocodile tears are prior to sympathy; they are the tears of a raging, insistent, "ruthless primitive self" which can view the world only in light of its own hungers and desires. Dickens needn't explain all of this to us, needn't even "know" it, in a biographical, historical, awake-in-the-daylight sense. He need only, with the economy of a dream, allude to the Crocodile-Book.

David Copperfield has sometimes been described as an extremely Freudian novel, and it certainly has the basic elements: the son seeks to replace the beloved dead mother with the inappropriate first wife, and only at that wife's death does he succeed in freeing himself from the need to marry his mother. (The same pattern recurs in D. H. Lawrence's *Sons and Lovers,* perhaps the most Freudian novel ever written, as the title makes clear. But in that case Miriam needn't die— needn't even become the first wife—to begin freeing Paul Morel from his mother; she need only be consumed and then rejected.) Dora, the first wife, is the scapegoat for David's hatred of his mother, a hatred which he cannot acknowledge directly but which he gives us—as readers—ample evidence to reconstruct. The failure to acknowledge that hatred is what makes Dickens sentimental. "Sentimentality is useless for parents, as it contains a denial of hate," Winnicott says in another essay, "and sentimentality in a mother is no good at all from the infant's point of view." Winnicott is speaking about a mother's natural hatred for her child, but the same applies even more strongly to a child's hate for its mother. It is the sentimentality in Dickens that makes us weep. (By contrast, Harold Brodkey's stories about his dying mother, though sad, do not make us weep, for they have been completely purged of sentimentality: the hate has been and, through the stories, *is* being acknowledged.) I do not mean to insult Dickens by calling him sentimental; that is part of the genius of his technique. Without the hate which his sentimentality covers over—without that biting crocodile down in the primitive depths—Dickens's weepy passages would produce no effect at all. They work because of our capacity, our desire, to forget the hate which is nonetheless buried in all of us. And they embody the authorial extortion of sympathy which

imitates, in its ruthlessness and power, the mother's original extortion. Especially in Dickens, our sympathy, our pity, are forcibly ripped from us.

The sentimental passages are, in addition, psychologically true to the narrator of *David Copperfield*. If, as Winnicott says, "sentimentality in a mother is no good at all from the infant's point of view," this is partly because such an attitude, such a need to cover over reality, is likely to be transmitted from mother to child. David Copperfield is truly his mother's child: "'He's as like her, Dick,' said my aunt emphatically, 'he's as like her, as she was that afternoon, before she began to fret. Bless my heart, he's as like her, as he can look at me out of his two eyes!'" And one way he is like her is in his refusal to see evil in the world. What Murdstone was to her, Steerforth is to him, a beloved object whom he allows to be the instrument of others' doom. Both David and his mother permit their sentimentality to blind them. And David, because he is an author, also manages occasionally to blind *us* with tears. But because he is a good author, he looks at things "out of his *two* eyes" rather than just one. So when he gives us sentimentality, he also gives us the instruments (wit, hatred, resistance, perception, memory—they are all related) to uncover that sentimentality and make it reveal the truth.

David Copperfield is the one Dickens novel in which the main character is a writer, the only novel in which Dickens comments on how he became a writer and what that means to him. It seems to me no coincidence that it should also be his great novel about loving and losing a mother, about seeking to recreate that mother in a wife, and about finally freeing himself from the desire for that particular kind of woman. What the works I look at in this chapter all share is a sense that in order to become a writer a man must both immerse himself in his mother and free himself from her. To become a writer, particularly a writer able to tell the story of his own mother, is to learn both sympathy and the limits of sympathy. It is to get inside the woman who once contained you, and then get out. The difficulty of doing this cleanly and neatly is where the problem of extortion arises: the writer, like his mother, will invariably want to demand more sympathy, more empathy, than one can easily give.

Near the beginning of *A Sorrow Beyond Dreams,* the true story of his mother's life and suicide, Peter Handke says: "The desire to tell someone about it cheered me up. It was such a bright day; the snow;

we were eating soup with liver dumplings; 'it began with . . . '; if I started like this, it would all seem to be made up, I would not be extorting personal sympathy from my listener or reader, I would merely be telling him a rather fantastic story." Handke doesn't really mean this; or rather—as so often in these stories about mothers—the truth is inextricably mixed with a lie. So he means it exactly as much as his mother does when she says in a letter to him written shortly before her suicide: "I know I ought to find some way of making life bearable, I keep thinking about it, but nothing occurs to me. Just read this and forget it as fast as you can, that's my advice." Like the writer—and *as* a writer, if only a letter-writer—the mother feels a responsibility not to burden the reader, her son, with the pain of her pain. And yet in expressing this sense of responsibility, she and Peter Handke both make the transmitted pain more intense. Their apparent act of self-abnegation, which really pleads for sympathy, exacerbates our sympathetic pain by adding to it both disgust (at the transparency of the lie) and guilt (at the disgust).

A similar duplicity shapes Harold Brodkey's "A Story in an Almost Classical Mode," where he prefaces the excruciating tale of Doris Brodkey's slow death by cancer—and her infliction of that slow torture, through the mechanism of sympathy, on her son Harold—with the remark: "I do not think you should be required to give sympathy." The similarity is not, I think, entirely coincidental. Brodkey's fiction-disguised-as-autobiography bears a visible relationship to Handke's autobiography-disguised-as-fiction, and Brodkey has shown himself to be aware of Handke when he says elsewhere: "The phenomenological distance from facts—the facts underlying an argument—is what 'Not very alive' means. Too distant from the real, from actual phenomena. It is not a terrible pejorative. It applies to writers as successful as Updike and as serious as Handke." Even this is duplicitous, or at least double-edged. Is "Not very alive" not a pejorative at all, or simply a minor (not terrible) one? Is Handke being praised for his difference from Updike (his seriousness, as opposed to commercial "success"); or is he being insulted by being lumped with Updike; or is he being compared unfavorably—a pitiable, self-pitying, overly serious failure—with the self-confident, successful Updike? Does Brodkey see Handke as intentionally "distant from the real"? Does he acknowledge it as a reasonable, at times necessary approach to dealing with feeling?

"I do not think you should be required to give sympathy." There

are all sorts of ambivalent, multifarious words in this sentence. There is, first of all, the central ambivalence of "not," the essential duplicity of denial. (Freud says in his essay "Negation": "'You ask who this person in the dream can have been. It was *not* my mother.' We emend this: so it *was* his mother.") And there is the questionable value, for Brodkey, of the verb "think." "Almost everyone I knew could *think* better than I could," he says later in the same story. "Whenever I thought anything through, I always became a little angry because I felt I'd had to think it out to reach a point that someone better parented would have known to start with. That is, whenever I thought hard, I felt stupid and underprivileged. I greatly preferred to feel." The whole story is the story of hard, intense, self-resisting, occasionally triumphant thought, yet Brodkey instructs us to mistrust his ability to "think." But even beyond that is the greater uncertainty of the word "you." On the one hand, it can be treated as the generalized person, the colloquial American version of the British "one." "I do not think anyone should be required to give sympathy"—and in particular this anyone, myself, Harold Brodkey, should not have been *required* and should not now be required to give sympathy to the sympathy-demanding Doris Brodkey. But in the context of the whole story, the word is just as likely to mean a particular "you"—you the reader to whom this story is addressed. The last line of the story is "Make what use of this you like." This has not, then, been an internal, purely self-therapeutic meditation; there's an audience to Brodkey's, or "Brodkey's," tale, and that audience is us—or "you." Even the way the pronoun shifts suggests both the inevitability and the impossibility of actually climbing inside someone else's skin.

Fiction is about such climbing inside of other skins, and writing about one's own mother challenges the possibility of such fiction-making. When a son sits down to create the character of his mother, complete identification with her—an identification which, perhaps, was demanded of the child implicitly or explicitly during the whole of their joint lives—becomes manifestly impossible. His own sense of self-preservation prevents it, not to mention his very real memories of her as a separate, not-at-all fictional person. But if the writer cannot get inside his mother, nor can he get completely outside her. She remains resistantly mysterious but permanently joined to him, an inscrutable double whom he cannot escape even as effectively as he occasionally escapes himself. Handke puts it this way, in a long parenthetical observation:

I try with unbending earnestness to penetrate my character. And because I cannot fully capture her in any sentence, I keep having to start from scratch and never arrive at the usual sharp and clear bird's-eye view.

Ordinarily, I start with myself and my own headaches; in the course of my writing, I detach myself from them more and more, and then in the end I ship myself and my headaches off to market as a commodity— but in this case, since I am only a *writer* and can't take the role of the *person written about,* such detachment is impossible. I can only move myself into the distance; my mother can never become for me, as I can for myself, a wingèd art object flying serenely through the air. She refuses to be isolated and remains unfathomable; my sentences crash in the darkness and lie scattered on the paper . . .

If to be an artist, a writer, is to fly unburdened with the weight of reality, then to think about one's mother—to attempt to think oneself *into* one's mother—is to be brought with a crash down to Mother Earth. Brodkey notices the same vertiginous effect:

Riding on the bus I tried to imagine myself—briefly—a loose-fleshed, loose-boned soft-looking woman like my mother with her coarse am- bitiousness and soulful public manner (when she wasn't being shrill) and the exigent fear of defeat that went with what she was . . . I did it sort of absently, almost half drowsing, I thought it was so, well, dull, or unilluminating. But suddenly I experienced an extraordinary vertigo, and a feeling of nausea, and I stopped quickly.

What seems at first to be uninterestingly easy—the fall out of oneself into the mother—turns out to be terrifyingly easy. Yet a great resis- tance prevents the son from actually taking that fall: hence the vertigo, the fear of falling.

D. W. Winnicott has looked psychoanalytically at this kind of ver- tigo, and in his essay "Anxiety Associated with Insecurity" he quotes from C. F. Rycroft's paper "Some Observations on a Case of Vertigo":

Vertigo is a sensation which occurs when one's sense of equilibrium is threatened . . . As the infant learns to crawl and later to walk the supporting function of the mother is increasingly taken over by the ground; this must be one of the main reasons why the earth is uncon- sciously thought of as the mother and why neurotic disturbances of equilibrium can so frequently be traced back to conflicts about depen- dence on the mother.

"Conflicts about dependence on the mother" is a dry and drastically understated description of what goes on in Brodkey's story, the central

problem of which is to determine precisely who—the mother or the son—was more dependent on whom. (Hitchcock's use of the title *Vertigo* is also pertinent here. At the core of Jimmy Stewart's problem in that movie is his extreme need to separate romance from maternal affection, to separate the parts of his emotional life satisfied by the imaginary Madeleine/Carlotta from the parts related to the earthy Midge—Midge being the aspiring girlfriend who, when she visits him in the mental hospital, creepily reassures him: "Don't worry. Mother's here.")

Brodkey's attempt to identify with his mother is an extremely physical one, much more so than Handke's (or, for that matter, than anyone else's I've read). Somewhat later in the story than the vertigo experience described above, he actually makes an effort to transform his body imaginatively into hers:

> I imagined my hips as being my shoulders: I hardly used my hips for anything; and my shoulders, which were sort of the weighty center of most of my movements and of my strength, as being my hips. I began to feel very hot; I was flushed—and humiliated. Then after a moment's thought, going almost blind with embarrassment—and sweat—I put my behind on my chest. Then I whacked my thing off quickly and I moved my hole to my crotch. I felt it would be hard to stand up, to walk, to bestir myself; I felt sheathed in embarrassment, impropriety, in transgressions that did not stay still but floated out like veils; every part of me was sexual and jutted out one way or another.

The power of this description lies in its awkwardness, its grotesqueness, its failure to effect a complete transformation. This is no easy, seamless conversion of man to woman, like Dustin Hoffman's in *Tootsie,* where you can't tell the finished product from a born female. It's more like the comic, awkward woman Jack Lemmon turns into in *Some Like It Hot* (where Lemmon is always losing his bosom when his brassiere breaks, as if the acquired pieces weren't fully in place, "did not stay still"), except the comedy of that movie has been replaced here by the discomfort of pure embarrassment. The mood of Brodkey's story is so wrenching, so deeply gouging, that it leaves no room for giggles. The absence of ease and the failure of artifice are the point here: Brodkey works like a demon ("blind with . . . sweat") to picture himself as a woman, does as much as anyone could ever ask a man to do, and still comes up with only a grotesque approximation. It's in

Brodkey's admission of failure—the failure of empathy and literary self-transformation—that the moral charge of this story rests. For it seems to me that no male artist or writer, once having read this passage, can ever confidently and comfortably claim to identify fully with women, to reach "the woman in himself." Such sympathy, if it is to be entirely honest, entails the acknowledgment of profound and ineradicable difference.

Brodkey goes "almost blind with embarrassment" when he tries to imagine himself as his mother. It is not coincidental that Oedipus's punishment for sleeping with Jocasta was to have his eyes gouged out. The relationship between mother and son, if it becomes too intimate, is necessarily one of averted eyes—averted because to stare directly, to acknowledge the connection, would be too painful. "Simply contemplating the fact, the phenomenon of middle-aged women, I seemed to myself to have entered on obscenity," says Brodkey. "Well, then, I ought just to take them for granted and avert my eyes. But then I could not imagine what it was to be Doris or what she was going through." It is through the eyes, the image, that we are literally able to imagine, as Brodkey points out when he brings these two terms together. Seeing from the outside (as Degas suggests in his painted, self-enclosed nudes) is often the closest we can get to feeling another's life from the inside. Elsewhere Brodkey forces us not to avert our gaze, lets *us* in for some of the transmitted, sympathetic pain, by describing in detail his mother's cancer-destroyed chest: "She lowered her nightgown to her waist. The eerie colors of her carapace and the jumble of scars moved into my consciousness like something in a movie advancing toward the camera, filling and overspreading the screen. That gargoylish torso. She spoke first piteously, then ragingly. Her eyes were averted, then she fixed them on me." The moment of horrible reality is the moment at which the mind clings to the possibility of artifice—"like something in a movie advancing toward the camera." But his mother is not safely up on a screen; she can and does meet his gaze.

Peter Handke makes a similar attempt to grasp onto artifice in a similar scene about looking at his mother. "I found her lying on her bed with so wretched a look on her face that I didn't dare go near her . . ." he says. "It was a torment to see how shamelessly she had turned herself inside out; everything about her was dislocated, split, open, inflamed, a tangle of entrails. And she looked at me from far

away as if I were her BROKEN HEART, as Karl Rossmann was for the humiliated stoker in Kafka's novel." His mother's bodily dislocation and inflammation are *imagined* by him, not *seen*, as Brodkey's "gargoylish" vision is. Where Brodkey is relentlessly concrete, Handke is relentlessly metaphorical.

For Handke as for his mother, books offer a saving way of thinking about oneself: "To her, every book was an account of her own life, and in reading she came to life." Yet this is not mere escapism on either his or her part, not merely a failure to confront the tragedy of existence. The mother's ability to face that tragedy is proven by her suicide; Handke's is proven by his examination of her suicide. If he can do the examining only by turning her life and death into a book, that too is part of his self-discovery, and of his tragedy. Artifice and metaphor can be a respite, as he shows when he says on the last page of the memoir: "Then again, something cheerful: in a dream I saw all sorts of things that were intolerably painful to look at. Suddenly someone came along and in a twinkling took the painful quality out of all these things. LIKE TAKING DOWN AN OUT-OF-DATE POSTER. The metaphor was part of my dream." But the title of his book is *A Sorrow Beyond Dreams,* a grief that cannot be appeased by these temporarily soothing moments of artifice. To dream in metaphor, and to *know* that the metaphor is within the dream, is to acknowledge the limits of metaphor as a healing device. Handke is not unwittingly failing to marshal the intensity of gaze that Brodkey brings to bear on his subject; he is, rather, pursuing the implications of his own need to flee such concreteness of vision. With honesty and self-scrutiny equal to Brodkey's, he is acknowledging the painful but saving distance between himself and the woman whose body he once inhabited.

For both Brodkey and Handke, the distance between themselves and their mothers—that necessary separation that keeps them from entering imaginatively into these women—is akin to the distance between adult self and child self, between the self who experiences and the self who remembers, between the man who lives in the world and the man who writes about that life. Brodkey's remark that "art involves at least one convincing voice plus at least one other genuinely existent thing" is echoed in the opening sentence of "A Story in an Almost Classical Mode": "My protagonists are my mother's voice and the mind I had when I was thirteen." Thus the story actually has three characters, each of whom partially inhabits the other two: the mother's

voice as the adult Brodkey remembers it, the thirteen-year-old mind as the adult Brodkey remembers it, and the remembering adult. Much of the emotional pressure of the story, especially at the end, comes from the power of hindsight, the adult's perceptions of his younger self's mistakes: "I had no notion that dying had educated her . . . I guessed wrong on that last occasion . . . I refused to understand." It is precisely the act of memory that the young Brodkey refused to engage in ("So far as I knew I didn't blame her, not for anything; but not blaming someone is very unlike forgiving them: if I was to forgive her it meant I had first to remember"), and it is that act of memory—in the form of this story—which makes possible and actually becomes Brodkey's act of forgiveness. Despite all its cruelty and pain, the story finally reaches a redemptive note, not only because the mother was able to act well and honestly on her deathbed, but because Brodkey himself is finally living up to her honesty by writing this story.

In Handke's case, the doubleness of vision is both temporal (the past remembered versus the present in which the writing is taking place) and attitudinal (the objective report versus the subjective experience). Both dualities appear in the first two paragraphs of *A Sorrow Beyond Dreams:*

> The Sunday edition of the *Kärnter Volkszeitung* carried the following item under "Local News": "In the village of A. (G. township), a housewife, aged 51, committed suicide on Friday night by taking an overdose of sleeping pills."
>
> My mother has been dead for almost seven weeks; I had better get to work before the need to write about her, which I felt so strongly at her funeral, dies away and I fall back into the dull speechlessness with which I reacted to the news of her suicide.

The past—the recent past, less than seven weeks old—and objective reality are represented by the first paragraph, the present and subjective reality by the second. It is only through the act of writing that the present can conquer the past, that the active self-assertion of speech can conquer the passive "speechlessness" of experience. Yet this imposition of the present self on the past involves, paradoxically, a distancing from the self. To make his mother into a character in a book, Handke must also make himself into one. As in Dickens—and with something of Dickens's affection for trivial detail—the child self is seen through the telescope of memory. "In general," Handke writes,

"these memories are inhabited more by things than by people: a dancing top in a deserted street amid ruins, oat flakes in a sugar spoon, gray mucus in a tin spittoon with a Russian trademark; of people, only separate parts: hair, cheeks, knotted scars on fingers; from her childhood days my mother had a swollen scar on her index finger; I held onto it when I walked beside her." He, the small child, is the last and least of the items in his memory list.

The recreation of the childhood self through memory is also the process of creating for the first time one's adult sense of one's mother. For the male author, his birth and his mother's rebirth are brought together in his own act of storytelling. Brodkey talks precisely about this in his story "Ceil"—another story about a mother, but this time about his real mother, who died when he was two, rather than the adopted mother he confronts in "A Story in an Almost Classical Mode." For Brodkey, the distinction between the two mothers is a crucial one, for it allows him to think of himself as having absorbed two kinds of language, two kinds of intelligence: the first, as it were, genetically and bodily, the second environmentally and consciously. And this gives him a different kind of "double look" from that of either Handke or Dickens.

"Ceil" begins: "I have to imagine Ceil—I did not know her; I did not know my mother. I cannot imagine Ceil . . ." and goes on to say later in the first paragraph: "I see that she is not human in the ways I am: she is more wise, more pathetic—whichever—in some way larger than my life, which, after all, she contained for a while. I was her dream, her punishment. She dreams me but she bears me, too." Though stylistically so different, this passage bears an uncanny affinity to the way Dickens conjures up the mother in *David Copperfield*. Even the mother's name, with its evocations of heaven (though, practically speaking, it may only be a Jewish-sounding abbreviation of the name Celia), brings to mind David's angelic images of *his* mother. But what the two works crucially have in common, and what they share with Handke's memoir, is the sense of the mother as both created by and creating her son. "I have to imagine Ceil . . . I was her dream." Who is the dreamer and who the dreamed? If the child did not exist until the mother called him into being, there is also a sense in which she does not now exist until he calls *her*, or recalls her. David Copperfield says of his mother:

Can I say of her face—altered as I have reason to remember it, perished as I know it is—that it is gone, when here it comes before me at this instant, as distinct as any face that I may choose to look on in a crowded street? Can I say of her innocent and girlish beauty, that it faded, and was no more, when its breath falls on my cheek now, as it fell that night? Can I say she ever changed, when my remembrance brings her back to life, thus only . . . ?

The writer-son is the Orpheus who crosses the time-barrier between life and death to retrieve his lost Eurydice, his dead mother. But unlike the original Orpheus, this one succeeds. He succeeds by recreating her, as if she were a fictional character.

David Copperfield is a novel that plays repeatedly with the distinctions among the real, the remembered, and the fictional, the fluid borderlines between those who have died, those who were never born, and those who exist only in the imagination. There is, for example, David's imaginary sister, Betsey Trotwood Copperfield, whom his aunt always evokes when she wishes to bring him up to standard. But this "sister" is actually his nonexistent double, the self he would have been if his aunt had got her way and he had been born a girl rather than a boy. The connection she represents between the living, the dead, and the nonexistent is revealed at the end of the first chapter, "I Am Born":

I lay in my basket, and my mother lay in her bed; but Betsey Trotwood Copperfield was for ever in the land of dreams and shadows, the tremendous region whence I had so lately travelled; and the light upon the window of our room shone out upon the earthly bourne of all such travellers, and the mound above the ashes and the dust that was once he, without whom I had never been.

That "he" is David's father, dead before his birth and lying out in the graveyard, as unreal to him as the sister/self who was never born.

The unstressed pun on "bourne" (in a chapter where "born" appears in the title) draws on the same sources as Brodkey's "I was her dream, her punishment. She dreams me but she bears me, too." And the present tense—of Dickens's "I Am Born," of Brodkey's "She dreams me but she bears me, too"—suggests that the painful birth is taking place at this very minute, as the author imagines his birth, as the reader reads of it. What is born is not just a person who will ultimately

turn into a writer—*that* happened years ago, decades ago—but a character, the character of himself, whom the author is creating exactly at this moment. There is the moment lived, and then there is the moment written about, and then there is the same moment consumed by the reader.

Hence all the foreshadowing in *David Copperfield*. "I cannot bear to think of what did come, upon that memorable night; of what must come again, if I go on," says Copperfield about the evening of Little Emily's disappearance with Steerforth. "It is no worse, because I write of it. It would be no better, if I stopped my most unwilling hand. It is done." But it is *not* done within the novel, and won't be, for him, until he writes it down, and won't be for us until we read of it. Dickens admits as much when he says "of what must come again, if I go on"—a striking contradiction to his profession of helplessness, a testament to the simultaneous powers of memory and authorship. Yet the power of authorship, like that of memory, is partly unwilled. "Unwilling" as Copperfield's hand is, it must still go on, a slave to the narrative to which it has given birth. Handke gets at the same notion of unwilled creation when he invokes the idea of dreaming: "(At best, I am able to capture my mother's story for brief moments in dreams, because then her feelings become so palpable that I experience them as doubles and am identical with them; but these are precisely the moments I have already mentioned, in which extreme need to communicate coincides with extreme speechlessness . . .)"

The speechlessness is not just that of dreams, but that of mothers. For Dickens, Brodkey, and Handke, the mother is a person whose relationship to language is indirect, restricted, limited. She cannot give voice to her own being, and this is only partly because she is dead; she is less literate, less literary than her son, who is destined to become a writer. In fact, it may be that he becomes a writer precisely to give voice to her unspoken secrets. This, too, is duplicitous. For it is in the very nature of secrets to remain unspoken. The writer who tries to put his mother's secrets into words will be violating their essential, speechless quality, and in attempting to tell the deepest truths he will find himself venturing into lies, or at the very least contradictions.

In a brief but powerful memoir called "Her Secrets," John Berger recalls his mother's life and death, and her influence on his vocation. As the title suggests, secretiveness is, to begin with, *her* characteristic. "She was secretive, she kept things to herself," Berger says. But this

then becomes a characteristic of the writer as well. "If her hopes of my becoming a writer—and she said they began on the night after I was delivered—were eventually realized, it was not because there were many books in our house (there were few) but because there was so much that was unsaid, so much that I had to discover the existence of on my own at an early age: death, poverty, pain (in others), sexuality . . ." Even when he becomes a writer, what his mother values is not so much the books he produces (she doesn't read them) as the profession of writing itself. "A writer was a person familiar with secrets. Perhaps in the end she didn't read my books so that they should remain more secret." That seemingly casual witticism betrays a deep paradox: the writer may be a possessor of secrets, but he becomes a writer only by giving them away. Her secrets remain secrets for her because she doesn't read his books; we, his readers, find the secrets exposed, made un-secret.

Though not quite. John Berger's touch in this essay is so delicate, so hesitant and at the same time so sure-footed, that he manages to discuss the existence of secrets—his and his mother's—without ever fully giving them away. "To be a writer was to be able to see the horizon where, anyway, nothing is ever very distinct and all questions are open": this definition, expressed on behalf of his mother, is also his own. All Berger's work—not only this essay—possesses an oblique tone, a way of stating things that is never straightforward and finished. At the end of any Berger piece a voice hangs in the air, silent but having just spoken, leaving us listening for a conclusion that will never quite arrive. "Her Secrets" ends:

> Love, my mother had the habit of saying, is the only thing that counts in this world. Real love, she would add, to avoid any factitious misunderstanding. But apart from that simple adjective, she never added anything more.

Berger leaves us with the voice of his dead mother hanging in the air, as if hers will indeed be the last words we hear. But where she refuses to add anything, he does add—both an explanation ("to avoid any factitious misunderstanding") and a denial ("she never added anything more"). That last line both strengthens and undercuts her silence, explicitly reinforcing it and yet simultaneously intruding on it with *his* added words. But "intruding" is too strong a verb for the quiet, understated way in which, throughout the essay, Berger gives language

to a woman who is beyond language, a woman whose death has only made her more secretive than ever.

The subtlety of his effort is apparent even in the final word, "more," which—in both its sound and its sense—manages to leave things open even as it officially closes them off. As Edgar Allan Poe said in "The Philosophy of Composition," about his refrain in "The Raven": "That such a close, to have force, must be sonorous and susceptible of protracted emphasis, admitted no doubt: and these considerations inevitably led me to the long *o* as the most sonorous vowel, in connection with *r* as the most producible consonant." These being the sounds required, "it became necessary to select a word embodying this sound, and at the same time in the fullest possible keeping with that melancholy which I had predetermined as the tone of the poem. In such a search it would have been absolutely impossible to overlook the word 'Nevermore.'" John Berger, approaching the problem of a lost and never-to-be-recovered woman from an entirely different angle, nonetheless arrives at the same word, albeit broken up: "she *never* added anything *more*." Berger's seems the most open, the most happenstance of written languages—a kind of writing that owes an enormous debt to the speech of ordinary people—and yet it finally resembles in peculiar ways the highly wrought artificialities of a poet who claimed to "admit no doubt" in working "inevitably" from sound to sense. It is with such duplicities of writing that Berger consciously sets out to deal. The very effectiveness of his language—its skillful and almost invisible manipulation of sound and sense—both supports and betrays his honest attempts at sincerity.

For both Brodkey and Handke, as for Berger, to write about one's mother's death is both to acknowledge and to betray a secret. "All at once," says Handke, speaking of his feelings on the day of his mother's funeral, "in my impotent rage, I felt the need of writing about my mother. In the house that evening I climbed the stairs. Suddenly I took several steps at one bound, giggling in an unfamiliar voice, as if I had become a ventriloquist . . . Then slowly, with a sense of self-importance, as though I were the holder of a unique secret, I went back down the stairs." The sense of ventriloquism perhaps comes from a feeling of having acquired his mother's "unique secret" and thus being ready to speak for the previously speechless. But this feeling that he possesses the truth is temporary and illusory. "Writing has not, as I at first supposed, been a remembering of a concluded period in

my life, but merely a constant pretense at remembering, in the form of sentences that only lay claim to detachment," he confesses in the paragraph after the remark about ventriloquism. The writing itself is the lie: it falsifies the feeling that was connected to (not detached from) the "unique secret."

For Brodkey, the question of whether to lie or tell the truth, to keep secrets or reveal them, is at the very heart of "A Story in an Almost Classical Mode." His adoptive mother at first advocates lying: "Don't ever tell anybody what goes on in this house: they won't give you any sympathy; they don't know how—all *they* know is how to run away. . . . Take my advice and lie, say we're all happy, lie a lot if you want to have any kind of life." Brodkey, the boy in the story, takes that advice and constructs a lie that saves them both: the lie that she is a noble, self-sacrificing, long-suffering mother and he is the beneficiary of that sacrifice. "Of course, it was a swindle all the way," he says. But it is a swindle that works: "She almost became good-tempered . . . She practiced a polite death or whatever, a sheltering politeness, which wasn't always phony . . ." Yet at the end it is Doris who tries to break through the lies and get him to acknowledge what he's done to help her: "What a liar you are. And I always thought I was a liar . . . Don't you know what you did for me? You made it so the pain was less." And he, paralyzed by self-protective obliviousness, can only reply, "Momma, I didn't do anything." The Harold Brodkey who was there at her deathbed was inadequate to the truth his mother demanded of him. It is only the older Harold, looking back on the experience, who can be truthful in this confrontation with "my mother's voice." Not only does he keep her alive by preserving her voice in the story. He also enables their relationship to develop beyond the point it had reached at her death. In violating her secrets ("Don't ever tell anybody what goes on in this house"), he finally gives her heroic stature, in an almost classical mode. She becomes, in retrospect and at the end, the noble, self-sacrificing mother he once pretended she was. So the lies of autobiographical fiction and the truths of daily self-deceit become inextricably merged.

Brodkey's mother is hardly speechless, but she shares with the mothers in Dickens, Handke, and Berger an odd and evasive relationship to names. For a son, of course, his mother has no proper name: she is simply "Momma" (Brodkey), "my mother" (Handke and Berger), or, as David Copperfield generally calls her, "my poor mother."

But it is not only in relation to the son that the mother is nameless. As these writers acknowledge, a woman's connection to her own name is a larger problem, a problem of society at large. She is, for the most part, given her name by her husband—technically, by taking his last name, and conversationally, because he is the one most likely to use her first name. In Handke's case, even this remnant of individuality is taken away from his mother: "At home she was 'Mother'; even her husband addressed her as 'Mother' more often than by her first name." Berger acknowledges the husband's power by omission: his father is almost entirely absent from "Her Secrets," and so his mother remains nameless. It is only he, the author, who is named, and that naming ("John") comes only in direct conversation with his mother—as if he is giving her back, in the form of the power to name him, some of the authorial power he acquires by telling her secrets.

In Brodkey's story, the problem of his mother's name and identity is intimately tied to the problem of his love for her: "I loved my mother. But that is an evasion. I loved my mother: how much did I love Doris Marie Rubinstein? Doris Brodkey, to give her her married name. I don't think I loved her much—but I mean the *I* that was a thirteen-year-old boy and not consciously her son." Brodkey suggests the way in which every label—her maiden name, her married name, her status as "my mother," and even his own status as "I" and "her son"—is an evasion of sorts. By merely being named, a person is made distant, made falsely separate. (This is the distancing power of language that Handke refers to when he talks about "sentences that only lay claim to detachment." And it may have something to do with what Brodkey means when he accuses Handke of being "too distant from the real." The real and the nominal are opposites.) To name one's mother, or even to name oneself, is to begin the fictionalizing process. "I am only equivocally Harold Brodkey," he says, ostensibly because he was adopted, but actually because no name imposed from the outside can be anything but equivocal, evasive, false. Brodkey's rabbi ancestors "pursued an accumulation of knowledge of the Unspeakable—that is to say, of God." To be absolutely true (the kind of truth only God can have), a thing must remain nameless.

David Copperfield's mother remains nameless until the moment when he acquires "a Pa . . . A new one," as his nurse Peggotty calls his stepfather. "A new one?" David echoes, for he correctly surmises that "Pa" is a name which can only, for him, belong to one ghostly

person. Up to this point his mother has been so seamlessly a part of his life that she doesn't need a proper name. We learn that she shares her first name with Peggotty ("It's her surname," the mother explains to the visiting Betsey Trotwood. "Mr. Copperfield called her by it, because her Christian name was the same as mine"), but we don't learn what that name is until Mr. Murdstone uses it to admonish her for her tenderness to David: "'Now, Clara, my dear,' said Mr. Murdstone. 'Recollect! control yourself, always control yourself.'" A proper name is thus explicitly an agent of control, as would be used to control a dog, or a servant.

This acknowledgment of women's submission in the matter of names is not accidental in Dickens. Elsewhere in the book, Peggotty loses her absolute possession of her own name (even her brother is only "Mr. Peggotty," a possessor by relation to her) when she marries and becomes "Clara Peggotty Barkis" (or "C. P. Barkis," as her husband calls her)—though David, throughout his narrative, loyally continues to call her Peggotty. Betsey Trotwood reverts to her maiden name (and to the impossibility of anyone's imagining her with any other) when her marriage turns out badly. David himself is subjected to nominal enslavement—though in a benevolent way—when Aunt Betsey gets him to adopt the name "Trotwood Copperfield" preparatory to becoming her heir. Losing one's own name is thus not strictly a matter of gender, but of power and financial relations. As Dickens realized, however, the power to impose a name was generally on the side of the man. (In *Great Expectations* he gives us "Joe" and "Mrs. Joe," as if to suggest that even a woman's first name can disappear behind that of her husband.) And certainly the name "Clara"—in each case imposed by the husband—seems, from our viewpoint, a lot less true to the woman who bears it than either "my mother" or "Peggotty." The latter names, of course, also express a relationship to a man: they are what David calls these two important women in his life. Any name can only signify a relationship of some sort. But in most of the stories about mothers, the unspoken first name seems closest to absolute truthfulness, closest to the independent existence we grant "the Unspeakable."

The unspoken name of the mother takes an odd and significant form in D. H. Lawrence's story "The Rocking-Horse Winner." Like the mother stories I've already mentioned, Lawrence's is about a son who sympathizes with and suffers his mother's pain. That this pain is

relatively superficial—the desire for more wealth, the petulant regret at not having married a "lucky" man—matters to us as readers, but not to the son. He takes his mother's suffering as seriously as Brodkey does his mother's slow death by cancer or Handke does his mother's suicide. More seriously: for in this story it is the son who dies and not the mother. The story, for once, is not told by the son himself, but by that strangely distant, passionately implicated Lawrentian narrator who tells us things like: "She had bonny children, yet she felt they had been thrust upon her, and she could not love them. They looked at her coldly, as if they were finding fault with her. And hurriedly she felt she must cover up some fault in herself. Yet what it was that she must cover up she never knew." Like Berger's essay, it is a story of secrets, of "what she never knew." Like Brodkey's, it is a story of a son's half-conscious and partially successful attempt to compensate for the distress life has inflicted on his mother. Like *David Copperfield*, it is a tale told at two levels, with one set of meanings for the child in the story and another for the adults reading it. And, like Handke's memoir, it keeps secret the name of the mother—until, that is, the very last paragraph of the story, when the boy has died and left his mother a fortune, which he won by betting on horse-race winners whose "secret" names were revealed to him when he was riding his rocking-horse. "My God, Hester," says Uncle Oscar to the mother, "you're eighty-odd thousand to the good, and a poor devil of a son to the bad. But, poor devil, poor devil, he's best gone out of a life where he rides his rocking-horse to find a winner."

Paul, furiously riding his nameless rocking-horse, heard the names of horse-race winners and knew in advance how to bet. Lawrence, riding his hobby-horse about men and women, is no less specific in his choice of the mother's name—a name that stands out the more because it has been suppressed throughout the rest of the story. Hester, singularly and notoriously, is the name of the central character in Nathaniel Hawthorne's *The Scarlet Letter*. A year after he first published the volume of stories in which "The Rocking-Horse Winner" appears, Lawrence published his *Studies in Classic American Literature,* which includes an essay on *The Scarlet Letter* that can reasonably be described as a rant. "Oh, Hester, you are a demon," Lawrence says in that essay. "A man *must* be pure, just so that you can seduce him to a fall." And, a few pages later: "Poor Hester. Part of her wanted to be saved from her own devilishness. And another part wanted to go

on and on in devilishness, for revenge. Revenge! REVENGE! It is this that fills the unconscious spirit of woman today. Revenge against man, and against the spirit of man, which has betrayed her into unbelief . . . " This is hardly what we are accustomed to think of as literary criticism. But Lawrence's rant does say something pertinent about works of literature, both Hawthorne's and his own.

"The Rocking-Horse Winner" borrows from Hawthorne's tales a romantic, fable-like element—the presence of magic in the real world—and also the element of hidden sin made visible. But whereas in *The Scarlet Letter* the mother bears all the suffering for both her own sins and those of her adulterous lover, with the impervious child Pearl merely serving at times as further punishment to her, it is the *child* in "The Rocking-Horse Winner" who suffers for his mother's sins (envy, greed, and the failure to love). In his essay, Lawrence makes much of Pearl: "Hester simply *hates* her child, from one part of herself. And from another, she cherishes her child as her one precious treasure. For Pearl is the continuing of her female revenge on life. But female revenge hits both ways. Hits back at its own mother." True as this may seem about *The Scarlet Letter,* it seems even more true of Lawrence's own Hester. And in Lawrence's story, the suffering child (who is also, because of his suffering, the agent of the mother's punishment) is, significantly, a boy child rather than a girl. For it is only through a boy—both herself and not herself, both ally and enemy—that the mother can fully receive both revenge and punishment.

The essay on *The Scarlet Letter* is where Lawrence makes some of his most extreme remarks about women: "Woman is a strange and rather terrible phenomenon, to man. When the subconscious soul of woman recoils from its creative union with man, it becomes a destructive force. It exerts, willy-nilly, an invisible destructive influence . . ." And much more of the same. Winnicott, in an essay called "The Mother's Contribution to Society," traces such attitudes directly back to a failure to acknowledge the importance of mothers:

Many students of social history have thought that fear of WOMAN is a powerful cause of the seemingly illogical behaviour of human beings in groups, but this fear is seldom traced to its root. Traced to its root in the history of each individual, this fear of WOMAN turns out to be a fear of recognizing the fact of dependence. There are therefore good social

reasons for instigating research into the very early stages of the infant-mother relationship.

The critical tendency, when dealing with a self-exposing writer like Lawrence, is to produce such Freudian findings in an "Aha!" tone of voice. But are Winnicott's remarks necessarily an *exposure* of Lawrence? Might they not, just as easily, be a *translation* of what he is saying— if not here, then in his fiction? Lawrence, after all, is the critic who tells us, in this very same *Studies in Classic American Literature:* "Never trust the artist. Trust the tale. The proper function of a critic is to save the tale from the artist who created it." And he is only half joking.

If "The Rocking-Horse Winner" points us, through the single use of the mother's name, toward the essay on *The Scarlet Letter,* that essay in turn points us back to *Sons and Lovers.* The pointing gesture comes in a passage that is such a non sequitur it leaps off the page. In the midst of a discussion about mind-consciousness and blood-consciousness, Lawrence suddenly interrupts himself to say:

> My father hated books, hated the sight of anyone reading or writing.
> My mother hated the thought that any of her sons should be con-demned to manual labor. Her sons must have something higher than that.
> She won. But she died first.

In addition to being a startling piece of autobiography embedded in a critical essay (what is your mother doing *here?* we want to ask, but don't, because we know perfectly well), these three brief para-graphs are an excellent summary of *Sons and Lovers.* It is a novel in which all the complexities raised by Berger, Handke, and Dickens— of the writing son speaking on behalf of a speechless parent—get reversed and made more complex. Here it is the father, Mr. Morel, who is speechless and unliterate, the mother who represents verbal expressiveness. In explicit ways (in part, of course, by *being* a verbal expression), the novel itself seems to side with the mother against the father, to side with "high" ideas and correct pronunciation against manual labor and dialect or silence. But because he is so vastly out-numbered, with even the highly articulate narrative voice ganging up against him, Mr. Morel begins to seem heroic, or at least pathetic. ("She is more wise, more pathetic—whichever," Brodkey says of his real mother, Ceil.) Morel begins to take on the heroic pathos of the

Dickensian waif, the character whose very illiteracy and speechlessness make him, or her, the emotional center of the novel. But he only *begins* to do this, for Mrs. Morel is such a powerful character that he can never quite take the novel away from her. She is the beloved but imprisoning mother who struggles against all other women for her son Paul's soul. (The son, pertinently, has the same name as the boy in "The Rocking-Horse Winner.")

Because it is such an explicitly Freudian novel, *Sons and Lovers* is extremely resistant to any kind of Freudian analysis. In this it bears a great affinity to Brodkey's "Story in an Almost Classical Mode": the pain, the extorted sympathy, the hatred, the love, the resentment, and the forgiveness are all there on the surface. Yet in both cases that seemingly direct treatment of deep psychological material is finally what makes the works so mysterious, so full of secrets. They explain and yet they fail to explain, and a new explanation must be worked out by each of us, individually, every time we read them. Lawrence's novel and Brodkey's story have other things in common as well: a father who essentially disappears from the plot; a mother who turns her son into an artist; a son who identifies excessively with his mother; a wrenching deathbed scene; and the temporary breakdown of the son's personality at the death of his mother. "I had a nervous breakdown when she died. After a while, I got over it," says Brodkey. "Now she was gone abroad into the night, and he was with her still," says Lawrence. "They were together. But yet there was his body . . . He could not bear it. On every side the immense dark silence seemed pressing him, so tiny a spark, into extinction, and yet, almost nothing, he could not be extinct." Sympathetically experiencing the mother's death, they "almost" die, but they eventually come alive again: "I got over it"; "he could not be extinct." Only through the deaths of their mothers can these sons become artists, writers. It is as if the worst must be experienced before it need no longer be feared. Henceforth the writer-son is free: if not unfettered, if still held by memory, then at least free of the fear of dependence.

Which entails, almost by definition, the fear of loss. "From the age of five or six I was worried about the death of my parents" is how John Berger begins "Her Secrets." Later in the essay he comments that their eventual deaths would seem the appropriate occasion to begin writing about himself: "Autobiography begins with a sense of being alone. It is an orphan form." Later still, he remarks: "Truly we

writers are the secretaries of death." The one death almost certain to be "recorded" by the writer (in feelings if not in language) is the death of his mother. (*David Copperfield* shows us why this certainty does not apply equally to the father: he can and sometimes does die even before the child is born.) So the fear of dependence that Winnicott and Lawrence discern can actually be linked to the far more rational fear that one's mother will eventually leave one, by dying. The writer is not only the secretary of death in general. He—at least in the cases of Berger, Brodkey, Dickens, Handke, and Lawrence—is very specifically the secretary who transcribes his own mother's death.

In each case, the transcription is an attempt both to remember and to get free of the past. "If I was to forgive her it meant I had first to remember," says Brodkey, and he speaks in a way for all of these writers. The product of this particular release is not oblivion, but literature: the horrifying events are there, written down on the page, to be experienced over and over again as each new reader comes to them. "It would be no better, if I stopped my most unwilling hand. It is done," says Dickens. What the work of literature has in common with the Freudian life-story is that it is at once determined and free. Everything is written down beforehand; the plot can't change; the same fate will be repeated and repeated, endlessly. But with knowledge comes the freedom of perspective—not the ability to change the way the story turns out, but the ability to see things differently. And with this distance (or perhaps it is, rather, a more interior kind of closeness, a matter of being inside things rather than naively witnessing them) comes a kind of sympathy that is *not* extorted. When the son reaches this point with his mother, he may be able to understand her without involuntarily identifying with her: she may achieve, for him, the literary grace of a fictional character who has a being separate from his own.

Though Dickens is the only one of these writers to come before Freud, it is through Dickens, I think, that one can best perceive the odd companionship of determinism and freedom. Things come around again, but they never come around in exactly the same form: to Orwell and myself, for example, *David Copperfield* became a different novel when we read it as adults, though the words on the page hadn't altered one iota. Even within the novel, and especially in relation to the women characters, there is a sense that life contains second chances. Martha and Little Emily, both of whom are "fallen" women, get a

new life in Australia. Agnes gets a second chance to marry her beloved David when his first wife dies, and for David the new wife *is* his new life. Betsey Trotwood gets a number of second chances: to be an aunt (after initially rejecting the nephew who failed to be a niece), to be wealthy (after losing her fortune to Uriah Heep's machinations), and to be single (after first divorcing her prodigal, pestering husband, and then surviving him).

But all of these are examples of actual plot turns, and do not fully show what I mean by a change in perspective. That, perhaps, is best illustrated by Miss Mowcher. When this little dwarf, who specializes in giving manicures and haircuts, first appears in order to attend Steerforth, she comes across as the worst of Dickensian cartoons. We cringe in embarrassment at her grotesqueness, her inappropriate flirtatiousness, her big mouth, and her garish winks; and we cringe at our own oversized tendency to find her dwarfishness funny. When she returns, serious and considerate, it's to voice an attack on precisely that cartoonish attitude toward her:

> "Yes, it's always so!" she said. "They are all surprised, these inconsiderate young people, fairly and full grown, to see any natural feeling in a little thing like me! They make a plaything of me, use me for their amusement, throw me away when they are tired, and wonder that I feel more than a toy horse or a wooden soldier!"

It is Miss Mowcher who, at the end, collars Steerforth's evil man-servant and brings him to justice. So our, and David's, and even (apparently) Dickens's first impression of her, as a comic vaudevillian dwarf, gets heavily revised by the end of the book. Miss Mowcher alters greatly as a character, not because of any inherent changes in her personality, but because we see her from a different angle.

David offers us a hint about the significance of Miss Mowcher when he says, as early as the second chapter, that he can remember his mother and Peggotty "dwarfed to my sight by stooping down or kneeling on the floor." Like the comic dwarf, the beloved mother of childhood memory is essentially a music-hall cartoon, a two-dimensional character not meant to alter with time or situation. Most boys do eventually grow up to the point where they in turn "dwarf" their mothers. David Copperfield never had the chance to do that: his mother died when he was still a child, so he could never revisit her as an adult. What he does, instead, is to substitute for that dwarfed

mother a real dwarf—someone who seems at first frozen into silly smallness, and who nonetheless manages to transcend that position. Dickens uses Miss Mowcher to free David's stilted vision of his mother in much the same way that David (or Brodkey, or Handke, or Berger, or Lawrence) uses his autobiography—his story about the death of his mother and his growth as a writer—to free himself.

Degas's Nudes

3 In the century that has passed since Degas exhibited his earliest nude bathers in the Impressionist show of 1886, the tone of the debate about them has remained pitched at the level set by the infamous J. K. Huysmans, the critic who most notably and forcefully accused Degas of misogyny. Even when recent critics take issue with Huysmans's specific assertions—even, for instance, when they argue from a feminist rather than a "gallant male" perspective—they continue to look at Degas's pictures with eyes that search for crimes against women.

My own experience of Degas has been very different. I first encountered him as poster art in the bedroom of a girl who lived down the street from me—a pretty, prissy girl who, when we were both sixth-graders, wore her hair pulled into an imperious dancer's bun on the top of her head, and never besmirched her frilly white blouses. I, with my unruly red hair and permanently scabbed knees, saw her pristine smoothness as both unattainable and, at root, undesirable (though I perceived that most of the boys in our class thought otherwise); and I associated the Degas ballet dancers on her wall with that excessively feminine condition. I have never gotten over this feeling about the dancers. They are probably much better than I think they are, but I do not like those paintings. So it came as a complete shock when, at the age of about twenty, I first saw some of Degas's nudes at New York's Metropolitan Museum of Art.

Imagine walking into a smallish alcove and finding, with absolutely no preparation, the *Woman Having Her Hair Combed (La Toilette)* of 1885. A pale, full-bodied woman sits naked on a white cloth which is draped casually over a yellowish upholstered chaise. She sits sideways on the couch, her feet planted softly but firmly on the cloth-draped floor; she is neither facing you nor in profile, but angled in between,

the line of her body perpendicular to the chaise, which in turn forms a strong diagonal line across the painting. Behind the woman and the couch stands the maid who is brushing her hair. You cannot see the maid's head at all, because the picture ends at her shoulders, but you can see her strong forearms (the only other flesh in the room, besides that of the naked woman), and her orange dress (which picks up flecks of the same color from the chaise and the blue-green carpet and the gold curtains against the far wall), and her apron (white, like the cloth on the chaise, but neatly vertical rather than freely crumpled). The woman who is having her hair combed leans her head slightly back into the pull of her maid's hands. She supports her lower back by placing her hands just above her hips (they leave a slight shadow of impression in the flesh, but do not seem at all clenched or pressured), and as a result her back is comfortably straight. Her shoulders are thrust gently forward, her breasts are uplifted, and her belly rests softly in the curve of her thighs. She is not fat, but her body is expansive and unfettered, like her wonderful hair, which falls—soft, heavy, and auburn—through the maid's ministering hands and down the front of the apron. There is a lightly cross-hatched triangular space between the lifted hair and the back of the woman's tilted neck, and within this space you can feel, as if it were on the back of your own neck, the pleasure of having your hair touched and lifted. The woman's face is uninsistently, almost expressionlessly tranquil. Her eyes are half-closed—not in thought or even in dream, but in the attentive contemplation of fleeting sensuous pleasure. She is focused on that point at the back of her neck, a point you cannot see, though the triangle of empty space directs your attention to it. (Like you, she cannot see it. This pastel is about feeling what can't be seen: it uses visual data, but it evokes the sense of touch.) She is not ignoring her body, but it does not distract her: it almost seems to float in the center of the paper, despite the grounding, the gravity, of feet and buttocks* and supporting hands. The feeling of the picture is at once of lightness and heaviness, of radiance (her whole body has a sheen of white

*One result of Degas's unusual delicacy in his treatment of female nudes is that I've had a hard time finding a word to describe this part of their bodies. "Buttocks" sounds too clinical, as if they were about to get a shot or be dissected; but everything else sounds either childish, salacious, or aggressively crude. Our language (perhaps any language) does not possess the neutrality—in this case, the uninflected corporeality—that would be necessary to describe Degas's paintings with complete accuracy of tone.

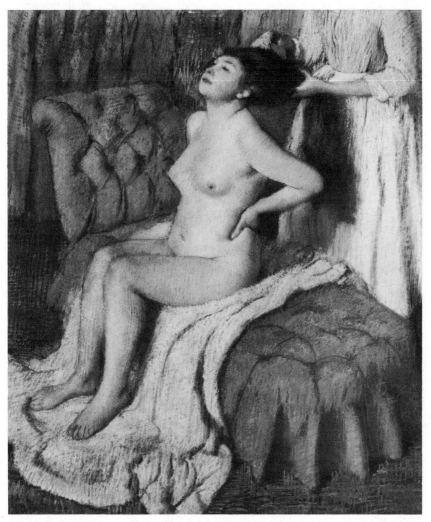

A Woman Having Her Hair Combed

strokes) and weight. She is not looking at you, and you are looking intently at her, but there is no feeling of voyeurism or peeking, there is no discomfort on your part, because you are more than invisible. In the realm of this picture, you are simply not there. ("Simply" is a deceptive word for the magic Degas performs, the act of grace whereby he leaves this woman's privacy untouched—untouched even by her maid, whose headless body is unseeing.)

It is this very painting which provokes in Richard Thomson—noted Degas scholar and curator, author of the comprehensive and instructive *Degas: The Nudes*—the remark, "In a composition that betrays his middle-class, masculine attitudes, Degas literally effaces the subservient maid and makes a patronizing pun between the mistress's breast and the buttoned sofa." Where does this kind of thing *come* from? Certainly not the painting itself, to which it is utterly inappropriate. If beauty is in the beholder's eye, then so, one is tempted to say, is misogyny.

Thomson is far from the worst offender. The original attack—from which Thomson, for one, attempts to defend Degas—came from Degas's contemporary Huysmans, who in 1889 described various Degas nudes as "fat, pot-bellied, and short, burying all grace of outline under tubular rolls of skin," or "dumpy and stuffed, back bent, so that the sacrum sticks out from the stretched, bulging buttocks," or "a big, squatting lump." "Such, in brief," Huysmans concluded, "are the merciless positions assigned by this iconoclast to the being usually showered with fulsome gallantries. In these pastels there is a suggestion of mutilated stumps, of the rolling motion of the legless cripple— a whole series of attitudes inherent in woman . . . frog-like and simian when, like these women, she has to stoop to masking her deterioration by this grooming." Nearly a hundred years later, in 1988, the *New York Times* reviewer of the Degas show in Paris wrote: "Degas's attraction to images of women washing themselves suggests a painful anxiety about cleanliness and dirt and women's bodies." The tendency, as you can see, is to assign the sense of anxiety or repulsion to Degas himself. He has also been accused of voyeurism, to varying degrees: Gustave Geffroy's review of the original Impressionist show, published in 1886, commented that Degas "has wanted to represent the woman *who doesn't know she is being looked at,* as one would see her hidden behind a curtain or through a keyhole," while the article George Moore wrote about Degas in 1890 attributed the "keyhole" description of his approach to Degas himself.

Modern critics have taken this intrusive gaze even further, to the point where Carol Armstrong sees the supine figure in *The Bather* (also known as *After the Bath*) as "the relaxed, abandoned sensuous body of the goddess of love transformed into the resistant, disarticulated one of the martyr, and the look declared as a kind of pressure, a violence inflicted on the body like a rape or a subtle torture"; while Thomson describes the same nude as having "nothing to do with bathing, with washing or drying. It is helpless, defensive, inexplicable in its context." He then goes on to characterize a number of the nudes as manifesting "a fascination with the fantasy of woman at the mercy of the intrusive male gaze." Even Edward Snow, whose reading of Degas's nudes is beautiful and astute, senses in the artworks Degas's "ontologically negative sense of himself as a man," and feels that the paintings of women alone ("delivered not only from the male gaze but from any introjected awareness of it") are "haunted by the ghost of someone still there, looking, watching, invisible and excluded."

I do not feel this sense of exclusion in Degas's nudes. Nor do I feel the violence, the degradation, the contortion, and even the "torture" that other critics have perceived in the bathing bodies and the attitudes they assume. To me, the paintings and pastels are entirely about grace: the natural physical grace that unselfconscious bodies feel and convey; and the spiritual grace—the sense of release from mortal limitations—that enables painter and viewer to enter and yet not enter, to see the unseeable, to touch with the eyes rather than the hands.

A too-easy explanation for this is that I am a woman, and am therefore not burdened with the masculine guilt and voyeurism that other viewers bring to Degas's paintings. Carol Armstrong is also a woman; yet she describes *The Tub* from the Musée D'Orsay—perhaps my favorite pastel, with its rich, self-enclosed tenderness—as implying "a threat, an unseen presence, with whom we are forced to identify, as we identify with the camera angle when it moves with a perpetrator or a protagonist and forces us to see past thresholds, past the edges of doors and windows, to a victim's unaware back." She stresses that "we are made aware of the viewer (whom we, along with Snow and Huysmans, assume to be male)." Armstrong accurately perceives that there is no room for an actual viewer where the painting posits one: Degas, in looking down on the woman who crouches in her bath and squeezes a sponge over her shoulders, gives us (in Armstrong's words) "an impossible, awkward, too-close view which speaks so much to

exclusion that it allows no place for the viewer to stand." She sees, yet she doesn't believe. She insists that the posited viewer must be merely concealed—dangerously invisible—rather than entirely absent from the scene.

Picture, for a moment, an attitude toward drama which assumes that beyond the theater's fourth wall, in every single play, lies an audience of whom the play's characters must be uncomfortably aware. Or imagine, in a similar strain, an insistence on knowing exactly where—on which patch of ground in *Middlemarch,* in which corner of *The Golden Bowl*'s drawing rooms—the omniscient narrator is standing. Such ideas are interesting (they form, for instance, the basis of Brechtian theater), but they are clearly limited in application, and in some cases ludicrous. Yet the critics who discuss Degas appear to assume that some such regulation governs Degas's art. He painted from a naturalistic, real-world viewpoint (the implied argument runs), and therefore that standpoint must exist in the world of the painting itself. In this scheme, the artist has visited the bath scene and literally seen into it, and the viewer (occupying, perhaps, the same keyhole) in each case simply steps in to fill his physical place.

But if they must insist on a spatially present viewer, why do all these critics further presume that the viewer must be male? Degas himself made no such assumptions. In his print *Mary Cassatt at the Louvre,* done in the 1880s, he presents us with a viewer of paintings who is female—and who is, moreover, an artist herself. In other words (the print seems to say), the person who paints pictures and the person who looks at them can both be female. And Degas makes the story even more complex: he has Mary Cassatt stand for both the viewer and the thing viewed. She looks at a painting containing human figures; we (and Degas) look at her looking at the painting. But we see her only from the back, so her experience of seeing remains an essentially private, personal one. (Degas made several sketches of Cassatt at the Louvre, at least one of them from the front—so he actively *chose* the view from the back for an etching, a pastel, and other more finished versions of the subject.) Her body blocks much of the painting from our view, and even so we see more of the painting itself than of her reaction to it. Gesture and pose, the tilt of the head and back are her only way of speaking to us about what she sees. But whatever her private thoughts, she is, in any case, clearly a *woman* viewing paintings—generically so, since there is nothing in the picture itself to

identify her as Mary Cassatt, and in some versions the title is simply *At the Louvre.*

There is at least one sort of painting in which a built-in viewer is not presumed at all, and that is historical painting: the portrayal of scenes from history, myth, or literature, often from such a distance or such a standpoint that no individual human *could* have stood there. We do not ask where the viewer is standing in Botticelli's *Birth of Venus,* or Raphael's *Massacre of the Innocents,* or Michelangelo's *Battle of Cascina* or *Last Judgment*—all paintings that Degas copied and absorbed. Thomson very effectively shows how Degas came from a background of historical painting, and how he developed out of that into something closer to naturalism, while continuing to make allusions (especially late in his life) to those earlier Old Master poses. Thus a sketch for Leander which he did in 1855—a figure standing on its right leg, with the left leg bent at the knee so the foot can be placed on a raised surface, the body leaning forward from the waist, and the elbows supported on the left knee—reappears in the pose of *Study of a Nude Dancer,* which he did in the 1880s. Similarly, an 1860 sketch of a kneeling youth for *Young Spartans* resembles in posture the *Kneeling Nude* of 1888; while a copy made in the 1850s of a Michelangelo man from the *Battle of Cascina* (seen from the back lifting his leg as he climbs over a wall) reappears in the early 1900s in the pastel *After the Bath* (Phillips Collection), where the woman lifts her leg to get out of the tub. Thomson notes these allusions; what he doesn't note is that in each case the male figure has been turned into a female one. I think one could characterize the progress of Degas's career by saying that as he shifted from historical to modern subjects, from "elevated" to mundane material, he also shifted his attention from the male figure to the female figure—and the two shifts were connected. For Degas, women were the heroes of modern life, the figures whose actions mattered—and those actions were the gestures of daily living. To understand Degas, you must come to accept the importance he gave to dailiness, the beauty and significance he saw in seemingly trivial, repetitive acts like washing and drying and combing. "Why was Degas so concerned with repetition?" Thomson asks, and he answers his question with a primarily technical explanation, having to do with the obsessive working out of artistic problems. But there is a level at which one must take Degas's artistic repetitions, his re-use and re-fashioning of the same poses over and over, as parallel to

the repetitions of his bathers: as the simple, unreflective, but centrally important repetitions of daily existence.

The conventional female nude is motionless, a woman posed lying, sitting, or standing still. Part of what may have shocked Degas's viewers, what may continue to shock them, is the degree of motion and action implied in his bathers' figures. Some of the active poses are taken directly from masculine figures. Others are invented or painted from life; but they too imply a degree of strength and physical resilience unexpected in female nudes. This muscularity—though not visible as muscles, but softly delineated in flesh—may be what caused critics to refer to the "tortured," "contorted," "grotesque" quality of Degas's nudes. In his 1886 review, Octave Mirbeau remarked on "the terrifying sense of women under torture, of anatomies twisted and deformed by the violent contortions to which they are submitted." He looked at Degas's bathers and saw Michelangelo's *Slaves.* Michelangelo is somewhere in the background of Degas's work—in that sense the critics are right—but the pain and torture suggested by Michelangelo's sculptures have been transmuted, in Degas, into an unthinking effortlessness.

That's true, at any rate, of the late nudes. In his earlier paintings, where he worked with historical or literary subjects, Degas was directly translating male martyrs and warriors into female martyrs and warriors. It is these works Thomson and Armstrong draw on when they see martyrdom, helplessness, and victimization in the *Bather/After the Bath* of 1885. The bather's pose, as Thomson points out, "is close to that of one of the violated figures Degas had drawn for his *Medieval War Scene* thirty years earlier." That same early painting also contains another female figure—reaching backward and clutching a tree—whom Thomson accurately describes as resembling "a stereotyped St. Sebastian." And *Medieval War Scene* was alternately titled *The Sufferings of the Town of Orleans,* which I take to be Degas's oblique reference to Joan of Arc. The early paintings *were* interested in female victimization.

Young Spartans, for instance, is explicitly a painting about gender equality: a set of young women challenges a gang of young men to a race, with marriage as the prize. But the irony (given this theme of equality) is that the central figure in the painting is a young woman who, like Michelangelo's Adam, reaches with her entire body across the empty space separating the two groups. Iconographically, Degas

gives us woman as mortal, man as God. Yet this is a God who, unlike Michelangelo's original, doesn't reach back across the empty space in a mutual touching of fingers. On the contrary, the Spartan male holds his hands above his head in an O, touching his *own* fingers. (Armstrong uses the phrase "pictorial onanism" to describe *The Tub,* but surely it is far more appropriate here, applied to this self-embracing young man.) In these early pictures, Degas was already sympathetic to women, but he expressed his sympathy by showing them as victims in the battle of the sexes. By the time he painted his bathers of the 1880s and 1890s, the "intrusive," "violent" men had simply disappeared. The reclining woman in *After the Bath* may have a pose similar to that of a trampled, violated figure in *Medieval War Scene,* but there are no horses and male riders to suggest any such violation. Even if they were identical (and they are far from that: where the *War Scene* woman faces down into the ground, the bather's head is thrown back and up; the earlier nude is cold and still, while the late one shimmers with light), the context would make them different. Without men around— without *anybody* around—the woman in the late picture can be experiencing sleep or pleasure in a pose that elsewhere looked like death.

In 1856 Degas began but never completed a historical picture on the subject of King Candaules' wife. Nyssia (as the Queen was called) was caught, naked and in the act of getting into bed with her husband, by the peeking Gyges, who peered at her through a crack in the door. The story involved her shock at being seen, and Degas accordingly sketched Nyssia as she turned her face toward us and toward the peeper. Here, in capsule form, is the "keyhole" subject matter that critics later assigned to Degas's nudes. But it may well have been precisely the voyeuristic aspect of the piece—the peeking male, and the naked woman's shocked discovery of that peeking—which made Degas unable to finish the painting.

In a passage from his *Notebook 6* that accompanied his *Study for the Wife of King Candaules,* Degas wrote that "the whole body ought to be simple and quick, only the eye should be burning with shame and vengeance." (This is the translation given by Denys Sutton in his *Edgar Degas: Life and Work,* from which I've gleaned the quotation.) The burning eye, like the quick body, is apparently Nyssia's; but in the notebook sketch her face is incomplete—in fact, featureless. So we are left with the sense of another, unmentioned eye: Gyges', our own, Degas's. By implication, the picture becomes a commentary on the

shame and vengefulness inherent in voyeurism. This possibility is strengthened by another quotation, which Richard Thomson has unearthed from Degas's diaries of that period. "I don't know how to say how much I love that girl since she . . . me . . . ," Degas mumbles between erasures. "Monday 7 April. I have to admit . . . that it's shameful . . . a defenceless girl. But I will do it as little as possible." Thomson understandably succumbs to the temptation to interpret this entry as referring to a real-life event, and suggests: "Perhaps the *Candaules* project was stimulated, and finally stifled, by Degas's own sense of sexual uncertainty." But mightn't the passage also describe the process of conceiving the painting itself, a work of which Degas did indeed "do . . . as little as possible"? In the *Wife of King Candaules* material he had found the dark side of his own subject, the side he was eventually to transcend with the beautifully private, self-contained bathers. But until he found the solutions that would give rise to those paintings—solutions both technical and characterological, both aesthetic and moral—he was unable to work with the subject. He knew he wanted to deal with unaware nakedness and the perception of that nakedness, but he hadn't yet figured out how to do it.

The transitional nudes, which in many ways took him deeper into the dangerous territory of voyeurism, were the brothel pictures. They strike me as being by a completely different artist—or at least a different part of the artist—from the Degas who did the bathing nudes. I do not like the brothel monotypes as much as Denys Sutton does: "the monotypes," he says, "have a ring of truth about them and give the impression of being executed by a man who knew his way about such places and who accepted life in them for what it was . . . Often his monotypes of brothel scenes are marked by a sense of humour and a tolerance about life, which explains their appeal to Picasso." But nor do I dislike them as much as Richard Thomson, who sees in them "a world of shabby anticipation and transitory couplings," with the prostitutes envisaged "as bestial, keyed up for sex, beyond the bounds of decency . . . shown as women of a baser race." For me, they are rather as if Toulouse-Lautrec had suddenly inhabited the body of Degas and decided to draw some socially interesting nudes—not a bad thing in itself, but not the real Degas. The things to notice about the brothel nudes are that many of them are frontal poses, and that the presence of men is imminent even when not explicit. These two characteristics are linked: the brothel pictures are not about privacy, but about the

public, "sexy" selves women present to men. (Something similar can be said of Degas's nude portraits of dancers, which are also frontal, for the most part. The issue there is not so much sex per se as performance, even when the dancers are backstage and off duty.) The characteristics that were later to define the Degas nude—the tonal shading, the softness of line, and the delicate curve of back and shoulder blade—are completely absent from the hearty, blowsy brothel women. What is there instead, and what has to disappear before the bathers can come into being, is a strong sense of "overseeing," of peeping, of voyeurism. There are participatory or anticipatory men in many of these pictures, but there is another presence as well, another viewpoint: the viewer is not the John, but an additional gazer at the scene (whether madam, whore, visitor, or simply dreamer is never specified).

Two paintings, I believe, gave Degas the knowledge he needed to make the leap from the brothels to the bath scenes. The fact that they were painted a decade before he did the brothel monotypes does not disconcert me; it could well have taken longer than that for the knowledge to take root. I am convinced that the seed of Degas's discoveries lay hidden in two of his more "literary" paintings, *Mlle Fiocre à propos the ballet "La Source"* and *Interior,* both painted in the late 1860s.

Mlle Fiocre offered Degas, if nothing else, the story that constituted the ballet's subject. Eugénie Fiocre, a celebrated Parisian ballerina, was dancing the role of the beautiful Nouredda. In the particular scene Degas painted, Nouredda has stopped by a mountain pool; a passing hunter has picked her a flower. Degas captures Nouredda at the moment when she contemplates, with some melancholy, the fate of that hunter: he has been sentenced to death because he was "intrusive" enough to ask for the privilege of seeing her face.

Interior has been taken, for a number of years, to refer to a particular moment in Zola's novel *Thérèse Raquin.* Recent evidence suggests that the derivation may not be that straightforward; nonetheless, the novel's plot does provide a convincing psychological explanation for what we see in the Degas painting. In the Zola scene in question, a widow and her lover—having killed off her husband, the lover's friend—meet in a bedroom for the first time since the husband's death over a year before. It is, in fact, their wedding night, the culminating moment of their murderous plan; and yet the erotic charge that brought them

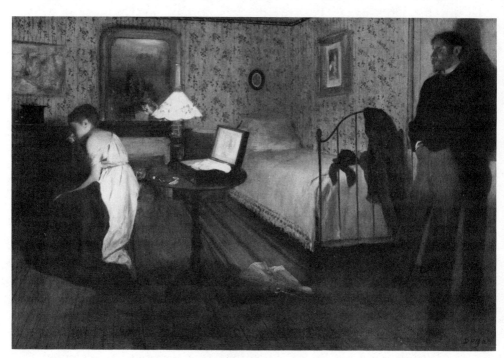

Interior

together has given way, by this time, to horror-struck anxiety and mutual disgust. In Degas's rendering, the two figures are frozen with guilt, or knowledge, or a sudden absence of intimacy: he stands, fully clothed, with his back against the door, while she sits across the room, one shoulder undraped, her face in shadow and her back to the man. Zola describes the scene as follows: "Laurent carefully shut the door behind him, then stood leaning against it for a moment looking into the room, ill at ease and embarrassed . . . Thérèse was sitting on a low chair . . . She did not look around when Laurent came in. Her lacy petticoat and bodice showed up dead white in the light of the blazing fire. The bodice was slipping down and part of her shoulder emerged pink . . . "

All this is in Degas's *Interior,* and what is there as well is the sense of that bare shoulder as a focus for the sexual tension of the scene. Erotic feeling is both invited and evaded, as it is in the novel: "He seemed to hesitate and then, seeing the bare shoulder, he stooped down tremulously to press his lips to the bit of bare flesh. But she freed her shoulder by quickly turning around, and stared at Laurent with such a strange expression of fear and repugnance that he backed away." Unlike the scene in the novel, though, Degas's picture has a prevailing sense of stillness: it is a moment outside life and outside time, safely removed from all witnesses and all judges. He manages to achieve in paint what Zola says he was trying to do in words. "While I was writing *Thérèse Raquin* I forgot the world and devoted myself to copying life exactly and meticulously," the novelist writes in the preface to the second edition, defending himself against charges of prurience. "The human side of the models ceased to exist, just as it ceases to exist for the eye of the artist who has a naked woman sprawled in front of him but who is solely concerned with getting on to his canvas a true representation of her shape and coloration." Yet even that doesn't do justice to Degas's technique. For Zola's words fail to describe the warmth, the human intimacy, with which Degas lifts his "naked woman" out of the practical, squalid, shame-inducing world into a private realm of her own—even in this early picture, where the presence of the man actively works against that sense of privacy.

The face that must not be seen; the naked back that faces outward, substituting for a hidden face. These are the characteristics that define, in part, Degas's radiant, weighty, self-enclosed bathers, the paintings

that (as Edward Snow puts it) locate feminine beauty "in the woman's own intrinsic experience, in the mundane, unselfconscious life of the body." It is the back, and not the face, that speaks so compellingly in those late pictures: the back has *become* the face. And in those rare instances, like *Woman Having Her Hair Combed* or the Tate's *Woman in a Tub,* where Degas has infused that sense of privacy and self-containment into a frontal pose, he has done so by lending the front some of the secrecy and hiddenness of the back.

Look, for instance, at *Woman in a Tub,* where the figure kneels in a low, round tub, sitting on her curled-under legs, her left arm out-stretched and her right hand toweling it dry. The face is not exactly averted—that implies avoidance—but the woman is so intently looking down and aside at her arm that her face is almost wholly in shadow. There is no gaze for us to meet: her eyes are invisible to us. Her body faces us, but the breasts and pubic area are deeply shadowed, and a towel hides much of her front—not out of modesty, but simply be-cause that's how it happens to fall from her arm. The woman's body is distinct from its surroundings (everything else—towel, tub, wall, floor, cloth draped over a chair—has flecks of blue, while her pink body has only a sheen of yellow and white, the colors of sunlight), but it is also encircled and echoed by those surroundings (the curve of the bath exactly picks up the rich curve of her buttocks and thigh). Like the *Woman Having Her Hair Combed,* though in a curled-up rather than stretched-out posture, she is turned inward on her own moment of bodily sensation, and we do not exist for her, we are not part of that unthinking moment of pure existence. (As Randall Jarrell says to his Girl in a Library: "I am a thought of yours: and yet, you do not think . . .") And, in part because we have become so attuned to the expressiveness of Degas backs, we are aware in this picture of the parts of her body that remain hidden from us—in particular, that eloquent curve of shoulder and upper back, that tender meeting be-tween the light patch of shoulder blade and the darker indentation of the spine, which forms the visual focus of most of Degas's pictures of bathers.

It's easiest to see what Degas does with the back by comparing one of his nudes with a similarly composed picture by another artist. Georges Jeanniot's *Woman Drying Herself,* a 1905 pastel, bears a notable resemblance to Degas's 1890s pastel of a *Nude Drying Herself.* (I am

indebted to Richard Thomson for this comparison, though he draws only on the likenesses, not the differences.) In Jeanniot's picture, a naked, heavy-bodied woman with extremely muscular, rather mannish legs and arms sits sideways in an upholstered chair, leaning over the right armrest and presenting the left side of her body to us. She towels the part of her ribcage next to her breast, completely obscuring her back from our view. Her face is deeply shadowed, but we can distinguish the features. The cross-hatching of pastel lines on her body is so strong and unidirectional that she seems (especially at the lower leg) to blend into floor and furniture, which are cross-hatched in the same way. The focus of light in the drawing is first of all on the towel, and secondarily on her hip and upper thigh (which look surprisingly bony, given her weight). There are no continuous curves of buttock or back; and her left breast and belly, bulging out equally and adjacently, seem a vertical parody of two breasts.

The Degas nude, on the other hand, faces away from us, so that most of the paper is taken up with a long, unbroken expanse of back. Her head is not even in the picture: what we see at the top of her spine is the towel with which she dries her neck. The right arm, raised to hold the towel, also lifts the right breast, which we see in gentle outline; farther down, the belly bulges softly before curving into the leg, which—in distinct contrast to that of the athletic Jeanniot nude—is almost nonexistent, dwindling away toward the bottom edge of the paper. A long stream of shadow runs from the socket above her right shoulder down her spinal column to the faint cleft between her buttocks, pooling into larger patches of darkness at the waist and shoulder blade. The contrast between pale, radiant flesh and shadowed spine is strongest just below the lifted arm; it appears again, in muted form, where hip blends into lower back. The bones of shoulder blade and ribcage are suggested, nothing more: this figure derives from Michelangelo but lacks the detailed muscular articulation of a Michelangelo, substituting instead the soft sheen of feminine flesh. Thomson's description of *The Tub*—"this remarkable record of light and the uninsistent erudition of the musculature of the back"—is highly appropriate to this pastel also. As opposed to the heavy, cruelly exposed Jeanniot nude, the feeling here is one of delicacy and privacy, and a large part of that feeling comes from the beautifully expressive back.

Even Degas's sculptures—which one would expect, given the three-

Nude Drying Herself

dimensional form, to do away with the notions of "front" and "back"—have the same quality as the turned-inward pastels. Take, for instance, the bronze *Seated Woman, Wiping Her Left Side,* executed sometime between 1896 and 1911 and now in the Guggenheim Museum's permanent collection. As in *Nude Drying Herself,* the emphasis is on the back. The sculpture has the same deeply indented spine, the same angelic shoulder bones, as the pastel. And though the bronze is indeed three-dimensional, the modeling on the back is much more careful and finished than on the front—as if we were meant to see even this nude from the back only. Another sculpture, Degas's 1896 *Woman Taken Unawares* (in the National Gallery at Washington), confirms the usual pattern by violating it. Here the nude woman's front is relatively finished, while her back is only roughly modeled; we are intended to see her from the front. Her pose—shoulders crouching forward, hands cupping belly, knees turned slightly inward—is that of someone surprised in a moment of private nakedness. Her face, however, is turned back, averted from us and looking slightly downward. My sense of the pose is that she has been suddenly "taken unawares" from *behind* and is looking back at the intruder. Thus the violater of her privacy is someone other than ourselves. We, the viewers, are in the still-private space, the frontal area that remains hidden from the intruder who has surprised her. The voyeur—if indeed that's what he is—is looking at her back. (Alternatively, she is hiding her face *and* her back from us, the viewers who take her unawares; the face and the back are thus the "private parts" that need to be hidden, while the front can remain relatively exposed. But this interpretation strikes me as much less true to the pose.)

The expressiveness of the back is something Degas might well have learned from watching dancers. For in dance, and particularly in classical ballet, the back must learn to be articulate, to speak the bodily emotions. Edwin Denby explains some of this when he says in his essay "Forms in Motion and in Thought":

No matter how large the action of legs and of arms, the classic back does not have to yield, and its stretched erectness is extremely long. The low-held shoulders open the breast or chest. But classicism doesn't feature the chest as a separate attraction the way advertising does; a slight, momentary, and beautiful lift of the rib cage is a movement of the upper back.

Degas's bathing nudes are not ballet dancers, and their movements are other than those of classical ballet. But the emphasis on the strong, speaking back lingers.

One is apt to forget, because they convey such a reassuring sense of eternal, silent existence, that Degas's nudes actually represent a captured moment in a continuous movement. What we witness in them is not prolonged strain, but strength in motion—an almost oblivious strength, a power to move that is taken for granted because it is so much a part of the woman's daily life. To describe these captured gestures as "tortured" or "awkward" is to misunderstand the difference between a single moment of continuous movement and a permanently held pose. E. H. Gombrich, in his essay "Moment and Movement in Art," points out that "the understanding of movement depends on the clarity of meaning but the impression of movement can be enhanced by lack of geometrical clarity." Thus the seeming awkwardness of Degas's bathers—both in terms of their own body positions and in terms of our odd, "impossible" viewing perspective—can be understood as part of the overall sense of motion in these paintings; so can Degas's "vague" draftsmanship, his tendency merely to sketch in a leg or an arm at an incomprehensible angle. Gombrich also reminds us of "the strangely frozen effect of instantaneous photographs," and even alludes at one point to the "'snapshot effects' of Degas." We see the bathers in one position forever; but, for the women who are taking their baths or drying themselves, this "pose" is only a fleeting gesture.

Denby is again instructive, this time in his "Notes on Nijinsky Photographs":

> It is interesting to try oneself to assume the poses on the pictures, beginning with arms, shoulders, neck, and head. The flowing line they have is deceptive. It is an unbelievable strain to hold them. The plastic relationships turn out to be extremely complex. As the painter de Kooning, who knows the photographs well and many of whose ideas I am using in these notes, remarked: Nijinsky does just the opposite of what the body would naturally do. The plastic sense is similar to that of Michelangelo and Raphael. One might say that the grace of them is not derived from avoiding strain, as a layman might think, but from the heightened intelligibility of the plastic relationships.

The analogy is not perfect, because Degas's nudes *are* doing "what the body would naturally do," and they are not performing for an

audience. But the link between grace and apparent strain, as well as the allusion to "the heightened intelligibility of the plastic relationships," applies perfectly to Degas. What Denby calls plastic relationships I would define as a mixture of the visual and the kinesthetic—the way the appearance of one's own body can be felt rather than seen, and the way that sensation (of feeling one's own body) can be conveyed to onlookers through purely visual means.

Bearing in mind Degas's discovery of the articulate back, I'd like to return now to *The Tub* and Carol Armstrong's critique of it. She sees the bodily gesture as awkward, and worse:

> *The Tub* fits the category of the grotesque in its disarrangement of the order of the body . . . it is an arm, and not the legs, which supports the body; a hand which makes contact with the floor and is therefore compared to the feet; thighs, not arms, which are aligned along the sides of the body . . . Not only is the female body constituted as an object that deflects the gaze and externalizes the viewer, thus negating the function of the nude; it is also presented as a profoundly unreadable entity, precisely because the female body as a field of sight and touch, as well as its function as gesture, are all turned in on themselves.

She then goes on to make the analogy I quoted earlier, between us (the viewers) and a horror-movie camera moving in on "a victim's unaware back."

This language hardly sounds like praise of Degas's technique, and I first read it as an outright attack. Only when I subsequently came across T. J. Clark's fascinating essay on Manet's *Olympia,* from which Armstrong has essentially borrowed her terms, did I realize that these terms were by no means intended to be pejorative. On the contrary: if one posits the painted nude as existing entirely for the benefit of the male gaze, which in turn is presumed to be aggressive and intrusive, then a body which "deflects the gaze" and "negates the function of the nude" is achieving a sort of feminist victory. It is because, educated in large part by Degas's own work, I do *not* so view the nude that I believe Armstrong to be wrong. Her definition of the nude seems so restricted and conventional that almost no great work of art would fit within it; nothing but a frontally faced, arms-to-the-sides, gaze-returning woman would meet its requirements. And a photograph would probably do so better than a painting, at least in terms of acknowledging the "presence" of its viewers.

What Degas understood is that with the advent of the camera, the

painter's special task became the rendering of scenes that, however lifelike, could not possibly have been photographed. A photograph of an intimate bathing scene is like a fingerprint at the scene of a crime: it testifies that somebody was actually there. But a painting gives no such testimony. However many sketches or even photographs he may have made from models, the painter can still assert that *his* bathing scene comes primarily out of his own imagination.* The painted picture can be private because it is imaginary—not necessarily the product of conscious "ideas," as in a history painting, but a felt response to a dreamed reality. (So that the bather might in turn be able to say to Degas: "I am a thought of yours: and yet, you do not think . . .") As witnesses to that executed dream, we are neither included nor excluded. We exist on a separate plane, rather like the angels in the Wim Wenders/Peter Handke film *Wings of Desire,* who can listen in on the thoughts of mortals and witness their private lives, but who can't actually affect their fates or participate in their world.

The "angel" bones, the delicate, jutting shoulder blades, are the focus of attention in *The Tub.* Lifting her right arm to sponge her neck as she squats in the shallow metal tub (but "squats" is far too awkward a verb for the way this woman delicately balances on three

*The subject of Degas and photography deserves a whole essay, but here I have time only for a footnote. The fact is that Degas's paintings bear a strange and not entirely oppositional relationship to photographs. He himself sometimes used photos as the basis for his work: witness, for instance, the 1896 bromide print of *After the Bath* and the numerous sketches and paintings that came out of it. The pose in all the *After the Bath* paintings—a woman kneeling on her right knee and left foot, her back to us, her body stretched to the right and draped over a chaise—is the same as in the photo, and the delineated, shadow-filled back is a crucial element in both cases. But the feel of the paintings is entirely different. In some, Degas has slightly altered the position of the viewer to make it impossible for a camera to have stood where *we* are; in others, he has simply relied on the color and texture of paint or pastel to soften the reality and make it dreamlike. Photography no doubt interested Degas because, like his own paintings, it sought to capture a single moment in a continuous, fleeting motion. (He worked at almost the same time as Muybridge, whose motion studies of women and horses he apparently was familiar with.) But photography made Degas's realism too real. At his best, in his pastels, he captured the naturalness of the photograph—its honesty about the body—at the same time as he infused his pictures with a sense of seeing the unseeable. Degas's great genius, in his pictures of bathers, was to take something that *could* be seen (a normal woman's body, unadorned and un-idealized) and turn it into something that had all the secrecy of the purely imagined, the definitionally unseen.

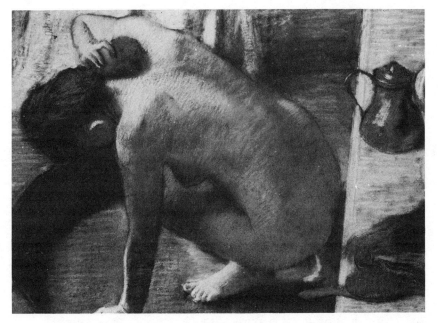

The Tub

aligned points), she simultaneously creates two extended curves: the opened-out, stretched curve running from the tip of her right elbow along the outline of her body to the deep blue shadow at her buttocks; and the more concave, bending curve suggested by her spine, from neck to lower back. Far from "deflecting the gaze," as Armstrong suggests, this body invites our lingering, caressing look: we roam among the light and shadows of the upper back, then slip gently down her left side to the shadowy breast, then down the thigh to circle the hip and come back up the rounded spine. The circle of her body encloses our gaze, just as the circle of the tub encloses her body. And far from negating "the female body as a field of sight and touch," *The Tub* merges these two senses, so that looking at this woman is a kind of handless touching. The pastels, with their sponge-like softness, reinforce this feeling: it is as if Degas's drawing hand, the woman's sponging arm, and our caressing eyes are all accomplishing the same gesture at once. (Armstrong is attentive to this, pointing to the "web of pastel marks in the room and across the back of the woman, like traces of her own sponge-wielding gesture.") A different sense of touch

is evoked here as well: touch as kinesthetic feeling, the ability to sense one's own body without looking at it. As we watch, we feel the pleasure of the long side stretch, the curved back bend; and, in particular, we focus our senses on the shoulder blades and the back of the neck. The point on which the woman focuses, on which she squeezes her sponge, is a part of her body she can never see directly. Hidden from her, it is visible to us; and yet the effect of that exposure is not to make her seem vulnerable, as Armstrong suggests with her horror-movie image. Rather, the upper back comes to be a place that is felt rather than seen: in looking at hers we are really feeling it from the inside, as if it were our own (which we ourselves cannot see). Looking at her body enables us, in part, to feel our own bodies. And it enables us to do so without discomfort or embarrassment, for her concentrated unawareness and safety from intrusion suggest that if we, too, are visible to anyone, it is only to ineffectual angels.

Perhaps more than any other Degas pastel, *The Tub* combines a discrete, private, self-contained sense of the body with a feeling that the body is continuous with its surroundings. Partly, this is done through color: flecks of reddish-gold appear not only in the woman's body but in all the surrounding furniture, echoing her orange sponge and her copper pitcher as well as her own red hair. And the wonderful Degas light, that sheen of white "shading," appears on the tub itself, on the adjacent shelf, and in a nearby cloth as well as on the woman's body. Contrary to Armstrong's assertion, this woman doesn't exclude the external world with her turning inward; rather, she is continuous with that world, even in her privacy. The very dailiness of her gesture is picked up in the dailiness of the objects next to her on the shelf—a brush, some tongs or tweezers, a switch of red hair, and the two vessels, copper and white. These last objects echo, in their rounded shapes and curving handles, the enclosing gesture she makes in her bath. Thomson sees a standard male pun in this echo—"The same patronizing metaphor is to be found in the 1886 suite, for both the Metropolitan and Orsay *Tub* images represent the figure with a jug juxtaposed with her hips and buttocks"—but surely that tone is all wrong for the picture. A pun points to its maker, suggests a conscious violation of the natural linguistic or visual order; but a sense of the maker as someone separate from the woman herself is utterly absent from this Degas pastel. The echo of shapes is a natural one—discovered, not created, and as seemingly unselfconscious as the woman herself.

Like a number of other Degas paintings—beginning, perhaps, with *Interior*—*The Tub* has a strong diagonal line running across it and cutting off the woman from the rest of the picture. In *Interior,* these lines were the floorboards; here, it is the edge of a shelf or possibly a table. Armstrong ingeniously sees the diagonal in the earlier painting as a remnant of, or reference to, the perspective lines in Old Master paintings, a guide to show the viewer where he is standing. But that interpretation can't apply to the later nude, where the line is flattened and the viewer is self-evidently nonexistent. I see this line, instead, as an instrument defining both the woman's separation—her privacy, her self-containment—and her continuity with the rest of daily life, of *real* life. Even while the diagonal cuts her off from things (the man in *Interior,* the maid in *Woman Having Her Hair Combed,* the objects on the shelf in *The Tub*), it also suggests the arbitrariness of such demarcation. The straight line in *The Tub* is unlike anything else in the curve-filled picture; the only thing it resembles is the edge of the paper. That, too, Degas suggests, is just an arbitrary separator. And if the woman is continuous (despite the line) with the objects on the shelf, she is also continuous with the world beyond the border of the painted space.

Degas's nudes are in part a definition of privacy. Privacy can exist if there is a world beyond the room. It can even exist, in some cases, if there is another person in the room, but only if that person allows one to be private. This, I think, is the lesson of the pictures involving maids.

In Degas's iconography, the maid is the opposite of a man. (Even the words, in English, suggest the contrast: virginal femininity versus masculine sexuality.) A maid is someone who can allow her "mistress" (again, think of the double meaning of this word) to exist in complete unselfconsciousness. I take this not as a class issue, as Thomson does ("Degas's images of mistress and maid are organized around polarities of subservience and control; like his brothel monotypes, they correspond to the status quo"), but as an issue of function. The maid's ability to become like a piece of the background does not dehumanize her, but rather suggests her human responsiveness: she is as attentive to the needs of her mistress as women normally are to the needs of men. And the fact that Degas does view the maid as another woman is evident in his handling of clothes and faces. In Degas's pictures of bathers and their maids, only one of the two women can have a face, and only one of the two can be clothed—but it is not always the maid,

or always the mistress, who is faceless or naked. In *Woman Having Her Hair Combed,* for instance, the maid is headless and the nude mistress shows us her face (if only obliquely); while in the 1885 *The Toilette after the Bath* (now in Copenhagen), the maid—played by a friend of Degas's, the actress Réjane—is fully shown from the shoulders up, and her naked mistress is almost out of the picture. Here the maid, who holds up a towel, is very pointedly glancing at her mistress's body, but that body's privacy is preserved by having most of it out of our visual range, with heavy shadowing around the parts of breast and pubic area that we *can* see. In particular, the naked woman's head, from the shoulders up, is gone from the picture—as if each bath pastel could contain only one face, whether maid's or mistress's. If the back, in Degas's work, becomes the face, then the face in some ways also becomes the back—the exposed part, the feature that must sometimes be hidden to preserve adequate privacy.

Another illustration of this maid/mistress pattern is the series of sketches that led up to *Breakfast after the Bath,* the beautiful late pastel in which a purple-bloused maid holds a blue cup full of coffee as her naked mistress towels her neck dry. In an early charcoal-and-pastel sketch (reproduced in Thomson's book), the maid stands nude, holding the coffee cup; the bathtub that separates maid from mistress is still there, but the mistress herself has almost entirely disappeared, with only a faint outline of her buttocks suggesting where she is to be. In a later sketch, the maid has been given a dress, but the outline of her breasts is still quite distinct, whereas the mistress is completely gone. And in the final painting, the maid is clothed (with no semblance of breasts visible beneath her soft, loose blouse) but still prominently in the foreground; we see her face in profile, while the naked mistress is faceless. Moreover, as if to deny Thomson's assertions about class distinctions, each woman performs a ritual, quotidian gesture: the maid bringing the cup of coffee, the mistress lifting her own hair (the maid's function in *Woman Having Her Hair Combed*) and toweling herself dry (the maid's function in *The Toilette after the Bath*). The maid is as focused on her cup as the mistress is on her drying task, so that, although the picture joins them compositionally (the maid's purple-blue blouse colors are picked up in the shadow of the mistress's towel, and the blue cup, from our perspective, stands out against the shadowed flesh of the mistress's buttock), each is rendered as a portrait of intent self-containment.

Not every woman can fulfill the delicate privacy-allowing function of the maid. In Degas's brothel pictures, for instance, the madam is clothed where the prostitutes are naked—but, unlike the clothed maid in the bathing pictures, the madam stands for the intrusion of the male world rather than its elimination. Take, for instance, the monotypes called *The Madam's Birthday*. In these, a nearly nude woman (naked except for stockings and shoes) stands next to the seated madam and rests her hand on the madam's head; other similarly undressed women sit or stand in the background. The standing nude is center stage and frontal, with strongly marked pubic hair and nipples. Several of the women's faces, including that of the madam, are visible to the viewer, though in at least one monotype the women all look off to the side (and there is a strong suggestion that a witnessing male, the object of their gazes, is seated offstage in that direction). Partly because of the technique employed in the monotypes—with their rough, scratchy, dark lines and with the artist's fingerprint marks on the whores' flesh—and partly because of the placement of the women's bodies, these pictures have a totally different feel from the later nudes: they suggest that even in a world of women, the prevailing tone can be exposure rather than privacy, naked sexuality rather than oblivious nakedness.

Degas was evidently a painter who took very seriously the story of Adam and Eve. He believed (or so his paintings would suggest) that after the Fall—after the acquisition of knowledge—sexuality inevitably entailed self-consciousness. If he wanted to capture the bodies of women in a state of prelapsarian unselfconsciousness, he had to banish the figures of men. I do not think this necessarily meant that he hated male sexuality, or himself as a man; but, having chosen to focus on women, he had to eliminate the overtones of conscious sexuality implied by the presence, or even the suggestion, of men. Of course, his choice of women as subjects was not arbitrary: he loved the shapes of their bodies, their elastic strength and softness, and he also loved the dailiness and repetition that their actions partook of. He did choose women over men—but I think that says far more about his feelings for women than it does about his attitudes regarding men.

Nonetheless, the world of Degas's bathing nudes is a world supremely and importantly without men. As Edward Snow says of these pictures, "Their atmosphere is one of primal discovery and arrival: the realm of grace opens before the artist—but upon moments from which

men and all thoughts of men have been excluded." It is a sign of the grace granted to Degas that he, a man in his corporeal life, could escape himself for his task as a painter. And in removing gender from the artist, he also removed it from the viewer. Part of what he confers on us is the ability to perceive these nudes androgynously. The sense of touch is transmuted from an actively sexual sensation to a very different kind of eroticism, an aesthetic and emotional one. We want to touch the soft curves of Degas's nudes, but it is a desire that can be satisfied with our eyes alone. And the sense of touch becomes internal as well as external: we can feel those female bodies from the inside even as we caress them visually from the outside. Particularly when we look at the exposed upper back, our visual caress is also a kinesthetic sensation, a sense of perceiving a part of our own body we never see directly. So we become, in looking at a Degas bather, both male and female—or, more accurately, neither male nor female, since the issue of sexuality has been entirely divorced from the issue of gender.

Degas has been quoted as saying about his female bathers: "I show them deprived of their airs and affectations, reduced to the level of animals cleaning themselves." Like all such explanatory statements on the part of authors and artists, this one is both disingenuous and accurate. On the one hand, he is trying to deny through exaggeration the charge of misogyny: he can't be accused of being rude to "the being usually showered with fulsome gallantries" if he decries such gallantries altogether and "reduces" women to animals. But, on the other hand, this statement is a key to what enabled Degas to transcend his position as a *male* artist. If his women were no longer women, then he in turn was freed from being a man: they could be reduced to animals and he to a combination of eye, heart, and hand. "Reduce" in this sense bears the meaning of boiling down to its essential elements. The result is not only concentration but freedom—from previous history, from cultural context, and even from the insistent demands of one's own body. And, particularly when one is interested in perceiving and delineating moments of physical gesture, the capacity to see people as animals and vice versa may be extremely instructive. Edwin Denby again has a pertinent observation:

The way a cat comes up to you at night in a deserted city street to be patted, and when you crouch to pat her, the way she will enjoy a stroke

or two and then pass out of reach, stop there facing away into the night, and return for another stroke or two, and then pass behind you and return on your other side—all this has a form that you meet again onstage when the ballerina is doing a Petipa adagio.

In Denby's description, when the "cat has had enough adagio, she sits down apart." We allow that kind of independence and self-containment to animals (at least, if we're not Milan Kundera, we do). Degas wanted to allow it to his nudes as well.

There is an eroticism in Degas's bathers, certainly, but it is a kind of unselfconscious eroticism, unmediated by mind, that we don't normally find in men's paintings of female nudes. It is an eroticism of color: the rich, fecund, exciting red of *The Coiffure* (where a red-haired woman in a red robe leans back to receive her maid's tender hair-brushing, both women being set against a dominant background of the same orange-red); the gleaming blue cup and the glowing purple blouse that are picked up in the flesh tones of *Breakfast after the Bath;* the luscious rose and violet hues in the 1895 *Seated Bather Drying Herself* (owned, perversely enough, by *Penthouse*'s Robert Guccione); or the golden-white body that shines out from a deeper gold background in so many of the bather pastels. It is also an eroticism of texture: the flecks, squiggles, and strokes that make up the bodies and their backgrounds, the tactile richness of the pastels themselves, which seem to carry with them the feel of an artist's working hands even as they become totally a part of the untouched women. It is an eroticism of pure desire that has no hope or need of fulfillment and yet receives fulfillment through the eyes alone. It is, in some sense, the desire of a small infant for its mother, or a mother for her small infant, at a phase when sexuality has not yet become conscious and gendered, and when the two beings are so close together that they barely have room to want each other. By giving us, specifically, *bathers,* Degas draws on that act of bathing which is both maternal and childlike, so that our relation to the women is both that of a mother to her child being bathed and that of an infant to its bathing mother. (The women's bodies, too, are maternal in their fleshiness, but with skin as soft and glowing as a baby's.)

And here lies the key to the kind of privacy these paintings depict. Degas's pastels give us the original moment of privacy, the first sense of being alone and yet entirely protected from danger. Winnicott described this moment as follows (the italics are his):

> Although many types of experience go to the establishment of the capacity to be alone, there is one that is basic, and without a sufficiency of it the capacity to be alone does not come about: *this experience is that of being alone, as an infant and small child, in the presence of mother.* Thus the basis of the capacity to be alone is a paradox; it is the experience of being alone while someone else is present.

That moment of otherwise irretrievable paradox is what Degas gives us when he allows his bathers to be alone in our presence and us to be alone in theirs.

The feeling of connectedness that we have when looking at a Degas bather is finally incompatible with our usual adult sexual feelings. It lacks the violence and conflict of sex, the sense of opposition and opposition overcome that sex gives us. A Degas pastel cannot, in that sense, be a model for the ideal sexual relationship. No real-world relationship between adult men and women (or, for that matter, between men and men or women and women) could attain the degree of privacy we see in a Degas nude; if it did so, it would cease to be a relationship and become instead either a complete identity or a complete separation. But, if they cannot offer such a model, Degas's nudes can nonetheless represent the vanishing point toward which the best forms of erotic love strive to move: that imaginary place at which the other being is left alone in her self-contained privacy even as one identifies with her body to the point of feeling it as one's own.

Gissing's Even-Handed Oddness

4 For much the same reasons that *Tootsie* is one of the best recent movies about men and women—because and not in spite of the fact that its central female is actually male—George Gissing's *The Odd Women,* first published in 1893, is one of the best portrayals of the women's movement, old or new. Unlike his near-contemporaries, Madames Sand and Eliot, this George *is* a man—and while that fact doesn't come through in any particular aspect of the novel, it colors the whole tone of the endeavor.

The nature of Gissing's authorial enterprise might almost be the subject of a crucial exchange in the novel itself, in which a woman character responds playfully but seriously to a man who has just praised her judgment over another woman's:

> "That compliment," she said, "pleases me less than the one you have uttered without intending it."
>
> "You must explain."
>
> "You said that by making Miss Barfoot see she was wrong you could alter her mind towards me. The world's opinion would hardly support you in that, even in the case of men."

The gentleman's unintended compliment to women has been his assumption that reason guides their behavior. In Gissing's case, the compliment—to both men and women—that he has "uttered without intending it" is his faith in empathy. In *The Odd Women,* he has doubted neither his own ability to portray male and female minds nor his readers' abilities to enter equally into both. Had the novel been written by a woman, it might well sound too much like exhortation;

a more assertively masculine novelist, on the other hand, might have made this topic the occasion for satire. It is to the degree that Gissing falls into neither camp that the novel succeeds both as fiction and as social comment.

Gissing is one of those writers whose work is surprisingly unknown and, where known, undervalued. His *New Grub Street* sometimes appears on reading lists about the sorry careers of writers. His books *Demos* and *The Nether World* might occasionally be mentioned in studies of the Victorian social novel. But Gissing is not a writer whom people still read. This is unfortunate because, without necessarily being as powerful a novelist as, say, his contemporary Thomas Hardy, he is engaging and frequently pertinent in a surprisingly modern way.

Part of the problem is that even the people who seek to reintroduce us to Gissing view him as a quaint period piece. Rarely have I encountered a writer so poorly served by the authors of his paperback introductions. (And the competition is fierce—*most* writers are unrecognizable in critics' introductions.) These well-intentioned souls always begin by recounting the sordid details of Gissing's life: his early marriage to a prostitute, their miserable poverty and her death, followed by his subsequent marriage to "a second working-class wife, Edith, who was hardly more suitable than the first had been." (This is Gillian Tindall, writing—unbelievably—in 1983.) These biographical facts are then held up as the prism through which the novels are seen. Thus Tindall characterizes Gissing's 1897 *The Whirlpool*—a book about a woman's struggle between the desire for a musical career and the desire for domestic happiness—as at times "demonstrating that almost all styles of matrimony bring trouble, and that the human race would be better off without 'the curse of sex' which leads men into this trap." Yet Tindall can also be a sensitive reader of Gissing's work, as she shows later in the introduction when she points out that "We sympathise with Alma: she is contemptible mainly in the way in which each person is occasionally contemptible to himself in his own heart"; and furthermore that "the personality of Alma expresses elements in Gissing's own"—in particular, "her preoccupation with the rival claims of art and life."

Far more typical of Gissing's present-day critics is John Halperin, who introduces a 1985 reissue of an 1890 novel, *The Emancipated*, by insisting:

The "emancipation" in the novel is that from narrow prejudice, mostly female, in social and religious matters . . . The book does not argue for the emancipation of women—except from prejudice; indeed, it suggests that some women think too much, are too "emancipated" from traditional roles. But on the subject of the emancipation of women from domesticity, the novel is sometimes incoherent—declaring, as Gissing himself believed, that although ignorant women make poor wives, emancipated women make worse ones.

Here it's not just a matter of trusting the tale over the teller, for Gissing himself, at least in this novel, never "argued" anything of the sort. It requires a determined misreading to produce such a summary. Halperin exhibits similar signs of willful uncomprehension when he takes the remarks on art and society that Gissing puts into the mouths of his least authoritative characters—two weak, untalented, lazy, women-betraying pseudo-artists—and calls them Gissing's ideas.

This is not to say that Gissing's own ideas are "coherent." But ideas (as T. S. Eliot suggests in his praise of Henry James) are not necessarily what we want from a novelist. Gissing's talent, in novel after novel, is to render conflict accurately and movingly. He gives us a series of choices in which there is no possibility of getting the "right" answer, except by chance. He sees danger in all extremes, in all directions. Gissing himself gives the best description of his own authorial tendencies when he has a character in *The Emancipated* say to Mallard, the painter who is the closest thing we get to a Gissing stand-in: "My dear fellow, you are a halter between two opinions. You can't make up your mind in which direction to look. You are a sort of Janus, with anxiety on both faces."

It is Gissing's anxiety, I suspect, which makes him seem so modern. And yet the novels also have a freedom from cant, from obsessive "relevance," that can be conferred only by the passage of time. A major problem with discussions in and around the women's movement is that they are overwhelmingly subject to the pressures of immediacy. They always seem likely to take off toward one absolute or another, as if *this* were the eternal situation. Or they are burdened with all the recent clichés of thought and language, so that however much one tries, the discussion can't break out of the current view. In this sense, feminist criticism—despite all the emphasis on "reclaiming women's history"—has suffered from a dearth of historical perspective. At its

worst, this takes the form of rejecting all works of art that were created before the present period of enlightenment. Gissing, especially in *The Odd Women,* somehow manages to transcend the limitations of both his time and his gender by remaining firmly rooted in both.

The novel's title refers, as one character puts it, to unmarried women—the "odd" ones left over after everyone else has paired up. This purely arithmetic definition gets picked up elsewhere in the novel in the profession of Mr. Micklethwaite, a mathematician who has written a book on "Trilinear Co-ordinates" and whose wife "never got much past the Rule of Three," though he hopes that they will be able to "gossip about sines and co-sines before we die." Such language suggests the humor of viewing odd and even as anything other than mere mathematical concepts. Yet in Gissing's time, as in our own, the word "odd" had a further meaning—that is, abnormal, strange, or eccentric.

In his essay "The Uncanniness of the Ordinary," Stanley Cavell refers to a moment in "The Purloined Letter" when Edgar Allan Poe uses exactly that conjunction between the mathematical and social meanings of the word. As Cavell remarks, Poe's detective

> begins by describing a childhood game of "even and odd" in which one player holds in his closed hand a number of marbles and demands of another whether that number is even or odd . . . Lacan to my mind undervalues the relation of Dupin's story of the contest to the Prefect's opening vision of universal oddness. This relation depends on taking to heart Poe's pun, or pressure, on the English word *odd.*

For Cavell, that pressure is connected not only to "Lacan's fruitful perception that Poe's tale is built on a repetition of triangular structures," but also to his own perception that this story asks "to be read as the work of one who opposes me, challenges me to guess whether each of its events is odd or even, everyday or remarkable, ordinary or out of the ordinary." And the pronoun grammar of "*one* who challenges *me*" implies a further perception: that reading and writing are inherently singular activities, and therefore "odd" in their own ways.

All three observations—about the fictional use of triangularity, about the authorial challenge regarding ordinariness versus extraordinariness, and about the singular relationship (the marriage, one might almost call it) between reader and writer—apply equally well to Gissing's *The Odd Women*. Cavell calls one of his earlier essays on

Poe "Being Odd, Getting Even," and my title for this Gissing chapter draws on the same pun. In his novel about single women, Gissing goes so far as to imply that being a woman is itself "odd"—not only because woman is inevitably viewed as the sequential, matching, "next" figure to society's basic biped, man; but also because, compared to man, she is likely to seem eccentric, out-of-the-ordinary, possessed of special perceptions and anxieties. A woman (especially an unmatched woman) is thus more likely than the "average" man to be a singular case—to resemble, that is, the anxious, eccentric Gissing himself.

The Odd Women is about a number of such "cases": Mary Barfoot, a handsome forty-year-old woman who runs a clerical training school for young women; Rhoda Nunn, her strong-minded thirty-year-old assistant; the Madden sisters—Alice, Virginia, and Monica—who turn out to be a couple of pathetic spinsters and an unhappy young wife; and assorted other single women ranging from Miss Eade (a shopgirl turned prostitute) to Miss Royston (who poisons herself after being abandoned by her married lover) to Miss Wheatley (who marries Micklethwaite after a seventeen-year engagement) to Miss Haven (who plans to start the first women's newspaper). All except the first five are basically walk-on parts, and even the two elder Miss Maddens, Alice and Virginia, are mainly foils for their stronger companions. But Mary Barfoot, Rhoda Nunn, and Monica Madden, along with the men who touch and enter their lives, are fully developed characters who illustrate the central difficulties and pleasures inherent in living alone—or at least unmarried, which is not always the same thing. Each of these women defines for herself, differently at various times, the extent to which "alone" (unsupported by a husband) is equivalent to "lonely" (without friends) or even "lone and lorn" (poor, unprotected); and that definition in turn determines the degree to which she feels marriage is either essential or unnecessary.

Monica Madden is perhaps the least "modern" of the three, in that she somewhat resembles our standard notion of the nineteenth-century fictional female. Like Becky Sharp or Jane Eyre, she aspires to a marriage above her station; like Rosamund Lydgate or Gwendolyn Harleth, she hastily marries one man and then falls in love with another; like David Copperfield's mother or the first Mrs. Dombey, she dies as a result of childbirth. Yet Monica—the only married woman in this group of odd women, and therefore "odd" in a contrary way— is far more strong-minded than the stereotypical Dickensian angel, the

simperingly sweet Dora or Ada or Bella.* Monica knows herself well enough to dread the secretarial career for which Misses Barfoot and Nunn want to prepare her, and she also sees her unmarried elder sisters—a decreasingly genteel lush and a fat but sickly governess—as frightening counter-examples. She fears poverty, but she won't marry for money alone: first she must convince herself that she loves her prospective husband, and when she realizes her self-delusion she feels morally obliged to leave him. She is not a feminist by principle, but in practice she rebels against the restrictions of the feminine fate.

Monica's marriage, because it is the only marriage seen from the inside, gives Gissing his only opportunity in this novel to explore the boundaries of marital jealousy and possessiveness. Monica's husband, Mr. Widdowson, begins by being too devoted and ends by being jealously tyrannical; but even Widdowson, though he is perhaps the most exaggerated of the central characters, has a human softness as well. Just before he and his wife have their final break, Gissing gives him a moment of transcendent self-perception. "We are unsuited to each other," he thinks to himself:

> ". . . My ideal of the wife perfectly suited to me is far liker that girl at the public-house bar than Monica. Monica's independence of thought is a perpetual irritation to me. I don't know what her thoughts really are, what her intellectual life signifies. And yet I hold her to me with the sternest grasp. If she endeavored to release herself I should feel capable of killing her. Is this not a strange, a brutal thing?"
> Widdowson had never before reached this height of speculation.

What makes Gissing's vision of sexuality so modern—so much closer to early Lawrence, say, than to early Dickens—is that it encompasses the desire for power and possession. In Monica's case, this desire destroys the marriage because it overwhelms the puny sexual attachment between the two partners; but in the case of Rhoda Nunn, this will to power represents the cause as well as the fatal flaw of her only major love affair.

Rhoda's lover is Everard Barfoot, Mary's ne'er-do-well cousin (and

*That the term "Dickensian," when I use it, is frequently a term of abuse does not take away from the fact that Dickens is my favorite novelist. I couldn't love him as well as I do if I didn't, at times, also hate him. His habitual if occasional manifestations of breathtaking stupidity only make the surrounding brilliance more surprising, and therefore more moving, as if to suggest that even a mortal can write like a god.

the man, incidentally, for whom Mary has harbored an unrequited passion for most of her life). Rhoda, as her last name suggests, is not the sort of woman who has had much to do with men. She thinks she has chosen the single life freely and with conviction; she scorns marriage as she scorns weak women; but a secret corner of herself mistrusts her motives and wonders whether her staunch position is simply the result of never having been asked. Soon after she meets Everard, she makes up her mind to force him to propose; he has already decided to win her over to a "free union" without legal marriage. Each initially considers this a mere game of wills. Yet even after they have actually fallen in love, the need to win still dominates both of them. The proposal scene (in which he wants her to agree to a free union before he will propose, and she wants a proposal before she will agree to a free union) might have come directly out of *Women in Love*—and in the end, like Gudrun and Gerald, they lose each other through the hardness of their wills. There is a lesson implied here: Gissing seems to want men as well as women to be "womanly" (tender) without being "womanish" (weak). But there is also a counter-lesson, in the tremendous appeal of Rhoda's and Everard's willful passion. Such fierceness is the root of their love as well as its poison, and the tension between them is what makes the affair Lawrentian in stature and strength. Gissing, clearly aware of this essential element, at one point compares Everard's ideal of marriage to the happy marriage of his friend Micklethwaite:

> Micklethwaite walked with him to the railway station; at a few paces' distance from his house he stood and pointed back to it.
>
> "That little place, Barfoot, is one of the sacred spots of the earth. Strange to think that the house has been waiting for me there through all the years of my hopelessness. I feel that a mysterious light ought to shine about it. It oughtn't to look just like common houses."

And just as we are about to react with smug superiority to this treacle, Gissing—in the form of Everard—pre-empts us:

> On his way home Everard thought over what he had seen and heard, smiling good-naturedly. Well, that was one ideal of marriage. Not *his* ideal; but very beautiful amid the vulgarities and vileness of ordinary experience. It was the old fashion in its purest presentment; the consecrated form of domestic happiness, removed beyond reach of satire, only to be touched, if touched at all, with the very gentlest irony.

A life by no means for him. If he tried it, even with a woman so perfect, he would perish of *ennui*. For him marriage must not mean repose, inevitably tending to drowsiness, but the mutual incitement of vigorous minds.

To leap in one paragraph from a tender appreciation of the Dickensian hearth to an argument for Lawrentian conflict is no mean feat, even if the prose *does* creak a bit in the process.

Lest it begin to seem that this book about single women is really about marriage, I should point out that the third central figure, Mary Barfoot, is utterly removed from the prospect of romance. Yet she remains a sympathetic figure—in many ways the *most* sympathetic ideologically, if the least accessible in fictional terms. I would have liked to know more about her pain and indecision; we are told they exist, but we never see them up close the way we do Rhoda's. Gissing may well have deemed this unnecessary because Mary is already "womanly" enough: she advocates the importance of tenderness and mercy, and the addition of her own sentimental episodes might have overbalanced the portrait in the direction of mush. Rhoda, on the other hand, needs to be seen from the inside if she is not to seem utterly hard-hearted. In a way, the three central women form a kind of bizarre trinity wherein Rhoda, through Monica's suffering, is brought to a state of redemption that resembles Mary's initial state of grace. Having previously rejected Mary's belief that women ought to preserve a nurturing, maternal quality, Rhoda finds herself at the end of the book holding Monica's orphan daughter: "She gazed intently at those diminutive features, which were quite placid and relaxing in soft drowsiness. The dark, bright eye was Monica's. And as the baby sank into sleep, Rhoda's vision grew dim; a sigh made her lips quiver, and once more she murmured, 'Poor little child!'" The child who provokes Rhoda's maternal pity is not just the orphan, or not just Monica embodied in her daughter, but also the child Rhoda herself might have had if she had chosen to marry Everard—as well as Rhoda's own child self, that naively tough woman who finally disappears only when Rhoda herself begins to understand the power of passion.

If I have made *The Odd Women* sound like a treatise in favor of womanly virtues, I have done it an injustice. The novel makes a tremendous effort (in which it largely succeeds) to show a number of different alternatives for women's lives without either urging one over

the other or seeming to present a sociological smorgasbord. The achievement is not an easy one: most recent novels about "women's issues" have erred in either the former direction (think of Marilyn French, Mary Gordon, Alison Lurie) or the latter (Sara Davidson, Margaret Drabble). It is very hard to balance good fiction with self-conscious feminism—or, for that matter, with self-conscious ideologies of any sort. What Keats said about poems—"We hate poetry that has a palpable design upon us"—is also, though less obviously, true of novels.

Both the virtues and the shortcomings of Gissing's "feminist" novel are especially evident when it is set beside an obvious counterpart: Henry James's *The Bostonians*. James's novel appeared seven years before Gissing's, in 1886, and there is some indication that Gissing was familiar with it. (At least, he borrowed its heroine's surname, Tarrant, for a central character in his 1894 novel *In the Year of the Jubilee*—but I suppose that could be coincidence.) Still, nobody would ever accuse Gissing of cribbing either his plot or his "message" from James. Where *The Odd Women* is an eminently fair, consciously anti-romantic, intellectually respectful appraisal of the women's movement, *The Bostonians* is a melodramatic, intensely emotional, potentially offensive portrait of an easily manipulated feminist "preacher" torn between her lesbian colleague and a powerful male suitor. Only the most hard-line feminists would take issue with Gissing, but few would be able to stomach James. Yet *The Bostonians* is the better novel—in large part because, like the subjects it discusses (sex, power, politics), it is a bit crazy. Evenhandedness, in other words, is the weakness of *The Odd Women* as well as its strength.

Compare the passages I've quoted from *The Odd Women,* for instance, to the paragraph that ends *The Bostonians*. This final scene follows on nearly a hundred pages of high-pitched suspense, in which we don't know whether Verena Tarrant will leave her family, profession, and friend Olive to marry Basil Ransom or not. (Nor can we be sure, I think, which we want her to do.) The novel ends with Verena's abrupt disappearance from her final speaking engagement:

"Olive, Olive!" Verena suddenly shrieked; and her piercing cry might have reached the front. But Ransom had already, by muscular force, wrenched her away, and was hurrying her out, leaving Mrs. Tarrant to heave herself into the arms of Mrs. Burrage, who, he was sure, would,

within the minute, loom upon her unattractively through her tears, and supply her with a reminiscence, destined to be valuable, of aristocratic support and clever composure. In the outer labyrinth hasty groups, a little scared, were leaving the hall, giving up the game. Ransom, as he went, thrust the hood of Verena's long cloak over her head, to conceal her face and her identity. It quite prevented recognition, and as they mingled in the issuing crowd he perceived the quick, complete, tremendous silence which, in the hall, had greeted Olive Chancellor's rush to the front. Every sound instantly dropped, the hush was respectful, the great public waited, and whatever she should say to them (and he thought she might indeed be rather embarrassed), it was not apparent that they were likely to hurl the benches at her. Ransom, palpitating with his victory, felt now a little sorry for her, and was relieved to know that, even when exasperated, a Boston audience is not ungenerous. "Ah, now I am glad!" said Verena, when they reached the street. But though she was glad, he presently discovered that, beneath her hood, she was in tears. It is to be feared that with the union, so far from brilliant, into which she was about to enter, these were not the last she was destined to shed.

Unlike *The Odd Women,* this novel ends with the requisite marriage, with the salvation of the maiden by the powerful knight who rips her from the jaws of danger. Yet he rips her a bit harshly ("Ransom had already, by muscular force, wrenched her away"), in a manner frighteningly sexual ("Ransom, as he went, thrust the hood of Verena's long cloak over her head"; "Ransom, palpitating with his victory"), and he seems too eager to efface her maidenly independence ("to conceal her face and her identity"; "It quite prevented recognition") even before she has fully left it behind. And then there are those tears. If they are not because the marriage is "so far from brilliant" (and James's ironic "It is to be feared . . ." suggests that they are not), then perhaps there is a stronger and less ironic reason for them. James has given us the marriage of which Gissing, in a spirit of anti-romantic truth-telling, has deprived us—yet it is James who finally leaves us with more doubts about the institution of marriage. We committed novel-readers may well find ourselves secretly wishing that Rhoda had given in and married Everard, but few of us will be sanguine about Verena's choice. However much we may want her to be "saved" from Olive and Mrs. Tarrant (and at least some of the cards are stacked in that direction), we can't help feeling apprehensive about this particular form of salvation. The tears that close this novel-with-a-happy-mar-

riage are far more tragic than those which dim Rhoda's vision as she looks at the sleeping baby. If the ending of *The Odd Women* confirms its message (that women can live alone, that independence need not be equivalent to hardness, and so on), the ending of *The Bostonians* turns the whole notion of "message" on its head. James's is a far more radical act of fiction.

But Gissing has his own special collection of literary virtues, not least among which is his ability to convey the economic and social texture of daily life. This concern with dailiness, with ordinariness, may well be another aspect of his "feminine" or at least "nonmasculine" cast of mind—a cast of mind similar to that which brought Degas into sympathy with his female bathers. To have this intimate attitude toward the ordinary is precisely *not* ordinary (as Cavell's remarks about Poe suggest).

What did it mean, specifically, to be a working woman in the London of 1893? *The Odd Women* provides all sorts of fascinating minutiae in answer to this question. Before reading this novel, I did not know that a single woman could get a room in a "respectable" boarding-house for five shillings sixpence a week—or slightly more if "attendance" (cleaning, meal service, etc.) was included; that unaccompanied shopgirls walked fearlessly through London at all hours of the day or night, though "ladies" were afraid to do so; that secretarial work was considered a male province (and therefore respected), while teaching and nursing were female (and therefore disdained); that a woman could be more compromised by going to a man's "flat" than to his house (where servants were likely to be present); that gin was readily available in grocery stores and affordable even to the poorest women, while brandy was the drink of more genteel alcoholics; and many more such informational tidbits. This is the kind of thing Gissing does so well in his other novels (*New Grub Street* and *In the Year of the Jubilee,* for instance): his grasp of social truth lies in a feeling for detail, an awareness of which facts will ultimately prove to have both historical and narrative importance.

Yet *The Odd Women* manifests one very strange difference from Gissing's other novels. *New Grub Street* and *In the Year of the Jubilee,* like the earlier *Demos, The Nether World,* and *The Unclassed,* are deeply concerned with the issue of class. Poverty is an evil not just in itself; its painfulness is exacerbated by the behavior of society's more comfortable members, who lead their lives as if the poor didn't exist. The

destitution of the starving writer in *New Grub Street* is set against both the idealistic world of literature and the existences of his better-off friends. In Gissing, the material world cannot be ignored and the power of money is never underrated.

To a certain extent these feelings make their way into *The Odd Women* as well. Thus the marriage between Micklethwaite and Miss Wheatley, delayed for years because of his financial inability to support a wife, is described in the following terms: "The simplest of transformations; no bridal gown, no veil, no wreath; only the gold ring for symbol of union. And it might have happened nigh a score of years ago; nigh a score of years lost from the span of human life—all for want of a little money." Similarly, Monica Madden's unhappy marriage is clearly motivated by her desire to escape poverty—again, a tribute to economic forces. And the central feminist "solution" in the book, the training of women for clerical jobs through which they can support themselves, would also seem to hinge on the power of money. But at some very basic level, economic issues are not the point of this novel. Miss Barfoot makes this clear to her assembled trainees when she says to them, "I am not chiefly anxious that you should *earn money*, but that women in general shall become *rational and responsible human beings*" (her emphasis).

In fact, *The Odd Women* has far less sympathy for the poor than one finds in most other Gissing novels. The only memorable portrait of a working-class woman occurs in the occasional appearances of Miss Eade, whose decline from shopgirl to prostitute is pictured as the inevitable result of her own stupidity, and whose intermittent screeches of envy and suspicion haunt Monica Madden during her simultaneous social ascent. The implicit principle—that class is a more damning limitation than gender—is made explicit in a conversation between Mary Barfoot and one Mrs. Smallbrook:

> "But surely you don't limit your humanity, Miss Barfoot, by the artificial divisions of society."
>
> "I think those divisions are anything but artificial," replied the hostess good-humoredly. "In the uneducated classes I have no interest whatever. You have heard me say so."

Miss Barfoot goes on to expound on her lack of interest in "the lower classes (I must call them lower, for they are, in every sense)," to which Mrs. Smallbrook responds:

"But surely . . . we work for the abolition of all unjust privilege? To us, is not a woman a woman? . . . I aim at the solidarity of women. You, at all events, agree with me, Winifred?"

"I really don't think, aunt, that there can be any solidarity of ladies with servant girls," responded Miss Haven, encouraged by a look from Rhoda.

"Then I grieve that your charity falls so far below the Christian standard."

That last line, the disdainfully diminutive ring to Mrs. Smallbrook's name, and the general sympathy accorded to Miss Barfoot's position are all enough to indicate the narrator's stance here: clearly this busy-body do-gooder is meant to be about as appealing as Dickens's Miss Jellyby, who enthusiastically organizes missionary trips to Africa while her own household falls apart around her. The message—whether it be Gissing's or that of the late-Victorian women's movement, as embodied in Mary Barfoot—appears to be that one should set one's own house, or class, in order first. As Miss Barfoot says: "I choose my sphere . . . I must keep to my own class." The novel itself presents certain possibilities for overcoming barriers between intelligent men and women (in the potential marriage of Everard to Rhoda, and in his actual marriage to Agnes Brissenden), but it presents none for overcoming class barriers.

It is customary to trace this pessimism to Gissing's own marital experiences. And it's true that after two unsuccessful marriages to working-class women, the middle-class Gissing may indeed have begun to believe that class barriers were insuperable. He certainly had more reason than most of his contemporaries to feel that men could directly benefit from the intellectual and economic independence of women—a goal that may have struck him, by this time, as more reasonable and practical than the entire restructuring of the social order. And he may also have been taking his cue directly from the women's movement of his day: given the accuracy of his other social observations, it is quite likely that the Mary Barfoots of his acquaintance were more convincing than the Mrs. Smallbrooks.

But the discrepancy remains disturbing. Educated, in part, by Gissing's own social awareness, we cannot quite swallow the inconsistency between the championing of female freedom and the trampling of society's weaker members. Mary Barfoot herself embodies this inconsistency, while Rhoda Nunn hardheartedly but logically evades it. In

a conversation between the two of them about women who can't be helped to independence, Mary says:

> "I don't like your 'ragged regiment' phrase. When I grow old and melancholy, I think I shall devote myself to poor hopeless and purposeless women—try to warm their hearts a little before they go hence."
>
> "Admirable!" murmured Rhoda, smiling. "But in the meantime they cumber us; we have to fight."

If we are torn between the logic of Rhoda's view and the appeal of Mary's, then Gissing has succeeded in revealing to us a crucial dilemma of the women's movement. He has taught us, too, to be "a sort of Janus, with anxiety on both faces." I can't speak for the suffragettes of Gissing's own time, but I know that modern feminists initially viewed themselves as part of the politics of the left: equal rights for women, like nuclear disarmament, socialized medicine, and full employment, was and still is seen as a liberal cause. Yet, as Margaret Thatcher's rise has demonstrated, there is nothing inherently left-wing in the assertion that women should be economically and educationally equal to men. This reform, if it could be effected in the blinking of an eye, would simply increase the available pool of those who might ultimately climb to power and wealth on the backs of others. In itself, it would do nothing to alter the *numbers* of those at the top or the bottom; it would merely alter their sexes.

I don't know exactly what to do with these realizations generated by *The Odd Women,* just as I have never known what to do with my feelings about the women's movement as a whole. The novel has condensed for me two conflicting and intertwined concerns: on the one hand, the sense that my being a woman is a crucial fact of my existence, justifying some feeling of kinship with women as a group; and, on the other hand, the belief that if we are ever to get anywhere in fixing up the world, we cannot sympathize only with those who are linked to us through such feelings of kinship. Gender is an insurmountable barrier that one must nonetheless try to surmount—as the author of *The Odd Women* so ably and generously does.

Henry James and the Battle of the Sexes

5 In her essay "Henry James's Unborn Child," Cynthia Ozick asks herself—and us—why it was that James never finished the story "Hugh Merrow." Unearthed in manuscript form from the basement of Harvard's main library and recently published by Leon Edel and Lyall Powers in their edition of *The Complete Notebooks of Henry James,* the story involves an artist, Hugh Merrow, who is asked by a childless couple to paint a portrait of their imaginary child. The imagining is left to the painter: he, and he alone, is to choose the child's sex. At that point the fragment ends. Ozick asks if the obstacle facing James here is the old one of imagination versus reality, of art as forgery. "But these questions point to only half the riddle of 'Hugh Merrow,'" she continues. "The other half may come nearer to the marrow of the self. (Is it unimportant, by the way, that 'Hugh' can be heard as 'you,' and 'Merrow' as 'marrow'?) The other half is psychosexual. It is Mrs. Archdean's intelligence that Hugh Merrow draws close to; she asks him to combine with her in the making of her child . . . Girl or boy? The painter must decide."

Ozick observes, with characteristic intelligence, that "James had often before made such choices. His novels and stories are full of little girls understood—and inhabited—from within. Sensitive little boys are somewhat fewer, but they are dramatically there." So Ozick concludes that in this case "James was pressing the artist—he was pressing himself—to decide his own sex, a charge impossible to satisfy." Well, yes, in a way; but references to James's bachelor state and homoerotic inclinations don't satisfyingly explain the intensity of this incompletion. It also has something to do with making an absolute choice—with accepting finality. For James, the idea of deciding *anything* "once and for all" is forbidding, terrifying, impossible. It becomes especially paralyzing when the choice involves a character's sex, because creating

characters, entering alternately into the selves of men and women, is James's own way of saying that nothing, not even gender, is completely fixed. (Ozick points this out, describing James "as protean artist, as imaginative tenant of the souls of both women and men.")

If fixed fate and fixed gender are linked in James's mind, then so, conversely, are ambiguity and the possibility of genderlessness. For James, ambiguity—along with its concomitant feature, the tortuously obscure sentence or image—is an escape route from the entrapment of permanently being a man or a woman; ambiguity is the maze that leads from the absolute closure of life to the relative openness of art. But James himself would quibble with the finality of that formulation. It's life, he might say, that is ephemeral, changeable, and therefore open, while art is fixed forever on the page or canvas. The point, if we take his ambiguous approach seriously, is to give both sides their due, to choose neither absolutely—neither male nor female, neither life nor art. And yet James makes even that compromise difficult for us, for he repeatedly insists on the necessity of making choices.

People who object to Jamesian tortuousness seem to feel that it's a con job, a performance aimed at confusing the reader and, by contrast, elevating the writer. But James does not exempt himself from the judgments imposed by those magisterial sentences. His ambiguity is a technique that cuts both ways, lifting the writer *and* his readers out of their personal selves. Ezra Pound, contemplating James's style, commented on how "the momentum of his art, the sheer bulk of his scriptorial processes" worked to "heave him out of himself, out of his personal limitations"—as if James the man, like little Charlie Chaplin in *Modern Times,* had been swallowed up by the huge machine of the Jamesian style. What Pound discovered is the blessed impersonality at the root of that eccentric, distinctive, unmistakable style. Though gossip, as both literary technique and social phenomenon, is the cornerstone of most of the novels, and though the final novels were actually dictated aloud, "voice," as we usually think of it in connection with spoken language, is strangely absent in James. Voice implies an individual stance, personal opinions, the helpful prejudices of daily existence. But James's insistent tortuousness forces him, as it forces us, to leave behind the instantaneous, black-and-white discriminations that enable us to get through our days in reasonable time. And yet the words "insistent" and "force" belie James's actual technique, which is one of seductively witty conversation. It is a pleasure to yield

ourselves to those charming, flattering sentences: their very length and digressiveness mark, for us, the author's respect for *our* conversational subtlety, *our* impressionability to nuance and detail. James does not stoop to conquer; he draws us in as equals.

The Jamesian style places a premium on certain attributes which are linked to an appreciation of ambiguity: sympathy, receptivity, wit. And the fictional plots themselves confirm and affirm these judgments. The characters who are best at exercising sympathy, who are most receptive to the tonal ambiguities of the world, and whose wit softens the severity of those perceptions, are the ones we like best: I'm thinking particularly of Ralph Touchett in *The Portrait of a Lady,* or Fanny Assingham, whose enlightening presence in *The Golden Bowl* makes its obscurities somewhat more penetrable. Yet it is impossible to read James's novels as morality tales about the triumph (or even the tragic failure, which is triumph reversed) of virtuous qualities like sympathy, receptivity, and wit. For even those qualities are not unmixed blessings. If you truly believe in ambiguity as a moral force, then *no* quality can be an unmixed blessing. The triumphant Jamesian character can never simply arrive at the perception of a virtue and then carry it to its extreme conclusion. He (or, more often, she) must constantly be teetering in the balance between extremes, seeking to placate the authorial fates by darting first in one direction and then in its opposite. That there are so few "triumphant" Jamesian characters testifies to the difficulty of the enterprise. More often, James's figures flounder in their efforts to pursue singlemindedly a supposed Jamesian virtue. Thus Fleda Vetch in *The Spoils of Poynton,* John Marcher in *The Beast in the Jungle,* and Merton Densher in *The Wings of the Dove* all get hoist by their own passive receptivity: they are so busy embodying Jamesian appreciations of ambiguity that they fail to live their own lives.

James never lets us forget that sympathy's opposite virtue is discrimination; that receptivity's opposite is active will; and that the opposite of wit is seriousness. By "opposite" I don't mean the antithesis, or the vice that corresponds to each virtue (as, say, hardheartedness does to sympathy, or humorlessness to wit). I mean, instead, the virtue at the opposite end of the positive spectrum—as if all good attributes, like colors on a paint store's sample card, were laid out in a row with their related attributes. If sympathy, receptivity, and wit lie at one end of their respective spectra, discrimination, will, and seriousness are at the

other. Taken to an extreme, these virtues verge on vices—which is why they require the admixture of their opposites to moderate and complicate them. James appreciates both ends of each spectrum, for he is always willing to have things both ways, even if neither his readers nor his characters can fully go along with him. (And yet that "always" marks a moral flaw too, for anything undiluted by its opposite can be dangerous. James's premium on ambiguity is so infinitely regressive that even he cannot escape its toils: he teaches us to hold his own unremitting ambiguity against him.)

These preliminary remarks about ambiguity are in part an attempt to define the terms on which one must take James's "statements"— not only about women, but about everything else. They point, that is, to the trickiness involved in the effort to figure out what James is saying about women: one can't pin him down to an absolutely unambiguous position, but nor can one simply throw up one's hands and say, "He's just being ambiguous." That would be the John Marcher solution, the tactic of a creature so fearful of making a mistake that he can never exercise a single option. James advises us that we *must* choose something, even if the choice is bound to be partially wrong. And I think that in regard to his portraits of women this pressure to formulate some attempt at a conclusion is even greater than usual— not just because you or I might think "the woman question" is important, but because James himself did. He may not have viewed it as narrowly as Olive Chancellor and her fellow sufferers and suffragettes do in *The Bostonians,* but James was nonetheless extremely interested in the rules, instincts, privileges, and characteristics that defined—and perhaps still define—the feminine. For James, the behavior of women in civilized society (with "civilization" carrying all of its Freudian drawbacks as well as virtues) was part of the same subject as the paired attributes of moral understanding he repeatedly explored: sympathy versus discrimination, passive receptivity versus energetic exercise of will, wit versus seriousness. (To these I would also like to add, at this point, knowledge versus innocence and renunciation versus possession. The latter is not quite the same thing as passivity versus will, for the effort to renounce must often be an extremely powerful one.) How these oppositions get worked out in James's vision of women will be the subject of the rest of this chapter. In pursuing this train of thought, I will try not to forget T. S. Eliot's notion that James's mind was "so fine that no idea could violate it."

Often misappropriated as an insult, this remark is instead a wise admonition about keeping our own crude "ideas" separate from James's infinitely painstaking workings-out.

When Elizabeth Hardwick was once asked, during a panel discussion about American literature, to name "our greatest female novelist," she promptly responded "Henry James." The remark's wit lies in part in its accuracy. James saw things, for the most part, from the woman's point of view; even his refusal to see that as a particular "point of view" had in itself an element of female identification. Thus, in an 1868 review of a book called *Modern Women and What Is Said of Them,* the young Henry James—tempted into the kind of generalization that rarely if ever escaped him later in life—wrote: "We are all of us extravagant, superficial, and luxurious together. It is a 'sign of the times.' Women share in the fault not as women, but as simple human beings." This, in vastly transmuted form, was to be the keynote of his as-yet-unwritten fiction.

James's sympathy for his female characters would be unusual in any country and in any era; but coming as they do from the same culture that gave us Melville's sailors, Twain's picaresque heroes, and Howells's businessmen, James's women are nothing short of thrilling. They leap whole from his brain as Athena did from Zeus's—and, like Athena, they dominate the intellectual atmosphere of their respective cities. (In fact, James's urbanism seems intimately linked to his feeling about women, in the sense that women require cities—the *civi* of civilization—in order to achieve the full flowering of their social and intellectual powers. This may explain why so many Jamesian heroines, like their author, end up fleeing provincial America for urban Europe.) There is something capacious and awe-inspiring and incomparable about the masculine fiction of nineteenth-century America; I'm not in any way trying to deny the virtues of *Moby-Dick* or *Huckleberry Finn.* But there is also something discomforting about the process of actually reading these great books. They are prickly and a bit cold, like a cave; whereas James's novels are like a beautiful house whose hostess has prepared everything to suit her own exquisite taste and our comfort.* James made the American novel habitable.

*The discomfort comes only after the visit, when we wonder what our charmingly gossipy hostess is saying about *us* to her subsequent guests. In other words, James's novels are pleasurable to read but difficult to resolve; there's always something that nags and festers, preventing us from feeling safely finished with the book.

Like Elizabeth Hardwick, I had always assumed that the pleasure I felt in reading James's novels stemmed in part from their congenial feminine sensibility. (Harold Brodkey has called James's "an invented female voice.") So it was with some surprise that I first discovered the feminist anger at James. This reaction tends to be set off, primarily and perhaps predictably, by *The Bostonians.* I taught it one year to undergraduates at UC Santa Cruz and was met with cries of outrage on the part of my more vociferously feminist students, who felt that James was travestying Olive Chancellor. And then I found the same kind of complaints in *The War of the Words,* the first volume of Sandra Gilbert's and Susan Gubar's three-part feminist study, *No Man's Land.* What Gilbert and Gubar do is to take Basil Ransom—"the impoverished southerner who speaks for masculine values in *The Bostonians*"— as a stand-in for Henry James. They argue "that Basil's aesthetic is an essentially Jamesian one, a belief that a man of letters must set himself against 'an age of hollow phrases and false delicacy' . . . and that Basil's rescue of Verena from the diseased clutches of Olive and her band of fanatical acolytes reflects James's desire to tell women that 'Woman has failed you utterly—try Man.'" They also make a glancing reference to "James's suspicion that Olive's lesbianism is a symptom of social disorder."

This perspective on Henry James is so different from my own that my first tendency is merely to gasp with disbelief: can we really be speaking about the same novel? However, misrepresentations and inaccuracies like Gilbert's and Gubar's (which I will address in some detail later) arise from the same sources as the outrage of my undergraduates—and outrage, when honestly felt, generally points to something worth looking at. In other words, while I feel that the feminists are wrong in their specific interpretations of *The Bostonians,* I'm persuaded that their feeling of violation springs from real disturbances created by James's novel. For somewhat different reasons, the book caused outrage when it was first published in 1886; and, perhaps because he never got over that adverse reaction (as well as because of other, more pressingly financial reasons), James did not include the novel in his New York Edition. *The Bostonians* is not the comfortable, well-appointed house that most James novels are: it has lovely architectural features and a charming color scheme, but it also has unexpected trap doors and hidden pin-cushions in the overstuffed chairs. Any discussion that deals seriously with James's feelings about his female characters must surely take account of *The Bostonians,* and I

intend to make it the centerpiece of my discussion. But I propose to approach it in reverse, by beginning at the end of James's career and working backward in time to the composition of *The Bostonians*. Only in comparison to later works that reworked similar patterns—specifically, in comparison to *The Golden Bowl* and *The Wings of the Dove* and, to a lesser extent, *The Spoils of Poynton* and *The Portrait of a Lady*—does the true complexity of *The Bostonians* emerge. I will start, then, at the end, with *The Golden Bowl,* which is in many ways the most perfect and triumphant example of James's intentional ambiguousness.

The central geometric pattern in fiction (and perhaps, if we agree with Freud, in life) is the triangle. But in James's fiction the figure is more likely to be a lopsided quadrangle: the usual three (with two "suitors" battling over one "object") and a fourth character situated somewhere between participant and observer. This fourth character is not divorced from the action; on the contrary, the outcome of the battle will affect him (or her) significantly, and he often has a great deal of influence on that outcome. But for some reason—having to do with family relationships, or prior history, or inappropriate age and gender, or mere lack of animal appeal—he is not an object of sexual desire for any of the other three, nor is he allowed to possess fully the one of the three that he desires. And therefore he (or, as I say, she) is outside the triangle of competition.

In *The Golden Bowl,* this peripheral figure is Adam Verver. The real fight is between Maggie and Charlotte over the Prince; Adam is merely married to Charlotte, for convenience (for Maggie's convenience, as both he and Maggie acknowledge). The true object of Adam's desire is Maggie, his own daughter. For obvious reasons, he cannot keep her forever. (By desire I do not necessarily mean overt sexual desire. In this case, it refers instead to a more domestic feeling, a wish to be with the other person intimately and continuously, as in fact Maggie and Adam *have* been together up until her marriage to the Prince.) There is no way, given the structure of things, that Adam is going to end up with all his wishes gratified; the best he can do is to sacrifice himself on behalf of the person he loves. This he does by removing both himself and Charlotte from the scene, thus leaving the Prince completely to Maggie. Whether this final "act" is due to his or Maggie's decision is never made quite clear: their understanding is so complete that whatever one intimates, the other feels.

Like the other objects of triangular desire in James's work (for

example, Merton Densher, Owen Gereth, and Verena Tarrant), Prince Amerigo is something of a black hole; or perhaps it would be more accurate to say he's a deep, dark well into which one peers intently without ever being sure how much water (if any) is at the bottom of it. The Prince is, almost by definition, subtle and intelligent. If he weren't so on his own, centuries of family history—all those bound volumes of archives Maggie is so fond of consulting—would combine to make him so. He possesses enormous taste and discrimination. It is he who instantly spots the flaw, the crack, in the eponymous golden bowl, and leaves the Bloomsbury shop so as not to have to listen to the dissimulating sales pitch; while Charlotte, who *wants* the bowl, and therefore wants it to be desirable, stays on. But, like the other "dark wells" of Jamesian fiction, the Prince is on some level stupid, or at least obtuse. At best, he is only passively intelligent. Throughout most of the novel, he depends on Charlotte's superior intelligence, her willingness to lay things out for him. "What in fact most often happened was that her rightness went, as who should say, even further than his own," James tells us, speaking for the Prince's own perceptions; "they were conscious of the same necessity at the same moment, only it was she, as a general thing, who most clearly saw her way to it." Yet as the novel hurtles to its close and Maggie clearly stands to win, the Prince abruptly changes sides, betraying both himself and Charlotte, as they were at their best. "'She's stupid,' he abruptly opined," giving his wife his final take on Charlotte. But in delivering this opinion—based, as he says, on his sense that Charlotte doesn't know Maggie "knows"—the Prince reveals his own stupidity. Taste alone fails him, and self-protection triumphs over acute perception. He takes Charlotte's proud, pained performance for the real thing, though even Maggie sees through it: "'She knows, she knows!' Maggie proclaimed."

Knowledge is a central question for Maggie, and her own changing relationship to it determines our shifting sympathy for her. In the first half of the novel, when she's innocent and ignorant, it's hard to be either for or against her: she's simply not much of a factor, whereas the Prince and Charlotte are both wonderful. In the second half, as she increasingly becomes the most knowledgeable character in the drama, our feelings for her undergo a strange transformation. We both respect her more (because she's intelligent) and pity her more (because she perceives she's been betrayed); but, as she begins to use

this knowledge to alter her situation, we also begin to draw back from—what to call it?—her exercise of power, her manipulation, her emotional tyranny. Why should it be worse for her to manipulate Charlotte, after discovering the adulterous affair, than for Charlotte to manipulate *her* during the affair? Perhaps because, in the novel's second half, Charlotte knows she's being manipulated, and Maggie knows she knows; and in this novel, knowledge is everything, the source of all pain and all power. No—knowledge and money together are everything, as Maggie and Adam triumphantly demonstrate. Neither alone is sufficient to carry one very far.

Charlotte understands this from the beginning. She understands that her tragedy is to be poor, that poverty prevents her from having what she most wants in life—namely, the Prince, whom she meets and falls in love with before Maggie ever sees him. If Charlotte is materialistic, she is no more so than the novel as a whole, or than any Jamesian novel; James was never one to underestimate the importance of money. Yet Charlotte never allows gross materialism to dampen her passions: she knows that life is to be lived, not to be speculatively evaluated for its possible worth. She has more courage than any of the other three comfort-seekers. "Don't you think too much of 'cracks,' and aren't you too afraid of them?" she says to the Prince, in a conversation that alludes to more than the gilt-crystal bowl itself. And then she accurately remarks about herself: "I risk the cracks." She has enormous pride (it's her pride that forces her, in the end, to pretend that *she* has urged Adam to make the move back to drearily provincial "American City"), but she is willing to abandon that pride when it's in contest with love. Just before the Prince's marriage, having wangled an hour alone with him, she makes a declaration of her love: "I don't care what you make of it, and I don't ask anything whatsoever of you—anything but this. I want to have said it—that's all; I want not to have failed to say it." That willingness to reveal herself may be another and even deeper kind of pride.

Charlotte is the culmination of one tradition of Jamesian heroine: the appealingly independent, energetically ambitious, but initially penniless young woman. She bears a superficial resemblance to Isabel Archer, who is also poor, also "independent," and also attractive in an extremely American, "free" way. But in some respects she's much more similar to Kate Croy of *The Wings of the Dove*. Both Kate and Charlotte are capable of feeling and engendering deep love for and in a man—

a man, whether it be Merton or Amerigo, who cannot necessarily rise to the high levels of courage they themselves exemplify. Both refuse to marry in poverty (Kate has excellent reasons, with the example of her sister's sordid domesticity always before her), and both choose less direct and less socially acceptable ways of possessing their beloved. Finally, both attain their ends by manipulating an innocent young woman (Milly/Maggie) whose discovery of the deceit destroys the Kate/Charlotte plot; and both nonetheless, and surprisingly, remain sympathetic characters.

Yet they too differ in important ways. Kate is a far more active manipulator, a far more culpable perpetrator of morally dubious "plotting," while Charlotte merely falls—though knowledgeably, it's true— into her complicated situation. (Despite my apparent criticism, Kate Croy is my favorite of all James's characters; perhaps I even love her *because* she's so filled with active will.) And Milly's victory over Kate is ambiguous—Milly is, after all, dead—whereas Maggie's victory over the banished Charlotte is complete. Charlotte, as victim, thus has something in common with an entirely different order of Jamesian heroine: the Fleda Vetch type, the "renouncer." Charlotte too renounces, not only at the novel's beginning, in her last meeting with the as-yet-unmarried Prince ("What she gave touched him, as she faced him, for it was the full tune of her renouncing. She really renounced—renounced everything, and without even insisting now on what it had all been for her"), but also at the end, when she agrees to be packed off to America. In the famous passage in which James metaphorically conveys her submission to Adam Verver's will, it is our sense of Charlotte's initial proud freedom that makes her final entrapment all the more painful:

> Charlotte hung behind, with emphasised attention; she stopped when her husband stopped, but at the distance of a case or two, or of whatever other succession of objects; and the likeness of their connection would not have been wrongly figured if he had been thought of as holding in one of his pocketed hands the end of a long silken halter looped round her beautiful neck. He didn't twitch it, yet it was there; he didn't drag her, but she came.

The connection between marriage and possession is one that James stresses in *The Golden Bowl*. Critics have often commented (I have myself, elsewhere) that Adam and Maggie buy their spouses outright.

This both is and is not true. Certainly neither marriage would have taken place if great sums of money were not involved. If money were not an object, Amerigo and Charlotte could have married each other prior to the beginning of the book, and we would have had no book. James is not just saying that money is always, to some extent, an issue (though he is, I think, saying that); he is also remarking on the kinds of nonfinancial "possession" entailed in marriage, and even in love outside of marriage—a topic he explored repeatedly in the novels preceding *The Golden Bowl.*

Near the beginning of *The Wings of the Dove* is a beautiful image of what it means to fall in love at first sight, as Kate and Merton do at the party where they first meet:

> They had found themselves looking at each other straight, and for a longer time on end than was usual even at parties in galleries; but that, after all, would have been a small affair if there hadn't been something else with it. It wasn't, in a word, simply that their eyes had met; other conscious organs, faculties, feelers had met as well, and when Kate afterwards imaged to herself the sharp, deep fact she saw it, in the oddest way, as a particular performance. She had observed a ladder against a garden wall, and had trusted herself so to climb it as to be able to see over into the probable garden on the other side. On reaching the top she had found herself face to face with a gentleman engaged in a like calculation at the same moment, and the two inquirers had remained confronted on their ladders.

It seems impossible that this image of perfect mutuality, perfect equality, could ever be shattered; and yet that feeling of liberated recognition does give way eventually to the coercive tone with which Merton insists Kate must "come to him"—must allow him to possess her, sexually—if he is to continue submitting to her will in the plan regarding Milly.

The entire trajectory of Kate's and Merton's love affair, from magical pairing to entrapment and loss, is mimicked in one sentence of *The Golden Bowl,* where Maggie contemplates what has become of the love affair between her husband and Charlotte Verver: "Behind the glass lurked the *whole* history of the relation she had so fairly flattened her nose against it to penetrate—the glass Mrs. Verver might, at this stage, have been frantically tapping, from within, by way of supreme, irrepressible entreaty." The transparent but solid material which once

enclosed the two lovers in their own impenetrable world now serves only to imprison Charlotte. She alone, and not the equally culpable Prince, suffers the consequences of the affair's discovery.

This is not just because society is harder on women—though James isn't above making that point as well. Look at the way, for instance, he deplores, in *The Spoils of Poynton,*

> the cruel English custom of the expropriation of the lonely mother. Mr. Gereth had apparently been a very amiable man, but Mr. Gereth had left things in a way that made the girl marvel. The house and its contents had been treated as a single splendid object; everything was to go straight to his son, and his widow was to have a maintenance and a cottage in another county. No account whatever had been taken of her relation to her treasures . . .

Society and its laws *were* unfair to women, but that, from James's viewpoint, wasn't the worst of it. Women suffered more because, in his view, they were capable of suffering more: their sympathy, their intelligence, their knowledge made them suffer, whereas men were generally, like the Prince, protected by a layer of self-serving obtuseness.

In all of James's work, there is no marriage in which the man understands more than the woman. (The possible exception is in *The Portrait of a Lady,* where the husband at first seems more intelligent and knowledgeable than his wife. But what Osmond possesses in the realm of taste and knowledge, he lacks in terms of the capacity to transmute that knowledge into feeling; his intentional coldness finally makes him stupid, while Isabel's suffering makes her wise, or at least wiser.) And especially in *The Golden Bowl,* the pattern is one of men taking the lead from women: Charlotte always formulates their mutual idea before the Prince can put it into words; Adam marries at Maggie's hinted suggestion; Fanny Assingham has to explain every nuance of the plot to her endearingly dense husband, Bob; and Maggie takes the responsibility for saving everybody at the end, while the Prince, relying on her to fix things up, merely and passively waits. James suggests near the beginning of the novel that this had always been Amerigo's self-confessed way of dealing with women (and, by extension, every man's way of dealing with every woman):

> This was *his,* the man's, any man's position and strength—that he had necessarily the advantage, that he had only to wait, with a decent patience, to be placed, in spite of himself, it might really be said, in the

right. Just so the punctuality of performance on the part of the other creature was her weakness and her deep misfortune—not less, no doubt, than her beauty.

James's novels are, in part, about mutuality in love; but there is a limit to how mutual love can be if one member of the pair is invariably morally, emotionally, and intellectually superior. Men in James are always being a little dense: "'I say, you know, Kate—you *did* stay!' had been Merton Densher's punctual remark on their adventure after they had, as it were, got out of it; an observation which she not less promptly, on her side, let him see she forgave in him only because he was a man." It might even be their stupidity which makes them lovable. That seems, for instance, to be Owen Gereth's chief appeal to the intelligent Fleda Vetch:

> He had neither wit nor tact, nor inspiration . . . He had clean forgotten that she was the girl his mother would have fobbed off on him; he was conscious only that she was there in a manner for service—conscious of the dumb instinct that from the first had made him regard her not as complicating his intercourse with that personage, but as simplifying it. Fleda found beautiful that this theory should have survived the incident of the other day . . .

This built-in disparity between the sexes gives even James's most tragic novels an affinity with screwball-comedy movies (where the women are also braver and more intelligent than the men, and where individual jokes as well as entire plots get constructed on this discrepancy). There is a way in which James always seems to be hinting that men and women ought to aspire to a marriage of equals, even if one sex (the feminine) is a little more equal than the other.

The degree to which James favors his females may backfire with some readers. "The endings," Harold Brodkey has said of the novels, "tend to be overdetermined and cruel in their attribution of *real* impotence to the men: the male characters are granted their success, if they are allowed any, by women—often caryatid-like, androgynous women, or an angelic one here and there—and by their own efforts never, except their efforts of understanding the monsters, the sphinxes and angels, that James posits." This is an exaggeration. But it's based on enough truth to give one pause. How, if he always makes women superior to men, can James be credited with true fairness in the realm of gender? Fairness is by no means the only criterion of aesthetic achievement; but in the novel, where the author by definition starts

with a stacked deck, it's an extremely important one. We've got to feel that the author is giving all his characters their due—giving each one a fair shake, as it were—if we are to sympathize at all with their fates. Their tragedies, to move us, must seem dealt by an impartial (or close to impartial) universe rather than by a crooked dealer. I said above that James "always" hints that women are superior, that "every man" asks to be saved by "every woman." But what James actually does is to couch that expression of "the man's, any man's, position" in the words of Amerigo's perceptions: even this casual generalization inevitably derives from, and is qualified by, a very individual point of view. For James, the specifics of character always matter more than generalities and categories—even, or especially, when the category is as enormous as gender.

That, in a way, is the central point of *The Bostonians*. This novel sets out to question the degree to which any generalizations can safely be made about men and women, and it does so by overturning the sexual patterns that James was to work so hard constructing elsewhere in his fiction. If Olive Chancellor is wrong, it is not because she believes women to be superior (as James apparently did) or is attracted to her own sex (as James apparently was to his). It is because she allows those private beliefs and feelings to influence her vision of what a completely moral universe would look like: she wants the world to be as she is. And yet Olive is no more wrong than Basil Ransom, who is equally monomaniacal in his vision of the world. The fact that they are a woman and a man is—for once, in James—irrelevant. They are a perfect match in terms of strength of will, intensity of desire, intelligence, discrimination, and force of personality. It is as if Kate Croy had reached the top of her ladder to confront, not the face of her beloved, but that of her absolute enemy.

In the lopsided quadrangle that underlies the structure of *The Bostonians,* Adam Verver's participant-observer role is played by Miss Chancellor's sister, Adeline Luna. Like Adam, Mrs. Luna is desired by none of the other three and herself desires someone she can't have (Basil Ransom). The reason she can't have him, however, is merely that he doesn't find her attractive—an insult so immense that it fuels her lunatic behavior, which in turn pushes along the plot. It is Mrs. Luna who, out of self-destructive willfulness, keeps Basil from listening to most of Verena's New York speech. (This gives rise to one of the best scenes in the novel, where Basil's urge to abandon Mrs. Luna is

brought into direct conflict with his Southern chivalry: we relish his squirming dilemma and at the same time empathize with his palpable desire to get rid of her.) This trick of hers, by keeping him from Verena, actually makes him more aware of how much he loves the girl. Mrs. Luna then trots off to Olive to tell her about Verena's hidden relationship with Basil, perversely insuring that Olive will cling tighter and Verena will inevitably have to break away. Mrs. Luna accomplishes nothing that will either help herself or injure Ransom (her two conscious motives); she succeeds only in ultimately harming Olive.

Verena Tarrant is possibly the darkest of James's deep wells of desire, in that it is almost impossible to understand why two intelligent people are so wildly attracted to her. Even James doesn't have much to say in her favor, aside from the fact that she's pretty. "Her ideas of enjoyment were very simple," he comments early on; "she enjoyed putting on her new hat, with its redundancy of feather, and twenty cents appeared to her a very large sum." This is innocent ignorance carried to a ludicrous extreme: Maggie, by comparison, is Charlotte's twin. Even Ransom, who loves Verena, perceives her silly side, though he finds it charming: "There was indeed a sweet comicality in seeing this pretty girl sit there and, in answer to a casual, civil inquiry, drop into oratory as a natural thing. Had she forgotten where she was, and did she take him for a full house?" Yet Basil doesn't appreciate having anyone else notice her silliness: "The only thing our young man didn't like about Doctor Prance was the impression she gave him (out of the crevices of her reticence he hardly knew how it leaked), that she thought Verena rather slim." By this late point in the novel, we have come to know that Dr. Prance is the closest thing James gives us to the authorial viewpoint, the voice of sense and reason.

In most of the other Jamesian triangles, two women are in competition for a man: Charlotte and Maggie battle it out for Amerigo, Milly and Kate for Merton Densher, Fleda Vetch and Mona Brigstock for Owen Gereth, and so on. The prominent exception to this pattern, other than *The Bostonians,* is *The Portrait of a Lady,* in which Gilbert Osmond and Caspar Goodwood compete for Isabel. (Lord Warburton represents a mere diversion from Goodwood, like a small path off that particular road—the road not taken.) But even the exception proves the rule, for that plot still involves two adventurous, strong-minded women, Madame Merle and Isabel, revolving around and determining

the fate of one essentially passive man. *The Bostonians* turns this pattern upside down and inside out. Not only is the object of contention a woman (so that the charge of being passive and insubstantial shifts from the male gender to the female), but the competitors—for the first and only time in all James's work—are of opposite sexes. Everywhere else, the structure relies on pitting one woman's feelings against another's, and the essential story lies in their differing capacities for willed action, deep passion, renunciation, and suffering. But here the novel pits a woman against a man, and *their* respective capacities for feeling and action are accordingly brought under consideration. The mold is broken, and all the usual bets about gender are off.

One of the most troublesome questions in the novel is the extent to which James identifies with, sympathizes with, or even likes Basil Ransom. (In that sense, Ransom is very clearly the Maggie of this book.) In *The War of the Words*, Gilbert and Gubar assume that the identification is complete. Is this because James and Ransom are both men? That hardly does justice to James's sympathetic portraits of women throughout his books. Is it because Ransom is occasionally given the linguistic wherewithal to poke fun at the women's movement? But so is Mrs. Luna (some of her comments are really hilarious), and hers can hardly be considered the authorial viewpoint of the novel. Gilbert and Gubar feel that "Basil's aesthetic is an essentially Jamesian one"—but James clearly finds something amusing in the response of the editor who told Ransom "that his doctrines were about three hundred years behind the age; doubtless some magazine of the sixteenth century would have been very happy to print them." It is hard to take Basil seriously as a writer. If the possession of "doctrines" alone were not enough to warrant his exclusion from the Jamesian "aesthetic," we would still have his naive careerism: he is ready, for instance, to marry on the strength of one accepted but not yet published article.

Perhaps some of this misleading "writer" issue is what accounts for Gubar and Gilbert's even more incomprehensible statement to the effect that "Basil's male bonding with the fallen Union dead memorialized in the Harvard library reflects James's own fellowship with lost New England forefathers." For one thing, Harvard's Memorial Hall, where Basil has his epiphany, is not a library, so there are no books present to remind James of either his or Basil's literary connections. (And in any case it's dangerous to assume James always "iden-

tifies" with the act of writing: when authorship appears in his fiction, it's usually a highly suspicious activity.) In fact, Basil's sympathy for his brave Civil War opponents—far from cementing old-boy alliances—acknowledges the importance of reaching across barriers to sympathize with one's enemies, rather than just reaching backward to one's own antecedents. Basil's sympathetic journey from South to North can be taken as a mirror for James's from North to South (James did, after all, lose family in the war, and yet he found himself able to create a brave Southern veteran). If James identifies with Basil at all in this novel, he does so through the act of reaching out of himself toward an opposite. For a writer like James, it is much harder to get inside a man like Basil Ransom than it is to imagine oneself a Jamesian heroine.

Though feminist readers have felt impelled to rescue Olive Chancellor from James's diseased clutches, it is Basil Ransom who is in many ways the easy mark of this novel. Olive stands on her own: she has a force, a character, even a degree of appealing inconsistency, that suggest she has earned her author's ultimate respect. Basil, on the other hand, at times comes so close to being a caricature that James feels impelled to step in and protect him from us. Thus the moments at which James most obviously distances himself from Ransom are the very moments when, subtly and ironically, he also criticizes *us* for our distance. For instance, he says of Basil: "When I have added that he hated to see women eager and argumentative, and thought that their softness and docility were the inspiration, the opportunity (the highest) of man, I shall have sketched a state of mind which will doubtless strike many readers as painfully crude." The presentation of Basil seems to call into question the whole enterprise of authorship, as if James wants to shirk the responsibility for having created such a creature (resting it instead, perhaps, on society-at-large's shoulders) and simultaneously to take credit for inventing and sympathizing with such an alien character. In what may well be the prime example of this ambivalence, he remarks:

> The historian who has gathered these documents together does not deem it necessary to give a larger specimen of Verena's eloquence, especially as Basil Ransom, through whose ears we are listening to it, arrived, at this point, at a definite conclusion. He had taken her measure as a public speaker . . . From any serious point of view it was neither

worth answering nor worth considering, and Basil Ransom made his reflections on the crazy character of the age in which such a performance as that was treated as an intellectual effort, a contribution to a question.

We are both totally inside Basil and entirely removed from him here, just as James is both an objective "historian" and an opinionated member of the listening "we." The ironies are such that any feminist readers who feel Basil's stance is "neither worth answering nor worth considering" are forced, if they are honest, to recognize the parallel between their own prejudices and his.

One of Basil's chief flaws is that he consistently underestimates Olive Chancellor, and if we view her as a caricature of the typical suffragette, we are ourselves guilty of Ransom-like obtuseness. A bundle of nerves wrapped around a core of iron, Olive is one of the most human and admirable of James's creations. She has chosen to lead a life in which everything material gets sacrificed to abstractions, and yet she's plagued by an underlying level of excellent taste. She's sincere but never stupid, as opposed to her sister Adeline, who is both dense and dishonest. James shows Olive to best advantage whenever he compares her to Mrs. Luna. In a relatively late scene, where Adeline is tattling on Verena and Basil, James gives us the following:

> Olive kept these reflections to herself, but she went so far as to say to her sister that she didn't see where the "pique" came in. How could it hurt Adeline that he should turn his attention to Verena? What was Verena to her?
>
> "Why, Olive Chancellor, how can you ask?" Mrs. Luna boldly responded. "Isn't Verena everything to you, and aren't you everything to me, and wouldn't an attempt— a successful one—to take Verena away from you knock you up fearfully, and shouldn't I suffer, as you know I suffer, by sympathy?"
>
> I have said that it was Miss Chancellor's plan of life not to lie, but such a plan was compatible with a kind of consideration for the truth which led her to shrink from producing it on poor occasions. So she didn't say, "Dear me, Adeline, what humbug! you know you hate Verena and would be very glad if she were drowned!"

The wit in that last paragraph is both Olive's and James's; in this moment of narration, the intimate "I" and the seemingly distant "Miss Chancellor" are inextricably intertwined.

Elsewhere James comes right out and praises Olive in terms that

truly reflect a "Jamesian aesthetic": "In reality, Olive was distinguished and discriminating, and Adeline was the dupe of confusions in which the worse was apt to be mistaken for the better." (This also says something, by implication, about Ransom, who is hated by the discriminating Olive and loved by the confused Adeline.) Part of what makes Olive discriminating, to James's mind, is her ability to let specific sense data triumph over her own abstract theories; it is this ability that gives her a charming inconsistency. Her passion for the cause of women does not prevent her, for instance, from noticing the foibles of her sex: "Olive was sure that Verena's prophetic impulse had not been stirred by the chatter of women (Miss Chancellor knew that sound as well as any one); it had proceeded rather out of their silence." It is Olive's admirable capacity for both discrimination *and* sympathy that enables her to draw this conclusion.

If innocence versus knowledge is the opposition that informs *The Golden Bowl,* with will versus passive acceptance structuring *The Wings of the Dove* and possession versus renunciation infusing *The Spoils of Poynton,* then sympathy and discrimination define the spectrum along which *The Bostonian* runs. It is a novel whose ostensible "subject" is discrimination (against women by male society) and sympathy (on the part of women for their less fortunate sisters). It is also a novel that functions largely by influencing our tendencies toward sympathy and discrimination, as James skips and hops among the characters, first dropping a kind word and then a snide remark, or simultaneously attacking and defending with irony. Sympathy and discrimination are both high Jamesian values, and they are also the values that most dispose us toward reading his novels: without sympathy we wouldn't care about his characters' fates, and without discrimination we would never appreciate the fine nuances of his sentences. In *The Bostonians,* these opposites are intermittently juxtaposed, enabling us to realize that sympathy without discrimination is relatively worthless, while discriminating taste without a shred of tenderness is hardly worth calling taste. Nowhere is this point made so clearly as in the portrait of Miss Birdseye.

When James first published *The Bostonians* serially in 1885 and 1886, the Boston responses to the book focused on the character of Miss Birdseye, whom people took to be mockingly modeled on one Miss Peabody. To a letter from his brother William on the subject, Henry answered with pained surprise:

I have the vanity to claim that Miss Birdseye is a creation. You may think I protest too much: but I am alarmed by the sentence in your letter—'It is really a pretty bad business,' and haunted by the idea that this may apply to some rumour you have heard of Miss Peabody's feeling *atteinte* . . . Miss Birdseye is a subordinate figure in *The Bostonians* . . . But though subordinate, she is, I think, the best figure in the book, she is treated with respect throughout, and every virtue of heroism and disinterestedness is attributed to her.

In other words, she's *not* Miss Peabody, but even if she were, Miss Peabody should be flattered rather than insulted.

When you turn from James's self-defense to the novel itself, the presentation of Miss Birdseye is likely to come as something of a shock:

She was a little old lady, with an enormous head . . . She had a sad, soft, pale face, which (and it was the effect of her whole head) looked as if it had been soaked, blurred, and made vague by exposure to some slow dissolvent. The long practice of philanthropy had not given accent to her features; it had rubbed out their transitions, their meanings . . . She belonged to the Short-Skirts League, as a matter of course; for she belonged to any and every league that had been founded for almost any purpose whatever. This did not prevent her being a confused, entangled, inconsequent, discursive old woman, whose charity began at home and ended nowhere, whose credulity kept pace with it, and who knew less about her fellow-creatures, if possible, after fifty years of humanitary zeal, than on the day she had gone into the field to testify against the iniquity of most arrangements.

Treated with respect throughout? Every virtue of heroism? Surely, we think, James is being disingenuous. But then we realize that this portrait of Miss Birdseye, though presented as if objective, is actually framed by Basil Ransom's perceptions. And we begin to understand that though the harsh description is in part James's own critique of unmitigated sympathy, it is also a critique—by implication—of the purely discriminating viewpoint that can't see the value of a Miss Birdseye.

We get the same "objective" information presented in a totally different tone in the last paragraph of the chapter, when we are looking at Miss Birdseye through another set of eyes:

Olive Chancellor looked at her with love, remembered that she had never, in her long, unrewarded, weary life, had a thought or an impulse for herself. She had been consumed by the passion of sympathy; it had crumpled her into as many creases as an old glazed, distended glove. She had been laughed at, but she never knew it; she was treated as a bore, but she never cared. She had nothing in the world but the clothes on her back, and when she should go down into the grave she would leave nothing behind her but her grotesque, undistinguished, pathetic little name. And yet people said that women were vain, that they were personal, that they were interested! While Miss Birdseye stood there, asking Mrs. Farrinder if she wouldn't say something, Olive Chancellor tenderly fastened a small battered brooch which confined her collar and which had half detached itself.

James ends the chapter there, with Olive's tender gesture, as if to say: yes, Miss Birdseye's unremitting sympathy is laughable; and yes, discrimination makes things hard-edged, distinct, meaningful, while too much sympathy produces soft vagueness, meaninglessness, the "crumpled" quality of an old glove; and yes, it requires discrimination (on Olive's part as well as Basil's) to perceive the limits of sympathy. But sympathy, in the form of a tender gesture, is nonetheless the final point. It's Olive's sympathy in the face of her ability to discriminate, rather than Miss Birdseye's easier, undiluted variety, that James encourages us to admire. Yet if we take this encouragement too far—if we choose to respect Olive and merely to laugh at Miss Birdseye—we show ourselves less capable of discriminating sympathy than Olive herself is.

Part of the way James plays on our own sympathies, in the competitive triangles he sets up in his novels, is by distributing power in unexpected ways. In *The Golden Bowl,* Maggie is innocent and somewhat dull, while Charlotte is witty, knowing, and beautiful; on the other hand, Maggie is enormously rich and Charlotte is poor. So at the end, when the marriage triumphs, our sense of virtue rewarded is somewhat mitigated by the fact that money won out. Similarly in the case of *The Wings of the Dove:* Milly, the rich, weak girl, wins by dying; Kate, who survives, fails to profit from her exercise in manipulation. You may admire Milly or Kate more, but whichever you choose, you can't make the sum come out entirely in your favor. Milly, too, is a manipulator (through her passive acceptance of others' tribute), and Kate, too, is subject to the corruption of money. Milly's death is

neither a complete tragedy nor a complete transcendent victory, and Kate's final loss is neither entirely her own fault nor entirely imposed on her. In extremely unequal ways, they are a fair match in the competition for Merton Densher.

In *The Bostonians,* Olive is the competitor who has money (Basil is notoriously and self-proclaimedly poor), yet Olive eventually loses the prize. Is this supposed to make us feel that untarnished virtue, unaided by filthy lucre, has for once triumphed? I doubt it. In the other comparable case, where Isabel Archer chooses the poor man (Gilbert Osmond) over the rich one (Caspar Goodwood), we live to see her regret that choice—not for financial reasons, but because she initially mistook poverty for virtue. *The Bostonians* doesn't let us peek past the final curtain of the marriage, doesn't let us confirm the rightness or wrongness of Verena's choice. But James does say of Verena's tears, in a final sentence that doubles back on itself with numerous ironies, "It is to be feared that with the union, so far from brilliant, into which she was about to enter, these were not the last she was destined to shed." The voice sounds pompously snobbish, like that of Mrs. Farrinder or Mrs. Burrage; but James has by now had nearly five hundred pages to train us in the distinction between personal appeal and veracity. Even if the voice is dislikable, it might still be telling the truth. The author, in any case, is not going to guarantee that Verena's choice (which, as sentimental novel readers, we might consciously or unconsciously have wished for) is going to prove the right one. More than any other James novel except possibly *The Wings of the Dove*—more, certainly, than the unsatisfyingly noncommittal *Portrait of a Lady*—*The Bostonians* leaves us with a truly ambiguous ending.

It's possible to argue that Olive "buys" Verena (she actually hands over large checks to Mr. Tarrant) whereas Basil wins her through sex appeal alone. But, as I suggested in talking about *The Golden Bowl,* James makes a good case for the idea that love in any form is inseparable from possession. What Olive is after, and what she intends the money to smooth the way toward, is a mutual and freely-entered-into compact of possession between herself and Verena. Verena has possessed Olive's affections practically since their first meeting; Olive only wants something similar in return. She is quite direct about explaining her notion of possession, or possessiveness, when she answers Verena's query as to why she won't visit the Tarrants' house: "Olive expressed her reasons very frankly, admitted that she was jealous, that she didn't

wish to think of the girl's belonging to any one but herself." Basil Ransom feels the same way, which is why he won't let Verena belong to him and to her public at the same time (not to mention, of course, Olive). But Basil assumes such sentiments are his rightful prerogative as husband and lover, whereas Olive offers them in a somewhat self-deprecating manner as mere personal description.

The crucial difference between the two is that Basil wants to win Verena through pure force of personality—wants, effectively, to overpower her will—while Olive wants Verena freely to choose her. Olive has, constitutionally, as strong a will as Basil's, and as detailed a knowledge of her own desires, but she doesn't want that will and those desires to be the only determining force. Early on in the novel, Verena offers to "renounce," to promise never to marry; but Olive refuses to accept the renunciation at that point because she wants the decision to be knowledgeable and mature, not the result of a weaker will's submission to a stronger one. A great part of Olive's tragedy is that she overestimates Verena, presuming her to be equal to herself. (This is also, I think, Kate's tragedy with regard to Merton and Charlotte's with regard to Amerigo; and it is to all of their credit that they make this mistake.) It doesn't really matter whether Basil over-estimates Verena, because for his purposes—a household angel to worship, and an admiring slave to be worshipped by—an inferior will do just as well.

I am doing an injustice to Basil here. In a Basil-like manner (as he does, for instance, with Olive), I am exaggerating someone's flaws and underestimating his subtlety solely because his principles are at odds with mine. In fact, Basil Ransom is in many ways an engaging character, and if I were being as fair and as unbiased as I take James to be, I would admire his ruthless exercise of will as I do Kate Croy's. Like numerous readers over the years, I have slipped into viewing *The Bostonians* as a battle between Olive Chancellor and Basil Ransom in which we must choose one or the other—and, in doing so, choose either women or men.

It's easy to see, with a novel like *The Golden Bowl,* that whom you side with and how you feel about the outcome depends on where you stand at a particular moment in time. As Gore Vidal suggests:

I barely noticed Adam Verver the first time I read the book. I saw him as an aged (at forty-seven!) proto-J. Paul Getty, out "to rifle the Golden

Isles" in order to memorialize himself with a museum back home—typical tycoon behavior, I thought; and thought no more. But now that he could be my younger brother (and Maggie an exemplary niece), I regard him with new interest—not to mention suspicion.

Vidal views Amerigo and Charlotte as the tragic victims of the plot; for him, Maggie and her father are "monsters on a divine scale." John Bayley, in an equally astute but much more balanced reading of the novel, says in *The Characters of Love:* "Certainly the victors in such a contest are not likely to appear in an agreeable light, and especially when the economic scales are weighted so overwhelmingly in their favour. I think, though, that James, the least sentimental of writers, would not feel himself bound to defer to the tendency to side with penniless passion and wrongdoing in defeat." Vidal and Bayley end up on different sides of "the Maggie question," but their discussions both acknowledge that one might, under other circumstances, come to the opposite conclusion.

The Bostonians, on the other hand, tends to sort readers vigorously into two opposing camps, with little or no acknowledgment that things could be seen another way. I do not think this is due to the inferiority of the earlier novel. Rather, I think it's because we—*unlike* James—do not have the capacity to take Olive's and Basil's roles equally seriously. It is we, and not James, who find a woman's love for a woman incommensurable with a man's. For James, Basil and Olive are intensely individual, tragically matched suitors competing for the hand of a specific (if not terribly worthwhile) love object. For us, they inevitably become symbols of two opposing sets of principles and two conflicting ways of life. But it is always a mistake, in James, to let the general prevail over the specific (in this case, to let the sexes of the competitors matter more than their individual identities). In *The Bostonians,* we find ourselves siding with Dr. Prance whenever she opens her mouth, and toward the end we understand why: "Olive had perfectly divined by this time that Doctor Prance had no sympathy with their movement, no general ideas; that she was simply shut up to petty questions of physiological science and of her own professional activity." It's the "petty" questions that, as a novelist (*his* professional activity), James finds interesting: the questions about how specific people will act under given circumstances and how we will respond to those actions, regardless of the general social laws or moral regulations.

I don't want, however, to suggest that James finds all outcomes morally neutral. (Dr. Prance is, after all, interested in curing her patients, not merely in exploring their respective physiologies.) Part of the reason for the heatedness of the critical discussions, whether about *The Bostonians* or about the other novels, is that the difference in the conflicting outlooks matters. It would be possible, of course, to write Jamesian criticism that suggested tolerance as the ultimate good, and that advocated equal sympathy for Maggie and Charlotte, for Kate and Milly, for Olive and Basil. Such criticism, in fact, might well have been written by Henry James's brother William, who cheerfully defined his pragmatic philosophy as simply a matter of making appropriate distinctions.

In the second chapter of *Pragmatism,* William James tells a story about being on a camping trip during which a philosophical disagreement took place. In discussing a hypothetical squirrel clinging to and circling a hypothetical tree trunk so as to remain hidden from an observer moving around the tree, one side insisted that the circling observer *did* "go round" the squirrel and the other that he did not. William was called upon to solve the dispute:

> "Which party is right," I said, "depends on what you *practically mean* by 'going round' the squirrel. If you mean passing from the north of him to the east, then to the south, then to the west, and then to the north of him again, obviously the man does go round him, for he occupies these successive positions. But if on the contrary you mean being first in front of him, then on the right of him, then behind him, then on his left, and finally in front again, it is quite as obvious that the man fails to go round him, for by the compensating movements the squirrel makes, he keeps his belly turned towards the man all the time, and his back turned away. Make the distinction, and there is no occasion for any farther dispute. You are both right and both wrong according as you conceive the verb 'to go round' in one practical fashion or another."

To the reader of this passage, it becomes instantly clear that William and Henry James grew up in the same family but drew totally different attitudes toward life from that experience. Both are believers in multiple viewpoints; both insist that the "right" answer differs as you shift from one position to another. But whereas William's ambiguity is completely resolvable—"Make the distinction, and there is no occasion for any farther dispute"—Henry's is not. In order to put William's

procedure into effect, you simply need to be sure of all the pertinent variables. But Henry would say, as he has Fanny Assingham say in *The Golden Bowl:* "One can never be ideally sure of anything. There are always possibilities." In William's pragmatic approach, one can use knowledge to make choices fearlessly and without regret; in Henry's view, knowledge is always imperfect, and some loss is inevitable.

To announce sunnily that Maggie and Charlotte, or Olive and Basil, can be "both right and both wrong" would be to do a terrible violence to Henry James's complicated vision. It would be to become vague, crumpled organs of undiluted sympathy, like Miss Birdseye—or, as I suggested near the beginning of this chapter, to become cowardly, passive John Marchers, afraid of committing ourselves to any choice. James's novels demand active choice, demand discriminations of sympathy, even as they suggest the dangers and insufficiencies of taking these positions. However carefully we make our choices, we can't, as readers of his novels, have everything our way. That's what makes them like life.

Hitchcock's Couples

6 Let's start with the Garden of Eden. Adam gives up a rib to produce Eve. This introduces the first horrible possibility: that woman is nothing more than an adjunct of man, that she is his "creation" in much the same way he is God's, and that she can therefore do nothing to surprise him, or transcend him, or be other than what he intends her to be. Yet Eve violates that expectation—and, in doing so, enables Adam to violate God's expectations as well. It is Eve who takes the lead in tasting the apple of knowledge, she who persuades Adam to join her in consuming its forbidden pleasures, and she who confers on humanity both its mortality and its sexual self-awareness. This introduces the second horrible possibility: that woman might be more adventurous, more knowledgeable, more powerful than man, and that she might use her superior power to betray him.

Hitchcock raises both these Edenic fears in his films. He raises them as if from the man's point of view, and yet we respond to them as if from the woman's. Hitchcock's women are neither uniformly strong nor uniformly weak, but we—or at least I—tend to remember them as victims, as helpless blonde creatures murdered or manipulated or "improved" by the men who encounter them. But if Hitchcock introduces the question of weakness, he does so to pose it as a question, to ask such things as whether men or women are indeed the stronger (and what that would mean, in either case); and how respect can exist under conditions of inequality; and how trust can exist under conditions of equality. If he victimizes his women, he does so in order to make us come to their defense, as D. H. Lawrence victimizes Walter Morel, the inarticulate but finally sympathetic father in *Sons and Lovers*.

The question of whether woman is man's equal or man's creation runs throughout Hitchcock's films, and plays off against other questions about fear of power and fear of weakness, fear of trust and fear

of betrayal, fear of knowledge and fear of ignorance, fear of being manipulated and fear of having to manipulate. The stakes on all these issues are raised by their being self-consciously brought into conjunction with questions about the creation of art. The filmmaker and the film-viewer form two halves of another kind of couple, and this couple, too, must be concerned with fears of manipulation, betrayal, dependence, and withheld knowledge. If Hitchcock's women are victims, then so are his audiences. And yet both parts of that assertion deserve to be challenged, for there is truly a kind of love in his relations with his audience (as there is between his heroes and heroines), and that kind of love cannot exist apart from independence and mutual respect. But there is no easy acknowledgment of independence or respect in Hitchcock: his films lure us powerfully toward the possibility of victimization, even as they urge us to try to escape.

I want to look, in this chapter, at a cluster of Hitchcock's best films in terms of two models, two old stories, that divide between themselves the Edenic concerns. One of these—Shakespeare's *Antony and Cleopatra*—pursues as far as possible the notion of equality in love, and the potential for mistrust and betrayal that such equality can give rise to. The other—the myth of Pygmalion and Galatea—examines the problems entailed in a love affair between a man and his creation (whether that creation be a woman or a work of art, or both). The two sections of this chapter will take on, each in turn, these two contrasting but obviously related tales of love. In the *Antony and Cleopatra* section, "Thoughts," I will pay detailed attention to Shakespeare's play as background for Hitchcock's movies—not because I think Hitchcock borrowed directly from Shakespeare, but because it is impossible to invoke Shakespeare *without* some detailed attention to his language. (Yet the brief analyses of Shakespeare are bound to seem scanty and broad, for the chapter is meant to be about Hitchcock, not Shakespeare. Shakespeare clarifies and enriches our understanding of Hitchcock; no such comparison can or need add anything to Shakespeare.) In contrast, the Pygmalion and Galatea section, "Second Thoughts," will hardly mention the myth at all, except to introduce the idea of making—or remaking—a beloved object.

In addition to indicating the sequence of my ideas, the chapter subtitles are meant to suggest a certain casualness, a lack of comprehensiveness, in my approach to Hitchcock. His output is so voluminous (and that of his commentators so much more so) that it would be ridiculous in a chapter-length work to try to encompass all the

issues Hitchcock's films address, even if I limited myself to the issues involving women. I am not, for instance, going to deal with the feminist criticism, which for the most part treats Hitchcock as the little boy in Freud's *fort/da* anecdote, a grinning imp who makes his mother repeatedly disappear and reappear in the symbolic form of a toy. Such Freudian criticism is as inadequate to Hitchcock as it is to D. H. Lawrence or Harold Brodkey, and for similar reasons: these artists wear their Freudian hearts so prominently on their sleeves that there is nothing for the surreptitious analyst to reveal. Hitchcock, as director, is his films' own psychoanalyst, conscientiously pointing out all the symbols for us. Nor does it make sense, if one is looking for artistic understanding, to conduct psychological interrogations of the biography. Hitchcock's recorded comments about his childhood traumas, his attitudes toward actors, his filmmaking intentions (or lack thereof), are just so many red herrings, for the films themselves radically transcend and obscure the man who made them. It's another case of what T. E. Lawrence said about Shakespeare in a 1925 letter to Robert Graves: "There was a man who hid behind his works, with great pains and consistency. Ergo he had something to hide: some privy reason for hiding. He Being a most admirable fellow, I hope he hides successfully."

Theory and biography aside, there remains the possibility of looking closely at the films themselves. In this endeavor every Hitchcock critic owes an unpayable debt to William Rothman, whose murderously intense gaze gives new meaning to the phrase "looking closely." I will acknowledge Rothman here, at this chapter's beginning, for I cannot hope to credit every point at which my own perceptions have benefited from his. In my approach to the question of literary "inheritance," and especially Shakespearean inheritance, I can be seen to be an ally and admirer of Stanley Cavell—particularly the Cavell of *Pursuits of Happiness* and the essay on *North by Northwest*. Like Rothman, Cavell is an influence on this entire chapter, but is cited only here. I would also like to cite his caveat: "I am not claiming that these films of remarriage are as good as Shakespearean romantic comedies. Not that this is much of a disclaimer: practically nothing else is as good either."

Thoughts

In performances, and sometimes in critical studies of it as well, Shakespeare's *Antony and Cleopatra* lends itself to oversimplification. The

tendency is to view it either as a feminist paean or, more commonly, as an attack on a castrating bitch. It is only by refusing to be either of these two things that it remains a great play, and it is this refusal—in the face of many compelling temptations—that it shares with Hitchcock's most interesting films.

The Royal Shakespeare Company, in the 1979 production that starred Glenda Jackson as Cleopatra, gave an instructive example of what can go wrong with the play. From the opening lines (as well as the first sight of Jackson's disconcertingly boyish haircut), it was clear that this was going to be a drama about how a selfish, manipulative, power-hungry woman robbed a lovable man of his career, his masculinity, and finally his life. Under Peter Brook's direction, Antony's tragic flaw was that he was too much of a soft touch: unable to resist Cleopatra's feminine wiles, he was "transformed / Into a strumpet's fool." That this characterization is delivered by one of Antony's most insignificant soldiers, a man distinguished neither for his sexual sensitivity nor his expansive perceptions of the world, did not seem to bother Brook; he took it as the nugget of truth buried in the play. Disregarding the complex vision of lust, love, and loyalty introduced by Antony's friend Enobarbus, and further disregarding the intelligence, wit, and passion manifested by Cleopatra herself, Brook chose to make this a highly conventional replay of the Fall, with Eve cast as the Devil and Adam as the poor soul who got taken in.

Almost as dangerous, however, is the tendency to turn this interpretation on its head, as feminist readers sympathetic to Shakespeare are inclined to do. In this version, Cleopatra becomes the ideal woman, capable of acting powerfully and passionately to get what she wants. Antony is about as "liberated" as any man in his position can be expected to be: he doesn't hold her advancing age or her checkered past against her; he takes pleasure in her strength, to the point of enjoying a little role reversal ("I drunk him to his bed; / Then put my tires and mantles on him, whilst / I wore his sword Philippan," Cleopatra recalls of one of their wilder nights); and, ignoring the accurate advice of his fellow soldiers, he even sanctions her masculine desire to fight alongside him in battle ("A charge we bear i'th' war," Cleopatra asserts with imperial plurality, "And, as the president of my kingdom will / Appear there for a man"). According to this view, Cleopatra is perfect and Antony has only one flaw: his inability to stand by her all the way. If only he could have renounced those war games perpetrated

by Caesar, Lepidus, and Pompey . . . if only he hadn't married Caesar's sister for feeble political reasons . . . if only he could have seen that his true fate lay with Cleopatra in feminine Egypt, and forgotten about masculine Rome . . . *then* (this interpretation suggests) all might have been well between them, and they might have lived happily ever after.

A major problem with this analysis is that it makes it hard for us to understand why Cleopatra should have loved Antony so much. If we persist in thinking of him as a not-quite-Cleopatra, we reduce her stature along with his, for we diminish her ability to love something that is not herself. Part of what is wonderful about Antony is that he is both a very passionate fellow and "the triple pillar of the world," a lover and a warrior, a man of diplomatic calculations and a man who will risk everything for emotion. An Antony who could be governed completely by Cleopatra wouldn't be of interest to her—or to us, I suspect. In the same way, a Cleopatra he could count on predictably is less than what Antony is capable of asking for: like Cleopatra, he is powerful enough to love that in her which is opposite to and finally destructive of himself. Antony and Cleopatra are both gamblers for the highest stakes, and in a practical sense they both lose. This is not mere coincidental bad luck. Loss is at the very heart of gambling.

In film after film—specifically, in *Spellbound, Notorious, Vertigo, North by Northwest,* and *Marnie*—Hitchcock raised the same specter of un-resolvable opposition that informs *Antony and Cleopatra.* We do not call these films "tragedies," because in most of them (*Vertigo* is the obvious exception) Hitchcock cavalierly cheated to create happy endings. But the cheating is too explicit to be accepted comfortably. In *North by Northwest,* for instance, where a quick cut of a camera is all that saves Cary Grant and Eva Marie Saint from their dangling near-deaths on Mount Rushmore, we can hardly take comfort in the possibility of such salvation. Hitchcock pretends to give us mere catharsis, but he never really lets us off the hook: he resolves only the most superficial elements of his plots, leaving all the dark undercurrents intact and unanswered. Those undercurrents—of sexual animosity and attraction, of betrayal and trust, of conflicting desires that can never be fulfilled—are what his films share with *Antony and Cleopatra.* Hitch-cock and Shakespeare each perceived the intimate link between power and love which makes the potential to harm a central aspect of the potential to cherish. For Shakespeare's Roman battles, Hitchcock has

substituted thriller plots; but in both cases the explicit enemies are the least important ones, and the concern with sexual love is what makes the works worth returning to over and over again.

Hitchcock's version of the Cleopatra female is a rather odd mutation. As opposed to the "tawny" queen who is no longer in her "salad days," the Ingrid Bergman/Eva Marie Saint/Kim Novak/Tippi Hedren character is young, blonde, and not overtly powerful. When she first meets her Antony—whether portrayed by Gregory Peck, Cary Grant, James Stewart, or Sean Connery—she plays to his position of strength. Even when she appears to take charge (as when Ingrid Bergman drunkenly insists on driving at the beginning of *Notorious*), the joke lies in the fact that the man is really in control. Yet these women always rise to a position of relative strength in the course of the film: they are always shown to have more guts than the men, at least in terms of obvious masculine tests such as putting oneself in danger or enduring pain. Thus the two fearful possibilities—that a woman might be weaker than a man, and that she might be stronger—are both raised in the course of each film.

The Antony figures of Hitchcock's world are closer to their originals than the Cleopatras are, but they too have suffered a kind of sea-change. What they have in common is a boyish good nature combined with a number of other boy-like attributes, including a noticeably present mother (think of Cary Grant's mother in *North by Northwest*) or a motherly female friend (Barbara Bel Geddes in *Vertigo*); a certain shyness with women (Gregory Peck in *Spellbound* and Jimmy Stewart in *Vertigo*); and an appealing quality of confusion in the face of the outlandish events that befall them. Like Antony, they all seem to be men whom both men and women would like: good guys with a sense of humor, able to function powerfully in the world, but also somewhat soft and sensitive. (The major exception to this pattern is Sean Connery in *Marnie;* I want to deal with that movie later as an overall reversal of the pattern, an extreme testing of the issues Hitchcock raises elsewhere.)

A corollary of this boyishness is the fact that Hitchcock's men always seem psychologically younger than the women they fall in love with. There may be a strong element of paternal protectiveness in the way they act toward their heroines (the thriller mode usually demands it), but this power is less self-conscious than that of the women: the men's behavior stems more from instinctive action than from thoughtful

intention, and it less often deserves to be called courageous. Hitchcock's blonde bombshells may be tryingly blank at times—and one certainly feels a degeneration in the tradition as it moves from Ingrid Bergman to Tippi Hedren—but they are never what you might call girlish. These are all worldly women, in the sense that they all have a past: a professional past as a psychiatrist in the case of *Spellbound*'s Bergman, a psychologically horrifying childhood in *Marnie,* and some combination of sexuality and mystery (the two frequently seem equivalent, to Hitchcock) lurking behind the heroines of *Notorious, Vertigo,* and *North by Northwest.* Nor is this past held against them by Hitchcock; on the contrary, he takes pains to teach his less amenable Antonys that it is something they must accept. In *Notorious,* for instance, Cary Grant initially refuses to understand that Ingrid Bergman is agreeing to sleep with the Nazi leader Claude Rains out of patriotism; he narrow-mindedly insists on seeing her only as a cheap slut, and Hitchcock makes us dislike him for it. By the time of *North by Northwest,* Grant is able to understand Eva Marie Saint's self-sacrificing patriotism the moment he learns she is a counter-agent—even though he has already been repelled by the discovery that she is James Mason's mistress. It is as if, between 1946 and 1959, the Cary Grant character learned to distinguish between politically necessary sexual favors and sexual promiscuity.

This happens to be a distinction that the original Antony has trouble making: he flies into a rage when he sees one of Caesar's servants kissing Cleopatra's hand, appalled that she could "let a fellow that will take rewards / And say 'God quit you?' be familiar with / My playfellow, your hand." His attack on Cleopatra's past at this point—"I found you as a morsel cold upon / Dead Caesar's trencher; nay, you were a fragment / Of Gnaeus Pompey's; besides what hotter hours, / Unregistered in vulgar fame, you have / Luxuriously picked out"—bears an eerie resemblance to Grant's hateful behavior to Bergman in *Notorious;* and, as with Grant and Bergman, it takes the threat of Cleopatra's death to bring Antony back to her in the end.

What the Hitchcock movies raise in an even more obvious way than Shakespeare's play is the fact that there *is* something repellent about the political use of sexual favors. Grant may be wrong in directing his animosity toward the woman, but he is right in feeling squeamish about the whole idea. It is difficult enough for us to acknowledge the link between sex and power in a love relationship, but to see this

power manipulated by a third party is quite disturbing. And nowhere is it more so than in the movies. Those men who sit in the political backrooms of Hitchcock's films—the Leo G. Carroll figures—can easily be seen as stand-ins for the Hollywood producers who insist on a little cheesecake in their movies; and we, the audience, are the "spies" who take up the sexual bribe. The voyeurism of Hitchcock's movies has been amply pointed out by other critics, and has been picked up and focused on by directors such as Michael Powell and Brian De Palma. But voyeurism alone would not unnerve us in the way Hitchcock's technique does: we would be able to see it as simply a momentary game played between the filmmaker and film-viewer, as we do with De Palma. What Hitchcock does is to uncover the connection between the exploitation of sexuality and the pleasure of love, between the fear of a sexual past and the enjoyment of conquering one's rivals, in such a way as to get at the very nature of our least comfortable feelings about sex. This is not something you can leave behind in the theater.

For Antony and Cleopatra, the extent to which they cannot know each other is both the root of their love and the source of its danger. Play-acting and deceit are essential to their enjoyment of each other—consciously on Cleopatra's part, less so on Antony's. In scene after scene we watch them "perform" their love affair, sometimes as "such a mutual pair / And such a twain" that "stand up peerless," other times as domestic celebrants of everyday occasions ("It is my birth-day," says Cleopatra after one of their reconciliations. "I had thought t'have held it poor. But since my lord / Is Antony again, I will be Cleopatra"). Yet constant acting leads, by way of deception, to the possibility of betrayal: since there is no permanent Cleopatra on whom Antony can depend, he must trust her anew at every moment. If his trust flags occasionally, we cannot blame it entirely on him, for she pushes him as far as he can go and even a little further. Being an Antony to her Cleopatra is hard for him, but it is also what makes him great; and the end of the play leaves us with the sense that both have become their largest selves through taking the leap of faith involved in loving each other. Death transforms them in the same way love has: dissolving into the universe, they become larger than life even as they lose their mortal individuality.

While the scale is far less grand, the stakes for Hitchcock's lovers are similar: deceit and disguise are essential to the love affair, but they

also endanger it. His characters are constantly deceiving their lovers by posing as things they are not. In *Spellbound*, for instance, Gregory Peck pretends to be a psychiatrist whom he mistakenly thinks he has murdered; without this apparently sinister disguise, he would never have met Ingrid Bergman, the doctor who loves him and helps him discover that he is not a murderer after all. In *Notorious*, Cary Grant pretends to be a party-crasher at Ingrid Bergman's apartment, where he has actually gone to recruit her for political work; and later Bergman pretends to be an ingenuous young woman, loyal to her father's Nazism, in order to meet and entrap Claude Rains. As the movies progress, the level of deception gets more complicated. In *Vertigo*, for example, Kim Novak first pretends to be another man's wife (with whom Stewart falls in love), and then disguises herself as a completely different woman whom Stewart meets and tries to remake into that lost love; there is thus an acknowledged level of disguise, where Stewart is dressing her as another woman who is really herself, and a hidden level where she poses as a self who is another woman. *North by Northwest* has a similar kind of circularity, in that Eva Marie Saint first appears as a casual fellow-passenger who is concerned for Cary Grant's welfare and eager to become his lover, subsequently turns out to be the villain's mistress, and is eventually revealed as an undercover agent who has in fact fallen in love with Cary Grant. And *Marnie* is a movie explicitly about the notion of multiple identities, in which Tippi Hedren flees from one role to another, complete with hair-color changes and new driver's licenses, in order to evade both her acknowledged criminal past as a thief and her psychologically repressed (and therefore unknown to her) criminal past as a murderer.

Naturally, the concomitant aspect of such role-playing is the potential for betrayal, and Hitchcock's lovers are all very anxious about the possibility of being taken in. Some of them actually do get betrayed by their lovers—notably Claude Rains in *Notorious* and James Mason in *North by Northwest*. It would be tempting to conclude from these two examples that only Hitchcock's villains suffer betrayal, while the heroes get well-deserved loyalty, but *Vertigo* clearly destroys this pattern: nice-guy Jimmy Stewart both betrays and is betrayed by the woman who honestly loves him. So love is not easily separable from sexual treason.

Betrayal in Hitchcock means more than just sexual infidelity; as in *Antony and Cleopatra*, it also means death. It is only chance that saves

Cary Grant from the crop-duster death to which Eva Marie Saint initially sends him; only chance makes the difference between a tragedy and a comic thriller. (It is typical of Hitchcock, especially in that movie, to allow such a major emotional problem to be resolved by a flick of coincidence.) The premise of a thriller is that people are going to get murdered, and quite frequently they end up getting murdered by their spouses or lovers. This tendency is taken to its logical conclusion in the late Hitchcock film *Frenzy*, where a homicidal Jack-the-Ripper figure kills all his lady loves; and the far more polished *Shadow of a Doubt*, as well as the famous *Psycho*, are also based on similar notions. But these films are finally less frightening in their vision of sexual homicide than the movies that use the *Antony and Cleopatra* material. The marriage in *Notorious* offers us Hitchcock's clearest image of the intimate enemy: Ingrid Bergman worms her way into Claude Rains's life purely to betray him, and he in turn begins to poison her once he discovers her true identity. *Spellbound* plays on a similar set of fears: when Gregory Peck wanders around in a state of semiconsciousness carrying a glinting knife, we are convinced he is capable of killing Ingrid Bergman in her sleep, and the fact that she is posing as his wife seems to make this only more likely. Again, the early (and not terribly persuasive) movie *Suspicion* is built entirely around the possibility that a husband might want to kill his wife, while the entertaining *Dial M For Murder* converts this possibility into the movie's factual premise. This is not Freudianism, but a kind of reverse Freudianism: a man murders, not the father whom he envies, but the mother whom he loves. *Psycho* is the most explicit rendering of the theme, but it lacks the actual adult love affairs that make the idea so disturbing in films like *Spellbound, Notorious, Vertigo,* and *North by Northwest*. The more sophisticated Hitchcock films manage to suggest that madmen are not the only ones who want to kill their lovers.

Marnie is an important member of the group of films I've been discussing because, though less successful as a thriller, it confronts the disturbing issues of male-female sexuality more directly than any of the other movies. In this film, Hitchcock seems to take each of the fears he has raised in the previous movies—each of Antony's fears in regard to Cleopatra—and give it solid grounding. The other women merely appear to be deceitful; Marnie really *is* hiding a shady past, and she really *does* steal from each man who trusts her. The other women seem to have questionable loyalty to men; Marnie has no

loyalty at all. The other women are perhaps too sexually knowing, but that hardly seems a valid complaint in comparison to Marnie's frigidity. Finally, the reverse-Freudian model is transformed from metaphor to reality in this film: Marnie, as a child, has actually killed the man who was having sex with her mother. Unlike Hitchcock's other men, Sean Connery has all the best reasons for mistrusting his mate, and still he persists in loving her; there is something quite admirable about his willingness to see the affair through.

Yet Connery is also presented as the height of male brutality—not because he is physically brutal, but because he is so eager to "tame" Tippi Hedren's Marnie. His sexuality, while compelling, begins to seem oppressive when he refuses to leave Hedren alone. The camera makes his kisses feel like rape. Even his understanding, sympathetic side comes across as an effort to control—a point which is made most strongly after Connery has been reading about abnormal female sexuality, and Hedren says to him: "I know, I know: you Freud, me Jane." This brilliant line not only echoes and mocks the Freudian element in all the previous Hitchcock films, from *Spellbound* through *Psycho;* it also stresses the disturbing way in which this film has given all the economic, intellectual, and sexual power to the male half of the couple. "You're afraid of powerful women?" the film seems to say. "You want to be the smart one, the strong one, the protector? Okay, *this* is what that would be like." The best that the hero can hope for, under such circumstances, is not a heroine who will bring equal enthusiasm to their union, but a passive victim who chooses him as the lesser of two evils. "Will I have to go to prison? I'd rather stay with you," are the film's last words, Marnie's pathetic capitulation to her husband.

The danger in a film like *Marnie* is that, like *Antony and Cleopatra,* it tempts one to join the battle of the sexes on one of the two opposing sides. Like the charming Antony, Sean Connery can be seen as all that's best in masculinity, confronted and taken in by all that's worst in women: deceit, flightiness, frigidity, and the will to murder. Seen from this angle, Marnie herself represents woman-as-pitfall. Yet to the extent it adopts Marnie's own perspective (as the camera frequently does), the film can be seen as an exposure of the brutality inherent in sex, with its inevitable capitulation of a weaker to a stronger partner. The problem, as with *Antony and Cleopatra,* is to enter into each of these insistent viewpoints and at the same time to quell their power.

What Hitchcock and Shakespeare can tell us is that love is frightening, that sexual power is also the power to harm, and that partners in love are also enemies in battle. To ignore these ideas is to miss all that's most important in these works. But to allow the fears to take over completely is as much a failure as to reject them outright. The "Antony" side of the story and the "Cleopatra" side—the *Spellbound* vision of me-Tarzan-you-Freud and the *Marnie* vision of you-Freud-me-Jane—must both be allowed to survive if men and women are to have anything useful to do with each other.

Second Thoughts

Vertigo is the crossover film, that movie the bridges the *Antony and Cleopatra* material and the Pygmalion theme, in that its lovers are worried by both the problem of mutual sexual betrayal and the problem of masculine control. On an obvious level, *Vertigo* is about a man who remakes a woman to suit his own desires; in that sense, it is clearly Hitchcock's version of *Pygmalion,* his retelling of the Shaw play as well as the ancient Greek myth. On a less obvious level, it is about the way a director conceives and remakes a film, and this too makes it a version of the Pygmalion myth, with the original artist—a sculptor—updated to a filmmaker. Specifically, *Vertigo* refers back to the 1956 remake of *The Man Who Knew Too Much,* which is in turn a movie about a man's "remake" of his wife. Seen in this light, the second version of *The Man Who Knew Too Much* becomes a far more interesting movie than most viewers of this Hollywood production have suspected—not only a key to the difference between early and late Hitchcock, but also a highly self-conscious meditation on the themes that were to reach maturity two years later in the masterpiece *Vertigo*.

A film that deals obsessively with the process of remaking, *Vertigo* is itself a movie that other filmmakers have, in one form or another, repeatedly tried to remake. Before delving into Hitchcock's "second thoughts," I want to take a quick glance at those of one of his imitators. For much of his career, Brian De Palma has tried to be Alfred Hitchcock. This debt is perhaps most noticeable in his numerous shower scenes, which allude explicitly to *Psycho.* (But then, so do the shower scenes in all thrillers these days. The shower scene has by now become an old chestnut, a purposeful cliché, like "To be or not

to be.") Still, *Vertigo* is the Hitchcock movie that has really dominated De Palma's imagination, to the extent that he has actually done two "remakes" of it: *Obsession* in 1976, and *Body Double* in 1984.

Obsession and *Body Double* are both rather bad movies, but they are good film criticism—that is, in their repeated mining of the *Vertigo* material, they tell us something about that film's inherent richness. Each one focuses on a different aspect of *Vertigo*'s concerns: *Obsession* on a man's overwhelming love for a dead woman, and his desire to recreate her in a living woman who incredibly resembles her; *Body Double* on the ways in which a film director is himself an obsessive recreator, substituting one woman for another and constantly remaking personalities. It is as if De Palma made one movie that he thought was about *Vertigo,* and then said to himself: "No, I've missed it entirely. Hitchcock's film isn't about sexual passion and romance, it's about movie-making. This time I'll get it right." But his second attempt, though more fun than the first, is still no closer to the Hitchcock original, in part because De Palma has allowed his revision to obliterate his initial vision. The power of a remake, if it is to be powerful, lies in its ability to suggest simultaneously both the first and the second versions. That Hitchcock himself understood this is clear in the denouement of *Vertigo:* when we finally see Kim Novak again arrayed as Madeleine, our whole response to the moment depends on our remembering her as the original patrician Madeleine *and* as the shopgirl Judy, now jointly incorporated into Jimmy Stewart's remake.

Both *Obsession* and *Body Double* are filled with allusions to *Vertigo* that are so obvious as to be parodic. For instance, the bouquet of flowers in Carlotta's portrait in *Vertigo*—an artist's mimesis, itself mimicked in Kim Novak's bouquet as she sits in front of the portrait— becomes still further removed from reality in *Obsession,* where it appears as the bouquet held by the Genevieve Bujold character in her dream version of her wedding. Similarly, the two primary architectural forms in *Vertigo*—the round-arched mission of San Juan Batista and the classically imposing Palace of the Legion of Honor—combine to produce the intensely stylized architecture of the tomb in *Obsession,* which in turn copies the Italian chapel at which the hero met his beloved wife.

In place of such visual doubling, *Body Double* focuses on character elements. It draws from *Vertigo* the crippling nature of its hero's fear (though it is claustrophobia, not acrophobia, that cripples him); the

scene in which the hero is unfairly castigated for indirectly causing a woman's death; and the pale blonde appearance of its threatened heroine, Holly Body (who is played by Melanie Griffith, the daughter of one of Hitchcock's favorite actresses, Tippi Hedren—another level of allusion, and surely not coincidental). And both De Palma movies contain wildly exaggerated renditions, *twice* in each movie, of the scene in which Jimmy Stewart first kisses the "remade" Kim Novak and the camera circles around them. In their bitten-off form, these mouthfuls of *Vertigo,* spat out into another film, become mere placeholders, symbols for the director's acknowledgment that he is borrowing from the Master's work. They are the "quotations" at the heart of De Palma's two essays in film criticism—except that, unlike well-used textual quotations, they yield up no meaning in themselves, functioning instead as mere attributive footnotes.

De Palma's approach to Hitchcock is repeatedly to make the implicit explicit. He informs us, for instance, that *Body Double* is about the deceptive nature of film by opening the movie with a scene that turns out to be part of a film-within-the-film. (This is such a common technique with De Palma—though it is usually a dream that fools us, rather than a film—as to have become his trademark by now.) Hitchcock, on the other hand, begins *Vertigo* with a scene that *looks* like part of a film—the thrilling cops-and-robbers chase across the rooftops—but in fact turns out to be part of the Jimmy Stewart character's real life. The same implicit comment ("You can't tell the difference between movies and real life") is made with much greater complexity than in De Palma's film, and we are never given the payoff line that assures us we are *now* in reality. Hitchcock's understanding of the dilemma is so deep that he can afford to leave it floating, and his respect for his audience so great that he never gives us the wink.

Nor does Hitchcock see plot as a mere throwaway convenience, the way De Palma does in *Body Double* and *Obsession.* (The De Palma of *Dressed to Kill,* on the other hand, exhibits a healthy respect for plot—but that is a far better movie, one that transcends its status as homage to Hitchcock and becomes instead a self-aware, Hitchcockian commentary on De Palma's own movie-making.) The plot lines along which *Obsession* and *Body Double* chug are cloddish at best, senseless at their worst. In the earlier film, for instance, the "double" eventually turns out to be the long-lost child of the dead, beloved wife and the obsessed husband—in other words, the hero's own daughter. To arrive

at this Freudian resolution, De Palma has had to cheat unmercifully, asking us to believe that the same actress (Genevieve Bujold, looking identical in both roles) could be two different women, a mother and her daughter. This is as ridiculous as Barbara Stanwyck expecting Henry Fonda to believe she is a totally different person, a complete stranger, when she meets him again in the second half of *The Lady Eve*. Preston Sturges, through his William Demarest character, treats this ploy with the wry contempt it deserves, and so should we when we run across it in *Obsession*.

Body Double's plot is even flimsier, raising such questions as: How could the villain Sam coincidentally meet our hero Jake for the first time one morning, and have the entire deception set up by that afternoon? If Sam's wife is *not* the same woman as the nude dancer, why does she cooperate in the deception by leading Jake on so lasciviously in the shopping mall scene? When we hear her tell a friend she's never home before seven, why doesn't Jake (standing right next to her) hear the same thing and know she can't be the woman he watches at sunset each night? But more important even than these errors is the remarkable shallowness of the plot constructed by Sam. Once it has been unraveled, it holds no further interest for us; it only functions as a temporary mechanism for fooling us while it fools Jake.

In contrast, the fantastic story at the heart of *Vertigo*—Madeleine Elster's obsession with her dead ancestress, the poor, mad Carlotta Valdes—has a power far greater than is required by its functional necessity in the plot. Even after we've learned that the story was made up by Gavin Elster to fool the acrophobic hero, and that this "Madeleine" never existed, but was played by Elster's mistress Judy, we still retain a sense of eerie fascination with the tale; and its influence—from beyond the grave, as it were—overshadows the second part of the movie. The idea of a dead woman who haunts the body of a living one reverberates not only within the plot—in Jimmy Stewart's treatment of Kim Novak's Judy—but also in a larger context, in Hitchcock's contemplation of what it means to be an actress. At Hitchcock's behest, the actress Kim Novak plays Judy, who in turn obeys her lover by playing the Madeleine of his creating, and who then capitulates to Jimmy Stewart by playing the Madeleine of his deluded imagination. The Stewart character compares all three kinds of transformation when, at the end of the movie, he berates Judy for her submission to Gavin Elster: "He made you over just like I made you over—only

better . . . Did he train you? Did he *rehearse* you?" Stewart's emphasis on that final verb moves the discussion outside the world of the film and into the universe of filmmaking, so that the "he" becomes Hitchcock as well as Elster. Where the actress (as actual woman) ends and the character (as imaginary creation) begins is impossible to determine, because the layers of acting-a-character and being-inhabited-by-a-character so interpenetrate each other. According to this vision, acting is less a willed deed than a process of submission to a force outside oneself—whether it be a director's instructions, a lover's commands, or the lure of a dead or imagined spirit.

It is through such interpretations of "performance," in the largest possible sense of that word, that Hitchcock brings together ideas about obsessive love affairs and obsessive filmmaking. For the two obsessions to matter in a movie, they must be seen as linked—which is why De Palma's decision to separate them, one for each film, leads to such a dead end. Hitchcock's movies suggest that the submission of personality required of a film actress is an aspect of the submission required of a "good" wife or mistress. In either case, a certain loss of identity—a rendering up of oneself to the mastering male—is both insisted upon and resisted. That Hitchcock is seriously contemplating a sexual tragedy, and not just entering unconsciously into an authoritarian mode of direction, is made evident in the plot of *Vertigo*. And this awareness of his becomes even more obvious when one compares the early and late versions of *The Man Who Knew Too Much*. In remaking his own film, Hitchcock apparently began to ponder very carefully the whole notion of a "remake," and thereby came to understand more fully the connections between the masculine desire to reshape the feminine and the director's desire to make, or remake, a film.

The 1934 version of *The Man Who Knew Too Much* has all the earmarks of an early Hitchcock film, and the people who vastly prefer it to the remake tend to be those who feel that Hitchcock's power as a filmmaker declined after he came to America. Certainly the earlier version has its own special charms, including the spunky markswoman mother, her amusing relationship with her typically English husband, and the usual stunning performance (or, given its resilient flatness, *non*performance) by Peter Lorre as the villainous kidnapper. The 1934 movie is light and witty in the manner of much early Hitchcock—that is, it entertains us all the way through and then lowers the boom at

the end. The film concludes with a hail of bullets unmatched until De Palma's *Scarface,* and though the kidnapped child is restored safely to her parents, she has seen her father shot and is inconsolably crying. The final implication—that the nice middle-class English family will never fully recover from the terror of these events—accords well with the dank settings and shadowy cinematography of this black-and-white film.

The 1956 *Man Who Knew Too Much,* which is shot in brilliant color, has its darkness concealed much closer to the core (if such a triumphantly two-dimensional medium as film can be said to have a core). Instead of the capable, dry-witted Englishwoman who shoots her child's kidnapper, we are given the ever ebullient Doris Day, who sings her way to victory. This alone has been enough to cause most viewers to give up on the film. But Hitchcock has used her Doris Day-ness in a very purposeful manner, matching it against Jimmy Stewart's Midwestern charm to produce a frightening portrait of the 1950s American family.

What critics see as a loss of feminist perspective between the two films, in the transformation of a masterful wife into a simpering songbird, is in fact a move in the opposite direction. It takes a very perceptive observer of the dynamics of marriage to cast Jimmy Stewart as an oppressive husband, thereby placing us unconsciously on the side of his ever-so-subtly imprisoned wife. In the very English marriage of the 1934 *Man Who Knew Too Much,* the wife's freedom includes the ability to flirt openly with a series of men whom the child calls "Uncle"; and I take the yarn scene (in which the husband ties the end of his wife's knitting to her suitor's suit, and the knitting unravels as "Uncle Louis" dances with the wife) as an oblique reference to Penelope, her suitors, her unraveled weaving, and the whole issue of marital fidelity. Such an issue would never even come up in the 1956 version of the movie, for that wife is tied too closely to her husband's apron strings even to *think* of dancing with another man. The Doris Day wife is so much a part of her husband—at least, from his viewpoint—that she can barely even salvage a separate identity from the marriage.

This becomes especially clear in the matter of names. Jimmy Stewart (Dr. Benjamin McKenna in the movie) repeatedly refers to himself and his wife as "Dr. and Mrs. McKenna." As soon as she is revealed to have her own first name, he feels impelled to explain to an inquis-

itive Frenchman that though her real name is Josephine, he's been calling her Jo "so long that nobody calls her anything else." "I do—Mummy," pipes up their rather obnoxious little boy Hank, suggesting that Jo has at least one other identity which her husband chooses to ignore. Oddly enough, it turns out that everybody calls her Jo, even her friends from before her marriage, so that Jimmy Stewart's claim to being the creator of that nickname begins to ring false. And when we find out that she was previously a well-known professional singer under the name Jo Conway, his position becomes highly suspect. Clearly Ben views his wife (Mrs. McKenna) and this professional woman (Jo Conway) as two spirits in direct competition for the same body, and he is trying to vanquish the latter. "You are Jo Conway," says a woman who recognizes the former singer in a restaurant, to which Jimmy Stewart responds, "We're Dr. and Mrs. McKenna." He receives his deserved comeuppance in a later scene, when Jo's old music-world friends bustle into her London hotel room and then remark to her husband, "Oh, Mr. Conway—didn't know you were there." One might be tempted to write all this off as mere humorous byplay, except that the film focuses on the question "What's in a name?" by making a crucial plot development hinge on the fact that Ambrose Chapel is a place, not a person. Just as it is Jo who makes this important discovery, it is she who realizes most deeply how closely one's identity can be tied to one's name.

Nor is naming the only front on which Benjamin McKenna persistently defends his authority. He is constantly bickering with his wife about their relative importance. Thus when she points out that Louis Bernard has been asking him a lot of questions without giving any information in response, Jimmy Stewart pooh-poohs her suspicions by saying, "You're sore because this fellow didn't ask *you* any questions." (As in so many other instances in the movie, Jo's instincts turn out to be better than Ben's here.) When they are being interrogated by the Moroccan police, McKenna answers all the questions and his wife merely receives a blank look from the officer when she tries to interject some important information. But later, when they are in the London police office, it is Jo who gets the policeman's persuasive attention, causing her husband to remark petulantly, "Louis Bernard talked to me, he didn't talk to my wife, you know." If the 1934 film shifts gradually from the wife to the husband, emphasizing his search for his daughter in its second half, the 1956 version focuses increasingly on the wife and her relationship to her kidnapped son; and the child's

sex has been transformed to allow this change in focus, from father-daughter to mother-son.

The most chilling example of Dr. McKenna's will-to-power is the scene in which he reveals to his wife that their son has been kidnapped. Having delayed telling her until they got back to their hotel room, he imperiously stops her from telephoning for the child ("Hold that call a minute." "Why?" "Because I asked you to") and then uses his medical authority to give her tranquilizers ("These are for you, Jo. Come on, I'm the doctor"). Though he is the one behaving strangely, he accuses her of being overexcited and too talkative, therefore "needing" the pills he has previously decided to give her. And when he finally does tell her the news, she is so angry at him for giving her sedatives that he physically has to hold her down on the bed. His oppressive love, in this scene, has affinities with that of Sean Connery in *Marnie:* in both cases, a man uses his superior strength to impose on his wife what he thinks is good for her.

The real disagreement between Ben and Jo McKenna is the fact that he has made her give up her career. A highly successful, internationally known singer when she met him, Jo now has no occupation but that of wife and mother in Indianapolis. That town's provinciality is stressed in several pointed remarks, such as Hank's suggestion that the Frenchman can eat the snails in their backyard. Jo would like to live in New York—where, as she accurately points out, a doctor can make a living—but Ben refuses to give up his practice in Indiana. Hitchcock repeatedly reminds us that Jo's career has been cut short by her marriage. For instance, when Louis Bernard first hears her singing to her child, he says to McKenna, "I can't tell you how beautifully your wife sings. Too bad it was interrupted"; and though he is referring to the fact that drinks were brought in, his comment also applies to the marriage itself. The song she sings, both here and at the film's end, is the familiarly sappy "Que será, será"—which, on close inspection, turns out not to be a general argument for fatalism, but a very specific examination of career choice. The verses all contain lines like "When I was a little boy, I asked my mother, what should I be?" and "When I was a child in school, I asked my teacher, what should I try?" Singing it at the film's beginning for her son, Doris Day uses the words "when I was a little boy," but by the end, when the song's relationship to her own position has become much more obvious, she substitutes the words "little girl" in that phrase.

In his heroine's blighted career, Hitchcock finds the perfect mech-

anism for bringing together the two kinds of makeover, a husband's transformation of his wife and a director's remake of a film. For what differentiates the late *Man Who Knew Too Much* from the early one is its emphasis on music. The crucial Albert Hall concert sequence appears in the earlier version, but almost by accident: it is a good scene and a clever way of staging the assassination attempt, but it has little to do with the rest of the movie. For the remake, Hitchcock seizes on that scene and makes it the epicenter from which the whole film is generated, going so far as to foreshadow it explicitly in the opening credits, where a title announces, "A single crash of Cymbals and how it racked the lives of an American family." By making the mother a singer rather than an expert markswoman, he inserts the musical context at the very beginning of the film and lets it build toward the concert scene. For the Albert Hall concert, he uses the same piece of music as in the 1934 version (something called "Storm Cloud Cantata" by Arthur Benjamin), but rearranges it so that it now features a female soloist against a choral background. This arrangement, mingled with our sense of Jo's lost career, gives to the scene in which she waits for the assassination an intensity that is utterly missing from the earlier film. Jo's evident emotion comes from two different sources of conflict: one, between her motherhood and her social conscience (since her son's life and the foreign leader's life hang in balance); and the other, between her choice of a family existence and her desire to sing. As one might expect from Hitchcock, the moment of "acting," Jo's warning scream, is virtually unwilled. When the man she saved thanks her, Jo tries to deny her action's volitional aspect by saying "It wasn't . . ." —to which he, stressing the results rather than the intention, responds: "But it was, my dear lady, it was."

It is through music, moreover, that Hitchcock implicates himself in this film. Instead of the anonymous conductor of the earlier version, he places the orchestra under the direction of his own score-writer, Bernard Herrmann, whose name and even face figure prominently in the concert sequence. Herrmann functions here as the stand-in for the director, turning a bare "script" of notes (on which the camera repeatedly focuses) into a moving performance. At the same time, the film pays tribute to Herrmann's own role in Hitchcock's American career—defining, as it were, the two Hitchcock periods as Pre-Herrmann and With-Herrmann. (De Palma alluded to this idea when he had Herrmann do the score for *Obsession*.) Finally, the Albert Hall scene

sets up an implied comparison between a film director's role, which involves doing something once and then leaving it that way forever, and a musical conductor's role, which involves reinterpreting a piece each time it is played, forever making it new. The 1956 *Man Who Knew Too Much* is Hitchcock's single attempt to be like a conductor: to redo his earlier performance and try to make it better.

If *The Man Who Knew Too Much* is Hitchcock's tribute to the musical element in film, *Vertigo* is his comment on the visual element. The movie's central premise, Jimmy Stewart's fear of heights, becomes *our* fear through the use of the camera (which is one reason why *Body Double* fails in comparison: claustrophobia is a far less visual fear than acrophobia, and hence less susceptible to camera treatment). All the emphasized details are visual, too: the portrait, the bouquet, the grave, the mission, Madeleine's apartment building, the trees of Muir Woods, the views of San Francisco. And Stewart's transformation of Kim Novak is essentially a visual one. He dyes her hair, restyles it, buys her new clothes, and thus turns her from one person into another— just as a filmmaker does with an actress. Here it is Stewart himself, rather than Bernard Herrmann, who stands in for the director. Much more explicitly than *The Man Who Knew Too Much*, *Vertigo* is about the notion of a "remake." Yet it took the 1956 film, with its actual process of remaking, to suggest to Hitchcock the ideas he finally brought forth in 1958; and he acknowledges as much by making *Vertigo* pay homage, in many of its details, to the second version of *The Man Who Knew Too Much*.

There is, to begin with, the use of Jimmy Stewart as the lead actor in both movies. Though the Jimmy Stewart of *Vertigo* is somewhat more cosmopolitan (he lives, after all, in San Francisco rather than Indianapolis), both roles are obvious versions of the actor himself: a well-educated, twangily Midwestern, very American character of Scottish ancestry. (He is even called "Scotty" Ferguson in *Vertigo*.) Both movies, moreover, take Stewart's friendly charm and evident lack of worldliness—his potential as a sympathetic innocent victim—and play them off against a darker, more manipulative side of his personality. Jimmy Stewart's dark side is something that Hitchcock recognized earlier in *Rope,* where he cast Stewart as the dangerously cavalier philosophy professor whose Nietzschean ideas led his two young students to commit a pointless murder. Though it was seen at the time as casting against type, *Rope* actually made use of an element in

Stewart's screen personality that perhaps only an Englishman could perceive: his embodiment of an American innocence that is also a kind of arrogance, an unquestioning assurance that one's own actions in the world will always be for the best. In a far more subtle way—because more unconscious on the character's part, and therefore more sympathetic—the same destructive capacity characterizes the Jimmy Stewart of *The Man Who Knew Too Much* and *Vertigo*. He is so sure he is the victim ("Why did you pick on me? I was the set-up," he says at the end of *Vertigo*) that he can't comprehend the ways in which he is also the perpetrator. Thus he perfectly spans the gap between the movie director and his audience, between the creator of violent suspense and the victimized voyeur.

In the place of the Doris Day of *The Man Who Knew Too Much*, *Vertigo* gives us two blondes: Barbara Bel Geddes' earthy, humorous Midge, and Kim Novak's otherworldly Madeleine. Hitchcock tells us that these two are the self-contradictory aspects of a single woman when he shows us Midge's version of the Carlotta portrait, with her own puckish face disconcertingly replacing the Carlotta with whom Madeleine identifies. Midge is the necessary counterbalance to the romantic Madeleine, the spunky, ever-curious side of Doris Day as opposed to her emotional, Albert Hall side. Like the Fool in *King Lear*, Midge inexplicably disappears halfway through the plot, when her role and Madeleine's are both subsumed in the down-to-earth Judy.

Though Doris Day and Kim Novak are hardly doubles, Hitchcock unites them by means of costuming. Throughout the second half of *The Man Who Knew Too Much*, when Jo has become the central figure, she wears a tailored bluish-grey suit that is virtually identical in style to the one Madeleine wears in *Vertigo*. Hitchcock draws this outfit to our attention by having Judy hide that suit in the back of her closet, and then having Scotty buy her a new one. When Jimmy Stewart takes Kim Novak to the dress store and insists on buying the suit for her (in a scene that pointedly resembles a director outfitting his star), the saleswoman mentions that this particular style was carried a couple of seasons earlier—in other words, two years before *Vertigo*, when Doris Day was wearing it in *The Man Who Knew Too Much*. It is as if Hitchcock, paying a visit to a women's clothing store with Kim Novak, were insisting that she be remade as the Doris Day of his memory.

Another link between Doris Day's Jo and Kim Novak's Madeleine

occurs in the figure of Carlotta. Just as Madeleine is influenced and inhabited by her ancestress Carlotta, Kim Novak is haunted by the figures of Hitchcock's other blonde heroines, and in particular by the nearly adjacent Doris Day. (*The Wrong Man,* which came between the two movies, belongs to a different genre of Hitchcock films—bleaker, more colorless, more focused on the male characters—and Vera Miles, the faded, mousy wife of that picture, can't really be viewed as part of the procession of blonde leading ladies.) Moreover, the story of Carlotta, as told by Midge's bookstore-owner friend, eerily resembles a distorted version of Jo Conway's tale: A young woman was found singing and dancing by a powerful man, who moved her into a sumptuous but imprisoning house (later renamed McKittrick's Hotel—an echo of McKenna?); she had a child who was eventually taken away, causing her to search desperately for it. Even the words that Madeleine/Judy murmurs as she plays the reincarnated Carlotta ("Have you seen my child?") could easily have been spoken by Jo in *The Man Who Knew Too Much*. Like Carlotta, Jo wanders the streets in search of her lost child, pacing back and forth on the deserted sidewalk in front of Ambrose Chapel. And the music that accompanies this pacing—the Bernard Herrmann score for this portion of *The Man Who Knew Too Much*—is an embryonic version of the Madeleine/Carlotta music in *Vertigo*. Did Herrmann know he was remaking his *Man Who Knew Too Much* music for *Vertigo*? Did Hitchcock tell him to?

Asking questions like these is a bit like trying to fathom the Carlotta portions of *Vertigo*. On the one hand, it's all a con job on the part of a manipulative fellow who is simply using our fears to make a profit—whether that be Gavin Elster or Hitchcock himself. On the other hand, it's too mysterious and compelling a story ever to be solved by purely rational means. Like a simpleminded version of the audience, Scotty is constantly trying to find the "key" to Madeleine's obsession, to locate her dreams and fears in everyday psychological reality. "You see, there's an answer for everything," he says triumphantly, pointing to a grey wooden horse as she recalls an actual grey horse in the mission stables of her childhood. This is the Scot as Enlightenment empiricist, the believer in visible truth. But it is the evidence used by empiricists—the evidence our eyes provide—that Hitchcock the filmmaker knows to be suspect. If a woman looks the same as another woman, *is* she that woman? Is Madeleine Judy? Is Kim Novak Madeleine?

Knowing *too* much is self-evidently dangerous. Not only might it lead you into trouble; it might also prevent you from fathoming the less easily known aspects of existence. Dr. Benjamin McKenna exemplifies both of these dangers: he knows too much and therefore understands too little. Scotty Ferguson, by the end of *Vertigo,* is in a similar position. Having exposed Judy's earlier treachery, he fails to understand the depth of her love, for she is no longer simply the creature of his creating.

To make something that then has its own existence, a creator must exceed the limits of his rational comprehension. I think that's what Hitchcock did in *Vertigo.* In the 1956 *Man Who Knew Too Much,* he brought everything under his control, subdued the eccentricities and digressions of the earlier version, and pressed the plot into shape the way Ben McKenna pressed Jo Conway's life. And then in *Vertigo* he took everything he had gathered up and enclosed in *The Man Who Knew Too Much,* and freed it. "One doesn't often get a second chance," says Jimmy Stewart in *Vertigo.* "I want to stop being haunted. You're my second chance, Judy—you're my second chance." But what becomes clear, by the end of the movie, is that one needs two second chances—one to do the remake, and the other to let something new and powerful emerge from that process of revision. Scotty Ferguson never got his other second chance, but Hitchcock did.

Randall Jarrell's
Sinister Beings

7 There is something inevitable-seeming about Randall Jarrell's choice of the dramatic monologue. His is a divided voice in any case, and the monologue, with its well-read poet speaking through an often-naive narrator, gives expression to this division. That this doubleness sometimes results in either cynicism or sentimentality is a charge that has been leveled against Jarrell. But it is probably not an accusation he could have avoided by choosing another form. The split in Randall Jarrell's writing voice—between critic and poet, male and female, persecutor and victim, wit and sentimentalist, aristocrat and democrat, bitterly knowledgeable adult and ingenuous child—explains much of what is best about him as a writer, even as it also makes some of his work problematic.

What draws us to Jarrell, what makes him seem perpetually interesting, is the same kind of split he perceives in the authors about whom he chooses to write criticism: the "other" Frost ("Besides the Frost that everybody knows there is one whom no one even talks about," he begins one essay); the multi-phase Auden (who moved ideologically, according to Jarrell, from "Freud to Paul"); the "double-natured" Robert Graves ("No wonder that the once-torn-in-two Graves becomes sure, calm, unquestioning . . . He has become, so to speak, his own Laura Riding"). The irony of this is that Jarrell's primary division is the one between critic and poet—between the sharp-eyed wit who can spot self-division in others, and the rather soft, emotional poet who can only manifest it in relatively unselfconscious ways.

For Jarrell, that divided nature is invariably connected with what he conceives of as a split between the writer's "masculine" side and his "feminine" side. Here's how he characterizes Graves's underlying ideology: "Men are as dry and as known to him as his own Ego;

women are as unknown, and therefore as all-powerful and as all-attractive, as his own Id. Salvation, Graves has to believe, comes through Woman alone; regimented masculinity can work only for, by means of, everyday routine . . ." Though the tendency is exaggerated in Graves—and Jarrell accordingly mocks it—this description is self-portrait as well as portrait: Jarrell sees remarkably similar tendencies in every writer whose work he loves. Writing about Frost's poem "Home Burial," he points out that "the woman has a motion language more immediate, direct, and particular than words," while her husband "resorts to a language of repeated proverbial generalizations"; and Jarrell summarizes the poem by saying it "might be called the story of a marriage between the will and the imagination."

In Jarrell's terms, poetry is the motion language of particularity, of the imagination, while criticism partakes of the masculine world of willed generalization. He consistently elevates poetry above criticism, even his own (not always great) poetry above his own (excellent) criticism. He notes in essay after essay that the critic's only function is to serve the poet, the artist: "Remember that you can never be more than the staircase to the monument, the guide to the gallery, the telescope through which the children see the stars." He begins his essay "The Age of Criticism"—an attack on criticism's dominance—by saying, "I wish that you would treat what I am going to write as if it were verse or talk, a conversation-with-no-one about our age of criticism," attempting to cloak himself in the attire of poet even as he embarks on the very act of criticism he is setting out to criticize.

In 1956, near the peak of Jarrell's career, James Dickey published an essay called "Randall Jarrell" in the *Sewanee Review*. It was almost the only piece of real criticism written about Jarrell during his lifetime, and it is also one of the few articles published before or after his death to take a negative view of Jarrell's poetry. Actually, Dickey's essay takes two views: it is structured as an argument between characters A and B over the merits of Jarrell's poems, with A taking the pro side and B taking the con. The issue is never finally decided, but although A starts and finishes the piece, one can feel that Dickey's heart is really in B. Among other things, B asserts that Jarrell's poems

> are the most untalentedly sentimental, self-indulgent, and insensitive writings that I can remember . . . Am I to believe that you and Jarrell think that comment of this rather tame and obvious kind constitutes

Triumphal poetry? . . . It is not enough that the poet's world be that of "all of us." Of course he must begin there, but that fact doesn't make him a poet, or his writings valuable . . . Jarrell evidently considers it a particular virtue, in his espousal of the "real," to cling like death to the commonplace, as though the Real were only the Ordinary, after all, and the solution that artists have sought for centuries were resolved in that recognition . . . I am disturbed, though, that despite all the pity he shows, none of it is actually brought to bear on any*one* . . . I don't think there are really any *people* in the war poems. There are only The Ball Turret Gunner, A Pilot from the Carrier, The Wingman, and assorted faceless types in uniform. They are just collective Objects, or Attitudes, or Killable Puppets. You care very little about what happens to them, and that is terrible.

I find Dickey's essay particularly irritating because it touches on so many real problems in Jarrell's work. One wants to lavish oneself unhesitatingly on Jarrell—to admire his brilliant essays, to be moved by his empathetic poems—and Dickey makes this kind of self-abandonment difficult. The conflicts that Dickey sees (and that he mimics in the dialogue form of his critical essay) are undeniably there in Jarrell's poems. But I would finally disagree with Dickey's assessment of their effect. If these contradictions are to blame for what is disturbing about Jarrell, they are also responsible for what is powerful and compelling in him. It is as if Jarrell has drawn into himself all of the various conflicts—personal, sexual, sociological, intellectual—that afflict the world in which he and his readers find themselves. "When you organize one of the contradictory elements out of your work of art," Jarrell once wrote, praising Whitman, "you are getting rid not just of it, but of the contradiction of which it was a part; and it is the contradictions in works of art which make them able to represent to us—as logical and methodical generalizations cannot—our world and our selves, which are also full of contradictions."

One aspect of Jarrell's divided sensibility takes the form of an allegiance to the ordinary individual on the one hand, and a temptation to mock or deplore "mass" taste on the other. This mixed attitude pervades much of the criticism he wrote and explains why he spent so much time discussing the poet's relationship to the wider world. Because of this honestly faced conflict, it is hard to classify Jarrell—not only in terms of sentimentality versus irony or sophistication versus naivety, but also in terms of his political or social stance. In

some respects, Jarrell seems filled with contempt for the "ordinary reader," and this contempt fuels many of his most darkly humorous remarks. In "The Other Frost," for instance, he savages public taste by asserting: "Ordinary readers think Frost the greatest poet alive, and love some of his best poems almost as much as they love some of his worst ones." In an even more brutal attack on the American non-reader, Jarrell notes: "A sort of dream-situation often occurs to me in which I call to this imaginary figure, 'Why don't you read books?'—and he always answers, after looking at me steadily for a long time: 'Huh?'" This enraged intellectual with the biting wit is hardly recognizable as the empathetic, perhaps even excessively humane Jarrell of the poems—the figure Dickey accuses of "clinging like death to the commonplace."

Yet the two personalities come together in Jarrell's concern over the fate of poetry. He is angry at non-readers and bad readers, but only in a secondary fashion; his real gripe is against the society that has deprived poets of their rightful public. If Jarrell is dismayed at the ordinary person's neglect of poetry, it is because he considers that audience essential to poetry. In "A Sad Heart at the Supermarket"— his attack on the effects of what he calls "the Medium"—Jarrell summarizes his reasons for dismay:

> Nothing is as dead as day-before-yesterday's newspaper, the next-to-the-last number on the roulette wheel; but most of the knowledge people have in common and lose in common is knowledge of such newspapers, such numbers. Yet the novelist or poet or dramatist, when he moves a great audience, depends upon the deep feelings, the living knowledge, that the people of that audience share; if so much has become contingent, superficial, ephemeral, it is disastrous for him.

Jarrell's divided poetry, with its odd combination of empathy and irony, stems from his attempt to hold onto both sides of a chasm that is rapidly widening. The sense of loss that pervades his poetry (surfacing in book titles like *Losses* and *The Lost World*) is one that applies to everybody, for, as he says, "the artist needs society as much as society needs him." Setting himself apart from the *Partisan Review* intellectuals, who sought to preach this truth to the worthy few, Jarrell refused to find consolation in enclosed literary circles; on the contrary, he worried that "as our cultural enclaves get smaller and drier, more hysterical or academic, one mourns for the artists inside and the public

outside." It was Jarrell's unfortunate fate to belong simultaneously to both camps. His own critical wit is exactly the sort that might have failed to appreciate the rather sentimental poems he wrote, had they not stemmed from the same individual. As it was, these two sides maintained only an uneasy truce.

Jarrell's self-division results, ironically, in the bringing together of two of his primary concerns: his fear that mass-produced, media-dominated society is ruining the imaginative life of individuals, and his sense that women are the repositories of that imaginative life. If women are victims in Jarrell's poetry, if they represent the bored or the fettered or the insufficiently educated (as they do, for instance, in "The Woman at the Washington Zoo," "Seele Im Raum," and "A Girl in a Library"), it is not because they are weak or inherently flawed; it's because they, with their greater receptivity and imagination, are more likely than men to suffer the consequences of a corrupt society. "Reader, isn't buying or fantasy-buying an important part of your and my emotional life?" Jarrell asks in the essay "A Sad Heart at the Supermarket." "It is a standard joke that when a woman is bored or sad she buys something, to cheer herself up; but in this respect we are all women together . . ."* He dredges up a stereotype of the consumerist female, but he surrounds it with remarks that implicate both himself and his readers, male and female, in that stereotype. "In this respect we are all women together" might be taken as the keynote of many of his best poems—even, curiously, some of the war poems.

In another essay, he describes writing "The Woman at the Washington Zoo" during the summer and fall of 1956, when he had just moved to Washington, D.C. The female narrator of the poem is "one of these hundreds of thousands of government clerks." She is woman as bureaucrat, woman as citizen, woman as direct victim of the federal government's huge, mechanical existence. "She is a kind of aging machine-part," says Jarrell. "I wrote, as they say in suits, 'acting as next friend'; I had for her the sympathy of an aging machine-part."

*Jarrell and Henry James were both reviewers for the *Nation,* but eighty years separated their stints, so it is highly unlikely that Jarrell was aware of James's 1868 review containing the words: "We are all of us extravagant, superficial, and luxurious together. It is a 'sign of the times.' Women share in the fault not as women, but as simple human beings." The uncanny echo is not an allusion, but a reinvention—a sign not only of the unchanging times, but of the inherent sympathies between these two writers.

Again, the joke at the woman's expense is immediately made into a joke at his own expense: Jarrell's is the sympathy of empathy, of identification.

And yet that "machine-part" line also gets at why his poems sound sentimental. As Dickey points out, Jarrell's poems ask us to expend emotion on characters who aren't quite real—or at least aren't quite human. Dickey calls them "collective Objects, or Attitudes, or Killable Puppets," but that doesn't strike me as exactly the problem. Jarrell's monologue characters are creatures in transition: they are halfway between formulations in his own mind—exaggerated versions of himself, or of one of his aspects—and living people out in the world. They are caught midway between Imagination and Reality, which makes them both larger than life and less alive. In that sense they are like opera figures, and in at least one case (the Marschallin in "The Face") they *are* opera figures. At its best, Jarrell's sentimentality is the open, straightforward, self-conscious sentimentality of opera.

Not all of Jarrell's women are victims. In some cases he very pointedly uses the feminine as he says Graves does: to represent fecundity, creativity, "natural" beauty, as opposed to the harsh intellectualism of a masculine mind. Classifying his critic-self as male and his poet-self as female, Jarrell suggests that only his feminine side has the ability to give birth to the characters in his monologues. This connection between author and mother becomes especially clear in the poem "The Lost Children," where the second stanza goes:

> It is strange
> To carry inside you someone else's body;
> To know it before it's born;
> To see at last that it's a boy or girl, and perfect;
> To bathe it and dress it; to watch it
> Nurse at your breast, till you almost know it
> Better than you know yourself—better than it knows itself.
> You own it as you made it.
> You are the authority upon it.

Though the lines explicitly refer to a woman and her children, there is a growing sense as one progresses through the stanza that they also refer to the poet and his dramatic voices; this interpretation is confirmed in the last line by the word "authority" (containing as it does the word "author"). Yet the *other* sense of "authority" (as discipline

or power), like the previous line's emphasis on "owning" and "making," sounds oddly masculine in this context—as if the actual creation might be a feminine process, but the self-conscious acknowledgment of that process is inevitably masculine. Jarrell echoes this feeling in the first line of "In Nature There Is Neither Right nor Left nor Wrong," where he says: "Men are what they do, women are what they are." The poet longs for the grace of unselfconscious feminine creation, but his very desire to possess and *use* it for poetic purposes strikes him as masculine.

This tendency to equate unthinking creativity with the feminine can have its nasty side as well. The same irritation that Jarrell directs against the common non-reader in his essays gets loosed against the subject of "A Girl in a Library." The narrator of this poem is attracted to the college girl by her effortless embodiment of her natural, uneducated self: "I love you—and yet—and yet—I love you," he says, in perhaps the closest approach Jarrell ever makes to what Peter Handke might call "a moment of true feeling." And yet he also despises her stupidity:

> Poor senseless Life:
> When, in the last light sleep of dawn, the messenger
> Comes with his message, you will not awake.
> He'll give his feathery whistle, shake you hard,
> You'll look with wide eyes at the dewy yard
> And dream, with calm slow factuality:
> "Today's Commencement. My bachelor's degree
> In Home Ec., my doctorate of philosophy
> In Phys. Ed.
> [Tanya, they won't even *scan*]
> Are waiting for me . . ."

Intermittently addressing Tatyana Larina—Pushkin's heroine in *Eugen Onegin*—Jarrell's narrator degrades his own "heroine" by suggesting that she fails to live up to a literary version of womanhood, a version more like Jarrell's own personality ("now young and shy, now old and cold and sure"). Earlier in the poem, the narrator has said to the college girl:

> If someone questioned you, *What doest thou here?*
> You'd knit your brows like an orangoutang
> (But not so sadly; not so thoughtfully)

> And answer with a pure heart, guilelessly:
> *I'm studying* . . .
> If only you were not!

The self-contradiction in this poem, which ranges in tone from virulent sarcasm to apologetic appreciation, becomes clearest when it's compared to a poem with similar explicit aims but far less ambivalent feelings, John Crowe Ransom's "Blue Girls." Ransom confidently advises his young beauties to "Go listen to your teachers old and contrary / Without believing a word"; rather than envisioning them as orangoutangs, he sees these hopeless students as delightful "blue-birds that go walking on the grass / And chattering on the air." His sense of roles is clearly established: *they* exist to be beautiful and *he* exists to codify their beauty in literary form:

> Practise your beauty, blue girls, before it fail;
> And I will cry with my loud lips and publish
> Beauty which all our power shall never establish,
> It is so frail.

If there is a hint of self-mockery or regret here (at the inability of poets' "loud lips" to create or even "establish" the kind of beauty they wish to celebrate), it is nothing compared to the self-lacerating despair that underlies Jarrell's poem. Jarrell's ambivalence—his refusal to be the comfortable male poet—strikes me as being to his credit. His girl in the library is inadequate to literature even as she transcends literature: she may be the real stuff of which poetry is woven, but the tapestry of art has created grand expectations that she cannot, in her mere girlish person, fulfill. Worrying about the relation between the "feminine" of literature and this particular female, Jarrell notes:

> (Yet for all I know, the Egyptian Helen spoke so.)
> As I look, the world contracts around you:
> I see Brünhilde had brown braids and glasses
> She used for studying; Salome straight brown bangs,
> A calf's brown eyes, and sturdy light-brown limbs
> Dusted with cinnamon, an apple-dumpling's . . .

Even as he mocks himself for his literary preoccupations, the poet hates this girl for contradicting and debasing them—and then hates himself for his ability to love her only with a feeling of "and yet":

> And yet, the ways we miss our lives are life.
> Yet . . . yet . . .
> To have one's life add up to *yet!*

The poet and the girl are each other's victims, each other's persecutors: he attacks her mindless self-satisfaction even as he envies it, while she destroys his confidence in his own ability to create and love literary characters. His perception of his own disdain for her makes him despise himself, and she reduces him to nothing: "I am a thought of yours: and yet, you do not think . . ." Still, the poem's last lines make a recovery of sorts:

> I have seen
> Firm, fixed forever in your closing eyes,
> The Corn King beckoning to his Spring Queen—

an acknowledgment that the girl has given him "art" even as she has taken it away.

"A Girl in a Library" is one of the few poems in which Randall Jarrell allows himself to waver back and forth this violently between the mockery that characterizes his essays and the unrepentant sentimentality that colors most of the poems. Because his humor generally takes such a biting form, wit in Jarrell's work inevitably gets linked to his harsh, masculine side; the female side that creates poetry is generally nicer and softer, but humorless. Aiming largely to render or transmit feeling, the poetry is dominated by sentiment at the expense of humor; when wit bursts out (as it does occasionally, for instance, in some of the passages quoted from "A Girl in a Library"), it attacks both the feminine *and* the sentimental.

An exception to this pattern, and a poem that allows its wit to turn back on itself, is "Three Bills." Jarrell begins snidely with:

> Once at the Plaza, looking out into the park
> Past the Colombian ambassador, his wife,
> And their two children—past a carriage driver's
> Rusty top hat and brown bearskin rug—
> I heard three hundred-thousand-dollar bills
> Talking at breakfast. One was male and two were female.

The poem proceeds to link money with masculinity—not only in the title pun (which leads us to expect that there will be three men named

Bill, and then gives us three pieces of currency), but also in the last few lines:

> I was sorry
> To see that the face of Woodrow Wilson on the blond
> Bill—the suffused face about to cry
> Or not to cry—was a face that under different
> Circumstances would have been beautiful, a woman's.

The feminine is presented, at the last minute, as the only possible salvation from greed, cynicism, and depersonalization. Yet what has characterized the narrator of this poem is a masculine wit: an ability to reduce his characters to paper "bills" and to plaster presidents' faces over their individuality. This is the same kind of Kingsley-Amis-like wit that Jarrell demonstrates in sentences like: "When I last read poems in New York City, a lady who, except for bangs, a magenta jersey blouse, and the expression of Palamède de Charlus, was indistinguishable from any other New Yorker, exclaimed to me . . ." (Like "Three Bills," that crack is based partly on the particularly urban indistinguishability of female from male—that civilized, citified merging of the sexes which is what made Henry James, and indeed Proust, choose capital cities for their novelistic settings.) Only in its final line does "Three Bills" reach toward the feminine—not only in its invocation of "a woman," but also in its directness of sentiment. It's a very tricky balancing act, because if the last line succeeds, it does so at the expense of the narrator's humorously cynical voice, while if the masculine voice carries the poem, the last line sounds womanishly sentimental by comparison.

Last lines are the Achilles' heel of Jarrell's poems. (They are not the strong point of his essays, either: even after the most piercing and witty analysis, he will rely for his closings on either final quotations from the work under review or banal assurances of "delight" and "enjoyment.") Especially in the dramatic monologues, the poet almost seems to give up at the end—to embrace sentimentality unstintingly, or to give his characters wooden lines that could never be spoken aloud. At his worst, he settles openly for cliché—an odd choice from the novelist who satirized cliché so vigorously in *Pictures from an Institution*.

One of Jarrell's typically problematic last lines occurs in the poem "A Sick Child," a monologue spoken by a bright and imaginative child

who is home sick in bed. The closing line—"All that I've never thought of—think of me!"—is impossible to read out loud. The tone is embarrassingly exuberant, and the word order is both uncolloquial and unchildlike, especially in the unwieldy abstraction "All that I've never thought of." The line is (to side regretfully with Dickey) sentimental in its over-emotionalism: it expects to draw on the real feelings we might have for a child, but it gives that child an adult's language, an adult's longings. And because the rest of the poem (unlike either "Three Bills" or "A Girl in a Library") is relatively straightforward in its treatment of the character, it is unclear whether this final infelicity is a little joke on Jarrell's part or a severe mistake in diction.

Earlier, in the second stanza of this poem, the child has the postman say: "This letter says that you are president / Of—this word here; it's a republic." This joke is funny and apt for at least two reasons. One is that it reflects a child's attitude toward words in a realistic way. Elsewhere Jarrell has equated poets and children by pointing out that to a child "a word has the reality of a thing: a thing that can be held wrong side up, played with like a toy, thrown at someone like a toy"— and that is exactly what this child is doing when he has the postman say "this word here; it's a republic." Furthermore, the postman is like a child (as a child's invented postman would naturally be) in that he cannot pronounce strange words; like Jarrell's monologue characters, the child's postman cannot really transcend the imagination of his creator. But more than that, the joke is good because it echoes the feeling that dominates the poem: "If I can think of it, it isn't what I want." The postman's inability to pronounce the word frees the child from having to specify the name and thus makes the republic something potentially outside himself, something not just invented by him. At this point we may begin to get suspicious. For a child to wish for "Something that's different from everything" is just plausible, but for him to incorporate this wish into a very clever poetic joke is not. Who *is* this child, anyway?

In *Pictures from an Institution,* the composer Gottfried Rosenbaum wishes that some people would come down from another planet and make him their pet. Jarrell links the two wishes—from the novel and the poem—and then ties them back to himself when he notes in one of his essays that "I have written about a sick child . . . and about an old man who says that it is his ambition to be the pet of visitors from another planet; as an old reader of science fiction, I am used to looking

at the sun red over the hills, the moon white over the ocean, and saying to my wife in a sober voice: 'It's like another planet.'" In response to Rosenbaum, the novel's Jarrell/narrator figure sympathizes: "You're big for a pet. But it's hard on you, being cleverer than other people—it *is* your turn to be stupider, I suppose," to which the composer "answered mockingly: 'Ah, how well you put yourself in my place!'" Jarrell's ability to put himself in the character's place is ironic on two levels: first, because he admits his own arrogance in empathizing with the other man's superiority; and second, because there is a very good reason for him to be able to empathize—he is the creator of that character. This second meaning is not obvious in the novel (the narrator is, after all, a character too), but the comparison with "A Sick Child" brings it out; and, once recognized, this becomes an issue in all of Jarrell's dramatic monologues. He may achieve warmth of feeling through a moment of empathy, and he may save the poems from sentimentality through humor, but the humor has a consistently Jarrellian quality, and the empathy forces us to realize that the character is really the sophisticated Jarrell intentionally putting himself inside a naive character.

Thus far I have been making inferences from the novel, the essays, and the poems, but I'll now cite some "direct evidence" of Jarrell's poetic intentions from the letters he wrote to his friends and colleagues. For those of us who have been wondering about that boy imagining a postman in "A Sick Child," Jarrell makes the following remark to Adrienne Rich in 1965:

> To have written one good poem—*good* used seriously—is an unlikely and marvelous thing that only a couple of hundred writers in English, at the most, have done—it's like sitting out in the yard in the evening and having a meteorite fall in one's lap; and yet, one can't believe that, and tries so hard, by willing and working and wanting, to have the mail man deliver them—and feels so disappointed, even, when he doesn't.

Aha, we think. So it *was* a poet-child, a Randall-child, who said of the postman in "A Sick Child": "Then he tells me there are letters saying everything / That I can think of that I want for them to say."

And if you had doubts about how the poet really feels about the heroine of "A Girl in a Library," here's the evidence from a 1952 letter:

> Would you believe that we had to stand in line for an hour and meet about three hundred people filing by? Each shook my hand, said "I

certainly enjoyed your speech, Mr. Jarrell"—and went on. Except for one fat girl, a far-worse-than-Girl-in-the-Library type, who giggled and said, "Oh, you're the man who read that *long* speech." I laughed and said gaily and forcefully, "Why, you can't open your mouth without putting your foot in it. You're supposed to tell me how much you enjoyed it." She was only momentarily taken aback and recovered with, "Do you *really* believe all that stuff?" I said, "Sure do." And we each said an amicable sentence and she went bumpity-bumpity on.

Now, answer this: does the poet love this "far-worse" girl or does he hate her? Does that refusal to be polite make her an idiot or Jarrell's alter ego? The letter raises almost as many questions as the poem.

As with all such supporting biographical material, we can never be sure when the letters are joking or lying. For instance, Jarrell apparently gives us one of the juiciest pieces of evidence when he says in a 1952 letter to his future wife, Mary von Schrader: "I've just taken a Rorschach test for Eileen Berryman—I am about the twentieth poet she's done." But just as we imagine we'll learn something essential, Jarrell undercuts the whole endeavor: "About once or twice I was honest enough to say what they looked like, but not thereafter, and after I stopped saying I more or less stopped seeing." He goes on to tantalize us with what is surely a revealing clue: "There was one particularly dull one, almost no interesting details, that I said I didn't like. It turned out it is usually interpreted as two old women arguing or gossiping, and it is called the Mother Card." But before we can even gasp out our "Aha!" he beats us to the punch: "Do you suppose I accidentally didn't like it? Or that I didn't like it because of the Feminine-motherly side of my mother, even though I didn't 'see' the women in it?" Are these lines mocking, or serious, or both? It is hard to tell, especially from the man who said in another letter: "I felt quite funny when Freud died, it was like having a continent disappear."

Both the Rorschach test itself and Jarrell's humorous treatment of it suggest how complicated his acknowledged relation to the feminine is. It is both something he longs for and something he fears, a side of himself he admits to and also rejects. He suggests how crucially the dramatic monologues rely on a feminine voice—not just the feel of the feminine, but an actual woman's voice—when he writes to Allen Tate: "The 'Christmas Roses' poem is supposed to be *said* (like a speech from a play) with expression, emotion, and long pauses. It of course needs a girl to do it. I can do it pretty well for myself, to anybody I get embarrassed. I'd like to hear it done really nicely by

somebody like Bette Davis." Here we get a ludicrous if fleeting image of Jarrell imitating Bette Davis in the privacy of his own room—but we also get a hint as to how poems like "The Face," "Seele Im Raum," and "The Woman at the Washington Zoo" are meant to sound. That the female characters in these poems are partially Jarrell himself is suggested in another letter to Tate: "I think all in all I've got a poetic and semifeminine mind." Sometimes the soft, feminine side of himself is what he most avidly mocks or rejects, but that very denial "proves" (in Freudian terms) its existence, as he implies in a 1948 letter to Elisabeth Eisler: "I guess one great principle of my life is: *O, don't bother, forget about it: I should worry.* (Probably this is because I have a quite emotional nervous temperament, and naturally tend to do the opposite.)" It is pleasing and moving to discover in such remarks that Jarrell understood, at least at times, his own divided and contradictory nature.

But if the letters give numerous hints about this contradictory personality, they do not represent it fairly. For the world of the correspondence (or at least the world of the published letters, in Houghton Mifflin's 1985 edition) is, on the whole, a cheerful world of humor, affection, and warm sentiments. There is little sense, in the brief line "Anything happening to one's cat is the most painful subject in the world, so far as I'm concerned," of the deep depression into which he fell when his favorite cat was killed by a car. And there are almost no direct references to the mental illness that finally killed him, the irremediable melancholy that led, by accident or suicide, to his own traffic-inflicted death. The letters are untrue to the dark side of Jarrell. If they were all we had of him, we might believe of Jarrell what he believed of a fellow-poet: "it's plain he manages his life by pushing all the evil in it out into the poems and novels. All his theory says is that the world is nothing but evil, whereas the practice he lives by says exactly the opposite." But Jarrell's poems and prose contain a mixture of evil and its opposite (hope? love? belief?), and we therefore sense that the life must have held a mixture too, despite the one-sidedness of the letters. Clearly something has been kept back in this correspondence, and even the sleuthing critic will finally be forced to admit that the letters constitute a less substantial form of evidence than the poems and essays. It is fruitless to hope, as the boy does in "A Sick Child," that the postman will deliver what is most important to us.

This is not to say that biographical material is irrelevant. Some of the best insights into Jarrell's character—and, through that, into his poetry and prose—are offered by the anecdotes his friends and acquaintances tell about him. For instance, the duplicity, or doubleness, that I've remarked in his writing apparently extended even to his personal manner. John Berryman's first wife, Eileen Simpson, recalling her first meeting with Jarrell, comments in *Poets in Their Youth:*

> The surprise of *The Nation* evening was Randall's speech and his voice. The author of those killer reviews, which set the literary world buzzing whenever they appeared in the quarterlies, studded his conversation with italics and out-of-date expressions like "Gol-ly," "Gee whiz!" and (my favorite) "Ba-by *doll!*"—all delivered in a high-pitched twang. It was difficult to believe that this was the same man of whom John said second-class poets were so afraid they thought twice about rushing into print.

So the terrible wit was also the Southern hometown boy, and the "high-pitched" voice—like a pair of secret bloomers hidden beneath a soldier's uniform—gave the lie to the assertive masculinity of the "killer" reviewer.

Jarrell occasionally seems to have used his mask of ingenuous straightforwardness in order to get away with actions that would otherwise be considered inappropriate or even malicious. Robert Phelps describes the destructiveness of Jarrell's reviews as originating in a kind of purity or innocence: "He was not vindictive or cruel or willful. He simply saw what he saw . . . Sooner or later, most of us compromise, water down, lean over backwards, pull punches . . . Jarrell remained innocent of this tactic . . . he remained blessedly 'naive,' blessedly 'impeccable,' in everything he wrote." One can see how Jarrell enacted this useful personality in the reply he wrote to a letter from J. Donald Adams, then editor of the *New York Times Book Review.* Adams had written to the *American Scholar* objecting to Jarrell's characterization of him, in the essay "Poets, Critics, and Readers," as the enemy of modern poetry. In the next issue Jarrell wrote back:

> Over the years I've come to think of Mr. Adams as a conservative and somewhat unimaginative critic, one with little sympathy for difficult or novel works of art. In remarking that a poem can sound old-fashioned to one sort of reader and excessively modern to another, I used Mr. Adams (along with Mr. Hillyer) as an example of the second sort. If I

have misjudged a sympathetic reader of modern poetry, I am sincerely sorry.

That last line sounds so direct that it is difficult to take it as ironic or sarcastic. But can one honestly begin an apology by calling someone "a conservative and somewhat unimaginative critic"? Only from a position of extreme naivety—or extreme irony. Jarrell's letter is so perfectly balanced that one can't exactly pin down his position—until, that is, one reads this passage from *Pictures from an Institution:*

> Gertrude and Sidney had, instead of pictures, two reproductions from the Museum of Non-Objective Art, in frames or containers half of plastic, half of mirror. One was romantic, and showed a kidney being married to the issue of a sterile womb, and trailing clouds of mustard— or Lewisite, I am not sure; the other was classical, and showed two lines on a plain—or plane, perhaps.
> "Is that a Mondrian?" Constance asked politely.
> Gertrude looked as if she had asked whether it was a Landseer. It was plain that Mondrian's day was past.
> Sidney said, saving things: "No, but it *is* influenced by Mondrian, I think."
> I did not want them saved. I said, "How can anything be? If it's influenced by Mondrian it's a Mondrian."
> There was a silence. I looked around me.

In that admittedly contentious "I did not want them saved," and in the pretended innocence of the action in "I looked around me," Jarrell gives away his own technique. If this novel is "mainly a book of Randall's witty talk" (as Peter Taylor has said), then this passage in particular demonstrates how Jarrell was capable of assuming a mask of naivety to disguise a searing sense of mockery. And yet to call it a mask is not quite accurate either, for something of Jarrell's own face was in all of the other faces he assumed. He looked at children or at women and saw himself.

The California poet Edith Jenkins met Randall Jarrell only once, when he came to San Francisco to give a reading at The Poetry Center in 1956. (This was the year he moved to Washington, the year he wrote "The Woman at the Washington Zoo.") They were invited to dinner together, and she was seated opposite him. All throughout dinner he stared at her. This alone might not have been surprising: now in her seventies, Edith Jenkins is still a very handsome woman,

and in 1956 she must have been extremely striking, with her dark hair and black-brown eyes. But the intensity of Jarrell's gaze suggested something more than admiration. At the end of the meal she said to him, "Why have you been staring at me like that?" "I've been thinking," he said, "that if you had a beard, you'd look just like me." There's a shred of truth to this—they *did* look a little alike—but that's by no means the whole story. The living woman, the female poet, had become for him a projection of himself, a mirror of his own face.

Mary Jarrell, in her essay "A Group of Two," says that her husband was obsessed with mirrors, that he used to do dramatic routines while looking into a mirror. His poem "The Face"—which John Crowe Ransom considered one of Jarrell's best poems—is about a woman looking at herself in a mirror. The Marschallin, a character Jarrell borrowed from *Der Rosenkavalier,* speaks the dramatic monologue as she stares into the mirror at her aging face. "This isn't mine," she says. A very Jarrell sentiment: "I just looked at myself in the mirror and said sadly, 'It's not my California face,'" he wrote to Mary in 1952, having just returned from a visit to her in California. As it happens, the original Marschallin of the opera is very close to the age Jarrell was when he wrote the poem—about forty. Like him, she is imagining growing old, but is not yet old herself. By borrowing from an opera, the poem introduces the theme of admitted pretense (after all, what could be more obviously a false view of reality than an opera?); but, like opera, the dramatic monologue also asks to be taken at "face" value—asks that the audience abandon its sophistication and immerse itself in the feelings generated by the piece. With this metaphor, Jarrell warns us that his character is unreal and then requests our sympathy for her anyway.

"The Face" has one of Jarrell's unsayable final lines—I mean literally unspeakable, in that one can't say it aloud. "It is terrible to be alive": even Bette Davis at her best couldn't make it sound other than self-dramatizing or banal. This is where Dickey's criticisms strike home with a vengeance. If the Marschallin is a real woman rather than just a prop for Jarrell's ideas, one cannot imagine her saying this line; nor, under such circumstances, can one read it as anything other than commonplace sentimentality. Jarrell once said of Christina Stead that she, "like Chekhov, is fond of having a character tell you what life is," and we may suspect he is trying to achieve that Chekhovian quality here. But the problem is that the line itself makes it impossible

for the voice to remain completely that of a fictional character. What saves the line (if anything does) is Jarrell's inability to create a character who is separate from himself. Just as the boy in "A Sick Child" is at least partly Jarrell, the poet is identified with the Marschallin of "The Face."

If the speaker of the monologue is at some level the poem's author, then what does this do to "It is terrible to be alive"? One possibility is that the line becomes heavily ironic, as if an outside voice—life itself—were suddenly to intrude and mockingly describe the human condition. Jarrell is fond of this sort of joke: a similar one occurs in *Pictures from an Institution,* where he says, "Life at Benton was a routine affair—and if you had told life that, it would have replied indifferently, 'It's life, isn't it?'" But this interpretation of "The Face" seems untrue to the feeling left by that last line; it doesn't *feel* like a cosmic joke. Instead, it makes sense to think of Jarrell's own voice coming in at the end—not his voice as a narrator, but his voice as a particular man, a particular writer.

"Terrible" was an important word for Jarrell: he repeated it at least three times within the single essay on Christina Stead, where he used it as a serious form of emotional and moral description ("how terrible it must be to be Henny"). If one imagines Jarrell thinking that last line, it becomes possible to read it seriously. Spoken by the female character, it would seem sentimental; spoken by an impersonal, omniscient narrator, it would be a sardonic joke. But the sense that Jarrell himself, with his curious mixture of sophistication and empathy, could write that line and mean it perhaps makes it possible for us to accept it (especially if we remember that the poet's own death, when it came, was probably a suicide—a serious comment on how "terrible" he thought life was). Finally, the reason the line cannot be said aloud is because it works only if it conveys two opposite ideas: both sentimentality and mockery, both being inside the character and being outside her.

Sentimentality is not a charge that Jarrell would have rejected completely. There are worse things than getting carried away with feeling, he might well have said. He describes one side of Kipling—an author whom he greatly admired—as someone who would write

a story about a boy who is abandoned in a little room, grimy, with spiders in every corner, and after a while the spiders come a little nearer, and a little nearer, and one of them is Father Spider, and one of them

is Mother Spider, and the boy is their Baby Spider. To Kipling the world was a dark forest full of families . . . This is all very absurd, all very pathetic? Oh, yes, that's very likely; but, reader, down in the darkness where the wishes sleep, snuggled together like bats, you and I are Baby Spider too. If you think *this* is absurd you should read Tolstoy—all of Tolstoy.

Yet in his very manner of justifying Kipling, Jarrell demonstrates why it is so difficult for him to handle sentiment: he can only slip a short way into "feminine" sentimentality before "masculine" wit begins to take over. It is as if sentiment is a yawning abyss which threatens to engulf him, a deep hole of mindlessness from which he must protect himself. The "feminine" side of poetry that Jarrell longs for is also a form of oblivion that he fears. This terror of losing conscious control—of surrendering sophisticated wit for something far less accessible to the intellect—comes through in "In Nature There Is Neither Right nor Left nor Wrong," where the poet refers to

> those wide-awake, successful spirits, men—
> Who, lying each midnight with the sinister
> Beings, their dark companions, women,
> Suck childhood, beasthood, from a mother's breast.

Randall Jarrell's "sinister beings" are the women and children of his dramatic monologues, the "dark companions" through whom he explores a side of himself that is rarely made manifest in his prose. And if the poems are less uniformly pleasing than the essays, it is perhaps because this exploration is still in process, and the poet himself is unsure of what he hopes to find.

The image of the mirror that underlies "The Face" is a good metaphor for Jarrell's poetry, in which there are always two Jarrells, one trying out self-conscious effects on the other. The face in the mirror may be two-dimensional, but it can claim visible being; the face that looks in knows itself to exist only by the fact that it can see the other face there: "I am a thought of yours: and yet, you do not think . . ." Jarrell's moments of deepest cruelty to his poetic characters—the points at which he most clearly deprives them of their human individuality—are also the moments at which he most tellingly rips into himself. "One sees in your blurred eyes," he snarls at the Girl in a Library, "The 'uneasy half-soul' Kipling saw in dogs'." And then he immediately adds: "One sees it, in the glass, in one's own eyes."

Beaton's Ladies

8 Cecil Beaton was an artist who took the artificiality of photography and, by exaggerating it, made it into a medium for telling the truth. He directly addressed the problem that Janet Malcolm points out in her book *Diana & Nikon:* "One of the chief paradoxes of photography is that though it seems to be uniquely empowered to function as a medium of realism, it does so only rarely and under special circumstances. If 'the camera cannot lie,' neither is it inclined to tell the truth, since it can reflect only the usually ambiguous, and sometimes outright deceitful, surface of reality." The superficial nature of photography was itself the subject of Beaton's photographs, which in turn became the means of delving behind and beyond the superficial. Beaton focused his efforts in those areas, particularly fashion photography and portraits of celebrities, which would seem the least susceptible to truth-telling; and he used forms of artifice—in particular, mirrors—which insured that his photographed world would not visually resemble our daily world. Despite this, his pictures comment trenchantly and enduringly on the reality to which they bear such an oblique relation.

Among other things, they comment on what it means for a woman to be the subject of a gaze, either her own or another's. Yet they do not pursue this line of inquiry by harping on a masculine sense of vision, an aggressively male gaze. In Beaton's photographs, the viewer—who could be Beaton or you or me, a man or a woman, a photographer or someone looking at photographs—looks into a rectangular viewfinder or a rectangular photograph, which resembles (and in many cases actually uses) a mirror, and gets back the image of a woman. Beaton's identification with the feminine—evident, for instance, in his fascination with fashionable women, mirrored female faces, and twinned pairs of male-female siblings—is not a narrowing-

down or exchanging of his masculine self for a feminine one; it is, rather, a broadening of the whole notion of "the feminine." For Beaton, woman rather than man is the representative figure.

Biographical reasons for this lie close to the surface. In "Beaton's Beauties: Self-Representation, Authority and British Culture" (an insightful essay, despite its unwieldy title), David Mellor begins an analysis of Beaton's identification with female subjects by quoting his autobiographical explanation for his chosen career. "When I was three years old," Beaton wrote in his *Photobiography,* "I used to be allowed to scramble in my mother's large bed and nestle close to her while she sipped an early morning cup of tea and opened her letters. One morning during this customary treat, my eyes fell on a postcard lying in front of me on the pink silk eiderdown and the beauty of it caused my heart to leap. The photograph was of Miss Lily Elsie . . ." The anecdote so perfectly encapsulates Beaton's obsessions—photography as stemming from the mother and the actress, woman as source of emotional sustenance and woman as pure artifice—that he couldn't have done better if he'd made it up. And perhaps he did. For elsewhere he gives us a different explanatory story. In the opening paragraph of the text to *The Best of Beaton,* under the chapter title "First Stages," he begins: "Although my father took photographs by squeezing a rubber ball attached to the end of an umbilical cord affixed to a largish camera of indefinite make, it was Alice Collard, my sisters' nurse, with her No. 2 Box Brownie, who first brought any great enthusiasm for photography into the family." In one of his very few appearances in all of Beaton's work, written or photographed, Beaton's father enters—only to disappear instantly, first by being transformed into a mother (complete with "umbilical cord") and then by being replaced, as that class of mother often was, by the family nurse. The story is different enough from the one in *Photobiography,* but it retains two important elements: the familial origins of Beaton's career, and the fact that the photographic muse was a woman.

Most of Beaton's earliest photographs were of his sisters, Baba and Nancy Beaton. Partly, of course, this was a matter of convenience: they were available, and were perhaps the only people young enough and devoted enough to pose for hours while this pipsqueak photographer rearranged lights and scenery. But the obsession with sisters—either twinned with each other or with their male siblings—persisted far into later life, when Beaton was famous enough to get any models

he chose. He did Zita and Theresa Jungman lying crown to crown, Angela and Daphne du Maurier in nearly identical haircuts (in both cases for a story on debutantes in *The Tatler,* headlined "Sisters—Two Pairs"). He did numerous studies of Edith Sitwell, both with and without her brothers, with whom she shared a familial face (as Beaton's photographs demonstrated) and a degree of cultural fame (as the photos implied). And later, in 1930, he did some wonderful photos of Fred and Adele Astaire which suggested the extent to which the sibling pair, who could dance "as one," represented a single split identity, two sides of one performing self.

In the most pointed of these photos, multiple portraits of both Astaires float in a nearly circular pattern around a central face (Fred's) that looks directly out at the viewer. Each sibling is only a "part" of a whole person, a head severed at the neck. (It is typically perverse of Beaton to photograph only the heads of a couple known mainly for their feet.) Their faces stand out against a black background—Adele paler, Fred darker and moodier-looking. There are six Freds and only four Adeles, and Fred gets the central position, the point of greatest visual focus; but in each case where an Adele head overlaps slightly with a Fred face, it is she who blocks out that small portion of him. The female half of the pair, in other words, has a strong if largely hidden power.

Beaton made several other photos of Adele alone, the most complex and interesting of which shows her leaning against the corner of an entirely mirror-walled room while Beaton, standing next to a tripod, photographs her. Because of the mirrors, the photo is filled with infinitely regressive Adeles and Beatons, some looking out toward us, others facing away. I assumed, on first looking at the photo, that the central Adele, who looks directly out at us, was "real," while the Beaton next to her, who also seems to look at the spectator, was a reflection of the "real" Beaton photographing her from approximately our place. But then I noticed that both Beaton's and Adele's feet (those elusive Astaire feet) occupied the same patch of floor in the photo, with no intervening mirror edge to separate them; so the central Adele and Beaton figures had to belong to the same order of reality, either "real" or mirrored. (I have put "real" in quotation marks because, of course, the photograph is itself a mirroring of reality, at least one step away from any kind of direct visual access.) A closer examination of the photo reveals mirror seams across the bodies of

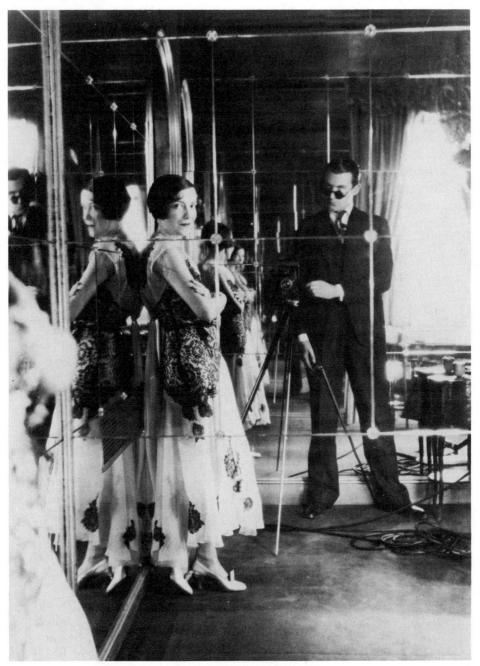

Adele Astaire and Cecil Beaton

both Adele and Beaton, as well as a blurred segment of an unseamed Adele in the lower-left corner of the photograph. The necessary conclusion is that both Adele and her photographer are reflected images, even in their most direct and central form, while the other reflections are all mirrorings of mirrorings. Beaton indeed stands where we do (as the camera must), but the "real" Adele stands too close to be captured directly on film.

The photograph implies not only an interchangeability between Adele and Beaton (both belonging to the same order of unreality, sharing foot-space in the mirror), but also, by extension, an interchangeability between Beaton and Adele's partner/brother. Stuart Morgan, in an essay called "Open Secrets: Identity, Persona, and Cecil Beaton," points out that Beaton, after seeing Fred Astaire, wrote, "I'd like to change my whole self." How odd for a photographer, especially one whose photographs emphasize pose and artificial stillness, to envy a dancer of such fluid grace. And yet not odd, for part of what he saw in Astaire was what he already possessed, on a more limited level: an alter-ego relationship with a female sibling. The Baba and Nancy photographs show this most clearly, but in some way all of Beaton's photographs of women have in them an element of David Copperfield's attitude toward Betsey Trotwood Copperfield: a sense of the girl he might have been if he hadn't been born a boy.

Perhaps the wish he was expressing was not just to exchange selves with Fred, but to give up his own "whole self" for a more obviously divided one, that of Fred and Adele together. Beaton must have associated dance with the literal figure of the androgyne, the male and female merged into one, for his portrait of Martha Graham shows her primly seated in her studio, her legs peeking demurely from under the knee-length hem of her dress, while two additional male legs protrude from either side of her waist. She faces the camera regally and quietly, as if unaware of the male figure lying behind and around her—as if unaware that she has, as it were, turned into a two-sexed, four-legged creature from the waist down.

She is, however, emphatically aware of the presence of the camera. Beaton shares with Degas an interest in women as visual subjects, but in crucial ways his interest is exactly the opposite of Degas's: where Degas's pastels are focused on the issue of women's privacy, Beaton's photographs deal unremittingly with the female awareness of being looked at. At all times there is an implied viewer standing in the

position of the photographer. Sometimes there is an additional implied
viewer in the form of the woman herself, looking into a mirror. If one
were tempted to give a Pre-Raphaelite title to these Beaton photos,
one might label them "The Vanity of Women" or "The Female Nar-
cissus." But such titles would be entirely inappropriate. For in each
case it turns out that the woman is actually looking at something other
than herself. The narcissism is implied and then withheld, suggested
but never carried through, as if to catch out the viewer in his (or her)
own presumptions about female vanity.

Two of Beaton's mirrored photos of his sisters—a 1924 picture of
Baba looking down onto a highly reflective table top, and a 1929 one
of Nancy looking into an ornately framed wall picture—demonstrate
this deflected or evaded narcissism. In both, the actual woman appears
to gaze intently at her own reflection. Baba's head, above naked

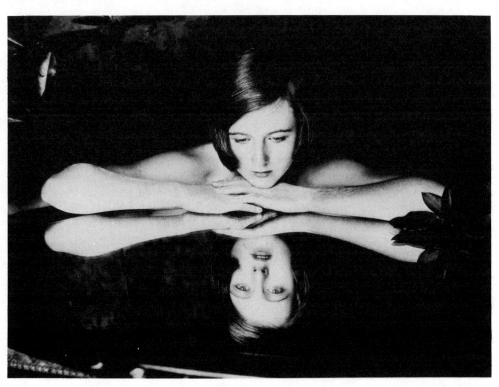

Baba Beaton

shoulders, rests on her crossed hands as her forearms stretch out to either side of her on the shiny table; her eyes are cast down, her expression one of quiet focus. Nancy's face, in its non-reflected form, is invisible to us: only the chin peaks out from a fluffy, schoolgirlish bob. Yet the reflected faces tell quite a different story. In each case, we see more of the woman's face in her reflection than we do in "actuality," and both reflections look directly out at us. That is, the woman is *not* looking at herself, but at the reflection of the photographer, who translates after the fact into the viewer. Moreover, the reflected faces convey an entirely different sense of each woman than do the photographed originals. In Nancy's case, the mirror presents us with a pensively sultry sophisticate rather than a fluff-headed ingenue, while Baba's face in the table top—open-eyed, open-lipped, and upside-down—is both more sensual and less "focused" (in both senses, photographic and psychological) than the primly attentive gazer in person. In each case, the woman seems to open out in the reflection; what was hidden and closed off in "reality" becomes revealed in the mirror.

Edward Snow, in his graceful and attentive essay about Velasquez's *Rokeby Venus,* has this to say about the way the mirrored face works in that painting:

> It is almost as if the woman herself, in all her precisely delineated reality, exists only to mediate between us and that vague evocation in the mirror: as if representing her were a matter of creating a stable space across which two vague threshold creatures—ourselves, suspended before the painting, and the image, floating behind the mirror—might come face to face across some benign fantasy of embodiment. At the same time the mirror image mediates between ourselves and the reclining woman— not simply because it relays her gaze to us, but also because it "reads" as an otherness reflecting either her *or* us.

Something quite similar applies to these two Beaton photographs of his sisters—especially the nude one of Baba, which is both softer and more sensual. The photograph converts us into both the female whose face is reflected out toward ours and the male observer who is generating that alluring, gaze-returning glance from the woman.

Yet because this is a photograph rather than a painting, the meaning of the gaze is slightly different from what Snow discerns in the Velasquez. The *Rokeby Venus,* much like Degas's pastels, is a painting of

a woman alone at her toilette (accompanied only by a little cupid, her equivalent of Degas's maids), so that the direct glance does not translate into a realistic intention. As Snow says, "The face in the painting's mirror has a disconcerting tendency to gaze—without the knowledge of the woman from whom it apparently derives—directly into the eyes of the viewer, with knowing intimacy." The central clause of that sentence doesn't apply to Beaton's photos of his sisters, for these women *do* know there's a viewer. What is disconcerting about Baba's or Nancy's direct gaze, therefore, is not its lack of intention, but the way it shifts the responsibility for narcissistic behavior away from the woman herself and onto the photographer-merged-with-viewer. In answer to Baudelaire's accusation about the evils introduced by Daguerre's invention of photography—"From that moment our squalid society rushed, Narcissus to a man, to gaze at its trivial image on a scrap of metal"—Beaton proposes Oscar Wilde's epigrammatic answer: "It is the spectator, and not life, that art really mirrors." The narcissistic figure is not the photographed creature who appears to look into the mirror, but the spectator (the photographer, the viewer) who searches in that mirror for his or her own image. Only in Beaton's own mirrored self-portraits (one of which, complete with dressing table and flowers, seems an exact parallel to his domestic photos of the women in his family) is the narcissism made entirely circular; for only there do we find that the mirror-gazing photographer and the mirrored subject are the same person.

One of the things Beaton discovered—or at least raised to an art form—is the connection between the photograph and the epigram. There is an inherent link between the two, as Susan Sontag implicitly acknowledges when she ends her book *On Photography* with a series of pithy, mutually enriching, occasionally witty quotations drawn from a range of other writers. A series of photographs, like a series of remarks, asks you to pause a moment over a thin slice of a larger reality. It asks you to make more of the surface than we normally do, and it requires you to draw the hinted-at connections for yourself. Sontag's use of quotations suggests the connection between the photograph and the aphorism (defined in Webster's as "a short, concise statement of principle; a maxim; an adage"), but leaves open the question of how a photograph might resemble an epigram ("any terse, witty, pointed statement, often antithetical").

Few photographs are as self-consciously epigrammatic as Beaton's.

His pictures ostentatiously engage in playful contradictions and superficial paradoxes, at the same time as they make compelling statements about their own form, and about the process of making and looking at them. Turning back on themselves, they turn us back on ourselves as well: the mirrors in these pictures work both ways. Yet in the end we carry away very little. It is hard to mine much ore from Beaton's silver nitrate; it is hard to mine *anything* from artworks that are so resolutely superficial. "When we try to examine the mirror in itself we discover in the end nothing but things upon it. If we want to grasp the things we finally get hold of nothing but the mirror.— This, in the most general terms, is the history of knowledge." Nietzsche's epigram, from *Daybreak,* points toward why Beaton's work, though brilliant and memorable, resists any attempt to convert it to obvious, knowledge-giving uses.

But is that in itself a flaw? "All art is quite useless," said Wilde, Beaton's own master in the art of the epigram. Beaton's published diaries confess to the imitation: "'Oh, you know, it's only serious people who can afford to be really frivolous,' I said in a desperate attempt to be Wildean." But that was the least part of his debt. In 1945, Beaton got his first big break as a stage designer doing the decor for John Gielgud's production of Wilde's *Lady Windermere's Fan.* And in 1946 he made his first appearance on a professional stage in the American production of *Lady Windermere,* playing (as he termed it) "the small but effective role of Cecil Graham." How perfect for the real-life Cecil that his own name should be mirrored in the character he played, for that is the kind of transgression of art on life—or life on art—in which he delighted. In this, as in much else, he resembled the great Oscar.

There are, to begin with, numerous biographical mirrorings: Wilde's and Beaton's parallel possession of strong, beloved mothers; their high-profile years at Oxbridge; their decades spent in the lap of a largely female, decoratively idle high society; their passion for the stage, and their corresponding allegiance to artifice in any form; their mutual interest in home decoration and fashion; their homosexuality, either interrupted or preceded by a single important liaison with a woman; their trips to, and fame in, America; and so on. Beaton, making use of all the coincidental resemblances that nature had bestowed, did his best to duplicate Wilde's career—barring, of course, that last tragic act of it. Yet his flattering imitation did not consist of

slavish mimickry, not of an *exact* mirroring, but rather of a reflection in tone achieved within two new media, visual rather than literary: photography (which had barely existed in Wilde's time) and film design (which hadn't at all) in place of the poem, the story, the play, and the epigram.

It was Wilde himself who pointed out that visual art could take on the quality of polished writing. About Whistler, his sometime friend and longtime antagonist, he wrote generously: "He has done etchings with the brilliancy of epigrams, and pastels with the charm of para-doxes, and many of his portraits are pure works of fiction." Whistler accomplished this (and here we tense ourselves for the expected but nonetheless pleasing Wilde paradox) through "his absolute separation of painting from literature." Unlike his contemporaries, the Pre-Raphaelite painters, he resisted using visual art to tell stories, to illustrate; instead he used it to render moments of perception and feeling. Whistler's paintings were, for the most part, figurative rather than abstract, but they took figuration a long way toward abstrac-tion—toward the condition of music, of pure form, that both Pater and Wilde set up as the goal of all the arts.

Beaton's photographs do something similar. If they are epigram-matic, it is not by virtue of their connection to language. One doesn't look at them and say, *Ah, yes, this is a story about an innocent girl who gets lost in a city,* or *Here is a man who had a sad past from which he is only now emerging,* or *These two people clearly loved each other, but could never bring themselves to say so,* or anything of that sort. Beaton's pictures are not about character at all; they are about surface. But, as Oscar Wilde said, "It is only the superficial qualities that last. Man's deeper nature is soon found out."

"Man's deeper nature," "Narcissus to a man": Wilde's and Baude-laire's phrases beg an important question, for in the realm of photog-raphy the creature who most often looks into a mirror is a woman. This is particularly true of fashion photography, a field that Beaton seminally helped to shape. In taking an interest in fashion, Beaton was again following Wilde's lead. ("One should either be a work of art, or wear a work of art," quipped Oscar, along with: "A really well-made buttonhole is the only link between Art and Nature.") Yet, like Wilde, Beaton continually raised doubts about the very elements of high fashion that interested him: its artifice, its improbability. Wilde may have said, "The first duty in life is to be as artificial as possible,"

but he was also capable of asserting, "It is the secret of much of the artificiality of modern art, this constant posing of pretty people, and when art becomes artificial it becomes monotonous." Beaton took both of these contradictory dicta to heart, and by exaggerating the artificiality of fashion photography—by breaking out of its conventional artifice, and pushing that artifice to more bizarre and noticeable heights—he sought to break out of fashion's monotony as well.

Naturally the mirror is a key prop in Beaton's fashion photos, and nowhere more so than when he is photographing hats. Two of his best mirror-and-hat combinations were done in the 1930s: the 1930 photo of "Marianne Van Rensselaer in a Charles James hat," and the 1939 "New York model Helen Bennett wearing a John Fredericks hat." (These are Beaton's captions from his own selected collection, *The Best of Beaton*.) The former shows a member of New York's Dutch-surnamed upper class—an escapee from an Edith Wharton novel, as it were—standing with her back to a corner where two mirrors meet. The pose is almost nun-like in its enclosure and restraint. Her heavy-lidded eyes are downcast and averted, her arms cross over her waist to cradle her elbows in her hands, and the whole atmosphere is one of pensive solitude. The hat, like her dress, is dark and simply cut: it too has a somewhat medieval, wimple-ish quality. The point of bringing a mirror and a hat together is generally for the wearer to inspect the hat; this is especially so when one has access to a double-flap mirror that allows one to see the back as well as the front. But this woman is not looking in the mirror at all. The only function of the mirror is to duplicate her presence for us, to give us three versions of her instead of one. As in the Baba and Nancy pictures, each version of the woman is slightly different. (This is partly because of the hat's design, which droops over her profile on one side, and lifts on the other.) Yet, in contrast to the mirrored reflections of Beaton's sisters, these mirrored images tell us even less about the woman than the original does: their faces are even more averted, their features less visible. This picture, which is supposed to be about a hat, ends up being instead about the obscure and impenetrable self-containment of an aristocrat. And this too is a statement about style. As Wilde points out, "Only the great masters of style ever succeed in being obscure."

The other hat photo, though it contains similar elements, has just the opposite feel. Here, too, we have a woman who is apparently seated with her back to mirrors, yielding multiple images of herself.

She too wears a dark suit and a dark hat. But unlike the brunette aristocrat, this brassily blonde "New York model" stares directly into our eyes. Her glance is simultaneously sultry and self-mocking (*I'm just a brainless clothes-horse,* it appears to say), and her robotic expression is repeated identically on all four "mirrored" versions—including, it seems, the two we see only from the back. The hat itself is pert and jaunty: it takes off from one side of her head rather than enclosing it, as the aristocrat's does. Most tellingly, the blonde model grasps in her fingers an elaborately framed hand-mirror. She is not looking into it; she is looking at us instead. Like the Baba and Nancy photographs, this picture raises the issue of narcissism only to deflect it onto the spectator. But the replacement of reflected gaze with direct glance has the opposite of the expected effect: the woman seems less revealed than Beaton's sisters, rather than more so. The unmediated gaze is both brazen and impersonal, and the multiplication of images is excessive. Instead of conveying the secret inner life of the woman, the four duplications—like the "original"—suggest the monotonous uniformity of the conventionally fashionable. And indeed it turns out, on closer examination, that there is no original, for the photo shows no mirror edges or deflected angles, and was undoubtedly created through multiple exposures taken from different angles. Thus each version of the woman is neither more nor less real than its four counterparts. She's a mass-produced object, a work of art in the age of mechanical reproduction.

The closed and highly artificial circle of the world of fashion is pointedly remarked on in Beaton's 1956 photograph of Coco Chanel. Chanel (dressed, of course, in one of her own accessorized suits) is climbing a circular staircase flanked by a pleated, many-paneled mirror that resembles—though on a much wider scale—the folded texture of a Fortuny dress. We look down on Chanel from above, and she stares up at us, her unsmiling face large in proportion to her foreshortened body. Yet it is not a cruel photograph (as it would be, for instance, if Richard Avedon or Diane Arbus had done it), for Chanel looks spunky and endearingly mortal in a universe that significantly lacks any other element of the human. For all the mirrors, there are no reflected human figures, neither that of the photographer nor—more suprisingly—that of Chanel herself. All we see in the mirrors is a dizzying series of fragmented stairs and bannisters. The fashion "system" that surrounds Chanel apparently exists for its own sake, with no regard for the

fashionable women it ostensibly serves: its reflections are unreflecting, its images contentless. Even this woman who helped create the system looks helplessly out of place against its surfaces of shining artifice.

While the Chanel portrait features innumerable mirrors without any reflections, other Beaton fashion photographs create multiple images without the use of mirrors. Sometimes this is done through multiple exposures, as in the "New York model" hat picture. At other times Beaton dresses several women identically, as in his balloon-, cellophane-, and flapper-filled photo of Baba Beaton, Ward Baillie-Hamilton, and Lady Bridget Poulett, or his picture of Marian Moorehouse and Lee Miller standing together in a doorway of Condé Nast's

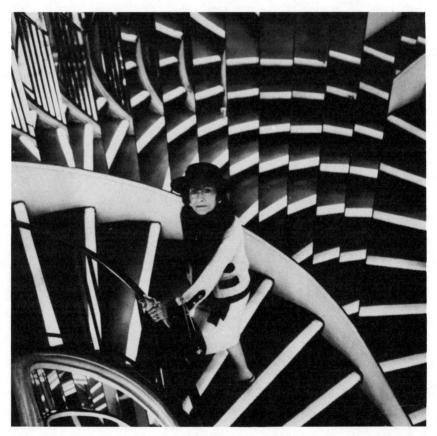

Coco Chanel

apartment. In the latter cases, makeup, hairstyle, and clothing have been used to make different women look identical. This technique creates an entirely different impression from Beaton's multiple images of performers and actresses like Adele Astaire, Tallulah Bankhead, Marion Davies, and Beatrice Lillie. In the performer pictures, where three to five extremely different poses of the same woman are floated against a dark background, Beaton stresses the diverse natures inherent in a single being. In contrast, the aristocrat-filled photos of different women dressed identically make the opposite point: that these high-society ladies, unlike their more talented actress-and-dancer sisters, have less than one personality to share among themselves.

Despite his royalist leanings and his manifest worship of the upper class, Beaton could be a bitingly sharp social critic in the manner of Wilde's "The Soul of Man under Socialism." Nowhere is this more evident than in the Ascot scenes he did for *My Fair Lady*. The musical comedy based on Shaw's *Pygmalion* was in any case a perfect vehicle for Beaton: as a male photographer who repeatedly transformed hired models into expensively dressed ladies, he was well equipped to understand the myth of Pygmalion and Galatea. According to Philippe Garner (whose essay "An Instinct for Style" focuses on Beaton's fashion photography), "Irving Penn acknowledged Beaton's skill in creating with such apparent facility the images of beauty which he pursued. 'He could take a store girl from Texas or New York and transform her.'" *My Fair Lady* was itself the opportunity for Beaton to explore this transformation, and largely through his costumes and designs he managed to change the movie from a story about auditory transformation (Henry Higgins's conversion of Eliza Doolittle's accent) to a story about visual transformation (the emergence of the beautifully dressed princess from the Covent Garden ragamuffin). He did this despite the fact that it was a musical (which would seem to favor the auditory over the visual), and despite the fact that he was up against the highly verbal directorial genius of George Cukor and the elegant delivery of Rex Harrison. Or perhaps these two men, both proven gallants toward the fair sex, abetted him in his theft. In any case, Beaton and his designs stole the show, converting *My Fair Lady*—and in particular the Ascot sequences—into a commentary of sorts on Beaton's ideas about photography, fashion, and society.

In the plot of the movie, Ascot is to be the first testing ground for Higgins's experiment, the moment when he first dresses Eliza as a

lady and tries out her new accent on an unprepared but acutely judgmental audience (his mother's classy friends). The Ascot sequence begins with a series of still-photograph-like poses of elegantly dressed ladies and gentlemen (one of whom, in a Hitchcockian signature, is Cecil Beaton himself). These perfectly clad mannequins then break into the only kind of song of which they seem capable—quiet to the point of lifelessness, machinelike in its uniformity and stiffness of gesture, utterly rigid and restrained. This is Beaton and Cukor's harshly satiric portrait of the upper class. (Compare its characteristics, for instance, with the color, movement, and unexpectedness that prevail in the lower-class Covent Garden sequence featuring Eliza's drunken, "do-little" father.) The colors Beaton selected for Ascot—black, white, and grey—stress both the origins of the scene in still photography and the "colorlessness" of that class of person. All the men are identically dressed in grey (except Higgins himself, who willfully—or perhaps only carelessly—mars the uniform picture with his individualistic and informal brown suit). All the women (again with one exception) are dressed in black and white, including the newly promoted Eliza.

Yet the women, unlike the men, have an individuality of sorts: their dress fashions vary slightly and their hats vary enormously. "Enormous" is the operative word here. Each hat is at least twice the size of the woman's head, and Eliza's—the largest, the grandest, the most ridiculous hat of all—seems larger than Audrey Hepburn's whole upper body. To the extent that the women are individuals, they *are* their hats. Nietzsche, in the ever-pertinent *Daybreak,* has an apposite remark:

> We are too prone to forget that in the eyes of people who are seeing us for the first time we are something quite different from what we consider ourselves to be: usually we are nothing more than a single individual trait which leaps to the eye and determines the whole impression we make. Thus the gentlest and most reasonable of men can, if he wears a large moustache, sit as it were in its shade and feel safe there—he will usually be seen as no more than the *appurtenance* of a large moustache.

In the Ascot sequence, Beaton has converted this telling perception into a visual remark. The women are mere appurtenances of their hats, and Eliza—scheduled to be judged "in the eyes of people who are

seeing [her] for the first time"—gets the largest possible hat so that she can "sit as it were in its shade and feel safe there."

But Eliza gives away the show when she starts to tell a story (a story, as it happens, about a hat). The accent is pure Kensington, but the story itself is Cockney to the core, and although the idiotic Freddy finds her slang charming, everybody else is rather taken aback. The point to this scene is that neither appearance *nor* voice is sufficient. The former is adequate for photographs alone, and the two together are enough for "moving pictures," where one's lines are given to one. But to fool people successfully in the world outside of pictures, you need a bit more coaching—which is what Henry Higgins proceeds to give Eliza. The film doesn't make a firm distinction between "masked" illusion and "honest" reality; it simply gauges the depth and strength of the mask that is necessary to carry off the appearance of honest self-representation.

The one woman who violates the Ascot dress code (though much more subtly than Henry Higgins violates the men's code) is Henry's mother. Instead of black and white, she wears a grey satin-and-lace outfit in which the grey is so warm as to be almost lilac. Instead of overpowering her head, her hat is relatively small and restrained. In other words, she is more like a man. ("Why can't a woman be more like a man?" Henry complains in one of his songs.) She is both the obvious source of Henry's originality (they both dress unconventionally) and an effective counter to his antisocial, antihuman tendencies. In the end, Eliza turns to Mrs. Higgins for refuge and advice; and it is in his mother's light-filled, white-painted, outdoorsy house (so different from his own dark, upholstered, wood-paneled, carpeted splendor) that Higgins begins to acknowledge his love for Eliza, at which point the balance of power shifts in her direction. Like Cary Grant in *North by Northwest,* Higgins boyishly turns to his mother for help; and she, in the most helpful fashion, refuses to lift a finger for him, and instead leaves everything to Eliza. (When the scene is over, we get the strong feeling that the mother and the girl—the two contrasting love objects—have plotted the whole thing together.)

In announcing her plans to marry Freddy Eynsford-Hill, Eliza succeeds in making Higgins jealous. Shaw, with his radical willingness to see his convictions through, left matters there. "Eliza, in telling Higgins she would not marry him if he asked her," he says in the afterword to *Pygmalion,* "was not coquetting: she was announcing a well-con-

sidered decision." The creators of the stage musical *My Fair Lady,* from which the film is closely derived, give us instead a "happy" ending, where Eliza returns to Higgins. (Neither ending quite works, perhaps for the reasons discerned by Oscar Wilde: "The nineteenth century dislike of Realism is the rage of Caliban seeing his own face in a glass. The nineteenth century dislike of Romanticism is the rage of Caliban not seeing his own face in a glass." Even in the present century, we are never satisfied with what the mirror shows us.) But for Beaton the movie ends where Shaw ended it. Everything after the scene in the mother's house—Higgins singing "I've Grown Accustomed to Her Face," Higgins listening to his recording of Eliza's voice, Eliza returning and mimicking her Cockney self—is part of an auditory conclusion. The visual conclusion took place in the mother's enlightened and enlightening rooms.

There are good psychological reasons behind Beaton's choices and sympathies—"good" in both Beaton's terms and Shaw's. The après-play explanation that Shaw gives us of Higgins's character reads like an exaggerated portrait of Beaton's own self-presentation:

> When Higgins excused his indifference to young women on the ground that they had an irresistible rival in his mother, he gave the clue to his inveterate old-bachelordom. The case is uncommon only to the extent that remarkable mothers are uncommon. If an imaginative boy has a sufficiently rich mother who has intelligence, personal grace, dignity of character without harshness, and a cultivated sense of the best art of her time to enable her to make her house beautiful, she sets a standard for him against which very few women can struggle, besides effecting for him a disengagement of his affections, his sense of beauty, and his idealism from his specifically sexual impulses.

Shaw, whose own mother treated him coldly, and whose "sexual impulses" found outlet in a series of probably platonic but definitely heterosexual affairs with actresses, undoubtedly had his tongue lodged well in his cheek when he outlined this method for creating an unmarriageable son. But for Beaton the description would have had a strong overtone of truth. He lived with his mother whenever he was in England, and relied heavily on her taste when it came to selecting a new house: "On the second visit to Reddish House I was elated—and my mother too. Her heart went out to the house of warm lilac-colored brick . . . My mother saw the possibilities of making the terrace, with its southern aspect and old-fashioned roses growing over

a balustrade, into a sheltered spot for outdoor lunch or tea." Though written seven years before the filming of *My Fair Lady,* this diary notation contains two of the central elements—the pastel color (lilac) and the exposure to the outdoors—that Beaton was to incorporate into the design of Henry Higgins's mother's house. Warm but delicate colors (apricot, lilac, peach, pink) were for Beaton the expression of the feminine, which in turn owed a great deal to the maternal. "Colour was for him a proof of artifice," David Mellor remarks perceptively, "and the difference (and identity) between woman and photograph: all those things that he described as having been first imprinted on his memory by his glimpse of the pink tinting on Lily Elsie's postcard. Colour was bound to infancy, to childhood and to adolescence and its world, elements that were all reconstituted in his plays and photographs." For Shaw's Higgins, the mother functioned as a blockade, keeping other women out; for Beaton, she represented the channel whereby the feminine in general could enter his work.

Only once did Beaton threaten to give up his "inveterate old-bachelordom," and in that instance he was very careful to pick a woman he couldn't have. Greta Garbo, who dallied with Beaton's affections for years, was not only an unattainable movie star; she was also involved with someone else (a "little man" who in turn was unavailable—for Garbo took no chances of getting permanently snared). And even in this case Beaton's situation was more that of twin than lover. According to his diary, when he actually asked Garbo to marry him, she objected: "But we would never be able to get along together and, besides, you wouldn't like to see me in the morning in an old man's pajamas," to which he responded, "I would be wearing an old man's pajamas, too." Or, if not twins, they were Cupid and Psyche, with Beaton taking the Psyche role, for it was Garbo who didn't wish to be seen "in the morning." Understanding on some level the myth he was supposed to be playing out, Beaton eventually took some photographs of the reclusive Garbo and published them in *Vogue*—at which point she, Cupid-like, disappeared from his life (or at any rate remained incommunicado for over a year). Shortly after the severing incident, Beaton's mother came to visit him in New York (where he had loved and lost Garbo), and mother and son then returned together to England, destined soon to settle into Reddish House. To go back to England was essentially, for Beaton, to go back to his mother.

But if, as Mellor stresses, Beaton saw the maternal/feminine as

identical with sources and origins (of photography, of color, of warmth, of life), he also saw the connection between mothers and death—the same connection that Dickens harped on in *David Copperfield,* and that D. H. Lawrence and Harold Brodkey picked up in their work. In two photographs brilliantly paired by Mellor, Beaton draws together Dickens, mothers, the prospect of aging, and the inevitability of death. One of these photos was taken during the 1946 filming of *Great Expectations,* when Beaton was the still photographer on David Lean's set: it shows the actress who played Miss Havisham seated before her cobweb-draped mirror. Twenty-one years earlier, Beaton had taken a startlingly similar photograph of his own mother seated at *her* dressing table. In both photos the women's faces are visible only in the mirror, and those reflected faces are the only signs of the women's advancing age; from the back they look young (and, in Miss Havisham's case, bride-like). Mrs. Beaton's reflection, in particular, looks both ghostly and angelic. Surrounded by a halo of light, her face is dimly featured and vague, as if she is already in transition to the final stage in the aging process, the stage of nonexistence that comes after death.

The mother as mirror: for D. W. Winnicott, the phrase referred to infancy, to the stage when the mother was the only reflection of one's identity, the responsive substitute for the outside world. But for Beaton the phrase is also a kind of *memento mori,* a reminder that one's mother's fate (aging visibly, and then dying) will eventually be one's own fate. This comes across most clearly in his portrait of Marianne Moore and her mother. The two women are side by side, and they look remarkably alike: their noses and mouths are almost identical, both wear their hair up, and both are in dark clothes set off by white blouses. (This is partly a trick of Beaton's photographic technique. In another picture taken the same day, with Marianne Moore looking thoughtful in the center foreground and Mrs. Moore vaguely visible in a corner of the frame, it is clear that the younger woman's skirt and jacket were actually much lighter and more variously textured than her mother's clothes; but for the side-by-side photo Beaton has intentionally made the poet's outfit look dark and drab.) It is a photograph that, as David Kalstone says, "makes them appear to be ravaged contemporaries, Marianne looking, if anything, older than her mother, more like a stricken sister than a daughter." They are twins—Siamese twins, almost, for their heads are too close together for normal seating, and the hand across Marianne Moore's lap could belong to either

woman. Because of their dark clothing we can't really see their bodies: Mrs. Moore, in particular, seems to be a disembodied head floating next to her daughter's face, like a reflection in a frameless mirror. Yet this face is softer, vaguer than the one it "reflects," and the eyes are much less focused: they lack Marianne Moore's intense visual interest in the world, and seem instead to be looking at something more ethereal, less tangible. The face that mirrors Marianne Moore's in this photo is not her reflection as she is now, but as she will one day be.

When Picasso painted Gertrude Stein's portrait, she reportedly said to him, "I don't look like that," and he replied, "But you will." Beaton's photograph of Stein appears to allude to this exchange, as well as to all the other occasions of mirroring and self-creation that appear in Beaton's work. Where Marianne Moore was accompanied by a disembodied version of her mother, Gertrude Stein is presented next to a reduced version of herself. The extra Gertrude figure substitutes for a mother (Stein was, or at least claimed to be, very much a self-created artist), but also, more specifically, for Stein's constant companion, Alice B. Toklas (who is Stein's creation in the autobiographies, as Stein, in those books, is hers). All the other photographs Beaton took that day include Alice B. Toklas as the secondary, smaller (because more distant) figure; only in this one is Gertrude presented as her own subsidiary twin. The larger Gertrude wears a coat and hat, while the smaller one is clothed in the embroidered vest and skirt Gertrude was wearing under her coat that day—as if to imply that the second image stands in not only for Alice but for Gertrude's "inner" self. "Gertrude Stein, for once without Alice B. Toklas, a monolith of strength, purity and honesty, transcends time and fashion," is how Beaton describes this photo. But "monolith" is an odd word to use for someone who appears twice, and the other words in the description seem similarly suspect. Precisely by "transcending" time—by appearing to be the same age as, or even younger than, her miniaturized portrait—Stein here reminds us of mortality and the passage of time (just as Wilde's Dorian Gray does, in conjunction with *his* portrait). If Gertrude Stein is presented in this photo as her own mother/mirror, she is also presented as an element in her own obituary notice. "To take a photograph is to participate in another person's (or thing's) mortality, vulnerability, mutability," says Susan Sontag in *On Photography*. "Precisely by slicing out this moment and freezing it, all photographs testify to time's relentless melt."

Death is the mother of beauty—and of photography, Beaton might

well have added. At times, he even acknowledged his own role as the angel of death, the shadowy presence, the mother's ghostly face seen dimly in the mirror. One of my favorite examples of this is a 1941 photograph described in a recent catalogue as *Rear Turret of RAF Bomber, with Cecil Beaton's Reflection.* The square picture conveys a mass of machinery made largely of metal and glass (in this respect, a bomber resembles a camera). On the right-hand side of the photo, peering out between the angular metal pieces of a gun, is the face of a handsome young man. If we look closely, we can see that he is wearing the cap and jacket that are a turret-gunner's emblems. On the left side of the photo, directly parallel to the young man but smaller

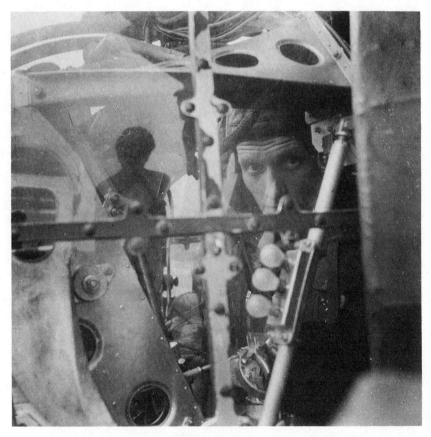

Rear Turret of RAF Bomber, with Cecil Beaton's Reflection

in scale, is a reflection so dark it has the unintelligibility of a shadow. Only the picture's label and our knowledge of Beaton's technique tell us that it is Beaton's reflection; this shadow could be anybody, young or old, male or female. But the *Rear Turret* photo is nonetheless a self-portrait of sorts, closely related to another picture from the same period, entitled *War Time Self Portrait,* in which Beaton himself, holding his box camera, is the one who peers out at us through a tangled mass of machinery. Viewed together, the two pictures show Beaton moving away from center stage, replacing his own singular self with two images: shadowy ghost and anxious airman, the mortal photographer and his doomed "other half."

In *Rear Turret of RAF Bomber,* the airman is looking out at the person whose shadow it is, and he looks as if he's staring at the prospect of his own death. The young man's fate is foreshadowed, for us, in his occupation, for the mortality rate among the rear-turret gunners of fighter planes in World War II was notoriously high. Randall Jarrell's most famous poem is called "The Death of the Ball Turret Gunner," and it goes:

> From my mother's sleep I fell into the State,
> And I hunched in its belly till my wet fur froze.
> Six miles from earth, loosed from its dream of life,
> I woke to black flak and the nightmare fighters.
> When I died they washed me out of the turret with a hose.

Beaton's photograph—taken before this poem was composed—captures all its elements, from the womb-like enclosure of the turret to the "hunched" posture of the gunner. It even, in its reflections and mirrorings, captures the poem's sense of rhyme and alliteration. And the "I" of Jarrell is replaced, in the photograph, by the "eye" of the photographer, the man who actually appears (if only as a shadow) in the picture he is taking. But Beaton is also the "mother" who gives birth to this doomed son (like his own mother in her mirrored portrait, Beaton is a shadow of death); he is the "earth" which dreams the young man into life; and he is the impersonal, social "they" who casually wash the dead gunner's remains away. Where Jarrell can be accused of melodrama, Beaton cannot, for his photograph has all the cool self-implication, all the acknowledgment of contradiction, that appears in a Wilde epigram—for instance, this epigram from the preface to *The Picture of Dorian Gray:* "The moral life of man forms

part of the subject-matter of the artist, but the morality of art consists in the perfect use of an imperfect medium." Beaton's medium is photography, whose imperfections lie in its inaccurate claims to superficial verisimilitude. Only by acknowledging and using photography's inherent link to artifice can Beaton make it achieve "the morality of art."

A great deal of what I have been calling the epigrammatic quality of Beaton's photographs stems from his *trompe l'oeil* use of mirrors. Yet the paradoxes he creates are not merely intellectual ones, reducible down to a linguistically stated problem of illusion versus reality, direct versus mediated vision. Beaton was, it is true, interested in those issues. (He designed, among other things, a stage production of Pirandello's mirror-riddled *Henry IV*.) But what the photographs show, in addition, is a felt concern with the relationship between vanity and photography, between self-regard and the perception of others, between wanting to be looked at and wanting to look. It is this mirror quality which makes the photos like epigrams. For epigrams, brief and unexpected as they are, tend to be at once the most self-displaying and the most reflexive form of writing: they emphasize their maker, but they also exist only in the eye of their beholder. Like jokes, they need an audience if they are to come alive. "We are like shop windows," says Nietzsche in the epigram in *Daybreak* titled *"The vain,"* "in which we are continually arranging, concealing or illuminating the supposed qualities others ascribe to us—in order to deceive *ourselves*." It is that back-and-forth exchange of deceit and identity—in particular, between the male viewer and the female viewed—which constitutes the subject matter of Beaton's most interesting photographs.

Quite a few of Beaton's mirrored self-portraits, perhaps more than half of them, show him photographing male subjects rather than female ones; for the one example of Adele Astaire, there might be three of a reflected Beaton taking a picture of Picasso, Lord Mountbatten, an RAF tailgunner. But even these unexceptional exceptions prove the rule. For when he includes his mirrored self in the photograph of a man, Beaton indirectly takes on the role of a woman. In the 1944 *Self-Portrait with Admiral Lord Louis Mountbatten,* for example, Beaton and Mountbatten both lie on their backs on a large bed, looking up at a mirrored ceiling and reflected, in turn, in the mirrored wall behind the bed. The two men are separated only by a large bolster, but if you look closely you can see that there is a crack beneath

the bolster; that is, two single beds have been pushed together to suggest the idea that these men are in bed together. So far we could be dealing with straightforward, man-to-man homosexuality. (And, indeed, Beaton elsewhere uses mirroring itself to suggest homosexuality, as in his two mirrored portraits of W. H. Auden, taken at an interval of twenty-four years. In the first, particularly, the young Auden appears to be flirting and mingling with his reflection.)

Self-Portrait with Admiral Lord Louis Mountbatten, Faridkot House, Delhi

But whereas the uniformed Lord Mountbatten is all right angles and military rectitude—he lies perpendicular or parallel to all the lines within the photograph—Beaton is something much more oblique. He reclines diagonally on the bed, so that whereas Mountbatten's reflected self makes a straight line with his body, Beaton's double self forms a broken V. (Actually, all the bodies in this photo are reflections but— as in the Adele Astaire picture—two portraits are reflected only once, off the ceiling, and for convenience I'm treating those as the "primary" set of bodies.) Mountbatten's legs are straight and merely crossed at the ankles, his arms by his side, while Beaton has one leg strongly bent at the knee and doubled up under the other, while his hands cradle, on his chest, a "box" camera. Beaton is clearly the oblique, the soft, the "sinister" member of the pair. I'm using the term with all its feminine implications, as Randall Jarrell does in his poem "In Nature There Is Neither Right nor Left nor Wrong," where he talks about "those wide-awake, successful spirits, men" who "lie each midnight with the sinister / Beings, their dark companions, women." The poem's title might almost describe the photograph: in Beaton's highly artificial portrait there is neither right nor left because of the mirrors. But if we work back from the mirrored image to the presumed reality, we can see that Beaton, who here appears to be lying on the right-hand side of the bed, must actually have been lying on the left. Beaton himself is the "sinister being" of this double portrait, the "dark companion" (his head and shoulders lie pooled in dark shadow, whereas Mountbatten's rest on white pillows); he is, in other words, the feminine half of the parodically matrimonial couple. His obliqueness would seem at first to make him the subsidiary half as well. But, as with Adele Astaire in the multiple Fred-Adele portrait, there is an element of hidden feminine strength: Beaton may be out of kilter with the straight lines created by the bed, the bolsters, the mirror edges, and Mountbatten, but it is *his* body, and not Mountbatten's, which is parallel and perpendicular to the edges of the photo.

Another of Beaton's odd and proto-feminine self-portraits is his 1933 photograph of Picasso. Surrounded by artworks, Picasso faces out into a large room, his back to an enormous mirror whose elaborately curlicued border echoes the frames on the surrounding paintings as well as the moldings on the elegant old walls. Picasso stares intensely at us, his face unsmiling, his body rather stiff and formally dressed. Over his right shoulder peers the face of a female sculpture; over his left (that sinister side again) we catch a glimpse of Cecil Beaton's head

reflected in the mirror behind Picasso. The miniaturized Beaton (smaller because, from the mirror's perspective, he is farther away, though in fact he stands where we do) is also unsmiling, formally clad, facing directly forward—a little echo of Picasso. There is in this photo the envy of a good artist for a great one (*For once, I am the master, you the subject, and I have captured you in my photograph—which is, as well, a self-portrait, so in portraying Picasso I have in a sense become Picasso, or at least his double*), and also the acknowledgment of the futility of that envy (*Even when I hold the camera and you stand idle, you remain the primary artist while I become a mere reflection of your power*). Because his head is framed by the doorway behind him, Beaton appears to be yet another of the artworks in the room, a matched pair with the sculpted woman who peeks over the other shoulder. If Picasso is the great painter of women, then Beaton—in this photo, at least—seems temporarily converted into one of those female subjects.

For me, the most thrilling of Beaton's mirrored self-portraits is one in which he doesn't appear at all. Entitled *Ouled Nails, Morocco,* the photo contains two human figures, both dark, heavy-set Moroccan women wearing long, multi-layered dresses. The nearer one, bare-headed and looking obliquely at us, stands in profile to the right of the doorway that occupies the center of the photo. Her feet are grounded on the same black-and-white-checked floor that leads from the camera position to the doorway, so she obviously inhabits the same unmirrored space as the photographer. The other woman—also in profile, also looking at us, but facing the other way and with her hair covered—occupies a much lighter rectangular space within the dark doorway. This proves, on close examination, to be another room, but it looks like a rectangular painting or photograph. (Due to the distance, this second figure seems smaller than life-size, or at least smaller than the near woman.) What it looks like most of all is a reflection in a rectangular mirror. This last possibility is stressed not only by the radiance of the distant woman's rectangle (which seems to reflect light, the way a mirror does), but also by the continuing checked floor, which extends beyond "our" doorway to the space beneath that woman's feet, as it would do if the doorway were indeed a mirror. Mirroring is also suggested by her pose (she is the left-hand counterpart to the nearer woman on the right, her reversed image) and by her distance (she seems to be exactly as far from the central doorway, on her side, as the camera is on this).

There is, in fact, a real mirror in "our" room—an oval glass,

Ouled Nails, Morocco

Gertrude Stein and Alice B. Toklas

suspended to the left of the doorway, across from the nearer woman—but it reflects nothing except the lush floral wallpaper that decorates the upper half of the room. The photographer, in other words, is not visible in the glass; we look for his reflection and find instead only the distant woman staring out at us, occupying the central position that is exactly parallel to our own. (This is a Vermeer-like relationship, and indeed the picture that generates it feels very much like a Dutch genre scene—specifically, like the *Interior with Woman at a Clavichord* by Emanuel de Witte. Beaton's photo might almost be a modern-day reworking of the de Witte, down to the checkered floor and the receding series of doorways.)

That distant woman is both Beaton's reflection and ours. Yet, despite our feminine image in the rectangular "mirror," the question of whether the viewer and the photographer are male or female is left unusually open. We have, it is true, been taken into the women's quarters in a Moroccan house—not a likely place for a man to be. On the other hand, we are definitely intruders, or at least strangers, to judge by the almost mistrustful or at any rate very aware glances of the two women who greet, or guard, our access to the inner room. The territory we have entered is definitely feminine; what remains in doubt is our own sexual identity. For Beaton, that mystery is an essential and intended aspect of the photo, as he demonstrates by using the same iconography of receding doorways, and almost the same placement of figures, in one of his double portraits of Gertude Stein and Alice B. Toklas—two women who, like the Moroccans of this photo, define and occupy an exclusively female domain.

One can contrast the delicacy of Beaton's uncertainty with, for instance, the crude effects in one of Robert Mapplethorpe's late works, an assemblage in which he places a real mirror between two detailed photos of male genitals. "*Now* who's the Narcissus? *Now* who's the voyeur?" accuses Mapplethorpe, refusing to implicate himself in any way. Beaton's photographs make no such accusations—cannot, in fact, be translated into words at all. Mapplethorpe's jest is too easy. It is far more difficult to give us, as Beaton does, a mirror that reflects back something other than our own faces.

The Disembodied Body
of Marilyn Monroe

9 There's something very depressing about setting out to write about Marilyn Monroe. It's not that her life was so sad, or that so much has already been written about her, or that the inevitable tendency in writing about her is toward excess, exaggeration, and a certain degree of inauthenticity—though all these things are true. The problem is that the closer you look at Marilyn Monroe, the harder it is to see her. As you peer through the structure and wreckage of all the news stories, biographies, gossip columns, and literary take-offs, not to mention the movies themselves, you begin to get the feeling that she's not really there at all. At the center of all this commotion, where there should be some tremendous motivating force, there is instead an empty hole.

And that, if you take it seriously, is extremely depressing. For writing about Marilyn Monroe goes far beyond the examination of one unfortunate woman's life. It raises questions such as "What is a person?" and "What is a movie?" and "What is the relationship between those two questions?" Norman Mailer, in typically backhanded fashion, hits the nail on the head when he says in his book *Marilyn* (quoting from his own earlier essay on his film *Maidstone*) that if an actor "has film technique, he will look sensational in the rushes, he will bring life to the scene even if he was death on the set. It is not surprising. There is something sinister about film. *Film is a phenomenon whose resemblance to death has been too long ignored*" (his italics).

Something about Marilyn Monroe pointedly raises all the questions—about authenticity and reality versus lies and illusions, about living people versus ghostly images, about tactile sexuality versus passive voyeurism—that are at the heart of movies. In a way, movies are defined by them. But it is a definition so basic to the form that most films don't bother to point it out, and as a result we don't normally

have to consider such questions in any conscious, felt way. Yet the Marilyn Monroe who comes through to us in movies, along with the one who comes through in "life" (or rather, in the effluvia surrounding those movies, for the two are inseparable in her case), forces us to think about those potentially disturbing oppositions.

The words "Marilyn Monroe" should be taken, insofar as is possible, to refer in this essay to a phenomenon rather than a person. There was a woman named Marilyn Monroe—or Norma Jeane Baker or Norma Jean Mortensen or Norma Jeane Dougherty or Mrs. DiMaggio or Mrs. Miller—who was born in 1926 and died in 1962. But I am not concerned with that woman here; I am concerned with the persona that arose around her. I wish to get away with cruel statements, to say things about the persona ("an empty hole") that it would be morally reprehensible, or at least rude, to say about a person. But of course I can't get away with it completely: the separation of person from persona is never entirely possible. So the cruelty becomes another poisonous aspect of writing about Marilyn Monroe.

One is faced with the choice of saying what one sees, and being accused of cruel treatment of a beloved figure—as Arthur Miller was accused by the public when he wrote *After the Fall,* and as Norman Mailer was accused by Arthur Miller when he wrote *Marilyn*—or protecting the poor orphan from the assaults of the nasty others, as feminist writers like Gloria Steinem and Graham McCann have tried to do. "It was the lost Norma Jeane, looking out of Marilyn's eyes, who captured our hearts," Ms. Steinem eulogizes plangently in her picturebook *Marilyn.* "Now that more women are declaring our full humanity—now that we are more likely to be valued for our heads and hearts, not just the bodies that house them—we also wonder: Could we have helped Marilyn survive?" Graham McCann's *Marilyn Monroe* (described in the jacket copy as "a dramatically liberating book" which "allows the reader, for the first time, to see Marilyn Monroe as she saw herself and as she wished to be seen") ends with McCann brooding about his attempt to "cancel out the other male texts . . . Interpreting Monroe, trying to think her thoughts, I felt both pleasure and painful self-doubt."

Such attempts to save her from exploitation are themselves exploitative. Exploitation was the essence of Marilyn Monroe—in its positive sense, as "full use," as well as in its negative sense. As a professional, Marilyn was always seeking out situations that would "use" her. Miller

reports on a filming of a scene in *The Misfits:* "Huston probably sensed it would only get heavier the more times he shot it, and rather than register a backward step on the first day, he elected to push on. From her viewpoint, however, she has not been exhaustively *used*" (his italics). Steinem and McCann are ostensibly trying to protect Marilyn from "use," from "exploitation"—yet in Steinem's case the effort goes to generating income and publicity for the Marilyn Monroe Children's Fund of the Ms. Foundation for Women ("Together, we can help Marilyn to help other children . . ."), while in McCann's it leads him to the instrusive process of "trying to think her thoughts." Everybody professes to be inside her, to know her true wishes and to be carrying them out. Nobody can leave her alone. She is there to be used, to be entered into. To deal with Marilyn at all is to become implicated in cruelty, or at least manipulation. As Arthur Miller understood in *After the Fall* ("Yes, not to see! To be innocent!"), one loses one's innocence just by looking too closely at her.

Being looked at was Marilyn Monroe's essential gesture, her defining role. Movies in general are about looking, and directors from Hitchcock to Michael Powell have harped on the sinister side of this fact. But with Marilyn the sinister element was hidden underneath; pleasure was the apparent motive, pleasure for both the viewer and the object of the gaze. "Dreaming of people looking at me made me feel less lonely," Steinem quotes her as saying. This is a sentiment worthy of Lewis Carroll ("Well, it's no use *your* talking about waking him," said Tweedledum to Alice, "when you're only one of the things in his dream. You know very well you're not real") and Randall Jarrell ("I am a thought of yours: and yet, you do not think . . ."). We, the viewers of Marilyn Monroe's movies, are creatures of her dream—and yet the dreamer herself does not really exist, at least in the form in which we see her.

She is a being who, despite the fact that the emphasis is on her body, is in constant danger of becoming disembodied, invisible, nonexistent. Of her performance in *The Misfits,* her last movie, Norman Mailer says: "She seems to possess no clear outline on screen. She is not so much a woman as a mood, a cloud of drifting senses in the form of Marilyn Monroe." This impression receives its fullest visual presentation, not in stills from *The Misfits* or any other film of hers, but in Willem de Kooning's 1954 painting *Marilyn Monroe.* De Kooning disembodies Marilyn in two senses: first, by taking apart her

famous body, rendering it as swift swatches of red or yellow or green paint, none in particularly female shapes; and second, by giving us a child's-art version of a woman's face—red-mouthed, yellow-haired, with wide-set lopsided eyes—in place of Monroe's emblematic celebrity visage. This is not our collective Marilyn, but de Kooning's own private one. Yet the painting is true to our deeper sense of her, for what it conveys is a vulnerable, quivering, exposed creature. Especially in the slashes of red, the disembodiment is also a disembowelment: this is Marilyn Monroe turned inside out (like Handke's mother in his dream of her). The critic W. S. Di Piero, writing about this painting in the context of the 1987 show *Made in U.S.A.,* astutely remarks:

> The full force of de Kooning's rage for form is lived out in the action of the paint, which registers the encounter between the painter and not only the husk of appearances of his subject but also the subject's consciousness. This is brutally apparent in the show, where it's displayed alongside Warhol's *Twenty-Five Marilyns.* For de Kooning what mattered was not so much the glamour-bound emblematic quality of his subject . . . as the aggrieved, proud, helpless, and nervously giddy offering of pleasure's promise.

As Di Piero suggests, the idea behind Warhol's Marilyn is exactly the reverse of what de Kooning gives us. Warhol too "disembodies" her, in the sense that he shows only her face. But it is the face which, after all, makes his painted Marilyn an emblem, makes her recognizable; and it is the instant recognizability of that face—even in its crude, debased, Day-Glo-color form—which makes Marilyn Monroe a celebrity. Typically, Warhol is not interested in the living woman, or in any direct and personal encounter between himself as artist and that woman as subject. He is interested in a notoriously and recently dead woman (*Twenty-Five Marilyns* was painted the year of her suicide) precisely to the extent that she is both famous and representative: he is interested in the way she exaggerates the "average" fifteen minutes of fame, multiplies it twenty-five times or more, into a brief lifetime of unreal existence. In Warhol's version of Marilyn, the apparent specificity—that is, the recognizable face—actually becomes its opposite, a kind of generic celebrityhood. The move toward art-as-commodity and the move toward woman-as-commodity are accomplished in a single self-annihilating gesture. For Warhol's failure to create a

real, personal Marilyn is an admission of an absence in *him,* just as de Kooning's painterly success in rendering her is a sign of his own vitality.

Some of what Mailer and de Kooning sensed in Marilyn can also be found in Cecil Beaton's 1956 portrait of her, a photo in which—clad only in a black slip—she sits in a rattan chair, lifts up her arms, and gazes obliquely over them at the viewer. Such a description makes the picture sound very sexy, but quite the contrary is true: this is Marilyn Monroe at her most vulnerable, her least glamorous. The arms are raised because she's covering her mouth with her hands, so almost half her face—the full-lipped, whispery, sensual half—is hidden from us. The curled palms of her hands face outward, as if to protect her. This is not a cat-like, sensuous stretch, but a defensive posture. The body, too, is distorted (still another version of disembodiment) by the extremely shallow focus of the photo: the right elbow and its exposed armpit loom out enormously at us, while the left elbow shrivels into the distance. Even her breasts are made unsexy, with one sheared off by the photo's lower frame, the other jutting out angularly as if in parodic imitation of the elbow above it. And the eyes that look out at us over these distorted body parts are hardly those of a dumb-blonde bombshell. They are beautiful, but they are also frightened of their own beauty. Those eyes are watchful, anxious, familiar with pain. What they ask of us is not entirely desire, not entirely sympathy, but a combination of the two; and they also ask us to blame ourselves for wanting to watch her, to intrude on her. Beaton's portrait gives us a Marilyn Monroe who is retreating behind her own body, using it as a screen with which to hide from us.

Even the man supposedly allowed behind the screen—or, maybe, especially that man—was made painfully aware of Marilyn's elusiveness. In *Timebends,* his autobiography, Arthur Miller describes the beginning of his love affair with Marilyn by saying about the two of them: "In each stood an image that could not yet be turned and seen full face but only obscurely, from an angle that drew us on, at first with curiosity, and gradually with the hope of being transformed by our opposite . . ." Yet when he tried to turn that fleeting glimpse into the full-face confrontation of marriage, the beloved creature disappeared, slipped away. That, at least, is part of the implication of the wedding scene in *After the Fall,* where Miller recalls the marriage between Quentin (based on himself) and Maggie (based on Marilyn).

"*He puts her arm in his; they turn to go. A wedding march is heard,*" say the stage directions. Then Maggie begins to move away from Quentin: "You're not holding me!" she says. Quentin is "*half the stage away now, and turning toward the empty air, his arm still held as though he were walking beside her:* I am, darling, I'm with you!" A little later, as he moves downstage with his arm around the still-empty space: "I'm holding you! See everybody smiling, adoring you? Look at the orchestra guys making a V for victory! Everyone loves you, darling. Why are you sad?"

The beloved who disappears when fully seen is, in its original version, the story of Psyche and Eros. That mythical union was a love affair between sexuality and soul, between pure bodily pleasure and pure spirit, a love affair doomed to end when any light was cast on it. Marilyn, to whom this myth is central, is herself both Eros and Psyche. In Mailer's picturebook—in *all* the picturebooks—the photos are there to focus on her body; but Mailer himself suggests that "One might literally have to invent the idea of a soul in order to approach her." And if Marilyn herself is the union of these two opposites, the light that rends them apart is the projected light of the movies.

Part of what makes Marilyn so engrossing as a movie actress is the way these two aspects of herself, the body and the soul, seem so at odds with each other. Presenting herself to our gaze, even flaunting herself with swinging hips and smoochy lips, she nonetheless seems to be hiding, to be shivering in agonized embarrassment behind that outward display. It's this quality of retreat, of disowning the body's behavior, that causes everybody to describe Marilyn as seeming "vulnerable" onscreen. It's that same quality that gives credence to Mailer's idea of the soul. For if the movies give us nothing but what is actually there to be seen, how can we be sensing that creature who hides behind or within the body? Yet Marilyn's is a version of the soul that can *only* be seen on film; all other renderings, from Miller's Maggie to Mailer's biographical Marilyn, fail to capture it.

Body and soul, flaunter and hider, liar and truthteller, willful aggressor and pathetic victim, family-less orphan and overdetermined child—Marilyn embodies the very idea of a divided self. As Mailer says, "We must live in two lives whenever we think about her one life." With more typical excess, but also with a great deal of crackpot insight, he also says:

If we are indeed born with a double psyche and so are analogous in our mental life to twin trees, possessed of one personality which is plunged into the life before us, and of another karmic root that retains some unconscious recollection of another existence from which we derive, it is not the same as saying that because each of us builds a mental life on two fundamentally separate personalities, that we are all therefore, in the old-fashioned sense, schizophrenic. Two personalities within one human being may even be better able to evaluate experience (even as two eyes gauge depth), provided the personalities are looking more or less in the same direction. A fragmented identity is the refusal of one personality within oneself to have any relations with the other. If such a notion has value, let us assume that the conditions of an orphanage are suited to creating too wan a psyche and too glamorous a one. Since the orphan's presence in the world is obliged to turn drab, the life of fantasy, in compensation, can become extreme.

Marilyn Monroe's twenty-one months in an orphanage constitute one of the most publicized facts of her life—one of the "factoids," as Mailer calls these items which a publicity department would have had to invent if they didn't exist. Arthur Miller places great importance on this aspect of her background: "she was able to walk into a crowded room and spot anyone there who had lost parents as a child or had spent time in orphanages," he says in his autobiography. Later he talks about their first meeting, a joyful occasion at which Miller feels "released not only by Marilyn's beauty but, I thought, by her orphan-hood, which heightened her charged presence; she had literally nowhere to go and no one to go to." (It's odd that both Miller and Mailer, writing about the ephemeral Marilyn, fall back on the almost-always-inaccurate word "literally.") But, as Miller points out later in the book, Marilyn wasn't *really* an orphan: her institutionalized mother and absent father were both, it turns out, alive at the time she was put in the orphanage.

Yet the image of the orphan has such a strong hold on the imagination that we can't let it go even in the face of bare facts. The pathetic Dickensian victim is a prominent inhabitant of our literary landscape, as Mailer points out when he ends his *Marilyn* book by telling the dead star to "pay your visit to Mr. Dickens. For he, like many another literary man, is bound to adore you, fatherless child." The orphan is someone who needs to be taken care of, as men—in life and in the

movies—were always offering to take care of Marilyn. The orphan is an eternal child (for who, when hearing the word "orphan," thinks of an adult?), as Marilyn in some sense appeared to be. But the orphan is also a positive, Huckleberry-Finn-like image of freedom and self-creation. Something of this is in the "release" Miller feels in her presence, and something of it also colors the pauper-to-princess ascent of Marilyn's movie career. The alternate orphan fantasy, the victorious rather than pathetic one, is the dream of not belonging to one's own family, of being aristocracy misplaced. Marilyn lives out that fantasy when Hollywood retrieves her from the nest of Bakers and Bolenders and Doughertys—those lower-middle-class, scrape-by, God-fearing folk—and declares her to be a "born" movie star. The myth of Marilyn Monroe, despite the dyed hair and fixed nose and changed name, is that she had some innate quality that made her a star, that separated her out from everyone else. And that myth may be as true as anything else about her.

Miller may have felt release in her presence, but what she offers on the screen is far from freedom. On the contrary, she seems to represent Fate personified—the fate of a doomed woman, or else the doom wielded by a beautiful woman when dealing with men. This is true even of her comedies: she is Tom Ewell's potential doom in *The Seven Year Itch* (a seductive doom—predetermined even in terms of its exact year—which he narrowly avoids), and she is herself doomed to "the fuzzy end of the lollipop" in *Some Like It Hot,* where she once again ends up with a handsome, irresponsible saxophone player. Because she was Miller's own doom, he sees her as somehow all will, all force. "My will seemed to have evaporated," he says of the early days of his affair with Marilyn, and later he compares his own relatively lackadaisical attitude toward his career to her firm need for control: "She could not imagine such yielding to fate, it seemed like inertia to her." But she is no Circe, no witch manipulating the strands of other people's fate. On the contrary, she herself is tightly bound up in the curse, its victim at least as often as its perpetrator.

It is not surprising that such a character should turn to Freudian theory for her solutions. "I will not discuss psychoanalysis, except to say that I believe in the Freudian interpretation," Steinem quotes her as saying. Freud, after all, was in the air of the American 1950s; every intellectual and intellectual's wife was in analysis, and Marilyn was no exception. What *is* surprising is the extent to which her life and her

movies jointly harp on "the Freudian interpretation," making it pertinent even where it might not have been. For instance, in the late 1940s she began studying acting with Michael Chekhov—best known to American audiences not for his status as Anton Chekhov's nephew, but for his role in Hitchcock's 1945 *Spellbound,* where he played Ingrid Bergman's European-born analyst/teacher. In typical Marilyn fashion, blurring the boundaries between life and movies, she chose for her spiritual advisor—a role that would later be filled by her psychoanalysts—a man who had *played* a psychoanalyst. Moreover, it somehow suits the character Chekhov played in *Spellbound* (a kindly old man who intuitively assesses the potentially-dangerous-but-actually-innocent Gregory Peck) that he, above all others in Hollywood, should have had the wit and the tenderness to spot Marilyn's talent.

If a movie-Freudian entered Marilyn's life, so did the "real" Freud (Freud being almost as much of an indeterminate quantity as Marilyn Monroe) enter her movies. Both of the films Billy Wilder made with her, *The Seven Year Itch* and *Some Like It Hot,* allude heavily to the connection between Freud and sex, and therefore the connection between Freud and Marilyn Monroe. In *The Seven Year Itch,* the Tom Ewell character is attempting throughout the movie to plough his way through a psychoanalytic manuscript about "the repressed urges in the middle-aged male." Eventually he meets its author, a doctor to whom he confesses his brief, nearly adulterous encounter with Marilyn. "I made a little boo-boo," he begins, to which the doctor responds: "Psychoanalysis does not recognize the boo-boo, as such." In *Some Like It Hot,* Tony Curtis's feigned problem with women—the one he invents to get Marilyn Monroe to seduce him—is given the full psychoanalytic treatment: "It's a mental thing," he says, and confirms its hopelessness by pointing out that "I spent six months in Vienna with Professor Freud."

The serious movies and the musicals are less likely to allude to psychoanalysis (though *Niagara* does give Marilyn a husband who definitely has a "mental thing," and in fact has already been hospitalized); instead, they embody it by recreating the Oedipal situation. From *The Asphalt Jungle* onward, she is almost always shown with a "sugar daddy," a man old enough to be her father but functioning as her illicit or aspiring lover. In *The Asphalt Jungle* she calls this man "Uncle" (he tries to discourage her from doing so, but she persists). And in *The Misfits* that older man is played by Clark Gable, who—

according to both Mailer and Miller—was at one point believed by Marilyn to be her father, since "his framed photo stood on her . . . mother's bureau." As audience members we cannot be expected to know this, but there is nonetheless something eerily disturbing about the scene in which Gable first awakens her with a kiss. We have last seen them driving in a car together, he paternally solicitous, she vulnerably drunk. In the next scene we see, she is asleep face down in a bed and he enters the room, fully clothed, to awaken her. He sits on the edge of the bed, as a father might—and then he leans over, lifts up her face, and kisses her heavily on the mouth. This scene was written by Miller, who knew about the photograph on the bureau, and directed by Huston, who was eventually to play, with sinister skill, the incestuous old father in *Chinatown*. Norman Mailer has this to say about the *Misfits* situation: "what portents she must have sensed playing love scenes at last with the secret father, what a cacophony of cries in the silence of her head when Gable was dead eleven days after finishing the film." Mailer is the director who, in his own play *Strawhead,* cast his daughter as Marilyn Monroe—an act that self-consciously closed, or disclosed, the richly Freudian pattern he'd already discerned in Marilyn's life.

There is a Freudian angle to Miller's play *After the Fall,* too, but here the Freudian notion of guilt (toward one's parents, toward one's lovers) is mingled with and augmented by other kinds of guilt—specifically the guilt of the survivor and the guilt of the liar. Before reading it, I had always thought the play was heavily, almost exclusively, about the marriage to Marilyn. The second of the two acts, which is by far the less persuasive one, does focus on Maggie and the disintegration of her marriage to Quentin. But in the first act Quentin's memory (where the entire play takes place) ranges over early traumatic scenes with his parents, arguments with his first wife about sex and psychoanalysis, the death of his mother, a love scene set in a former Austrian concentration camp, and an imminent (and immanent) appearance before the House Un-American Activities Committee. For Miller, all the kinds of guilt inhering in these situations are linked with one another. I think he wrongly believed that Marilyn (or rather, a theatrical representation of Marilyn) could carry the whole second half of the play because she was deeply connected, in his mind, with all these other forms of lost innocence.

If he was wrong dramatically, he may still have been right culturally:

something in America's love affair with Marilyn Monroe was determined by the nature of the 1950s. I am not talking here about the domestic exploitation of women, about housewives confined to the home; *that* is not at all what Marilyn represented (though it may be in part what she was a reaction against). She suggested the impossibility of combining innocence and sexual love (the title *After the Fall* refers, most obviously, to the knowledge that came with Eve's apple*). She hinted at the fragility of survival (which must have seemed particularly poignant to American Jews who lived through the war, like Miller, Mailer, and especially the immigrant Billy Wilder). And she embodied something about the nature of truth and falsehood. For Miller, this meant that she was crucially linked to the McCarthy era. As *After the Fall* suggests and his autobiography confirms, her crucifixion at the hands of Hollywood was forever linked in his own mind with his at the hands of HUAC. In a setting designed for the production of lies, there could be no possibility for speaking the truth. At best, one could only use falsehoods or silence as a means to suggest or approximate an unattainable form of authenticity. It was this that Marilyn Monroe managed to do in her acting.

Mailer, speaking about Monroe as a comedian, puts it this way: "she dramatizes one cardinal peculiarity of existence in this century—the lie, when well embodied, seems to offer more purchase upon existence than the truth." And of her special form of acting, which he calls "the first embodiment of Camp," he says:

> the art was to sustain non-existence, counter-existence, as if to suggest that life cannot be comprehended by a direct look—we are not only in life but to the absurd side of it, attached to something else as well—something mysterious and of the essence of detachment. So in *Gentlemen Prefer Blondes,* she is a sexual delight, but she is also the opposite of that, a particularly cool voice which seems to say, "Gentlemen: ask yourself what really I am, for I pretend to be sexual and that may be more interesting than sex itself . . ."

*Miller gives a much fuller meaning to the title in his autobiography, when he explains that it grew out of his consideration of Camus's *The Fall:* "*The Fall* is about trouble with women, although this theme is overshadowed by the male narrator's concentration on ethics, particularly the dilemma of how one can ever judge another person once one has committed the iniquitous act of indifference to a stranger's call for help . . . *The Fall,* I thought, ended too soon, before the worst of the pain began."

She is an "embodiment" of something that has no body: the imagined idea of sex.

Miller, perhaps because he knew her, sees her less complicatedly as the literal embodiment of the authentic, the true: "she had come to symbolize a kind of authenticity; perhaps it was simply that when the sight of her made men disloyal and women angry with envy, the ordinary compromises of living seemed to trumpet their fraudulence and her very body was a white beam of truth." (Both Mailer and Miller, when writing about Marilyn's sexuality, lapse occasionally into the kind of hyper-romantic tripe that the Tom Ewell character in *The Seven Year Itch* describes as "inwardly downwardly pulsating striving now together ending and unending" malarky.) But if in his autobiography Miller sees her as a beam of truth, he constructs *After the Fall*—which is, after all, Marilyn's play—around the question of what it means to lie. And even in the autobiography he observes in her acting the same duality Mailer perceives: "the secret of her wit's attractiveness was that she could see around it, around those who were laughing with her, or at her. Like almost all good comics, she was ruefully commenting on herself and her own pretensions to being more than a rather dumb sex kitten . . ." Like Mailer's remark, this strikes me as true enough, but not easily explicable. There is no obvious moment when Marilyn is giving us the wink, forging a bond between our mind and hers that transcends the silliness of the body. Her central characteristic as an actress is the appearance of sincerity—itself a contradiction, but an amazingly persuasive one. There is no point in either her serious movies or her comedies when she openly gives up that Marilyn persona: it's a constant that substitutes for truth, a completely unephemeral illusion, a lie without holes. As such, it seems the closest thing to honesty that the movies can offer us.

Marilyn's lifelong struggle with Method acting—her fanatical allegiance to Lee Strasberg and his emissary Paula Strasberg—stemmed in part from this curious duality of hers. Any other actor in the world might have been free to choose between internally generated Method acting and the more externalized British manner, which uses gesture, voice, and technique to create emotion rather than vice versa. Or perhaps not exactly to choose—but any other actor might have known automatically which of the two styles would better suit his talents. Not Marilyn. In her case, the power of her acting grows largely out of the conflict between internal and external: she gives the impression

of a serious, sensitive actress trapped inside the body of a blowsy, self-mocking comedienne (as if, say, Meryl Streep had to peer at us out of the eyes of Bette Midler). So she cannot solve the technical problem either by looking down into herself (where, in any case, she is dangerously likely to find the absence of a self) or by relying wholly on external gestures, which will inevitably betray the being trapped inside. She must do both at once. This is what makes her so fascinating onscreen. Marilyn Monroe is not a great actor, in any sense that we usually mean it. But when you try to look away from her at the better actors onscreen, at Thelma Ritter in *The Misfits,* for instance, or at Tony Curtis in *Some Like It Hot*—actors who, unlike Marilyn, are capable of taking over a role and giving it the illusion of life—your eye resists; it feels it's missing the main action. Because Marilyn does something onscreen that no one else seems able to do: she combines a hokey sense that she is acting a part with the conviction of utter sincerity. In that sense, she is the ultimate actress, the actress in whom the acting process is always visible and yet inseparable from the process of merely being.

Her movies take advantage of this characteristic by always assigning her the role of actress or performer *within* the film. In *All About Eve* she arrives at Bette Davis's party on the arm of the dastardly theater critic, obviously a piece of fluff in search of a stage career. In *The Seven Year Itch* she's an actress in television commercials, in *Some Like It Hot* she's a singer with a female band, and in her trashier comedies she's always some kind of showgirl, model, or other self-displaying lowlife. Even Miller follows the general trend: in *The Misfits* he makes her a dancer, and in *After the Fall* she becomes a well-known singer. To give an actress in a movie or play the profession of actress or performer is to create a hollow circularity. What is she when she's not being an actress? What is she *besides* an actress? Nothing; zero; the empty hole.

It seems amazing, in this light, that Marilyn never worked with Hitchcock, who was so repeatedly and obsessively interested in questions about deception, authenticity, and the female empty-vessel actress whom the male director fills with meaning. Marilyn may not have been empty enough for Hitchcock: she had the blondeness and the potential for victimization, but she lacked the utter vacuousness, the blank-slate quality, of actresses like Eva Marie Saint, Kim Novak, and Tippi Hedren. She didn't, at any rate, make any movies with Hitch-

cock. But she made a very Hitchcock-like movie with Henry Hatha-way—the best film of his career, and one of the best of hers.

Niagara is a thriller set at an enormously symbolic and symbolically enormous American monument; it was filmed in 1953, six years before Hitchcock used the gigantic presidents' faces of Mount Rushmore in *North by Northwest*. It has the *Suspicion, Notorious,* and *Dial M For Murder* plot of attempted murder of a spouse, the *Spellbound* plot of possibly murderous insanity, and a squeaky-clean American couple—complete with dominant-but-dense husband and smart, endangered wife—who might have stepped straight out of the remade *Man Who Knew Too Much*. It also has Joseph Cotten, whom Hitchcock had used ten years earlier in his own favorite movie, *Shadow of a Doubt*. As Marilyn Monroe's husband in *Niagara,* Cotten is both her victim and her murderer—a classic role for the men in her life, as her real husband was eventually to show in *After the Fall*. In many ways, though it comes relatively early in her career and uses her uncharacteristically, *Niagara* portrays Marilyn more astutely than any other film she made.

The movie opens, for instance, with Joseph Cotten looking out over the falls, muttering neurotically to himself about his obsession with the torrent of water, and then turning away to walk back to his tourist cabin. The falls themselves are shimmering with rainbows; as he walks back along the lawn-lined streets, the sprinklers he passes have rainbows in them too; and the place he is staying turns out to be called Rainbow Cabins. Capturing a rainbow on film must be a rather hard thing to do. It's a visual object—anyone can see it—but on the other hand it's not really there. It's a mere thing of beauty that has no solid reality, and yet it's one of the strongest positive images in mythical thinking: fairy tales place their pot of gold at the end of it. It's a perfect emblem for Marilyn Monroe.*

Cotten goes inside the cabin and we get a glimpse of Marilyn, who

* Lacan, in his lecture on "The topic of the imaginary" given during his 1953–54 Freud seminar, has an extremely pertinent remark about rainbows: "When you see a rainbow, you're seeing something completely subjective. You see it at a certain distance as if stitched on to the landscape. It isn't there. It is a subjective phenomenon. But nonetheless, thanks to a camera, you record it entirely objectively. So, what is it? We no longer have a clear idea, do we, which is the subjective, which is the objective." Lacan made this remark during the year *Niagara* was released—a coincidence, no doubt, but of the kind which causes one to feel that Freudian theory discovered Marilyn even before she discovered it.

is pretending to be asleep in the other twin bed. The bed is a classic Monroe location in her films: it stands for both her sexuality and her innocence (as a child is innocent when it sleeps). Our first glimpse of her in *The Asphalt Jungle*—her earliest noteworthy film, released in 1950—shows her asleep on a couch; and we again see her asleep (with an older, worn-faced man standing over her, as Cotten does here in *Niagara*) at the end of her career, in *The Misfits*. Sleep is the daily habit that Marilyn, in life, was to find far from habitual: she had to force herself into it with pills and alcohol. It is also the oblivion into which she sank toward her barbiturate-induced death.

Meanwhile, the Cutlers arrive at Rainbow Cabins—the fresh-faced, obnoxiously conventional pair so reminiscent of Hitchcock's Jimmy Stewart and Doris Day. As the plot suggests (the Cutlers can't get into their reserved cabin because the Loomises, played by Marilyn Monroe and Joseph Cotten, are still there), these two are a foil, an opposite, to the mysterious, murderous Loomises. As opposed to Cotten's shell-shocked veteran, Mr. Cutler is boringly, conventionally sane; he makes up prize-winning slogans like a character in a Preston Sturges movie and doesn't see anything humorous about it. His wife is far more interesting, and interested (it is she who collects all the clues in the Loomis plot), but she too is presented as an opposite to Marilyn, a good girl as opposed to a bad one. "That dress is cut down to the kneecaps," Loomis complains to Mrs. Cutler about one of his wife's slinkier outfits. "Would *you* wear that dress?" "I'm not the kneecap type," she calmly and self-effacingly replies. Yet her husband wants her to be a little more that type—to be less straightforward and pal-like, more self-displayingly sexy. He tries to get her to take a cheesecake pose for a tourist photo he's taking, and she complies, though it irks her almost invisibly. The photo session is interrupted by Marilyn (who is laying the groundwork for her role of grieving widow), and when she leaves the husband says, "Get back into that pose again." Like the Tom Ewell character in *The Seven Year Itch,* Mr. Cutler is the kind of wimpy guy who fantasizes about being with a woman like Marilyn Monroe and therefore undervalues his pretty, courageous wife. And, again as in *The Seven Year Itch,* he's a toady to a more powerful boss; he's a man who likes or needs to play up to a stronger man, and therefore wants to play down to women.

Niagara is, in subtle ways, a movie that comments on sexual roles. When the tourists go out onto the falls, for instance, the men all wear

dark blue slickers and the women all wear yellow. (This may be how it actually worked at Niagara Falls in the real-life 1950s, but in a color film it's more than a fact: it's a statement.) The Cutlers are supposed to represent this simple variety of gender division—he, the strong male, brings in the money and faces reality; she, the flightier woman, "imagines" seeing the supposedly dead Joseph Cotten—but in fact the indeterminacy of the Loomis marriage, where power shifts back and forth from moment to moment, invades the Cutlers as well, and in the end Mr. Cutler stands helplessly aside while his wife hurtles toward the falls on a boat with Joseph Cotten. "Scuttle it! Scuttle it!" is all he can pray; it's an acknowledgment that some situations (like conventional marriage, perhaps?) can be corrected only by shipwreck and destruction.

Marilyn's role in this movie draws on and elaborates that sense of duality, of movie deception and sincerity, which is so central to her career as an actress. When she first speaks, it's to ask the Cutlers and the motel manager whether she can keep the room a little longer— her husband's only just fallen asleep after an anxious night, and she wants him to rest. We have no sense yet (except the sense her sexy body always conveys) that we have any reason to mistrust her, and she sounds perfectly sincere; and yet there's some way in which we don't fully believe the words she's saying. As it turns out, the words themselves are true (he *did* just fall asleep after being anxiously awake), but the impression they convey—that she's a concerned wife with a potentially suicidal husband—is calculatedly false. All these layers of meaning are right there in Marilyn's delivery, and continue to be there in every scene, so that some of the sincerity even survives into her final moments, when we already know she's a plotter.

The movie uses her sexuality very skillfully. *Niagara* contains the standard scene in which she walks away and a man stares after her swinging hips (every Marilyn Monroe movie I've seen has this episode, as if it were always written into her contract). But here, with Mr. and Mrs. Cutler both staring after her, the scene suggests, not the division of male/female response to her, but its surprising uniformity. Commentators from Mailer and Miller to Steinem and McCann have insisted, in their various ways, that men and women react differently to Marilyn: that men want to love and possess her (or exploit her) while women want to compete with her (or protect her from men). But faced with a movie, you can't *really* do any of these things: you can

only watch. *Niagara* suggests—very accurately, I think—that men and women are similarly entranced by watching Marilyn. Being with Marilyn, it implies, isn't really a function of intimacy and possession: it's a function of distance. (When Marilyn has a final exchange with her lover about the plan to murder her husband, they communicate by postcard, even though they are in the same room—an apt metaphor for our intimacy with a movie actress.)

Being watched from a distance, seemingly oblivious to the viewer's gaze but actually with full knowledge and intention, is what Marilyn does as a character in this movie, and as an actress in all her movies. She "performs" a casual errand for Joseph Cotten, luring him to follow her, just as she performs for her whole audience in each movie she's in. We, the camera, and Joseph Cotten are all watching her, but she pretends that we're not—or seems to pretend that she doesn't know we are.

Niagara even gives a special, fuller meaning to the famous Marilyn walk: it's not just a sexy display here, but a hint of something fearfully negotiated at a dangerous height. As she wiggles away from the pursuing Cotten (now he's following her with murderous intent, and they both know it), a tourist guide in the background mentions a French tightrope artist who once walked across Niagara Falls. In *Timebends,* Arthur Miller says of her well-known hip swivel, "It was, in fact, her natural walk: her footprints on a beach would be in a straight line, the heel descending exactly before the last toeprint." Hers was, in fact, the walk of a tightrope artist—someone who knew that a fall was imminent, and that the medium she moved through was not intended to support a human being.

The director who best conveyed this precariousness, who most clearly understood what Marilyn meant on film, was Billy Wilder. *Some Like It Hot,* which he co-wrote and directed in 1959, is a comedy classic—probably Marilyn's most enduring film—and *The Seven Year Itch,* while in many ways a terrible movie, is filled with interesting ideas about Marilyn Monroe.

The Seven Year Itch, which came out in 1955, is more a blueprint of a movie than a movie itself. It's the kind of movie Bertolt Brecht might have made as a joke on Hollywood: all alienation effects and hard-sell sex. It's supposed to be a comedy, but it doesn't make you laugh. This is partly because of the unfunny pacing—static and stagey, it feels very much like a play that never quite gets off the ground—

but it is also due to the lacerating attitude behind the jokes. Disguised as a light sex comedy, *The Seven Year Itch* is actually a black comedy, more black than comic, about male sexual insecurities and the romantic lies created by the media. The male lead, Tom Ewell, is possibly the least attractive leading man ever to be featured in a Marilyn Monroe film, and the whole movie is an extended joke about how ludicrous it would be for him to snare Marilyn Monroe. She plays a model and aspiring actress, but she also very obviously plays a stand-in for herself. Toward the end of the movie, the married Tom Ewell (whose wife and son are out of town for the summer) is visited by another man, from whom he self-defeatingly tries to conceal the presence of the stacked blonde in the kitchen. "*What* blonde in the kitchen?" says the other man. "Wouldn't *you* like to know. Maybe it's Marilyn Monroe," taunts Tom Ewell. The joke here is not only that it *is* Marilyn Monroe, but also that in the context of the movie, it couldn't be: the other man would be right in feeling that a little drip like Tom Ewell and a sexy star like Marilyn Monroe couldn't possibly be together, even in a movie. Marilyn, as usual, both is and is not the thing she appears to be.

The movie is filled with references to other movies, to acting, and to the whole issue of technologically transmitted sexuality. "No girl in her right mind wants me; she wants Gregory Peck," says Ewell at one point. This, like the Marilyn Monroe remark, is the kind of thing a real-life man might possibly say, but it has a completely different feel when it comes out of the mouth of a movie character. It refers backward to *Spellbound* (another Freud-obsessed movie, in which Gregory Peck played one psychiatrist and Michael Chekhov, Marilyn's real-life drama coach, played another) and forward to *Let's Make Love* (where Marilyn was supposed to play opposite Gregory Peck, until he got cold feet and dropped out of the project, making way for Yves Montand, who briefly became her real-life lover).

The Seven Year Itch alludes, in particular, to other comedies. When Tom Ewell thinks about how to seduce Marilyn, he puts on a Rachmaninoff record and develops an appropriate fantasy to go with it: the scene is stolen directly from Preston Sturges's 1948 masterpiece, *Unfaithfully Yours*. And the most famous scene in *The Seven Year Itch*, when Marilyn walks over a subway vent and the air blows up her white dress, harks back to the "wind effect" in Leo McCarey's *The Awful Truth*. In the 1937 McCarey movie, Cary Grant is at a night

club with a brassy blonde when his estranged wife, Irene Dunne, shows up with her wealthy boyfriend, Ralph Bellamy. Before Grant can get too far with his taunting of Bellamy (who is a naive rural type, and therefore an easy mark), his date totally embarrasses him by going onstage for her act, which involves getting her dress blown up over her face as she sings a romantic song. Irene Dunne wins that round; and she wins again when she recapitulates the night club act ("There's supposed to be a wind effect here," she points out) as she is pretending to be Grant's drunken, lower-class sister in order to embarrass him in front of his society fiancée. What Wilder understands, as he shows by borrowing this little scene, is that Marilyn Monroe represents the triumph of the no-class little blonde. Prior to her, American comedy films favored aristocratic women like Irene Dunne, Claudette Colbert, Myrna Loy, and Katharine Hepburn. Marilyn is the brassy blonde winning out over the classy brunette, the one-night-stand triumphing over the wife. *The Seven Year Itch* catches that process in transition; it's a Thirties comedy updated to the Fifties.

The undervalued wife of *Niagara* has become a ghostly mirage in *The Seven Year Itch:* she's a figment of Ewell's straying imagination, though a figment that talks back to him and repeatedly attempts to puncture his ludicrously self-glorifying fantasies. "I have this animal thing where women are concerned," he boasts—as if he, and not Marilyn, were the charismatic sex symbol—to which his wife responds: "Lately you've begun to imagine in Cinemascope, with stereophonic sound." As if to emphasize the artificiality of the whole premise of the movie, Ewell constantly speaks to the audience in the manner of a Shakespearean monologuist. Not for one moment will we be allowed to forget this is performance rather than reality.

Marilyn herself, though she plays her part straightforwardly enough, is a parody of her usual role. When she first enters, her breasts are so prominent (they point outward like horizontal pyramids, suspended in the kind of cantilevered brassiere designed by the Barbara Bel Geddes character in *Vertigo*) that she appears almost to be lugging them around. She meets Ewell by accident, having dropped a tomato plant off her balcony onto his, and when she meets him again she says, "It's me—don't you remember?—the tomato from upstairs." The self-exposure is cruelly direct, and it makes us cringe; but it also makes us realize how other directors are using her in the same way, though more surreptitiously. There is even a reference to her famous nude

calendar shots, as she proudly describes a revealing picture of herself that appeared in a photographic annual. "It's called *Textures,*" she tells Ewell ingenuously, "because you can see three different textures in it: driftwood, sand, and me." When she's out of the room, Ewell takes a quick peek at the photo book, embarrassed to look even when he's by himself; he slams the book shut as if slamming the door on his id.

That gesture is, in a way, the key to how this movie approaches sexuality. Things that are intimate become public and therefore embarrassing. Sex goes from being a private encounter between two adults (as it can be only in real life, never in the movies) to a massive display before a supposedly drooling audience. "How many people were present when that picture was taken?" Ewell wants to know, and the question lies at the heart of one's reaction to Marilyn Monroe's movies. If being with Marilyn means being *alone* with Marilyn, if any man views any other man as undesirable competition (and the way Mailer and Miller tear each other apart in print would seem to suggest that this is so), then Marilyn and the movies are incompatible. For the movies can never allow privacy or sole possession. Everyone in the theater is getting the same thing you are; you are all in it together. This is especially true of comedy, where the communal laughter affirms the feeling of a group. The heart of *The Seven Year Itch*'s comedy— its violation of a man's private fantasies—is what makes it so unfunny. Wilder is attacking the very premise that supposedly makes Marilyn a star: the suggestion that she can simultaneously yet privately make love to every man in the audience. It's an attack calculated to make both men and women uncomfortable, because it gets at the root of our feelings about fantasy, sexuality, desire, and performance.

By withholding from *The Seven Year Itch* any leading man who would be worthy of Marilyn, Wilder leaves her available to the audience. But the audience can't really possess her, so the result is romantic frustration. Wilder recognized the problem, apparently, because he rectified it in *Some Like It Hot,* where a very attractive man (Tony Curtis) eventually gets Marilyn. Yet he's a man who spends most of the movie dressed as a woman, and who performs his climactic romantic scene—kissing Marilyn in front of hundreds of people, and finally being recognized by her—while still in his female disguise. The cross-dressing in *Some Like It Hot* is far from a casual comedy technique. It gets at a central truth about film, the same truth that *Niagara* pointed out when Mr. and Mrs. Cutler both watched Marilyn walk

away: if a woman is to be sexy in the movies, she has to simultaneously seduce the men and the women in the audience. The fact that this seduction does not entail real sex is also crucial. It's a public experience rather than a private one, and it hinges on our ability to imaginatively transform ourselves (from women to men, from observers to participants) through witnessing the transformation of others. Our relationship with Marilyn can only be as real as Jack Lemmon's with Joe E. Brown. It can't stand up to marriage or even sexual intimacy, but it *can* be a lot of fun.

The connection between actors and transvestism is as old and honorable as classical Greek drama, the Elizabethan stage, and the Japanese Noh theater. To act in plays is to be able to dress as a woman, if you are a man. If you are a Method actor, that means "finding the woman in yourself" (as Dustin Hoffman says he did in *Tootsie*). If you are a British-style actor, it may mean just putting on the right clothes, gestures, and voice. This is what the characters played by Tony Curtis and Jack Lemmon initially think they're doing: they're disguising themselves as women to escape from the murderous gangsters. (If we wonder what the gangster subplot has to do with the sexual plot of *Some Like It Hot,* we need only remind ourselves that the massacre witnessed by Lemmon and Curtis took place on St. Valentine's Day. Tony Curtis, in particular, must temporarily become a woman before he can end his protracted gang war with the whole female sex.) But if they start off merely putting on a disguise, they rapidly find themselves plunged into the maelstrom of Method acting. When Tony Curtis first makes the phone call to arrange their joining the female band, his face, even without makeup, takes on the prim, prissy appearance of the "Josephine" he's about to become. He enters the role, performing it visually even over the telephone. And Jack Lemmon becomes so involved in *his* female role that Curtis (who has earlier told him, "Remember, you're a girl") eventually has to warn him "Remember, you're a man" ("I'm a man, I'm a man, I'm a man," Lemmon moans to himself, trying to drill it in).

Jack Lemmon in drag makes a very unlikely looking woman (as opposed to Tony Curtis, whose masculine beauty can be made to seem quite feminine), but it is Lemmon who really becomes transformed in this movie. He's the one who develops a sisterly relationship with Marilyn while Curtis is out seducing her in double drag (male clothes on top of female clothes on top of a male body). It's Lemmon who

falls in love with—or at least falls in with—Osgood, the millionaire yachtsman played by Joe E. Brown. Lemmon's acquiescence to Brown's advances, his ambiguousness or doubleness in the face of male desires, is a version of Marilyn Monroe's behavior with men. We can't tell, watching Lemmon's face, whether he's enjoying being with Brown or just responding to Brown's own desire; that question, for him as for Marilyn, is moot. He's been talked into this position initially by his pal Curtis (as the passive, victimized member of the pair, he's already the female half of *that* couple), but he carries his role beyond its necessary limits, becoming truly attached to the idea of marrying Brown. "I'm engaged!" he joyfully announces to Tony Curtis when Curtis returns from his first night with Marilyn. "Congratulations!" Curtis responds. "Who's the lucky girl?" "I am!" says Lemmon. His response has the same kind of ingenuousness, sincerity, and witty distance from the self that characterizes all of Marilyn's humorous roles. Not only has he become a woman; he has become Marilyn Monroe.

When they get on the train together to join the other girls, Tony Curtis (Joe) announces that he's Josephine, and Jack Lemmon (Jerry), who's supposed to be Geraldine, forgets and says, "Hi! I'm Daphne," as if Daphne is the real female buried inside him, the one who pops up unexpectedly, not the superimposed Geraldine disguise. Daphne is just a funny name in Hollywood terms. But it's also the name of the mythical woman who was nearly raped by Apollo and was transformed, for her own protection, into a tree. Rape—or at least having to deal with unwanted male attention—is inherent in being a woman, as Josephine and Daphne soon discover when the aging millionaire and the pint-sized elevator boy make passes at them in the hotel. And being turned into a tree is somehow weirdly connected with Marilyn. In *After the Fall,* Quentin says of Maggie: "she was just *there,* like a tree or a cat." In *The Misfits,* Marilyn walks out of a house where a man (Eli Wallach) has just tried to force a kiss on her, and embraces a tree. There is also Marilyn's exchange with Eli Wallach about his dead wife: "She stood by me one hundred percent, uncomplaining as a tree." "Maybe that's what killed her." There is even, perhaps, Norman Mailer's image of the "twin trees" of the divided soul. So the Daphne myth is another if more mysterious connection between Lemmon and Monroe, another signal of the fact that Lemmon's transformation is more complete than Curtis's. (We also get that idea from

the final chase scene, which Lemmon does entirely in high heels, though both men are otherwise back in male garb. To run from gangsters in high heels is truly to have mastered the art of being female.)

If Lemmon is the male figure who comes closest to being female, he is also the movie's comic center, the guy who gets all the funniest lines and scenes. The two are not unrelated. The movie's humor involves seeing things from a position of greater knowledge: the more you know about the real situation (especially in comparison to the blinkered participants), the more you're able to find it amusing. Lemmon, being both male and female, has the greatest perspective on the sexual battles: like the audience (which is also both male and female, consisting as it does of men and women), he seems to have the kind of knowledge one can get only from sitting on the sidelines. Lemmon is the one who makes the jokes and plays the scenes that seem most directly aimed at the audience. As they get on the train to join the band, Tony Curtis tells the manageress, "We're the new girls," and Jack Lemmon adds, "Brand new." This is a joke aimed at Curtis but also at us—and only we can appreciate (because Curtis by that time isn't present) how much of a kick Jack Lemmon really gets out of his "brand new" self, the wild party girl who dances the tango all night with Joe E. Brown. Jack Lemmon may be a bit aggressive compared to the passive feminine ideal—"She's so eager!" Joe E. Brown gloats, and also warns, "Daphne, you're leading again"—but, as the movie says, some men like them hot.

The balance of aggression in the Daphne/Osgood relationship is no less lopsided than that between Marilyn's Sugar Kane and the Cary-Grant-like millionaire Tony Curtis is pretending to be. Intercut with scenes of Jack Lemmon leading in the tango, a rose gripped forcefully between his teeth, are the scenes of Marilyn on the yacht attempting to "cure" Tony Curtis of his purported frigidity with her steamy kisses. ("It's like kissing Hitler," Tony Curtis apparently commented during a screening of this scene. He was ostensibly expressing his anger at Marilyn's difficult behavior on the set, but the remark also seems to describe the oppressive, inescapable quality of her sexuality, and—coming from an American Jew—makes an interesting pendant to Miller's use of concentration camps as the background for *After the Fall*.) Like Lemmon's and Brown's, Monroe's and Curtis's relationship is about role reversals—only here it's a woman who goes after a "fake"

man (he's not, after all, either Cary Grant or wealthy) rather than a man who goes after a fake woman.

Tony Curtis's assumption of the Cary Grant voice is funny in several ways. It's another allusion to the movies ("And where did you get that phony accent? Nobahdy tawks loik thaht!" says Lemmon irately, but we know he's wrong: in the movies, one person *does* talk like that), and specifically to Marilyn's one movie with Cary Grant, *Monkey Business,* in which she played the dumb-blonde secretary opposite Ginger Rogers's smart, classy version of the wife. By extension, it's also an allusion to all the relationships between men and women in the old screwball comedies, where the hero was a suave fellow like Cary Grant or William Powell or Clark Gable. But there's a big difference between those films and *Some Like It Hot.* In the older movies, the heroine was generally upper-class, and the hero was either of her class (*The Philadelphia Story, My Man Godfrey, The Awful Truth*) or some roughneck or egghead whose manner was suave enough or endearing enough to raise him to her class (*The Thin Man, It Happened One Night, Bringing Up Baby*). In *Some Like It Hot,* the relationship is between two low-class types, Monroe and Curtis, each of whom is trying to fool the other into believing he or she is rich. It's as if, in *The Palm Beach Story,* Claudette Colbert and Joel McCrea were to think they were playing opposite Rudy Vallee and Mary Astor when really they were only playing opposite each other. Curtis knows more than Monroe, but he doesn't know everything—hence our laughter, at his expense, about his ignorance of upper-class life (he says the marlin over the mantel is a variety of herring, believes water polo is played with ponies, and so forth). Marilyn doesn't catch these *faux pas,* but we do; the obliviousness of both characters to the humor of the situation is largely what makes it funny.

Recognition and the failure of recognition are key plot elements in *Some Like It Hot,* providing both the moments of sharpest humor and the moments of greatest psychological depth. There's a lovely scene when Jack Lemmon first runs across Tony Curtis in his Cary Grant get-up: he begins to walk away, and then does an exaggerated double-take. The ensuing conversation, full of double-entendre remarks between the men, is all for our benefit; Marilyn, who witnesses it, hasn't a clue. Marilyn never does see through Tony Curtis's disguises, despite the fact that Lemmon (who knows him well) and the gangsters (who hardly know him at all) see through them almost instantly. It's not

until he kisses her in his Josephine disguise that it finally dawns on her what's been going on. The point appears to be that people in love don't see each other very clearly. It's not a mistake confined to women: Joe E. Brown makes a similar error with Jack Lemmon. Brown's classic remark when he learns Lemmon is a man ("Well, nobody's perfect") would seem to suggest that the error isn't really all that important. In the movies, at least, gender differences are only a kind of minor disguise. Their unmasking is a useful source of humor but of very little value in the arena of romance.

Throughout *Some Like It Hot,* there's a running joke about Type O blood. At first, it's a joke between Curtis and Lemmon (it refers back to some lie they had to tell a woman), but eventually it gets broadened beyond that, becoming a private joke with the audience. Alone on the yacht with Marilyn, for instance, Curtis tells her he has Type O blood, and we're the only ones present who are capable of getting the joke. To a certain extent the joke is just that: the kind of meaningless repetition that gains its power purely by dividing those in the know from those who don't get it. But I can't help seeing it as something more. We all have blood in our veins, and it *looks* the same in every-body, but there are actually life-or-death differences—not, significantly, according to gender or other obvious distinction, but according to the invisible blood type. Type O makes you a "universal donor," a person who gives to everyone—which, at least on an emotional level, is what Marilyn's film character was often expected to do. And Type O is the most common type, as the comedy is a "common" type of movie, and as jazz—the musical background to this film—is "com-mon" rather than classy ("Well, I suppose some like it hot; I prefer classical music," says the disguised jazz-saxophonist Tony Curtis to Marilyn, in his pretentious Cary Grant voice). Marilyn, too, is com-mon stuff—not the class act of a Myrna Loy or an Irene Dunne, but the little girl from a poor home. (Sugar Kane, she tells us, started out as Sugar Kowalchik.) She's common but essential, like our blood, and the power of her acting, despite its blatant superficiality, is really all on the inside—again, like blood. And yet when she or anyone else tries to gaze inside at the source of that power, nothing can be seen, nothing can be pointed to. "I could register in the hotel as Miss None," Maggie says to Quentin in *After the Fall.* "N-u-n?" he spells out. (Miller had his own obsessions to contend with.) "No—'n-o-n-e' —like nothing," she replies. "I made it up once 'cause I can never

remember a fake name, so I just have to think of nothing and that's me!" Miss None, Type O: we've come back around again to the empty circle, the woman who is nothing when she's not playing at being an actress.

With appropriate circularity, Marilyn's first and last important roles were in two films directed by John Huston, *The Asphalt Jungle* and *The Misfits. The Asphalt Jungle,* which came out in 1950, was not her earliest film, but it was the first screen appearance in which she attracted any attention. Actually, she's only onscreen for about ninety seconds of the movie. But Huston not only uses her well during that time; he also constructs much of the rest of the movie around the *idea* of women like Marilyn, sexy women whom men think exist to be looked at. Thus Doc Riedenschneider, the pivotal character behind the jewel-robbery plot, has an Achilles' heel: he likes to look at pretty girls. Early on, we see him snatch a glimpse of a pin-up calendar when he's alone in a room for a moment, having just gotten out of prison; in the end, he gets captured by the police because he waits a few extra minutes to watch a girl dance to a jukebox. So the entire movie surrounds Marilyn's ninety seconds with tremendous pressure on the idea of the luscious, photogenic dame; and she embodies that character for the brief time she's visible to us. Like Doc, we have to snatch our glimpse of her before Huston snatches her away. He understands the narrative limitations of cheesecake: "Why should I buy it?" says a peripheral character after leafing through a girlie magazine. "I already seen all the girls in it."

As the title emphasizes, the movie is about the cold, hard city, where the blood-surging vitality that one might normally associate with the jungle's dangers takes on a dead, mechanical quality. In this movie, the nicest people have strong feelings about animals: Gus the bartender likes cats, and Dix (the male lead) loves horses. During her brief time onscreen, Huston stresses the animal side of Marilyn. We first see her asleep on a couch, curled up like a cat; and when she awakens she stretches, again like a cat. Nor are men unaware of this "animal thing" she has (as the Tom Ewell character calls it in *The Seven Year Itch*). Sent to interview her for an alibi for her wealthy mobster boyfriend, a cop returns to the station to report to his sergeant. "How did she impress you?" says the sergeant. "Very much," says the cop. "I mean, was her manner straightforward?" the sergeant says exasperatedly. "Well, I guess she was telling the truth," replies the patrolman. Here,

in miniature, is the question that was to dominate her film career: what is the source of Marilyn's apparent sincerity? Is it her body that makes us believe her words, or is it her body that makes us mistrust them? The movie also contains a small scene introducing Marilyn's tendency to divide and conquer, to achieve her aims by sowing competition between men. "Do I have to talk to him?" she says to one of the arresting officers. "Couldn't I just talk to you?" And she is, as always, the actress following a script. "Was it true?" the arresting policeman says about the alibi she earlier provided. "No, sir," she answers. "He told you exactly what to say and made you learn it by heart," he prompts. Marilyn agrees ("I mean, yes, sir") after bursting into tears. Men write her lines and she says them.

This feeling—of Marilyn trapped in a script created by men—so overwhelms *The Misfits* as to make the movie viscerally oppressive. In a screenplay written by her soon-to-be-ex-husband, Marilyn plays a character named Roslyn (not too distant from her own real name) who, after getting a divorce in Reno, takes up with three underemployed cowboys played by Clark Gable, Montgomery Clift, and Eli Wallach. She is thus placed in her usual situation (in life as in the movies) of playing off one man against another, acting the daughter/lover to one (Clark Gable) as she auditions for the role of mother/lover to another (Montgomery Clift, who lies in her lap like a Pietà Christ and who mistakes her for "Ma" when she covers him with a blanket). It's probably the most static film ever directed by Huston (prior to *The Dead,* that is—another film shaped around a woman's presence as felt and responded to by the men who love her). It is as if the presence of a central female character weighs down the action, confining most of it to interiors, backyards, and parking lots. Only in the mustang-chasing scenes (where Marilyn's role, though significant, is small—she stands at a distance and shrieks hysterically about the men's cruelty) do we feel the usual Huston pacing, the usual sense of men in conflict with one another and with the environment. For the most part, the movie lacks energy: like Marilyn herself, it almost seems to be sedated.

The role Marilyn plays in this film is at once uncharacteristic and uncomfortably close to her real-life self. She is thinner than in the Billy Wilder films, her hair is longer and straighter, and she wears very pale lipstick instead of her usual dark red; like the film (which is shot in black and white), she seems to be portraying a colorless, leached-

out version of herself. The ditzy-dame role, previously Marilyn's terrain, is here handed instead to Thelma Ritter, who plays a combination of down-to-earth female and flaky "character." Her name in the movie is "Is"—just like Arthur Miller's father. In his autobiography, Miller describes a moment of childhood embarrassment when, applying for a library card, he is afraid to say his father's name, the obviously Jewish "Isidore" or "Izzie," and settles instead for "Iz." The librarian looks puzzled. "'Is?' she asked. I nodded. 'Is what?'" That's the kind of question Roslyn, the Marilyn Monroe character in *The Misfits,* asks about every aspect of life, including herself—but the Thelma Ritter character just *is.*

Unlike Marilyn's other roles, even the kittenish one in the equally dark *Asphalt Jungle,* Roslyn hasn't a shred of oblivious humor. Everything she says or does seems utterly self-conscious, utterly serious and "felt." Even a supposedly blithe moment, like the one when, clad only in a bathrobe, she walks and then runs in and out of the house, saying to Clark Gable, "I can go in . . . and I can go out . . . ," has the pressure and symbolism of a rat caught in a maze. The native sense of self-exposure that we feel in Marilyn's other movies combines here with the horribly self-conscious lines of dialogue to produce a terrible feeling of unease. If Miller was trying for a movie that for once would bring out Marilyn's tortured soul at the expense of her cheerful body, he may have succeeded. It's in that success that the movie's failure lies, for the double Marilyn, the one hiding behind the other, is missing here.

Some of the parallels between real life and this movie were beyond Miller's control. He did not foresee, when he began work on the screenplay, that his own marriage to Marilyn would be breaking up in the course of the shooting, lending added weight to the general sense of divorce and dissolution. Nor, he says in his autobiography, did he design the role of Perce specifically for Montgomery Clift. Still, there's something quite unnerving about hearing the recently sewn-together Clift—the man who essentially had to be given a new face after a serious auto accident—say in a phone conversation with his mother, "My face is fine, just as good as new." With Marilyn's character the overlaps with life were far more obvious and intentional. Miller gives Roslyn an excessive sensitivity to animals' pain, a delight in fixing up a decrepit old country house, an orphan background, an incomplete high school education—all characteristics which, as Miller

says in *Timebends,* belonged to Marilyn herself and to her life with him. He also steals from his own conversations with Marilyn at least one crucial exchange between the Gable and Monroe characters: "You're the saddest girl I ever met." "You're the first man that ever said that." And he gives her the profession of performer—specifically dancer, about which he has her say, "Little by little it turned out that people ain't interested in how good you dance. They're gawking at you for something else entirely." No wonder Marilyn had doubts about taking this role; no wonder she grew angrier and angrier at Miller for putting her into this centrifugally disintegrating plot. When he says in his autobiography that "the work I had created to reassure her that a woman like herself could find a home in the world had apparently proved the opposite," we don't know whether to criticize him for his disingenuousness or for his obtuseness.

Perhaps the most depressing aspect of the film, at least from Marilyn's point of view, is the equation it sets up between women and horses—in particular, between women like Marilyn and the wild mustangs that are gradually dying out. Just after the famous scene in which Marilyn, wearing a bright polka-dot dress, repeatedly bats an elasticized ball (swinging her hips in time with the batting motion) in front of an audience of cheering cowboys, the rodeo loudspeaker announces that the next horse—the only named horse in the film—will be "Polka Dot." Shortly after we've learned that the few remaining mustangs are used for canned dog food, the Montgomery Clift character says about Nevada life: "I don't like to see the way they grind up women out here." This movie has the requisite scene of a man (Clark Gable) watching Marilyn's hips swing from side to side as she moves away from him; but this time she is sitting on horseback, so the sway is actually due to the horse's walk and not to her own. Given the fate of the horses—their sadly reduced numbers, their debased use as dogfood, the end of their once-exhilarating life in the wild—the application to Marilyn's own situation can only seem sinister. When Eli Wallach toasts her with the line, "Here's to your life, Roslyn; I hope it goes on forever," post-1962 audiences can only shudder at the irony. But even at the time it was written, Marilyn had already tried suicide several times. And nobody's life goes on forever: even Marilyn was mortal.

The fact that *The Misfits* is actually about her mortality comes through in a couple of the movie's lines. At one point Eli Wallach

says, apropos of nothing, "That star is so far away that by the time the light from it reaches us, it might not be there anymore." That, indeed, is the effect of *The Misfits:* the "star" who played in it ceased to exist the year after it was made, but we still see her, as if alive, every time we watch the movie. At the film's end Clark Gable says, "Just head for that big star straight on. The highway's under it. It'll take us right home." As the last lines in the movie, they are meant to have a consoling, comforting sound. But to use a star as a signpost is to aim, in some sense, for heaven; "home" thus carries an ominous Dickensian resonance, an undertone of death. The line must also have seemed ironic for Marilyn herself, to whom stardom had provided the only direction in her life. She, above all, must have known how illusory such a signpost could be. And if she did not feel this, then we, watching *The Misfits,* nonetheless imagine her feeling it.

Arthur Miller was aware, when he wrote *The Misfits,* of the extent to which it was partly a commentary about the myths and illusions created by movies—and, by extension, created by Marilyn herself. He had first begun to develop the idea for the story four years earlier, while waiting outside Reno for his divorce to come through so he could marry Marilyn. At that time he met some of the cowboys who gave him the basis for the male characters in the film. But it wasn't until it was actually made into a movie that he fully understood what the story meant to him. "Four years later," he says in *Timebends,*

> one of these men showed up on location when we were shooting *The Misfits,* and after a good reminiscing talk, he watched from beside the camera as Clark Gable happened to be telling Marilyn some details of his character's past, which I had drawn from this cowboy's life. When the scene was finished he turned to me shaking his head, excited and pleased: "Sounds real as hell." But he clearly showed no sign of recognizing his own biography as the source, or even the possibility of such a metamorphosis. Nevada thus became a mirror to me, but one in which nothing was reflected but a vast sky.

For "Nevada," Miller might almost have substituted "Marilyn." She was his mirror, the alter ego into whom he gazed seeking the answers about himself, as she did into him, "with the hope of being transformed by our opposite, as light longs for dark and dark for light." Repeatedly in his art he associated her with mirrors. In *The Misfits,* we first see her as she sits at a dressing table, looking into a mirror

and muttering unintelligibly to herself as if rehearsing lines for a role. (She is in fact rehearsing her testimony for the divorce court.) Later in the same film she walks into Harrah's for a drink, and the camera seems to be tilted at an odd angle, with Marilyn framed and isolated by bars or posts. Then we realize we're seeing her reflected in a large mirror—it's the mirror, and not the "unmediated" camera eye, that tips and isolates her. Yet she's not a creature that can be seen undistortedly, in any more direct fashion. She's like a ghost that can only show up in mirrors. (We might think of the Cutlers speaking about Marilyn Monroe and Joseph Cotten in *Niagara*—"We wait three years for a honeymoon and spend it with a couple of spooks"—and we might also recall that the Elizabethan word for actors was "shadows.") Miller's connection between mirrors and Marilyn is even stronger in *After the Fall*, where he says in one stage direction: "*Maggie is nervous, on the edge of life, looking into a mirror.*" Elsewhere she is "*turning herself, wide-eyed, in an unseen mirror.*" The mirror was the only place Marilyn could look to try to find the excitement and allure others saw in her, the only external answer to that sense of a missing self. But the mirror, like the movie camera, could offer only appearances. It could never really confirm that there was something inside the image.

For Norman Mailer, Marilyn represents a different sort of mirror, a set of correspondences and similarities rather than oppositions. He sees her as the ultimate divided soul, the "twin trees," the "double psyche"; but he himself is certainly the most self-conscious practitioner of the category, with his self-critical interruptions in *Advertisements for Myself*, his division between Historian and Novelist in *Armies of the Night*, his separate incarnation of Western and Eastern voices in *The Executioner's Song*, and even his intrusion—as the smart, dissatisfied, self-undermining Playwright character—into the action of the otherwise banal *Strawhead*. Arthur Miller says angrily about Mailer's version of Marilyn: "If one looked closely, she was himself in drag." I doubt that Mailer would totally disagree. In *Marilyn*, he strings together a series of exaggerated, sometimes insulting labels for Marilyn, ending with: "In her ambition, so Faustian, and in her ignorance of culture's dimensions, in her liberation and her tyrannical desires, her noble democratic longings intimately contradicted by the widening pool of her narcissism . . . we can see the magnified mirror of ourselves, our exaggerated and now all but defeated generation." He might appear to be talking about a whole generation of Americans, but Mailer's

own self-conscious narcissism insures that he's really talking primarily and astutely about himself. He suggests no less a few pages later when he comments (with the typical use of third person, the self-divided distance from self): "For a man with a cabalistic turn of mind, it was fair and engraved coincidence that the letters of Marilyn Monroe (if the 'a' were used twice and the 'o' but once) would spell his own name leaving only the 'y' for excess." Part of what is humorous in this convoluted mirroring is that it leaves out the most obvious parallel: that between Marilyn's original first name, Norma, and the author's own first name.

Norman Mailer clearly viewed Marilyn Monroe as some sort of reflection—not only of all men's desires ("She is a mirror of the pleasures of those who stare at her") but of his own particular obsessions. Because of that, his 1973 book on Marilyn eerily foreshadows the better work to come—in particular *The Executioner's Song,* which shares with *Marilyn* not only the initial collaboration with Larry Schiller, but also the mixture of "true-life" and novelistic materials, the introduction of the idea of reincarnation, the sense of an impending and at least partly desired death, and, most of all, the feeling of an intense connection between the book's dead subject and the author who never met that subject. That the greatest sex goddess of the 1950s should come to resemble, in Mailer's hands, the most notorious criminal of the 1970s may say more about Mailer than about anything else; but it does, at least, testify to his ability to find monumental figures as his obsessional mirrors. And if, as he says, film does bear a resemblance to death, then Marilyn Monroe might well be seen as a version of Gary Gilmore—if in nothing else, then in the degree to which both finally became pure features of the media, drawing their tenuous existence only from the dreams, fears, and illusions of others. For Mailer, the great irony is that he should see himself reflected in these two, should find his identity in people who are, by his own description, identity-less. In the case of Marilyn Monroe, it may well be that very lack of identity which makes her the perfect mirror for all of us. For, perceiving the tremulous, beseeching absence of a self, our own self rushes in to fill the void.

Stanwyck

10 Barbara Stanwyck is the exception to the elegant, aristocratic standard that prevailed among the "smart" Hollywood heroines of the 1930s and 1940s. In the movies of that era, there were essentially two ways for women to be powerful: overtly (as in the case of Irene Dunne, Rosalind Russell, Katharine Hepburn, Myrna Loy, and Claudette Colbert) and covertly (as in the case of Carole Lombard, Jean Arthur, and—in some roles—Hepburn and Loy, where the intelligence lay precisely in their ditzy-dameness, their unpredictable literalness). Barbara Stanwyck would seem at first to belong to the former category. But she lacks the aristocratic polish, the shiny veneer, of a Colbert or a Dunne (even when such women play down-and-outers, as Colbert does in *The Palm Beach Story,* they come across as upper-class women temporarily short of funds); and she lacks the easy hardness that Russell brings to her role in *His Girl Friday,* or Hepburn to her part in *The Philadelphia Story.* Stanwyck's relationship to the camera is far more intimate, less "actressy," less glamorous. She's capable of playing aristocratic glamour (as in *The Lady Eve*) or hardness (as in *Double Indemnity*), but when she does so the role always seems to be a superficial mask imposed on her real self—a characteristic the directors of those two movies show themselves to be aware of, as they use it centrally in their plots. More than any other actress of the period, Stanwyck seems to be revealing herself when she acts. Yet the quality of vulnerability this creates is not the soft, victimized, helpless vulnerability of a Marilyn Monroe. It is, instead, a fully conscious and intentional vulnerability, a courageous willingness to embrace even the painful aspects of experience, an openness comparable to that of Charlotte Stant in *The Golden Bowl,* who accurately says of herself: "I risk the cracks."

I cannot imagine any of those other actresses in the title role of

Stella Dallas. But then, before I saw the movie, I couldn't imagine Barbara Stanwyck in it either. My vision of Stanwyck had been dictated by later movies—*Ball of Fire* and *The Lady Eve,* with their wisecracking heroines, and *Double Indemnity,* with its coldly repressed murderess. I couldn't imagine the actress who played those parts cast in the role of a self-abnegating mother, a tear-jerking participant in a "women's weepy." For my vision of *Stella Dallas* had also been dictated in advance, primarily by two sources of information: on the one hand, casual and embarrassed references to it by people who confessed to wallowing in its sentimentality; and, on the other hand, the recent feminist critics who have adopted this film as their whipping boy. To critics like Mary Ann Doane, E. Ann Kaplan, Robert Lang, and (to a certain extent) Linda Williams, *Stella Dallas* represents the triumph of conventional "patriarchal" values. In their view, the movie succeeds by making us feel that Stella is right to give up her daughter, that her despicable lower-class vulgarity will otherwise infect the child's life, and that this kind of self-sacrifice is simply what male-dominated society expects of good mothers. Stella is thus "made to desire her own repression" (in Lang's words), reduced at the end of the movie to a "contented and passive spectator, weeping but nevertheless recognizing and accepting her position on the margins of the social scene" (as Doane says). The implication is that, despite our own tears, we approve of this banishment, and are made to approve of it by our identification with the oppressive patriarchal order.

I expected to cry at the end of *Stella Dallas*—perhaps to be forced, furiously, into crying, as I had been by other parent-sacrifice movies like *Kramer vs. Kramer* and *Terms of Endearment,* both of which I disliked. What I did not expect was to see a wonderful movie. King Vidor's 1937 *Stella Dallas,* a remake of an earlier silent film by another director, is so subtle an exploration of women's roles and women's relationships that it has yet to be surpassed, even by a good woman director like Gillian Armstrong (with whose *High Tide* it has affinities). Especially in the scenes involving two women together (Stella and her daughter Laurel, or Stella with Laurel's new stepmother, Helen), the feeling of the film is so intimate that one not only doesn't sense the presence of "patriarchy"—one doesn't even sense the presence of a male director. Vidor achieved this, I think, largely through the use of Barbara Stanwyck, whose intimacy with the movie audience brings to the character of Stella a very special kind of power: the power and

the courage of self-exposure. Throughout the movie, Stanwyck, or Stella (the two become strangely indifferentiable), seems to be both acting a role and being thoroughly herself—not alternately, but simultaneously. In fact, the whole idea of putting on a role, and the comparative transparence of various people's built-in roles, end up being partly what the movie is about.

If Stella is an embarrassment to everybody else in the movie, one of the reasons is that she makes this process of constructing a self so obvious and so intentional. She reveals the "acting" that lies beneath all of their behavior, and yet she does so in a blessedly unreserved way, without manipulation or skill—in other words, in a way so deeply true and undeniable that it gets everyone else's back up. From her introductory scene, in which she hangs around her front fence all dressed up and reading a book, waiting to catch the eye of the well-born Stephen Dallas, we know that Stella is someone whose deceptions will be transparent and often unsuccessful. The effort in this case is so obvious that her rather dopey brother teases her for it, yet not obvious enough to attract the attention of the oblivious Stephen. (William Rothman, *Stella Dallas*'s best critic, accurately characterizes Stephen by quoting a remark from the second Mrs. Dallas: "'Couldn't you read between the lines of that pathetic note?' she asks Stephen, who is singularly incapable of reading between any lines.") When Stella does finally succeed in getting Stephen to look at her, it's after a series of small but carefully prepared subterfuges that involve bringing her brother's lunch to the factory where he and Stephen are both employed (her brother in the works and Stephen, naturally, in the front office). As we watch Barbara Stanwyck calculate her responses and gestures, we get some of the complicitous pleasure we always get from watching Stanwyck set up a man—as she does, for instance, with Henry Fonda in *The Lady Eve*. But here the calculation is so childlike, so mingled with unreserved and natural responses (for instance, her caressing his jacket when she's alone in the office—because the material is beautiful and expensive? because it reminds her of him? we can't be sure), that our sense of complicity is mixed with a more distant sense of amused pity, or possibly wry condescension. These early scenes are the ones that set us up to feel superior to Stella—not only in terms of class, but in terms of our ability to mask our feelings and deceive successfully (which is seen, in this film, as a function of class).

That split between us and Stella becomes even more marked when

she and Stephen go to a movie on one of their early dates. When characters in a movie go to a movie, one can generally assume that some point about identification is being made: we watch them watch a movie, and their reality mirrors ours. But the striking thing about the movie scene in *Stella Dallas* is that the audience—the *real* audience watching King Vidor's movie—generally succeeds in missing the point. We become as oblivious as Stephen. (Perhaps obliviousness is also a function of class.) We are shown a set of actors behaving in a typical-movie upper-crusty fashion, and we are shown Stella wishing to be like these characters. "I don't want to be like me," she tells Stephen after their movie date, "not like the people in this place, but like the people in the movie—you know, doing everything well-bred and refined." Stephen's answer is essentially what ours would be, what our sophisticated, refined sensibility tells us: "Stay as you are, Stella. Anyway, it isn't really well-bred to act the way you aren't." Yet his later gripe against her is precisely that she fails to become something other than herself, that she resistantly refuses to be well-bred. After they're married, when he wants her to fit into his rising-executive life, Stephen tosses this wish back at her: "Once a long time ago you said you were crazy to learn everything, *become* someone . . . I want you to make an effort . . . Give up a few things, try to adapt yourself." "How would it be for *you* to do a little adapting for a change?" she retorts.

We may applaud her retort, but to the extent that we laugh at Stella's vulgarity—at her grammar ("An affair between Spencer Chandler and I!" she exclaims), at her working-class accent, at her increasingly overdone outfits, her loud, unrefined voice, and her forceful, unladylike walk—we are siding with the film's aristocrats. We look down our noses at the life Stella creates for Laurel—an apartment rather than a house, only one servant or even none, public school, home-made dresses; life without expensive frills—and think instead of Helen Morrison's country mansion, horses, vast acres, and Manhattan townhouses as "our" sort of existence, complete with "our" social manners. In fact, I grew up in a house much more like Stella's and Laurel's: a single-parent family, not a lot of extra money to spend, certainly no horses or country acres. I'd be willing to bet that far more than half of Vidor's movie audience in 1937, and certainly most of the people who have seen the film since then, lived in economic and social conditions closer to the adult Stella's than to Stephen's and Helen's.

Yet I—they—we nonetheless identify with the rich folks; not necessarily with their behavior in plot terms, their mistreatment of Stella, but with their manners and their place in the social order. We see ourselves as their social equivalents because the movies have taught us to do so. Only Stella has enough sense of self to realize the distance between the refined-sounding well-bred characters in the movie— the people she would initially like to resemble—and the person she actually is.

Feminist critics who notice this problem have a tendency to imagine they are perceiving something that King Vidor didn't. The film's "ambivalences and contradictions are not cultivated with the intention of revealing the work of patriarchal ideology within it," insists Linda Williams. "Modern viewers may find these scenes embarrassingly crude in their idealization of upper-class life," says E. Ann Kaplan, "but within the film's narrative this is obviously the desired world." To make such remarks is to deny one's own involvement in crude idealizations—an involvement without which this movie, and indeed most movies, wouldn't work at all, and which Vidor very intelligently manipulates. The critics' condescension toward him can't help sounding, under such circumstances, like Stephen's condescension toward Stella.

It seems the fate of Barbara Stanwyck to be paired with men who start off seeming merely naive and rapidly deteriorate to pomposity, self-righteousness, and downright betrayal. This is true of Henry Fonda in *The Lady Eve,* and, in a very different way, of Fred MacMurray in *Double Indemnity:* they look like pretty good catches to begin with, but their characters aren't strong enough to survive the pressure of the kind of truth Barbara Stanwyck emanates, and each eventually takes up with another, easier, more conventional woman. (In *The Lady Eve* that "other" woman is also Barbara Stanwyck.) Stephen Dallas (played by John Boles, who portrayed a similarly unappreciative man opposite Irene Dunne in John M. Stahl's 1932 *Back Street*) is one of these men. He's flawed but not evil, and Stella's tragedy, if it is indeed a tragedy, cannot be laid entirely at his doorstep. She, after all, wanted to marry him more than vice versa—and she, being the stronger character, got her way. When she says after they see the movie, "I want to be like all the people you've been around— well-educated and speaking nice," he pretends to disapprove but he's really flattered. She, on the other hand, may or may not be telling the

truth: by this time she's so far into her pursuit of the role of Mrs. Stephen Dallas that it's not clear to either her or us when she is acting and when she's being sincere. The point, with Stanwyck, is that both can be true at once. So when Stephen tells her, "It isn't really well-bred to act the way you aren't," he's showing a deep misunderstanding of many things—not only the extent to which training in how to "act," in manners and speech, makes people into what they "are," but also the unseverable connection, for both Stanwyck and Stella (for Stanwyck *as* Stella), between "acting" and "being."

Robert Lang's desire to see Stephen as the villain of this film is so pronounced that he actually misquotes the line as, "It isn't really well-bred to act the way you feel." He wants Stephen, the capitalist male, to be the outspoken agent of repression all the way through, from his first appearance in the town of Millhampton (the opening scene's music "conveys a lively sense of industry and, befitting a melodrama, seeks to present a picture of the world before the villain enters it," says Lang) to the film's end (where it establishes "an older, reassuring order, of villains and figures of virtue, upper classes and lower classes"). According to Lang, Stephen himself may not be personally at fault, but his type certainly is: "Society—bourgeois ideology itself—is the villain, even though its ideal as represented by Stephen and the Morrisons is not unattractive." This attempt to salvage the worth of *Stella Dallas* as social commentary saves the villagers by destroying the village, in that one of Vidor's more obvious points would seem to be that typing by class is an insufficient way to see people. Lang's view also denies (though he wavers a bit in that "not unattractive") the extent to which we, as movie viewers, identify with Stephen's and Helen's upper-class behavior. The film's use of "audience identification" is far more complex than Lang grants in his use of that phrase. Vidor enables *Stella Dallas* to turn us against ourselves, paving the way for a whole questioning of the idea of "identification," the idea of dividing the world sharply into "like us" and "not like us."

Most critics, for instance, seem to think that we identify easily with Laurel, the innocent young daughter for whom Stella makes the maternal sacrifice. Laurel, they imply, is the naturally aristocratic, classless equivalent of an intellectual (in other words, she is "like us," the critical-theorist filmwatchers). "The film finally endorses a dubious genetics according to which Laurel inherits only the best from both parents, while each parent remains in the class into which he or she

was born," says Lang. Doane insists that "the separation between mother and child is ultimately predicated upon this lack of proportion on the part of Stella, the fact that she is an embarrassment to Laurel, who has outstripped her mother in the social arena (inheriting her refinement, no doubt, from her father)." Though she's snide about what Lang calls the film's "dubious genetics," Doane nonetheless assumes that we are meant to side with Laurel—that Stella's "lack of proportion," rather than Laurel's teenage "embarrassment," is at fault. Even William Rothman, whose reading of this film is sensitive and astute, uncharacteristically misremembers a Laurel-related element of the plot: he assumes she has gone "off to college," where, "at the end of the term, Stella visits her daughter and, with her vulgar, affected manner, unknowingly makes a spectacle of herself." As a college girl, Laurel would be more like us. But in fact Laurel is not a college girl. She is just an appealing young woman whom Stella—as a mother anxious to further her daughter's social opportunities—has brought to a rich people's resort (where, indeed, she *does* meet the man she is ultimately to marry, so Stella was at least right about that).

Laurel is never, in my opinion, a character with much interest on her own. Our concern about her derives almost entirely from our concern about Stella (as well as—and this is an important exception— our concern for our own easily embarrassed, parent-rejecting teenage selves. To the extent we never outgrow our own adolescent disgust at our mothers—the disgust Harold Brodkey portrays so movingly—to *that* extent we indeed identify with Laurel. But I think such identification on our parts is largely involuntary and impersonal, though it is an important source of the movie's powerful feelings of conflict). As the movie progresses and Stella's vulgarities become more blatant, Laurel in turn becomes more irritatingly feminine, more blandly re-fined. The sweet and appealing girl of the birthday scene, when none of Laurel's friends show up for the party, is eventually replaced by a smoothly coiffed debutante whose little gestures and facial exclama-tions—particularly on the bicycle ride with Dick Grosvenor—are clearly "affected" within the film's own terms. Laurel has learned (perhaps from her visits to Helen Morrison) to be the kind of girl whose presence flatters a man, and whose own pleasure comes mainly from pleasing him and being pleased by him. Compared to Stella's vibrant personality, Laurel's self seems rather puny and colorless— except, that is, when she is called upon to empathize with her mother.

Two of the crucial scenes between mother and daughter take place in front of mirrors: the scene at Stella's dressing table, when Laurel has just returned from her first visit to Helen Morrison's house, and the soda fountain scene, when Stella embarrasses Laurel with her outlandish get-up. I want to quote at length Mary Ann Doane's paragraph about these two scenes, because I think it is typical of the way the movie and its treatment of Stella have been misread. "A mirror is always a proper representation of its referent," Doane begins,

> and the specular relation is one to which women are expected to adhere. Laurel's gradual disengagement from her mother is figured in two separate scenes in which a mirror dominates the mise-en-scène and acts as a relay of glances. In the first, Stella applies cold cream to her face and peroxide to her hair as Laurel speaks admiringly of Mrs. Morrison. Concentrating on her image in the mirror, Stella inadvertently smudges with cold cream the photograph of Mrs. Morrison which Laurel shows her. Laurel reacts with a kind of horror which is the effect of the radical divergence between the photograph, reflecting an easy and composed attractiveness, and the mirror image of Stella, revealing through curlers and cold cream the straining, the excessiveness of her cumbersome narcissistic machinery. In a subsequent shot both mother and daughter are reflected, side by side, in the mirror. Looking at her mother via the mediation of two images—photographic and specular—Laurel sees her differently. The mirror, site of identity and narcissism, initiates the disjunction between mother and daughter. The second scene that stages a specular mediation of the daughter's gaze at the mother takes place at a soda fountain. Laurel and her date are sitting slightly apart from a crowd of young people, facing a large mirror, when Stella walks in in her "Christmas tree" attire. Laurel's friends begin to whisper and make mocking comments about Stella. Presently, Laurel looks up, sees her mother reflected in the mirror, and runs out of the shop, acutely embarrassed. Her gaze mediated via the gazes of others and the mirror, Laurel finally recognizes an accurate, or "proper," reflection of her mother's disproportion. It is as though the closeness of the mother/daughter relation necessitated the deflection of the gaze, its indirection, as a precondition for the establishment of difference.

"Proper" is one of those giveaway words generally used, under such conditions, to mean: "Other people believe in this conventional nonsense but I, of course, see around it." Yet, despite the quotation marks that greet its second appearance, Doane uses the word as the equiva-

lent of "accurate"—especially in its first appearance, where it is coupled with the adverb "always" and employed entirely without ironic tone. Somebody is being accused of defending the proprieties, but whether it is this particular movie, the society depicted within it, or society at large is unclear from Doane's description. She seems to run them all together, as if the movie had no perspective, no shaping sensibility, no irony of its own. I hope I have shown in the preceding chapters of this book that a mirror is *not* "always a proper representation of its referent": precisely what artists like Beaton and Jarrell and Huston and Miller call into question is the "accuracy" of the mirror's reflection. The mirror is not merely a "site of identity and narcissism," but a place where one can sometimes see reflections of faces other than one's own, get outside one's limited vision, achieve (for all practical purposes) eyes in the back of one's head.

What Doane's description ignores is the fact that Laurel is just a teenager, a sensitive, impressionable girl at an age where embarrassment is one's primary emotion. Laurel, that is, can be wrong; her response to things is not necessarily equivalent to the movie's, or ours. And Laurel is also capable of cruelty—the thoughtless, unintended kind that teenagers are masters of (and that immature, spoiled adults, like Stephen, have never outgrown). What is actually happening in the dressing-table scene is that Stella, as she puts on her cold cream and other beauty aids, is being told for the first time of Stephen's girlfriend: a rich, kind goddess who, according to Laurel, needs no creams or makeup to appear young and beautiful. When Stella asks how old this paragon might be, Laurel hazards a guess that she is about twenty-five. As adults, we know that Helen is really about the same age as (or even older than) Stella, in her late thirties or so. Having seen Helen, we also know that her beauty isn't as "natural" as Laurel thinks: she just applies her makeup a lot more subtly. In other words, Helen's "acting" is more polished than Stella's, more likely to deceive.

When Laurel gets furious at Stella for getting cold cream on the photo, this is the final step in a series of gratuitous acts of cruelty, beginning with her snobbish rejection of Stella's self-sacrificing offer of a fur coat (because Helen says young girls shouldn't wear fur coats), leading through her lavish description of Helen's mansion and her wish that *they* could have just a "little" house, and ending with her praise of the youthful goddess's beauty. So despite our visual alienation

from the cold-creamed, hair-curlered Stella, we feel the pain from inside Stella: in that sense, she mirrors *us*. But Vidor doesn't leave the scene there. He brings Laurel back to Stella, and back into our range of sympathy, by having her gently and apologetically offer to fix her mother's hair. Both women's faces then become our reflection in the mirror, as they join together emotionally in this tender, utterly feminine, and far-from-aristocratic ritual. And yet even here they are not equally or inseparably our reflection. Knowledge (Stella's and our knowledge, as opposed to Laurel's oblivious innocence) divides them, and it also divides us from Laurel, making Stella the figure who more fully reflects our own self-image.

Something similar but even more pointed happens in the soda fountain sequence. Again, we are visually alienated from Stella—she really does look bizarre, with her tropical-flowered dress trimmed with oceans of black lace, a big black hair-bow perched atop her head (complete with black face net), a white fur stole with the animal's legs dangling down, vertiginously high heels, heavy makeup, and about sixteen sparkly bangles on her arms. The costume is so extreme as to seem just that: a costume, a disguise, which by its very extremity calls attention to the discrepancy between the external image and the real person inside. Just as we are thinking all sorts of cruel, teenager-ish thoughts about Stella's bad taste, we hear our worst selves reflected in the dialogue of Laurel's upper-class companions: "It's not a woman, it's a Christmas tree." "And it walks." "And talks." "She's an ad." "An ad for what?" Stella here becomes the victim of the most overt cruelty in the movie—worse than the nonappearances at the birthday party, worse than Laurel's unintended cruelty at the dressing table, and worse even than Stephen's obtuse selfishness when he takes Laurel away at Christmas; because these remarks imply that Stella is not a person ("It's not a woman, it's a Christmas tree") and that she therefore has no feelings to be hurt. The comments are hurled as if at an unresponsive movie screen, and indeed Stella in the mirror of the soda fountain looks like nothing so much as a character framed within a movie, with Laurel and Dick placidly and obliviously drinking their sodas in the film's foreground. So the cruel teenagers seem to be doing just what we are: feeling superior to a vulgar, bizarrely costumed "character" in a movie. Yet Stella—the figure we see when we look in the mirror— is again our own reflection as well. We feel the shame on her behalf, because she fails to perceive the need for it. Stella, the least narcissistic

character in the world, doesn't even glance in the mirror (if she did, she would see Laurel, for whom she's been looking). This lack of "self-regard" is both Stella's greatest virtue and her greatest flaw: she doesn't see herself as if from the outside, doesn't view herself with others' eyes, and as a result she's able to be both laughably vulgar and blessedly generous. When she makes sacrifices for Laurel, they aren't like most people's self-dramatizing sacrifices, because they aren't meant to have an audience.

The reconciliation scene after the soda fountain, the equivalent of Laurel's remorseful hair-dressing, takes place much later, on the train back home. Laurel, who ran out of the soda fountain in shame, has insisted that they leave the resort, but without telling Stella why. Stella thinks it's because Dick has dropped her: "If it were me, I'd stay on only to show them that there was other fish in the sea. Oh, Lolly—it's only for you. Why, you said this morning that you'd never been so happy in your life. And so was I, too." This speech shows the differences between Stella and Laurel at their most pointed. If Dick *had* dropped Laurel, she probably *would* be a wreck, while Stella's opinion of herself is not contingent on anyone else's: there are always "other fish" for her, not necessarily other men, but other things to keep her interested in life. (Lang inaccurately sees Stella as "too sexy" for Stephen Dallas; according to him, "Stella does not find money and social position sexy enough." But sexual desire is not what motivates Stella. The bond between her and Ed Munn, for instance, has much more to do with laughter.) Stella's generosity is the honest generosity of mutual pleasure: she was happy at the resort, too. When Laurel talks at the end of the movie about going back to her mother, duty rather than pleasure calls her. "I've been with Mother all these years because I needed her, and now she needs me," Laurel says primly, adding with typical moral excess: "My home will be with my mother as long as I live." Stella would never talk this way, about one-sided need. She has loved loving Laurel, and she has acted on feelings that were simultaneously selfish and generous: it gave her pleasure to give Laurel pleasure.

On the train, Laurel and Stella, each in their separate curtained bunks, hear some snippy girls talking in the corridor about the bizarrely dressed creature at the soda fountain. "Laurel Dallas's mother? You mean that pretty little girl? She seems so pretty and sweet. Isn't it weird—to have such a common-looking thing as a mother." Laurel,

suddenly shamed and guilt-ridden at having shared this condemnation of her mother, as well as deeply concerned that her mother may have heard this, creeps down from her bunk to be with Stella. But Stella, always sensitive to Laurel's feelings, pretends to be asleep, pretends she hasn't heard the wounding words. She welcomes Laurel into bed with her usual cavalier warmth, not with the special emotions we know she must be feeling. Here it is Stella's lack of self-regard that makes her able to be a true actress, to fool even her daughter. She doesn't show her pain, but we feel it nonetheless. We share both Laurel's and Stella's feelings in this scene, but again we are closer to Stella's, because we and she know everything, while Laurel is to some extent in the dark.

The same mechanism, constructing sympathy on the platform of our shared knowledge, operates in the final scene between the two, when Stella is performing her most vulgar self in order to get Laurel to leave her for Stephen and Helen. Having dug up the declining and drunken Ed's long-since-forgotten address, she proceeds to stage a scene in which the vulgar strumpet is ridding herself of her daughter so she can take up with her man. "I've spent the best years of my life on you," she says to the aghast Laurel. "A woman wants to be something else than a mother, you know." What makes these remarks so poignant is that they are both true and intentionally misleading. Stella has spent her best years *with* but not *on* Laurel: she never saw it as an expenditure, as money going out. And she has always been "something else than a mother"—she has been resolutely herself, even when she was most concerned about furthering Laurel's interests. With her hair looking like a Harpo Marx wig, Stella mimes carelessness: lighting a cigarette, flinging one leg over the other, flipping through the pages of a (no doubt trashy) magazine. If it weren't so sad, this scene would be hilarious, and even so it's partly funny. We can feel all the layers of acting at once—classy Barbara Stanwyck acting the part of the vulgar Stella acting more vulgar than herself—and yet the final impression is one of absolute intimacy, absolute contact. Laurel is (as usual) fooled, but we can see Stella's expression as Laurel hides her face against her, and we know what pain Stella is going through. Yet we also take a degree of pleasure in her garish performance, as she on some level appears to do as well.

Lang picks up on the parallel between this "vulgar" scene and the one in the soda fountain, but he draws a crudely false conclusion:

"The two moments differ, however, in that Stella in the first scene is in some sense being 'herself,' and in the later scene is staging a conscious suicide/sacrifice." On the contrary: Stella is never anything *but* herself, even when she's wildly disguised. This last performance derives from the earlier soda fountain scene, but it derives from the scene in its entirety, including the generous deception Stella practiced on the train. Lang's distinction between conscious and unconscious isn't pertinent to Stella: her soul is always in her acting, whether she's performing for herself or for Laurel, and she's finally incapable of any deep dishonesty. Despite the fact that freedom will bring her sorrow, there *is* something freeing about Stella's final performance for Laurel. Only a viewer who on some level believes that motherhood is woman's only role would equate Stella's "sacrifice" with "suicide."

The success of Stella's character stems in large part from Barbara Stanwyck's ability to make vulgarity, in both its "natural" and "intentional" forms, come across as directness and intimacy. This is explicitly true in the "I'm running off with Ed" scene, but it also colors, in different ways, Stella's scenes with the refined Helen and the extremely vulgar Ed. Lang essentially equates Stella's and Ed's vulgarity, arguing that, "in an extraordinary performance, Alan Hale makes Ed Munn a sympathetic character, as Stanwyck makes Stella fundamentally good and endearing." But precisely the problem with Ed's performance is that it seems so much like a performance. He—or Alan Hale—is "doing" the good-old-boy, the big-hearted drunk, to the hilt. In the Christmas scene, when Ed barges in and ruins the delicate if temporary reconciliation between Stella and Stephen, only part of our embarrassment comes from sharing Stella's distress; a large part of it comes from our sense that this is an exaggerated, vaudevillian kind of drunkenness, unsuccessful in its attempt at humor and embarrassing from an external, movie-criticism point of view. It is to Hale's credit, no doubt, that Ed comes across as such a bad actor: it takes excellent timing to create the bad timing of the unsuccessfully told joke. But in this and other scenes (for instance, the practical-joker sequence when Ed and Stella are on the train together and he administers itching powder to the unsuspecting passengers), we are strongly made to feel that Stella's (and Stanwyck's) acting is softer, more honest, more natural than Ed's.

If exaggerated acting is what makes Ed seem vulgar and stagy compared with Stella, then exaggerated refinement is what makes

Helen seem less real, less natural, more like a movie character. In the scene where Stella goes to ask Helen to keep Laurel, both women are presented sympathetically, and the camera frequently frames them together, as if to portion off an insulated, private space for them to share. The Stanwyck intimacy works here to create a lovely, uncompetitive, mutual generosity between the two women. But Stanwyck also reaches out to us, the audience, in a way that Barbara O'Neil's Helen doesn't. With her careful Thirties-movie elocution and perfect composure, Helen seems like an actress; she is polished, and finished, and not in need of our complicity. Stella, on the other hand, is like an invitation, an invitation all the stronger for not being calculatedly issued. Located between the train scene with Laurel and the performance scene *for* Laurel, in both of which we share Stella's superior degree of knowledge, this scene, too, asks us to join in on Stella's side. All of Stanwyck's confiding gestures—her scooting over on the seat toward Helen, her direct vocabulary, her untrained-sounding accent, her intimate tone of voice, even (for once) her tacky clothes—urge us to think of Stella as more of a real person than Helen. This doesn't necessarily mean that we've managed to overcome our false sense of belonging to Helen's and Stephen's as opposed to Stella's class, for it was precisely this quality of directness and honesty—of being singularly herself—that first made Stella attractive to the upper-class Stephen. In this film, as in D. H. Lawrence's fiction, intimacy is offered as a corollary of honest vulgarity; to be refined and well-bred is to lose contact with one's own intimate self, and with the intimate selves of others. Yet even in this respect Stella is generous: her warmth creates a bond with the other woman that brings out Helen's best, making her seem capable of warmth and intimacy as well. It may be Helen who finally gets Stephen to appreciate Stella, but it is Stella who gets us to appreciate Helen.

In the movie's final scene, at Laurel's wedding, it is Helen who insists the curtains to the street be left open. We aren't explicitly told why she does this: the gesture directly benefits the peering-in Stella, but Helen has just assured Laurel that her mother must be far away and ignorant of the wedding, and it doesn't sound like a lie when she says it. Like all of Stella's acts, this gesture of Helen's hovers between intention and instinct, conscious acting and unconscious being. Helen has, for the moment, become Stella-like, and her unspoken motive is part of that transformation.

During the wedding, Stella—unrecognized by all but us—stands

outside in the rain, by the street railing, and watches the ceremony through the window. Lang uses the word "anonymously" to convey her position here; Linda Williams also sees her as "the anonymous spectator," and says that at the end of the film "Stella loses her daughter and her identity"; and Doane, who has earlier criticized Stella's flounces and bangles as indicating a "lack of proportion," here describes her as "deprived even of the frills and jewelry, the excesses in clothing which mark her identity throughout the film"—as if Stanwyck's Stella were never anything more than the clothes she wore. But to interpret Stella as an anonymous, identity-less member of the watching crowd is to make the same mistake the policeman does. After first trying to move her along, he relents and lets her wait for the wedding kiss—not because he knows she is Laurel's mother, not even because he perceives something special about her, but because he assumes that, like all romantic women, she loves to cry at weddings and particularly loves the most romantic moment, the kiss. Doane, Williams, and Lang make the same error, fail in the same way to recognize the special identity of Stella-the-observer—but the camera does not. As Rothman points out: "It takes us a moment to pick Stella out of the crowd, but the camera unhesitatingly follows her as she makes her way to the fence in front of the house." And with this gesture of the camera, *outside* rather than *inside* becomes the place to be. As we watch the film of the wedding on a rectangular screen, Stella watches the wedding through a window that, as Williams points out, "strongly resembles a movie screen": in that sense, our identification with her becomes more complete than ever.

Feminist film theory seems to have got itself into rather a bind about the vexed issue of spectatorship. On the one hand, the presumed viewers of films are almost universally classified as male, so that women on screen are constantly being "violated" by aggressive, "voyeuristic" male gazes. Yet when Stella Dallas is depicted as the viewer of a film or a filmlike scene, she is described (in Doane's words) as a "contented but passive spectator." It isn't fair to have it both ways, unless one presumes—again unfairly, and moreover with retrograde inaccuracy—that male spectatorship is always aggressive, female spectatorship always passive. As Edward Snow suggests in his essay "Theorizing the Male Gaze":

> Nothing could better serve the paternal superego than to reduce masculine vision completely to the terms of power, violence, and control,

to make disappear whatever in the male gaze remains outside the patriarchal, and pronounce outlawed, guilty, damaging, and illicitly possessive every male view of woman . . . A feminism not attuned to internal difference risks becoming the instrument rather than the abrogator of that [patriarchal] law.

Such narrowness, in other words, ultimately does harm to women as well as to men. The notion that Stella's gaze is "contented but passive" gravely underestimates her own powerful role in shaping—through sheer force of personality—the fate that has been and will be hers; and it also ignores the obvious, unavoidable suffering that goes along with such an "outsider" fate.

"By the film's end," says Lang, "we must understand somehow that Stella is standing in the rain not because she is a woman or a mother, but because of a lack in *her* (as a person, a character)." But the lack is in us, not her—or rather, it is in our knowledge of her. As the camera shifts position to allow us to view Stella's face, we realize that we know less about her than ever. Emotionally, she is at this point impenetrable to us. She has gone beyond us, moved outside the realm of being a character in the movie (a participant in the wedding scene) and become someone much more like the people around us, people who don't give their life stories away with every facial expression. There are many things about this Stella we can't know. Why, for instance, is she still (or again) wearing a wedding ring? Why does she smile as she turns away from the scene? Why is her walk so energetic, so cheerful? Rothman astutely summarizes what's going on when he says:

> There is a mystery to Stella's transformation . . . Does the jaunty walk reveal that Stella has been transformed back to her original identity, or is she *playing* the old Stella again? If this is an act, who is the woman performing it, why has she chosen this role, and for what audience is she performing?
>
> One possible answer to the last of these questions is: for herself. Another is: for no audience on earth, that is, for the camera . . . Thus transfigured by the power to acknowledge the camera, hence to acknowledge herself, she no longer appears a pathetic figure, and we have no grounds for judging her noble. We don't know what has brought her back to life. We don't know what makes this woman happy, and in the face of her happiness we don't know what to feel.

The only thing I might quibble with is Rothman's use of the word "happiness," which seems to draw on the same sources as Stanley Cavell's *Pursuits of Happiness,* and to suggest that Stella (or Barbara Stanwyck) is marching off here to become a character in a screwball comedy. Rothman admits as much when he says, "Stella has been transformed—or transformed herself—before our very eyes, unveiling at last that power and mystery the camera discovers in Barbara Stanwyck in *The Lady Eve* and *Double Indemnity.*" Yes, up to a point; but this remark implies that *Stella Dallas* only has value as a transitional movie. Yet I think Vidor's masterpiece has as much to say about Wilder's and Sturges's great Stanwyck films as they have to tell us about it.

The mystery of that last scene is Stanwyck's as well as Stella's, and that means it contains intimacy as well as obscurity, pain as well as happiness, a sense of freedom as well as a sense of utter connectedness. We "don't know what makes this woman happy" because we don't know for sure that she *is* happy (we, like Stella, may well be in tears at this point). The smile could mean anything, or at least a range of things. Barbara Stanwyck is an actress who, in this and her later films, shows us the unbreakable continuum that extends from pity to terror to anger to laughter—shows us that we can never fully possess one without possessing the others as well. And in *Stella Dallas,* in particular, she shows us what it means to have a self. It means, among other things, the ability to be "selfless" (in the sense of completely generous)—just as Stella's lack of "self-regard," her inability or refusal to see herself from the outside, becomes in the end the power not to be seen and judged from the outside. By the end of the film, she has come to rely so completely on her own unique identity, her own *reality,* that she can afford to remain invisible to the other characters— as invisible as we are, sitting together but finally alone in the darkened theater.

As Rothman suggests, two of the most interesting films Stanwyck made after *Stella Dallas* are *Double Indemnity* and *The Lady Eve.* I don't mean to denigrate the wonderful performances she gave in Mitchell Leisen's *Remember the Night,* or Anthony Mann's *The Furies,* or Robert Siodmak's *File on Thelma Jordan,* or Douglas Sirk's *All I Desire* (which is a kind of *Stella Dallas* in reverse), or even Samuel Fuller's otherwise

ridiculous *Forty Guns.* But these movies all have, to varying degrees, the kinds of Hollywood shortcomings that one doesn't find in *Double Indemnity* and *The Lady Eve,* which strike me as exemplary Stanwyck vehicles. Though *The Lady Eve* was made three years before the 1944 *Double Indemnity,* I want to consider it last because, in the curious way that certain great films do, it seems to comment backward and forward on Stanwyck's whole career. So first I will look briefly at *Double Indemnity,* which takes the idea of Stanwyck's deceptive, betraying, "acting" woman as far as it can go, into the paranoid territory from which *The Lady Eve* rescues and redeems it.

The Barbara Stanwyck of *Double Indemnity* could not be more different from the open, intimate, endearing, mobile-faced woman of *Stella Dallas.* Here, in Billy Wilder's version of the 1936 James M. Cain mystery, Stanwyck's face is a pallid mask throughout the movie, her hair a stiff blonde helmet, her body rigidly controlled and encased in invariably sexy clothes. It is the most intense version there is of Barbara Stanwyck "playing" a glamorous, sexy, hard-hearted dame. Yet something of Stanwyck creeps through the mask, if only a hint that she is indeed play-acting, that there is some other kind of soul (a soul largely inaccessible, though, to this hard-edged movie camera) lying in hiding behind that tough exterior. Without this hint, the movie would lose ninety percent of its mystery and suspense—would become, essentially, the book, which is simply an incessant reiteration of male fears and doubts about women, most of which eventually get confirmed. "A woman is a funny animal," says Cain's narrator Huff, who tends to divide his women into the innocent (Lola Nirdlinger), the evil (Phyllis Nirdlinger), and all the other stupid ones ("even a dumb cluck of a woman reporter could see there was something funny out there," he says of an article on the Nirdlinger "House of Death").

The Phyllis of the novel is both less mysteriously alluring and more repulsive, more downright crazy, than Stanwyck's movie Phyllis. Our first glimpse of Cain's *femme fatale* is pedestrian in comparison to Stanwyck's towel-clad entrance on an upper balcony. "She was maybe thirty-one or -two," says Huff of Mrs. Nirdlinger, "with a sweet face, light blue eyes, and dusty blonde hair. She was small, and had on a suit of blue house pajamas. She had a washed-out look." In converting Phyllis Nirdlinger to Phyllis Dietrichson—and, in the process, Walter Huff to Walter Neff—Wilder also transforms that nondescript "washed-out look" to Stanwyck's terrifying paleness, making an ab-

sence of facial color into a positive presence. (In black-and-white *film noir,* white is the most prominent color.) But if he makes the initial Phyllis more seductive, Wilder refuses to take her all the way down the evil road Cain has laid out for her. Here is Huff's last vision of Phyllis, as they sail off toward Mexico and their just deserts (joint suicide):

> She's in her stateroom getting ready. She's made her face chalk white, with black circles under her eyes and red on her lips and cheeks. She's got that red thing on. It's awful-looking. It's just one big square of red silk that she wraps around her, but it's got no armholes, and her hands look like stumps underneath it when she moves them around. She looks like what came aboard the ship to shoot dice for souls in the Rime of the Ancient Mariner.

This Angel of Death has pathologically murdered a number of people (including an innocent child), has lured Huff into her murder-for-profit plan, and has then turned on him, coldbloodedly attempting to shoot him to death in a deserted park at midnight. Stanwyck's Phyllis, on the other hand, turns out to be much more of a victim: she falls in love, against her will, with Fred MacMurray's Neff, and ends up getting shot to death by him. There is no room in Wilder's version for the bizarre woman-as-death get-up, because his plot takes an entirely different turn. If Phyllis is a betrayer, then so is Walter, and their mutual betrayal brings about their mutual downfall.

I've found that most viewers, myself included, have trouble remembering the end of Wilder's *Double Indemnity.* They expect some kind of tightly woven double-cross, with the Stanwyck character triumphing over MacMurray, and instead they get a diffusing plot in which everything falls apart. Some of this expectation may have been anachronistically created by later films like *Body Heat,* which do involve a female double-cross. But Wilder's film itself sets us up—not only by drawing on a novel in which the woman *is* a skilled and unyielding betrayer, but also by constantly leading us to believe that something is going on in Phyllis's mind which we don't have access to. For instance, when Phyllis and Walter have just finished murdering Dietrichson and are about to make their getaway, the car (driven by Phyllis) won't start. Phyllis looks at Walter; he grabs the ignition key out of her gloved hands and succeeds in getting the engine going; they both sigh with relief (although the momentary terror has intro-

duced the beginning of the widening rift between them). "Aha!" I thought to myself. "She's getting his fingerprints on the ignition key so that later she can blame the whole thing on him." But nothing is ever made of this scene in plot terms. It exists only for its emotional impact, on the two characters and on us. The Phyllis of the novel would have been capable of exactly that kind of trick; at one point, planning the murder with Huff, she even says, "The day before he's to start, I could bang the car up. Mess up the ignition or something. So it had to go in the shop. Then he'd *have* to go by train." We keep wanting or expecting Stanwyck's Phyllis to be that kind of traitorous female, but she's not. The mystery beneath her mask does not refer to destruction, but to love. What she's hiding from Neff as well as from herself is that her feigned passion, her "act" of being in love with him, isn't just an act.

The moments of intimacy between Phyllis and Walter in this movie—and they are precious few—are moments of mystery which somehow exclude us. For instance, when MacMurray stands behind Phyllis as she's looking at herself in a mirror, he's close enough to smell her. "That perfume in your hair—what's the name of it?" he says. "I don't know," she answers, "I bought it in Ensenada." When and why did she go to Ensenada? Why will the place name mean anything to him? And what does any of this have to do with the mystery plot? Nothing. It's as if they're talking about a life outside the frames of this film, one we have no access to. The loose ends in this movie don't just add to the feeling of unresolvable mystery in thriller terms; they also give us the sense that these characters share a world of experience that is beyond what we're being shown. In this particular case, the experience they share has to do with smell, a sense that the movies (at least in their more conventional forms) can't convey to us.

Every time we start to feel superior to these characters—to feel that we, as the audience, know more than they do—the movie catches us and slaps us down. At one point, for example, we are only partially conscious of the music in the background of a scene—movie mood music, we assume. Then Phyllis starts nervously and says, "What's that music?" and Walter reassures her: "Radio up the street." We thought it was music for our ears only, but they heard it too; and in reducing it from movie background music to a "radio up the street," the characters also seem to be reducing our ability to listen in omnisciently,

reducing our power as an audience. If we expect from a mystery movie the reassurance that we can finally know everything, then Wilder's film sets out willfully to disappoint us, for part of what he shows us is the limitation of film—its failure, for instance, to penetrate Stanwyck's mystery, Stanwyck's mask.

Double Indemnity harps on the indirectness of intimacy, on the way we can't have access to people directly, but need to approach them in mediated ways. Hence all the emphasis on telephones, recording machines, and so on. At the end of the movie, Walter gives Nino, the sometime boyfriend of Phyllis's innocent stepdaughter Lola (the girl with whom Walter himself has fallen in love), a nickel to call Lola. He's urging him to become her lover again, that is, to call her on the telephone. Along the same lines, Walter and Phyllis, at the height of their murder plot, can't talk on the telephone—they can't risk that degree of "direct" contact—so they need to meet evasively, in person, in the aisles of an already-agreed-upon supermarket. This famous plot element is purely the invention of Wilder and his co-author, Raymond Chandler (it doesn't appear in the novel at all), and it backs up the movie's assertion that "face-to-face" contact is not the most personal, intimate form. This assertion is also made in Walter and Phyllis's most loving scenes, which always occur when one person's back is to the other, or when her face is otherwise hidden from him. When they face each other directly, it is usually in fear (as in the stalled car) or in hatred (as at the end).

If Neff's intimacy with Phyllis depends on indirection, then so does his intimate connection to Barton Keyes, the insurance investigator who is his best advisor, his confidante, and his nemesis. Walter learns of Barton Keyes's misplaced trust in him—learns, that is, of the determined investigator's progress in his researches, including his conclusion that his colleague Neff is innocent—by playing back Keyes's memos on his dictaphone. Most significantly, the whole film is structured as a dictaphone playback, Neff's message to Keyes about the real facts in the case.

Wilder was to use the voice-over technique again in *Sunset Boulevard,* and to great effect, since there he broke movie convention by delivering the hero's voice from beyond the grave. But here the voice-over has a different meaning. It is not the voice of a dead man, which only a tape or movie can deliver (though it is, in one respect, the voice of an already doomed man, whose soundless footsteps at an

early stage in the plot Neff himself ominously describes as "the walk of a dead man"). The voice is more quotidian than that: it is the routine, hardened voice of one insurance man speaking to another via dictaphone—but this time making explicit, through the confessional message on the tape, the intimate connection between them that lay buried all the years they worked together. "You know why you couldn't figure this one out?" Neff says to Keyes in the end. "Because the guy you were looking for was too close—right across the desk from you." "Closer than that, Walter," says Edward G. Robinson's Keyes, and then seals the exchange of identities by making Walter's characteristic gesture, lighting a match with his thumbnail. Does Keyes mean that he *is* Walter, in a sense—that he too would have been capable, under other circumstances, of trying to outwit the system? Or does he mean that he has always cared about Walter more than Walter had any way of knowing? As with its other mysteries, the movie keeps its own counsel on this.

The relationship between Neff and Keyes is by far the most intimate in the film—as if it benefits by siphoning off the intimacy which Barbara Stanwyck normally creates, but which she is artificially prevented from creating here. In that sense, *Double Indemnity* very self-consciously builds an intimacy between men on the basis of a mistrust of women. That mistrust is the core of Keyes's personality. At one point he tries to explain to Neff that he learned enough about dames, *all* dames, from his one sleazy ex-fiancée. "I get the idea," says Neff ironically. "She was a tramp from a long line of tramps." Neff is mocking Keyes's biases here, but the film pushes us hard into Keyes's corner. It offers us a choice of two women: the insipidly sweet Lola, Dietrichson's wronged daughter (but even she is a deceiver, for she sneaks out to see her boyfriend against her father's wishes), and the dangerous, seductive, hard Phyllis. Neff, being the idiot he is, comes to prefer Lola; but Wilder, who casts the powerful Stanwyck as Phyllis, knows better. Wilder never lets her deteriorate into the evil woman that Neff and Keyes (and Hollywood) want her to be. He pushes us to the edge of conventional misogyny, and then he lets Stanwyck's tragic mask retrieve us.

The intimacy of James M. Cain's novel—that narrative voice speaking directly to "you," giving us friendly advice about insurance methods and gambling odds, freely dispensing opinions and sordid stories, waxing loquacious in language as vulgar, as unliterary, as "real" as

Stella Dallas's—is replaced in the movie by Neff's voice speaking to Barton Keyes. Keyes, in that respect, has become synonymous with the audience. There's a certain pleasure in being identified with Keyes. He's sharp, he's funny ("I guess I was wrong—you're not smarter, you're just a little taller," he says to Fred MacMurray; or, "You'll never make the border. You'll never even make the elevator," when the injured Neff is trying to get away at the end), and moreover he's on the right side, for the right reasons: he's against disorder and confusion, in favor of clarity and resolution, just as we, the mystery-movie audience, are. It's not that he mindlessly upholds the rights of the insurance company or even the law; it just that he wants answers. But in the course of the movie this virtue comes to seem a little simple-minded, or at least inadequate to reality. For very much the same reasons that he hates women, Keyes hates mystery, hates obscurity, hates anything that can't be resolved by reference to his actuarial statistics. Stanwyck is such a mystery. By relocating all the novel's misogynist tendencies into the character of Keyes, and then by asking us to identify (as audience to Neff's tale) with Keyes, Wilder pushes us as far as possible outside the innate warmth and potential intimacy that Barbara Stanwyck is capable of generating. Yet he asks us to believe it's still there, underneath that mask and that hardness. In doing so, he asks us to transcend our identification with Barton Keyes—just as we transcend our status as audience, as mere listeners and viewers, when we take it on faith that there *is* a perfume that came from Ensenada, even though we can't smell it.

Barbara Stanwyck's perfume comes into *The Lady Eve,* too. "Holy Moses! That perfume!" says the Henry Fonda character when he's falling in love with Stanwyck's Jean, at their first meeting on the ocean liner. The sensual smell practically knocks him out. "I've just been up the Amazon for a year," he explains, in a running gag (funny to everybody but him) that reappears throughout the movie. By this he means that he's totally unused to things like ladies' perfume and other elements of female civilization. The perfume issue surfaces again in the second half of the movie, when Stanwyck, in her attempt to trick and punish Fonda, is disguised as the Lady Eve Sidwich (who looks exactly like the Jean he fell in love with, but speaks in an English accent). Fonda tries to explain to his streetsmart, tough-guy valet,

Muggsy (beautifully rendered by William Demarest), that the Lady Eve must be a different woman from Jean, because if Jean were in disguise she would at least have dyed her hair or something. "You trying to tell me this isn't the same muff as was on the boat?" Demarest growls. "She even wears the same perfume." Smell doesn't lie, Muggsy implies, even if looks and voice sometimes do. But looks and voice are all we have to go on in the movies. Muggsy may be able to smell Stanwyck, but we can't.

The Lady Eve is, in part, about the idea of being an actress who plays different roles in different movies. It may seem ridiculous that Henry Fonda is willing to take Stanwyck as a different person when she reappears with a different voice under a different name, but aren't we doing something similar when we believe that she can be Stella and Phyllis and also Jean? Hardened realists will say that we, as a movie audience, do not assess the credibility of a film character in the same way that her fellow film characters do. But films, or at least Barbara Stanwyck films, work precisely by drawing us in to the point where we feel we have our own intimate acquaintance with the central character, an acquaintance that comes to much the same thing as believing her and believing *in* her. And Preston Sturges comedies succeed precisely by boosting their characters out of the fictional framework into something much closer to an audience's level of knowledge. Sturges's films are funny, moving, and powerful in large part because their characters seem to know and acknowledge that they are acting in a movie. Stanwyck's films are funny, moving, and powerful in large part because she becomes, for us, something more real than either an actress or a fictional character.

The Lady Eve is also about how and why women terrify men. It takes the idea of the deceitful, vengeful, betraying woman—the idea that forms the core of *Double Indemnity*—and makes it the basis of a comedy. Sturges does this partly by shifting the viewpoint of the film from the man's to the woman's. "I loved her like a rabbit loves a rattlesnake," says the Walter Huff character in the James M. Cain novel as he has begun to realize how dangerous Phyllis is. "I need him like the axe needs the turkey," says Stanwyck in *The Lady Eve,* plotting her revenge against the criminally naive, stuffed-shirt Fonda. If Fred MacMurray's voice-over makes him, in some ways, the screenwriter and director of *Double Indemnity,* Stanwyck's framing of the action, her stage-managing of all the plots against Fonda (from the

cardgame cons to the mistaken marriage), makes her the representative of Preston Sturges in this film. He indicates as much to us in the early mirror scene, where Stanwyck, holding up a rectangular mirror from her makeup case, shows us the shipboard action surrounding Fonda and narrates its "meaning." Stanley Cavell suggests the significance of this scene when he says:

> One plausible understanding of our view as Jean holds her hand mirror up to nature—or to society—and looks surreptitiously at what is behind her is that we are looking through the viewfinder of a camera. In that case this film is claiming that the objects it presents to us have as much independent physical reality as the objects reflected in a mirror, namely, full independent physical reality. Their psychological independence is a further matter, however, since we are shown Jean creating their inner lives for us, putting words into their mouths . . . and blocking their movements for them . . . and evaluating their performances . . . We may take the world she has in her hand as images in her crystal ball, but however we take it we are informed that this film knows itself to have been written and directed and photographed and edited.

The self-knowledge granted in this scene is ours as well as the film's because, as Cavell suggests, that mirrored shipboard society is presented as our reflection as well as someone's creation. And the agent of that self-knowledge—the "stand-in for the role of director," as Cavell calls her—is the Barbara Stanwyck character.

One of the many remarkable things about this film is the way it manages to combine the woman's viewpoint with two explanatory myths—the Garden of Eden tale and the Freudian view of human psychology—that have generally been seen to be anti-female. Sturges brings together these two stories in Fonda's profession of ophiologist. Snakes pervade the first half of the movie: a cartoon of one wriggles through the "O" in Preston Sturges's name during the animated credit sequence; Fonda on shipboard reads a book called *Are Snakes Necessary?* (an allusion, perhaps, to James Thurber and E. B. White's *Is Sex Necessary?*); Fonda's pet snake Emma escapes in his stateroom and terrifies Stanwyck; Stanwyck awakens screaming from a nightmare about snakes. The Genesis aspect of all this is emphasized not only by the Eve of the movie's title (and Stanwyck's second name), but also by the fact that when Stanwyck first sees Fonda boarding the ship, she clunks him on the head with an apple. Yet the Freudian angle is

no less present, as Cavell's elaboration of the film makes clear. Well in advance of his time (Hitchcock's *Spellbound* wasn't made until 1945, and Wilder's *Seven Year Itch* didn't come out until 1955), Sturges was both using and mocking Freudian ideas in his conversation about men's ongoing battle with women. Even at this relatively early stage of psychoanalytic history, Preston Sturges was capable of seeing what the Bible story and the Freudian interpretation shared most deeply: a conviction that knowledge and self-knowledge are equivalent to, or at least firmly dependent on, an acknowledgment of sexuality.

Stanwyck's Jean may be the character who dreams about snakes and awakens screaming, but Fonda's Charles Pike (familiarly known as "Hopsie") is certainly the character most obviously terrified of sex. Even to say he is terrified implies a greater degree of self-knowledge than he has—implies, for instance, that he is like *Double Indemnity*'s Walter, who consciously fears the female rattlesnake. What Pike really possesses is a degree of willful ignorance, of boyish naivety, that virtually paralyzes him. His bashfulness makes him so clumsy that he is always falling in Eve's presence (like Adam, but repeatedly, and with slapstick exaggeration). Even his sexual innuendoes are entirely un-intentional: when he harps on about how he's been "up the Amazon," *we* may visualize female pubic jungles and powerful women warriors, but he's referring only to the idyllic time he spent in the company of "men like yourselves," as he called his scientific assistants. "Be careful of the dames," one of them warns him when he leaves the jungle. "You know me, Mac—nothing but reptiles," Fonda reassuringly responds.

Depending on our stance and our mood, we are likely to find this innocence veering from the appealing to the irritating. Pike's own father, charmingly played as a rich, vulgarian, grown-up baby by Eugene Pallette, clearly finds it irritating. "Oh, were you in love with her?" the Lady Eve asks Pike at the dinner party his family gives in her honor, where he has been staring at her as if he's seen a ghost (which, of course, he has). "Yeah, he was in love with her," snarls Pike Senior, "but he doesn't remember what she looks like." This foolishly asexual, snake-loving son seems a poor excuse for a man to a father who announces heartily, the first time he meets Stanwyck, "You're just the kind of girl I've been looking for all my life." (But that line also shows us how father and son are related, for Pallette's hearty if conventional compliment echoes, in a funny way, Fonda's romantic speech about having known her forever.)

To Stanwyck herself—or at least to her Jean incarnation—there's something very appealing in Fonda's unknowledgeable innocence. James Harvey (whose reading of *The Lady Eve* is inspired) points out the source of this appeal when he says:

> Stanwyck's heroine carries us into a troubling and ambiguous area of feeling . . . In a way we are in the same relation to the heroine's personal authority, her triumphant assertion of intelligent power, as she is: enjoying it, but somewhere uneasy about it, too. And this uneasiness suggests a larger point, already familiar to movie audiences from all those other tough-girl heroines who seem weary of their own toughness: that it's nice to know your way around, all right—but surely nicer in a way *not* to . . . So that it makes perfect sense that Stanwyck should fall in love with Fonda . . . not only in spite of his obtuseness but because of it.

Like Henry James's Fleda Vetch, who loves Owen Gereth for his "beautiful" lack of understanding—or, for that matter, like Stella Dallas, whose feeling for Stephen is fanned by his foolish willingness to fall for her obvious tricks—Stanwyck's Jean sees masculine stupidity as a form of masculine virtue, and at least temporarily gets us to see it that way too.

The lesson taught in *The Lady Eve* is not just to Henry Fonda, but to the Barbara Stanwyck character as well. She has to learn the insufficiency or inaccuracy of her original desires before she and Fonda can become a couple. The lesson taught to her is far less obvious than his because her flaws, her misapprehensions, are much less glaring than Fonda's. We side with her and are pleased to see him punished for being a dense, insensitive, scared-of-sex jerk. But once she's inflicted that punishment, neither she nor we can be totally happy about it, because her desire to punish him, though reasonable, stems from sources similar to his desire to drop her when he found out she was a con artist. Each is seeking in the other an opposite (a sweetly obtuse rich kid for her poor but brainy con lady, a sexy, worldly dame for his scared, isolated, boyish scientist), but each is irritated with the degree to which the beloved is not a perfect reflection of the self. Cavell says of Fonda's need to see the same woman (Barbara Stanwyck) as two women (Jean and Eve): "His intellectual denial of sameness accordingly lets him spiritually carve her in half, taking the good without the bad, the lady without the woman, the ideal without the reality, the richer without the poorer. He will be punished for

this." But though she does it much more subtly (as she does everything more subtly, more self-consciously, more humorously than he does), Barbara Stanwyck makes the same mistake in response to Fonda: she wants only the nice side, only the obtuseness that is appealing and useful to her, and not the obtuseness that makes him unthinkingly cruel.

We don't notice Stanwyck's moral limitations the way we notice Fonda's because, as Harvey points out, we are joyously in collusion with her throughout the film. We take her view of Fonda, initially and finally. "He is a 'developing' character in this respect," Harvey says,

> unfolding himself with a kind of terrible inevitability: his snobbery, his self-importance, his numbing male thickness. He not only gives a kind of permission to our cruelty, he even does it retroactively, so that the uneasiness that Sturges has inspired in us from the beginning is finally and hilariously resolved. The movie's instinct about this figure, enacted by the Stanwyck heroine from the opening scenes—that he was asking for it even when he seemed not to be—turns out to have been the right one. This is a Mr. Deeds we *can* punish—without feeling guilty about it.

Another way of putting this is that Henry Fonda stands in, as a willing sacrificial victim, for all the dense men who underestimate and betray the wonderful Stanwyck: Stephen Dallas, Walter Neff, even—for their initial sins—Gary Cooper's professor in *Ball of Fire* and Fred Mac-Murray's prosecuting attorney in *Remember the Night* (both of whom eventually end up loving her, against their "better" judgment). This totemic revenge against all dense males can be a lot of fun. But is it fair? Is it, in the end, even sufficiently rewarding? Barbara Stanwyck seems not to think so, as she turns away from us toward the train window, while the sputteringly angry Henry Fonda disembarks into a puddle of mud. We sense—from her posture as much as from her profile—that her little revenge drama, though satisfying on one level, has left her with problems she can't resolve. If Henry Fonda can sustain neither the appealingly dizzy Hopsie of the early love scenes nor the pleasurably despicable "piker" of the later revenge scenes, then neither can Stanwyck hold permanently to either of her two selves: the warmly loving, perhaps overly responsive Jean ("I'm going to be

exactly the way he thinks I am, the way he'd like me to be," she tells her father, speaking of Fonda) or the coldly calculating, consciously "acted" Lady Eve.

The conventional theatrical idea of identical twins, as paired but opposite halves of a single nature, has a ghostly existence in *The Lady Eve*. As a plot device, it is both suggested and strongly rejected. We know that Sturges had a fondness for this deliriously anti-realistic solution to comedy because he uses it to such good effect in *The Palm Beach Story*, where he introduces it briefly in the credit sequence (so quickly that we think, "What was all *that* about?") and then resuscitates it at the end to provide mates for all the desiring lovers. In that film there have to be two Claudette Colberts (one each for Joel McCrea and Rudy Vallee) and two Joel McCreas (one each for Claudette Colbert and Mary Astor) in order to keep everybody happy. *The Lady Eve* is in fact based on a Monckton Hoffe story, credited in the film, called "The Two Bad Hats," in which there really are twin girls (and in which—shades of *Stella Dallas*—their mother watches from the edge of a crowd as her only surviving daughter marries a wealthy society man). Sturges's brilliant move lies in converting the idea of identical twins pretending to be one character (still a Hollywood staple by the time of the 1946 *Dark Mirror*, not to mention the 1988 *Dead Ringers*) to the idea of one woman pretending to be doubles. What the twins story usually meant in Hollywood—what it meant in *Dark Mirror*, for instance, where Olivia de Havilland played both the tender, sweet Ruth and the jealous, murdering Terry—was that the qualities of a normal woman could be divided between a "good" twin and a "bad" twin. When Barbara Stanwyck plays both "twins," these two halves are forced to reunite in a single woman.

There's a sense in which *The Lady Eve* looks longingly toward the easy way out, acknowledges the wish that the twin story answers to, and then refuses to give us that escape. If Jean and Eve vary in their likability, and even their attractiveness (there is something cold and slightly unappealing about Stanwyck's appearance when she's playing Eve), they are nonetheless aspects of the same woman, and neither can be seen as wholly acted or wholly sincere. They are "positively the same dame," as William Demarest insists in the movie's last line. Sturges explicitly mocks the twin story by reducing it to a fictional subsidiary of a fiction. Eve's "uncle" (her father's old con-man friend Harry, posing as "Sir Alfred McGlennan-Keith, R.F.D.") whispers to

Henry Fonda an abbreviated tale about a secret illegitimate sister, as a way of explaining the physical similarity between the Lady Eve and the girl on the ship: "You see, into the gulf that separated this unfortunate couple—there was a coachman on the estate—a gay dog, a great hand with the horses—and the ladies—need I say more?" In a typical example of what makes Fonda the perfect sucker, Charles says, "A coachman!" in horrified tones, to which Sir Alfred answers, as if to a question: "A man who drives horses." "I know what a coachman is, I just don't—" Fonda attempts to reply.

The little scene underlines not only Fonda's obtuseness, his apparent failure to recognize the old chestnut of a twin tale, but also the disturbing class snobbishness that colors all his least likable behavior in this film. (Sturges, no doubt realizing he had gone some way toward creating a too-horrible upper-class prig, brilliantly thought up a way to cut across the film's rigid class divisions when, on the second or third rewrite of *The Lady Eve,* he switched Muggsy from being Jean and her father's sidekick to being Charles Pike's valet. This made all the difference, by giving Fonda a companion who could both soften and combat his unthinking snobbishness.) Fonda's class-bound attitudes reappear in the train scene, when the Lady Eve is regaling him, on their wedding night, with stories about all her previous—and previously unannounced—lovers. "A groom!" Fonda gargles ("as if he had swallowed vitriol" are Sturges's instructions in the screenplay, and Fonda manages it exactly). "Not really the groom, of course," says Stanwyck, in a pretense at attempted soothing. "He just put on the groom's uniform on his day off and then he'd be the groom that day—the rest of the time he was the stable boy." And that's only the beginning of her revenge.

The sins Fonda is being punished for, in this movie, are the everyday human sins of self-righteousness, snobbishness, pomposity, and self-engrossment. He is also, of course, being punished for his fear of worldly, sexy women—and his punishment is therefore to acquire a wife so "experienced" she makes the shipboard Jean seem naive and innocent. *The Lady Eve* is not, I think, one of Preston Sturges's falling-on-the-floor-with-helpless-laughter films; its comedy is too mixed with something more serious. If, in a film like *Unfaithfully Yours,* Sturges manages to create hilarious comedy about a Big Crime like jealous murder, here he manages with comparable skill to make a less hilarious but equally moving comedy about the bothersome smaller crimes of

normal existence, the crimes that most of us from time to time commit. James Harvey brilliantly summarizes the curious tone of the film when he says, about the proposal scene between Charles and the Lady Eve: "This is also one of those moments that remind us how powerful the feelings behind this comedy are—far, far behind it, like the smile behind Stanwyck's eyes. What we feel the force of at these comic high points is a kind of transmuted anger." As the audience, we sympathize with that anger and consider it justified. But even Stanwyck's most fervent supporters can't get rid of a nagging feeling that she carries out her revenge plot a little too enthusiastically, a little too determinedly. What marks the character of the Lady Eve is a quality that never, despite her often desperate life as a card-shark, appeared in Jean at all: that is, a quality of ruthlessness.

Here's what Sturges himself had to say about ruthlessness. The remarks appear in a letter he wrote to his producer, Albert Lewin, about the need for rewrites on *The Lady Eve*. (All my information on this and other matters relating to the Sturges screenplay comes from Brian Henderson, whose edition of *Five Screenplays by Preston Sturges* is invaluable.) Lewin had written to Sturges in January of 1939 with various criticisms of the first draft, recommending a ruthless rewrite, and Sturges replied in February:

> I agree with much that you say . . . On the other hand I am frightened to death by the word "ruthless." O ruth, what crimes have been committed in thy name! What destructions of Carthage! What massacres of St. Bartholomew! What throttling of beautiful poker scenes! How well I know the fanatical look in the eye, the light foam on the lips, the orgastic tension of the face muscles, and the sadistic smile on the face of the one who says: "I am going to be ruthless." It is such a beautifully positive thing to be, so decisive and virile, fraught with such a feeling of well-being, that it is almost irresistible. There is nothing puny and Coolidge-like about it. It is Rooseveltian (I am writing all this hogwash on my own time).

That "fanatical look in the eye" and "light foam on the lips" might almost refer to the horse who stands behind Fonda and Stanwyck in the proposal-at-sunset scene—that crazed-looking animal whose foolish nobility is the objective correlative of Fonda's Young-Mr.-Lincoln speech about forgiveness, understanding, and the other higher human virtues. It is in this scene that Fonda reaches the apogee of his fool-

ishness, repeating nearly word for word the romantic speech ("You seem to go way back—I see you here but at the same time further and still further away, way, way back always . . .") that earlier charmed Jean on shipboard. Yet the moment at which Fonda becomes most fatuous is also the moment at which we begin to feel uncomfortable with Stanwyck's revenge plot, for it is the moment in which she really bares the teeth of her ruthlessness. "I don't deserve you," he says, with characteristic pedantry, and she replies, "Oh, but you *do,* dear. If anyone *ever* deserved me, you do, dear—so richly."

If Preston Sturges could be described as a feminist (a fate from which his sense of humor has heretofore protected him), it would be because of his willingness to grant to his heroines the same flaws, the same comeuppances, the same problems with power, that most screenwriters and directors have only been willing to grant to their male characters. Here, he gives Barbara Stanwyck a substantial dash of that quality which he described in his letter as "so decisive and virile"— that flaw which masculine society, or at least the masculine worlds of war and business, had converted into "such a beautifully positive thing to be." Sturges disliked ruthlessness in men, despite its "almost irresistible" glow. It is to his credit that he was also willing to dislike it in women—even in such an irresistibly glowing woman as Barbara Stanwyck. If Sturges's films are to be meaningful to women as well as to men, if they are to hold up Stanwyck's rectangular mirror to flawed female faces as well as flawed male ones, then he has to see his hero *and* his heroine as in need of moral instruction; the lessons can't all be for the dense Fonda.

Cavell gets at this truth when he analyzes our reactions to Fonda's repetition of the we-go-back-a-long-way speech:

> we must understand ourselves to be embarrassed not by the openness of his insincerity but by the helplessness of his sincerity. He desperately wishes to say these words of romantic innocence to just this woman, even as she desperately wished to hear them. (This was a piece of her education.) Yet knowing this she feeds him with the fruit of the tree of stupidity. For this she will be punished.

Cavell's last line echoes the end of his previous paragraph about Henry Fonda's rigidity: "He will be punished for this." The equivalence measures respectfully the degree of Sturges's evenhandedness—an evenhandedness made especially difficult when one half of the couple,

the female half, starts off so much smarter and nicer than the other half. And yet Cavell, because he is so concerned with ideas of "education" and "punishment," is not quite the right guide to Sturges, who is really interested in wreaking havoc with any organized form of instruction or preconceived set of beliefs. If the Fonda and Stanwyck characters learn anything in the course of the movie, part of what they learn is to disregard or suppress or do without knowledge. "I don't want to know—I don't want to understand," are Fonda's pertinent words in their final, reconciliatory scene together. *The Lady Eve* takes its characters into the Edenic acquisition of knowledge and then back out again: it allows them to achieve something like the grace of prelapsarian ignorance, but in the form of a consciously treasured refusal of knowledge, premised on experience rather than lack of experience. The progress Henry Fonda makes, in particular, is to move from the pomposity of his blithely unaware meaning-of-marriage speech ("How wise you are," Eve mockingly says as he delivers it) to his purposeful embrace of ignorance at the movie's end.

The ludicrousness of Fonda's repeated speech is obvious; what is less obvious is its truth. By the time he makes that speech, they *do* have a past together, and Fonda would indeed be able to look back, way back, and see Stanwyck, if he would just open his eyes. The first time around the speech, though admittedly hokey (in the way that anything Hopsie says is bound to be kind of hokey), has the ring of accuracy: it does seem to us that these characters belong together, that there's something deep in their pasts that makes them fit together. (This is true of the whole genre of movies to which *The Lady Eve* belongs, which is partly why Cavell calls them "comedies of remarriage.") Sturges's producer, criticizing the screenplay's first draft, perceived this positive fact in negative terms. Their coming together was "all too easy," Lewin complained, "mainly because there is no character problem between them . . . They should be kept apart because he is the kind of a guy he is and she is the kind of a gal she is." Way back in the mists of time, in Sturges's first draft, they were perfectly suited to each other; but in the course of numerous revisions Sturges managed to throw up enough roadblocks to give them a plot.

Fonda is right in feeling that he and Stanwyck belong together. So why does his repetition of the speech make it wrong, the second time around? The issue is not just insincerity, but a specifically masculine and seemingly incurable kind of obtuseness. Randall Jarrell says of the

clumsily unemotional husband in Frost's poem "Home Burial": "if one only knew this man one would say, 'Man is the animal that repeats.'" In that poem, part of the husband's problem is his reliance on the proverbial and the rhetorical in the face of novel experiences that can't be met by such reliance. Something similar operates with the Henry Fonda character in *The Lady Eve,* and it is tied to his being a man: as Jarrell suggests, this particular kind of self-righteous, emphatic repetition is distinctly masculine in tone. But even that doesn't fully explain our discomfort at this scene. Somehow we too feel "taken" here, as if some precious illusion has been punctured for us.

I think that illusion is about sincerity in the movies. If we automatically connect repetition with insincerity, then we have to blind ourselves to the fact that repetition is central to the making of movies (an actor rehearsing his lines, a director doing a new take) and to the showing of movies (each screening in a theater, each repeated viewing on our part). Yet despite such repetition in their ingredients, we are able to respond emotionally to movies, to accept them as sincere. Does this mean we are fools, in Stanwyck's terms? Or is a certain amount of foolishness necessary in the realm of fantasy?

And not just fantasy. In our daily emotional lives, we are constant victims of unwilled, unconscious repetition, for reasons that can be found in both Genesis and Freud. The romantic origins to which *The Lady Eve* points back are located not just in the infancy of the species, in the Garden of Eden, but in the infancy of each individual creature. "I knew you'd be both husband *and* father to me," the Lady Eve tells Charles during their worst moments together on the train. The line is parodic and cruel—it harks back to Fonda's weighty, patriarchal tone in his speech about the significance of marriage—but it is also a necessary acknowledgment, just as Jean can be a wife to Hopsie only by also in some way being his mother. The mother/father model may be a less-than-perfect basis on which to choose a companion of the opposite sex, but it's nonetheless all we have to work with. Sturges emphasizes this not only in Fonda's fantasy, which goes back to both their childhoods, but also in the visual framing of two crucial scenes between Stanwyck and Fonda.

The earlier one is the first real love scene between Jean and Hopsie, when they're in his stateroom aboard the ship. She's lying on a chaise, recovering from her recent terror about Emma the snake, and he drapes himself on the edge of the chaise while sitting on the floor. As

they recline together, their two faces framed by the camera, she cradles his head and caresses his hair and ear with her fingers. Her face is higher than his on the screen, and it has a sultry, almost sleepy expression; his face, which we see more in profile, is anxious-looking, eyes and mouth wide open. Despite her recent scare (and at this point we don't know for sure that she really *is* terrified of snakes—that is, we suspect she might be acting to further her own ends, though her later nightmare defuses that suspicion), Fonda seems the one in need of comfort. One of the things they're discussing is her search for the ideal husband. "He's a short little guy with money," she says. "Why short?" Fonda asks. "So he'll look up to me—so I'll be *his* ideal," Stanwyck answers, looking down alluringly at the stony-faced Fonda.*

In the mirror image of this scene that takes place later in the movie, Fonda is delivering his weighty-importance-of-marriage speech and is about to launch into the embarrassing repetition of his going-way-back fantasy. Again the two of them are framed together on the screen. But this time he is on the right side, and higher up, where she was before: he is now the parental figure, the father, while she's been reduced to the more stereotypical "sinister being." He looks down at her, as she looked down at him during the stateroom scene, and she looks out and away, neither at him nor at us—again, as Fonda did in the earlier scene. But whereas his earlier expression betrayed the paralyzing nervousness induced by love (especially when it's combined with a fear of love, as in Fonda's case), Stanwyck's expression here is

*I've said before that Preston Sturges's heroines—and screwball comedy heroines in general—have a great deal in common with Henry James's heroines. There's a particular scene from James's *The Other House* that, when placed next to the Fonda/Stanwyck scene I've just described, bears me out. Rose, the novel's heroine, is sitting on a sofa while her fiancé kneels at her feet and fiddles with her dress. "He had dropped his eyes upon the crumple he made in her frock, and her own during that moment, from her superior height, descended upon him with a kind of unseen appeal." And then, a moment later: "She placed her arm with frank friendship on his shoulder. It drew him closer, and he recovered his grasp of her free hand. With his want of stature and presence, his upward look at her, his small, smooth head, his seasoned sallowness and simple eyes, he might at this instant have struck a spectator as a figure actually younger and slighter than the ample, accomplished girl whose gesture protected and even a little patronised him." No wonder James failed in his attempts to write for the stage. The "spectator" he wrote for was one who hadn't been invented in his own time: the moviegoer, the beneficiary of the close-up shot.

one of cold determination, or maybe just coldness. As in *Double Indemnity*, she has made her face into a mask, and the mask means the same thing here: a ruthless refusal to allow her softer emotions to obstruct her will. It is to the Stanwyck character's credit that in both films her willed effort is finally unsuccessful; she is not, finally, made for ruthlessness.

Yet there is a kind of ruthlessness that both Stanwyck and Fonda need to go through—that they do go through, and come out of, in the course of *The Lady Eve*—before they are ready to come together as adults. First they must be each other's parents, each other's willful infants. Here is D. W. Winnicott on infantile ruthlessness: "The normal child enjoys a ruthless relation to his mother, mostly showing in play, and he needs his mother because only she can be expected to tolerate his ruthless relation to her even in play, because this really hurts her and wears her out." Winnicott realizes that the mother, however loving, may be tempted to respond in kind, at least on an emotional plane: "A mother has to be able to tolerate hating her baby without doing anything about it. She cannot express it to him. If, for fear of what she may do, she cannot hate appropriately when hurt by her child she must fall back on masochism, and I think it is this that gives rise to the false theory of a natural masochism in women." This may help explain why we are so enthusiastic about Stanwyck's ruthless revenge: it gives us, in part, a fantasy that can never be played out in real life, an avoidance of masochism through the active expression of hatred for the beloved. There is something dreamlike, something unreal about the whole revenge segment—as Cavell suggests when he compares this movie and others to *A Midsummer Night's Dream*. Charles seems to acknowledge this dreamlike quality when he says to Jean at the end, "It would never have happened if she didn't look so exactly like you." He hasn't explained anything about the Lady Eve to her, yet he expects her to know the whole story, as if it's a dream they've had together, or a movie they've seen together—or, indeed, as if there were never two women but only one, the one who has been through it all with him.

The final scene between them is filled with the grace of unspoken forgiveness. They don't need to apologize to each other, in part because each perceives by this time the necessity for the intervening punishment. Consciously (in Stanwyck's case) and unconsciously (in Fonda's), each inflicts on the other a tremendously disillusioning ex-

'—(though why 'opposite' I do not know; what is the neighboring
?) But the fundamental thing is that women are more like men
an like anything else in the world." What the spectrum metaphor
ggests is that opposites can also be neighbors, at least to some
gree.

There is another image which turns opposites into neighbors, neigh-
rs into opposites, and that is the image of the mirror. I began this
ok by attempting to banish Lacan's mirror, by transforming the
th of Narcissus into Plato's myth of the divided beings. But the
rror repeatedly comes back to haunt me, in Jarrell's poems, in
aton's portraits, in Hitchcock's, Huston's, Vidor's, and Sturges's
ovies. The mirror is the instrument of self-regard, the image of the
f regarded. Yet what appears in the mirror is also the opposite of a
f: an empty shell, a soulless illusion. The mirror turns right into
t, solidity into unreality, warm tangibility into cold visibility. But
the hands of the artist (and, as artists like Beaton and Sturges show
in life as well), the mirror is not just a mechanical reflector. It
dn't give us only ourselves; it can give us the whole world—
niaturized, framed, and seen anew. Any mirror has the capacity to
e back faces other than those that look into it. And the artist's
rror can allow us to see our reflection in a face whose eyes are
rted (as we can never do with our own faces in our own mirrors).
ch a mirror is the perfect mediator not only between the artist and
female creation, but between the artist and his androgynous au-
nce. He, and we, look into the mirror and see *her*—a nonexistent
who is both our twin and our opposite.

Primo Levi said that writers, like other people, "carry from crib to
ve a doppelganger, a mute and faceless brother who nevertheless
co-responsible for our actions, and so for all of our pages." But in
artists I've looked at here, that figure is more likely to be a mute
faceless sister. She is the creature the artist would have been had
been born female, like David Copperfield's Betsey Trotwood Cop-
field, or Cecil Beaton's sisters Nancy and Baba, or James's Olive
ancellor, or Arthur Miller's opposite twin, Marilyn Monroe. Some-
es she is literally mute: Handke's and Berger's and Brodkey's moth-
silenced by death, with only their writer-sons to speak for them;
gas's quiet, self-enclosed nudes, who make the condition of mo-
ntary stillness seem eternal; Randall Jarrell's Woman at the Wash-
ton Zoo, to whom he must lend a voice, speaking on her behalf

perience. Yet even this, in the film's terms, is made redemptive. It is
part of what enables them both to grow up, to become loving adults.
Winnicott is again instructive, when he points out that "the mother's
main task (next to providing opportunity for illusion) is disillusion-
ment . . . In other words, this matter of *illusion* is one that belongs
inherently to human beings and that no individual finally solves for
himself or herself." We need someone else to help disillusion us, to
make us able to accept reality; and this is a process that is never
finished. "It is assumed here that the task of reality-acceptance is never
completed," says Winnicott, "that no human being is free from the
strain of relating inner and outer reality, and that relief from this strain
is provided by an intermediate area of experience . . . This intermediate
area is in direct continuity with the play area of the small child who
is 'lost' in play." A synonym for that "intermediate reality" might be
"the movies"—or so Sturges suggests when he has Stanwyck hold up
her mirror as a viewfinder, creating a director's "inner reality" that is
also a reflection of our "outer reality."

Stanwyck's great capacity as an actress turns out to be exactly this:
to disillusion and to sustain illusion at once. If she marches cheerfully
out of Vidor's *Stella Dallas,* it's not just to pursue her own happiness
(as Rothman implies), but to carry out the task of being a mother
elsewhere: to teach Henry Fonda about illusion and disillusion in *The
Lady Eve,* and in the process to teach herself and us. The specter raised
and examined by *Double Indemnity*—the idea of the woman as actress,
as liar, as fall-inducing Eve—turns out to be what makes this woman
so valuable to the man she loves. In the midst of comedy, she intro-
duces him to the possibility of tragedy, and in doing so enables him
to live his mortal life to the fullest. What Barbara Stanwyck does is to
suggest the idea of innocence beyond experience, of tenderness on the
other side of harsh knowledge and self-knowledge. She makes possible
an earthly kind of happiness, a tragedy-imbued happiness that is all
we can hope for after the Fall. Vidor robs Stephen Dallas of his chance
at open-eyed, sufficiently disillusioned, adult happiness when he allows
him to give up Stella, and Wilder takes away Walter Neff's chance
when he has him shoot Phyllis; that's partly why those movies aren't
comedies. But Sturges gives Charles Pike a second chance (or rather,
a *second* second chance), and that's why *The Lady Eve* is.

Closing the Circle

11 When I think about the risks these male artists take, the image that comes to mind is a cliff. Each of them walks up to the very edge of the cliff and teeters there. If he doesn't risk falling, he hasn't gone far enough. Falling is at the root of the encounter between men and women, between the male artist and his female subject. I don't just mean the original Fall, although that too is there: in Degas's prelapsarian eroticism, in Hitchcock's replaying of the Edenic possibilities, in the title of Arthur Miller's play about Marilyn Monroe, and in the title of Preston Sturges's movie with Barbara Stanwyck. But I mean actual falling as well: the vertigo of Brodkey's story and Hitchcock's film, the pratfalls of Henry Fonda's Charles Pike, the monumental sheer drop in *Niagara* and *North by Northwest,* the impending crash of Jarrell's ball turret gunner and Beaton's RAF bomber, the plummeting tomato plant that introduces Marilyn Monroe to her downstairs neighbor in *The Seven Year Itch,* Fred MacMurray's leap off the slow-moving caboose in *Double Indemnity,* and the watery deaths—the fall into the sea—of Ham Peggotty and James Steerforth, the two men who loved the same woman in *David Copperfield.* Falling in love becomes, in such cases, something more than a figure of speech.

All of the artists stand at the cliff's edge, but each of them looks out onto something different at the bottom of the abyss. For Degas, the faced and narrowly evaded danger is the threat of masculine voyeurism. For Beaton, it is the specter of feminine narcissism. For Vidor, it is condescending sentimentality. For Jarrell, it is the paralyzing division between masculine "thought" and feminine "feeling." Occasionally the dangers overlap, the adjoining cliffs face out on common ground. Hitchcock, Wilder, and Sturges all stare down into the chasm of woman-as-potential-betrayer. Hitchcock and Beaton gaze into the depths of the Pygmalion complex, the artist's overweening

pride in the woman he has "made." Henry James
glimpse, in very different ways, the terrors of er
and King Vidor peer down at the dangers of
Miller, Mailer, Huston, and Wilder all view M:
vast pit embodying the zero self, the absolute lo
tity. What lies below must be alluring as well a
as well as dangerous. To dangle over it must ar
as fear, so that the pulling back becomes as mu
resisted effort as the leaning out is.

Yet the word "willed" gives the wrong impres
absence of spontaneity, of immediate and felt
things these artists do, in their looking at wo
otherwise hidden connections between oppos
tional artifice and spontaneous unawareness,
emotion, between wit and sentimentality, betw
pendence, between intimacy and distance, betv
outward and the world regarding the self, bet
the real. In focusing on these apparent oppo
existence of a full spectrum in between, which
stand in for that other spectrum on which "mal
the endpoints.

The image of the spectrum, which I mentio
Henry James, is the opposite of the image of
movement rather than suspension, flexibility in
sion, the possibility of stepping sideways rathe
back. And yet "opposite" is itself a term that the
calls into question. The spectra I've invoked in
suggest that "opposite" needn't mean "antithesis
are linked, related, partaking of each other's q
in which both have a balancing function. In th
characteristic can have more than one oppos
more than one spectrum. As a man, one ha:
women one defines oneself as "opposite" to (a
for the gender spectrum is of course not the or
male artists can exercise this choice differently
very notion of opposition, in this sense, implies
affinities, not just resisted or antithetical qua
Sayers remarks in *Unpopular Opinions,* "The firs
careless observer is that women are unlike men.

"with the sympathy of an aging machine-part" for another aging machine-part. Sometimes she is literally faceless, either because her back is turned to us (as in Degas's bathers); or because she shares a face with other women, other images, and therefore loses her unique identity (as in some of Beaton's photographs); or because, like Barbara Stanwyck in *Double Indemnity,* she has only a mask for a face. But even when she is silent or hidden, she is nonetheless expressive. She may be nameless (like Handke's mother and Jarrell's Girl in a Library), or she may have multiple names (like Jean/Eve and Madeleine/Judy and Peggotty/Mrs. Barkis); her name is the least permanent, least singular thing about her. At her most extreme, as in Randall Jarrell's operatic creations or Hitchcock's bland blondes, she is both not quite alive and larger than life. But she can also be life itself, as Barbara Stanwyck is in *Stella Dallas* and *The Lady Eve,* or as the nude bathers are in Degas's pastels. She is the unborn self who lies behind the artist's work, the "ghost" writer who makes his work possible.

A male artist who thinks about that purely potential other existence—the self he might have been, the unborn sister he replaced—will also be thinking about determinism, and the possible ways around it. Art offers ways to break the cycle of determinism, to win a second try at getting things right. I think that's why so many of these artists focus on the idea of the second chance. When Dickens brings David's dwarfed-in-memory mother back as a real dwarf, Miss Mowcher; when D. H. Lawrence lets Paul Morel meet Clara after failing with Miriam; when Brodkey replays his mother's death and this time tries to render up the difficult truth; when Gissing allows Rhoda to have maternal feelings about Monica's child, or enables the Micklethwaites to marry after many years of waiting; when Hitchcock remakes *The Man Who Knew Too Much,* and then has Jimmy Stewart remake Kim Novak; when Preston Sturges gives Hopsie and Jean back to each other—they are all denying the idea that we only get one chance. It is an idea that deserves to be denied, for life too can offer us second chances, as many of these artists' own lives suggest. Their work implies that there are multiple lifetimes, multiple possibilities for each individual. If a male artist can (among other things) imaginatively transform himself into a woman character, then alternate lives may exist for all of us. We aren't limited to what we were born with.

This is also the idea behind the often-repeated image of the orphan—from Berger's assertion that autobiography "is an orphan form"

to Marilyn Monroe's crucial months in the orphanage; from David Copperfield's prenatal loss of his father and Brodkey's early loss of his mother, to Stella Dallas's voluntary renunciation of her daughter and "the mad Carlotta's" loss of her child in *Vertigo*. In its most positive sense, to be an orphan means to be free of the past, to be able to create oneself. Male artists who give life to women characters—characters who must be separate from their creators, to be fully alive—are forced to think about how one can give one's progeny their freedom, which may mean purposely orphaning them.

All of the artists I've looked at here are "figurative" artists, in the sense that their work evokes the human figure and its surrounding world. For me, the highest criterion on which such art can be judged is the extent to which the artist succeeds in freeing his creations, his human figures, rather than retaining possession of them as puppets of his own ideas and desires. This is what I have called fairness in the work of a writer like James or a filmmaker like Sturges; and its converse is what I have attacked in a writer like Kundera. Fairness—not in the sense of total objectivity (which I doubt can exist in art, or elsewhere), and not in the sense of rigidly observed evenhandedness (as if gender quotas prevailed in art), but in the sense of true openmindedness, true willingness to tolerate difference and disagreement and disobedience— that kind of fairness is essential to the male artist who sets out to create or render his lost female self.

And yet I don't want to imply that only male artists can be fair to their female creations—can feel separate or different from those creations—for that would be to introduce the kind of gender prejudice that is so blessedly absent from the work of these artists. Finally, I suppose, my point is that one can't generalize at all on the basis of gender. Each male artist defines his relation to the feminine—both its closeness and its distance—on his own; and it makes no more sense to speak categorically about male-artist attitudes toward women than it does to lump Willa Cather's female characters with Edith Wharton's, or Jane Austen's with Charlotte Brontë's.

So, after all this looking, I come back to the idea that great art, whether produced by men or by women, leaves behind the categories of "masculine" and "feminine." And perhaps this is true even of not-so-great art. In *Beyond Feminist Aesthetics,* a critical work which examines novels by (among others) mediocre writers like Marge Piercy and Marilyn French, Rita Felski repeatedly shows that "it is impossible

to speak of 'masculine' and 'feminine' in any meaningful sense in the formal analysis of texts." Women, that is, do not have any inherent claim on "subversive" or "experimental" literary styles, nor do these styles have any demonstrable connection with feminist politics. Felski aptly quotes the critic Michèle Barrett, who points out the danger of the "general tendency for feminist criticism to approach male and female authors very differently. Female authors are 'credited' with trying to pose the question of gender, or women's oppression, in their work, and male authors are 'discredited' by means of an assumption that any sexism they portray is necessarily their own." Such crediting and discrediting itself needs to be "discredited," or rather—since that word implies a merely political pressure—needs to be brought under scrutiny and subjected to the kind of fairminded skepticism that both Felski and Barrett demonstrate.

D. W. Winnicott, too, is finally unable to rest comfortably with the usual psychoanalytic distinction between masculine and feminine. "I was now no longer thinking of boys and girls or men and women but I was thinking in terms of the male and female elements that belong to each," he writes in a 1968 fragment. At the end of that same fragment he notes: "I cannot avoid it, but just at this stage I seem to have abandoned the ladder (male and female elements) by which I climbed to the place where I experienced this vision." Part of what enables Winnicott to abandon these distinctions is his acute perception of the divided nature of his own personality, his realization of the extent to which his own "masculine" sense of self was composed around another, beloved, once-possessed-but-now-lost female self. He says as much in a 1950 letter to his wife and fellow psychotherapist Clare Winnicott:

> Last night I got something quite unexpected, through dreaming, out of what you said. Suddenly you joined up with the nearest thing I can get to my transition object: it was something I have always known about but I lost the memory of it, at this moment I became conscious of it. There was a very early doll called Lily belonging to my younger sister and I was fond of it, and very distressed when it fell and broke. After Lily I hated *all* dolls. But I always knew that before Lily was a quelque-chose of my own. I knew retrospectively that it must have been a doll. But it had never occurred to me that it wasn't just like myself, a person, that is to say it was a kind of other me, and a not-me female, and part of me and yet not, and absolutely inseparable from me. I don't know

what happened to it. If I love you as I loved this (must I say?) doll, I love you all out. And I believe I do.

This is unembarrassedly akin to—though much more personal and more moving than—Freud's notion of the narcissist's beloved: "Someone who was once part of himself." And clearly it is also linked to Plato's myth of the divided selves.

Winnicott makes these connections explicit when he writes about Freud himself, in a 1962 review of Freud's letters. Speaking in this essay about the tendency to arrange around oneself a circle of friends, a circle of people to love, Winnicott says: "This seems to be the task of the male half in Plato's fabulous division, and to correspond to the complementary task of the female half, which is to form a circle around the newly conceived." He then follows this immediately with a reference to Freud's wife: "It was into this pattern that Martha evidently fitted well. She retained the position of being Freud's other half." Whether or not Martha Bernays filled this function for Freud (and more recent biographical evidence suggests that she may not fully have done so) is less important than Winnicott's feeling that she did. For to identify Martha as "Freud's other half" was to identify Freud, affectionately and empathetically, with himself: a man who truly did marry his other half, his "other me, and a not-me female, and part of me and yet not, and absolutely inseparable from me." Connecting Freud's marriage with his own was Winnicott's artificial but natural, invented yet discovered way of closing the circle (as we all need to do at times, and as I must do now), joining up the severed halves, bringing things to fullness.

Bibliography

Armstrong, Carol M. "Edgar Degas and the Representation of the Female Body." In *The Female Body in Western Culture*, ed. Susan R. Suleiman. Cambridge, Mass.: Harvard University Press, 1985.

The Asphalt Jungle, a film directed by John Huston, 1950.

Bayley, John. *The Characters of Love*. New York: Basic Books, 1960.

Beaton, Cecil. *Memoirs of the 40's*. New York: McGraw-Hill, 1972.

—— *The Best of Beaton* (photographs, with an introduction by Truman Capote). New York: Macmillan, 1968.

Benfey, Christopher. "The Woman in the Mirror: Jarrell and Berryman." *Pequod* 23/24, 1987.

Berger, John. "Her Secrets." *The Threepenny Review* #26 (vol. 7, no. 2), Summer 1986. Rpt. in *Graywolf Annual Three: Essays, Memoirs & Reflections*, ed. Scott Walker. Saint Paul: Graywolf Press, 1986.

—— "Painting and the Erogenous Zone." *The Threepenny Review* #35 (vol. 9, no. 3), Fall 1988.

Body Double, a film directed by Brian De Palma, 1984.

Brodkey, Harold. "Jane Austen vs. Henry James." *The Threepenny Review* #33 (vol. 9, no. 1), Spring 1988.

—— Letter to the Editor, *The Threepenny Review* #35 (vol. 9, no. 3), Fall 1988, p. 31.

—— "A Story in an Almost Classical Mode" and "Ceil." In Brodkey, *Stories in an Almost Classical Mode*. New York: Knopf, 1988.

Cain, James M. *Double Indemnity*. New York: Vintage Books (Random House), 1978.

Carroll, Lewis. *The Annotated Alice: Alice's Adventures in Wonderland and Through the Looking Glass*, ed. Martin Gardner. New York: Bramhall House, 1960.

Cavell, Stanley. *In Quest of the Ordinary*. Chicago: University of Chicago Press, 1989.

—— "*North by Northwest*." In Cavell, *Themes Out of School*. Berkeley: North Point Press, 1984.

—— *Pursuits of Happiness*. Cambridge, Mass.: Harvard University Press, 1981.

Clark, T. J. *The Painting of Modern Life: Paris in the Art of Manet and His Followers*. Princeton: Princeton University Press, 1984.

Danziger, James, ed. *Beaton*. New York: Viking, 1980.

Denby, Edwin. "Notes on Nijinsky Photographs" and "Forms in Motion and in Thought." In *Dance Writings*, ed. Robert Cornfield and William McKay. New York: Knopf, 1986.

Di Piero, W. S. "The Americans." *The Threepenny Review* #31 (vol. 8, no. 3), Fall 1987.

Dickens, Charles. *David Copperfield*. London: Hazell, Watson & Viney, no date; rpt. from the 1867–68 edition.

Dickey, James. "Randall Jarrell." In *Randall Jarrell, 1914–1965*, ed. Robert Lowell, Peter Taylor, and Robert Penn Warren. New York: Farrar, Straus & Giroux, 1967.

Doane, Mary Ann. *The Desire to Desire: The Woman's Film of the 1940s*. Bloomington: Indiana University Press, 1987.

Double Indemnity, a film directed by Billy Wilder, 1944.

Eliot, T. S. *Selected Prose*, ed. Frank Kermode. London: Faber and Faber, 1975.

Felski, Rita. *Beyond Feminist Aesthetics*. Cambridge, Mass.: Harvard University Press, 1989.

Freud, Sigmund. "On Narcissism: An Introduction" and "Negation." In Freud, *General Psychological Theory*, ed. Philip Rieff. New York: Collier Books (Macmillan), 1963.

Garner, Philippe. "An Instinct for Style: The Fashion Photography of Cecil Beaton." In *Cecil Beaton* (catalogue), ed. David Mellor. London: Barbican Art Gallery, 1986.

Gilbert, Sandra M., and Susan Gubar. *No Man's Land*, vol. I: *The War of the Words*. New Haven: Yale University Press, 1988.

Gissing, George. *The Emancipated*. London: Hogarth Press, 1985.

—— *The Odd Women*. New York: Norton, 1977.

—— *The Whirlpool*. London: Hogarth Press, 1984.

Gombrich, E. H. "Moment and Movement in Art." In Gombrich, *The Image and the Eye*. Ithaca: Cornell University Press, 1982.

Greskovic, Robert. "Choreography by Degas: A Retrospective at the Met." *New Dance Review* 1, no. 4, March–April 1989.

Handke, Peter. *A Sorrow beyond Dreams*, trans. Ralph Mannheim. In *3 × Handke*. New York: Collier Books (Macmillan), 1988.

Hardwick, Elizabeth. *Seduction and Betrayal*. New York: Random House, 1974.

Harvey, James. *Romantic Comedy in Hollywood, from Lubitsch to Sturges*. New York: Knopf, 1987.

James, Henry. *The Bostonians*. New York: Modern Library (Random House), 1956.

———— *The Golden Bowl*. New York: Popular Library, no date; rpt. from British edition published by Methuen in 1905.

———— *The Letters of Henry James*, vol. 3: *1883–1895*, ed. Leon Edel. Cambridge: Harvard University Press, 1980.

———— *Literary Criticism: Essays on Literature, English Writers, American Writers*. New York: Library of America, 1984.

———— *The Other House*. London: Rupert Hart-Davis, 1948.

———— *The Portrait of a Lady*. Harmondsworth: Penguin Books, 1966.

———— *The Spoils of Poynton*. Harmondsworth: Penguin Books, 1963.

———— *The Wings of the Dove*. Harmondsworth: Penguin Books, no date.

James, William. *Pragmatism*. New York: Meridian Books, 1955.

Jarrell, Mary. "A Group of Two." In *Randall Jarrell, 1914–1965*, ed. Lowell, Taylor, and Warren.

Jarrell, Randall. *The Complete Poems*. New York: Farrar, Straus & Giroux, 1969.

———— *Letters*, ed. Mary Jarrell. Boston: Houghton Mifflin, 1985.

———— *Pictures from an Institution: A Comedy*. New York: Knopf, 1954.

———— *Poetry and the Age*. New York: Knopf, 1953.

———— "The Reader Replies," *The American Scholar* (vol. 29, no. 1), Winter 1959–60.

———— *A Sad Heart at the Supermarket*. New York: Atheneum, 1962.

———— *The Third Book of Criticism*. New York: Farrar, Straus & Giroux, 1969.

Johnston, Claire. "*Double Indemnity*." In *Women in Film Noir*, ed. E. Ann Kaplan. London: BFI Publishing, 1980.

Kalstone, David. *Becoming a Poet*. New York: Farrar, Straus & Giroux, 1989.

Kaplan, E. Ann. "The Case of the Missing Mother: Maternal Issues in Vidor's *Stella Dallas.*" *Heresies* 16, 1983.

Kendall, Richard. *Degas: Images of Women* (catalogue and introduction). Liverpool: Tate Gallery Liverpool, 1989.

Kofman, Sarah. *The Enigma of Woman: Woman in Freud's Writings*, trans. Catherine Porter. Ithaca: Cornell University Press, 1985.

Kohut, Heinz. *The Kohut Seminars*, ed. Miriam Elson. New York: Norton, 1987.

Kundera, Milan. *The Unbearable Lightness of Being*. New York: Harper and Row, 1984.

Lacan, Jacques. *The Seminar of Jacques Lacan.* Book I: *Freud's Papers on Technique, 1953–1954.* Book II: *The Ego in Freud's Theory and in the Technique of Psychoanalysis, 1954–1955*, ed. Jacques-Alain Miller, trans. Sylvana Tomaselli and John Forrester. New York: Norton, 1988.

The Lady Eve, a film directed by Preston Sturges, 1941.

Laing, R. D. *The Divided Self.* Harmondsworth: Pelican Books, 1965; rpt. 1987.

Lang, Robert. *American Film Melodrama: Griffith, Vidor, Minelli*. Princeton: Princeton University Press, 1989.

Lawrence, D. H. "The Rocking-Horse Winner." In Lawrence, *The Complete Short Stories*, vol. 3. New York: Viking Press, 1966.

————— *Sons and Lovers*. New York: Viking, 1958; rpt. 1975.

————— *Studies in Classic American Literature*. New York: Viking, 1964; rpt. 1972.

Lawrence, T. E. *The Selected Letters*, ed. Malcolm Brown. New York: Norton, 1989.

Levi, Primo. *Other People's Trades*, trans. Raymond Rosenthal. New York: Summit Books, 1989.

Lipton, Eunice. *Looking into Degas: Uneasy Images of Women and Modern Life*. Berkeley: University of California Press, 1986.

Mailer, Norman. *Marilyn: A Biography*. New York: Grosset & Dunlap, 1973.

Malcolm, Janet, "The View From Plato's Cave." In Malcolm, *Diana & Nikon*. Boston: Godine, 1980.

The Man Who Knew Too Much, a film directed by Alfred Hitchcock, 1934.

The Man Who Knew Too Much, a film directed by Alfred Hitchcock, 1956.

Marnie, a film directed by Alfred Hitchcock, 1964.

McCann, Graham. *Marilyn Monroe*. New Brunswick: Rutgers University Press, 1988.

Mellor, David. "Beaton's Beauties: Self-Representation, Authority and British Culture." In *Cecil Beaton*, ed. Mellor.

———, ed. *Cecil Beaton* (catalogue). London: Barbican Art Gallery, 1986.

Miller, Arthur. *After the Fall*. New York: Penguin Books, 1988.

——— *Timebends*. New York: Grove Press, 1987.

Miller, J. Hillis. *Versions of Pygmalion*. Cambridge, Mass.: Harvard University Press, 1990.

Miller, Karl. *Doubles: Studies in Literary History*. Oxford: Oxford University Press, 1987.

The Misfits, a film directed by John Huston, 1960.

Mitchell, Juliet. *Feminism and Psychoanalysis: Freud, Reich, Laing, and Women*. New York: Vintage Books (Random House), 1975.

Modleski, Tania. *The Women Who Knew Too Much: Hitchcock and Feminist Theory*. New York: Methuen, 1988.

Morgan, Stuart. "Open Secrets: Identity, Persona, and Cecil Beaton." In *Cecil Beaton*, ed. Mellor.

Niagara, a film directed by Henry Hathaway, 1954.

Nietzsche, Friedrich. *Daybreak*, trans. R. J. Hollingdale. Cambridge: Cambridge University Press, 1982.

North by Northwest, a film directed by Alfred Hitchcock, 1959.

Notorious, a film directed by Alfred Hitchcock, 1946.

Obsession, a film directed by Brian De Palma, 1976.

Orwell, George. "Charles Dickens," in Orwell, *A Collection of Essays*. New York: Harcourt Brace Jovanovich, 1953.

Ozick, Cynthia. *Metaphor & Memory*. New York: Knopf, 1989.

Plato. *Symposium*. In *The Dialogues of Plato*, vol. I, trans. B. Jowett. Oxford: Oxford University Press, 1953.

Poe, Edgar Allan. "The Philosophy of Composition." In *Great Short Works of Edgar Allan Poe*, ed. G. R. Thompson. New York: Harper and Row, 1970.

Pound, Ezra. *Literary Essays*, ed. T. S. Eliot. New York: New Directions, 1968.

Psycho, a film directed by Alfred Hitchcock, 1960.

Ransom, John Crowe. *Poems and Essays*. New York: Vintage Books, 1955.

Rothman, William. "In the Face of the Camera." *Raritan*, Winter 1984. Rpt. as

"Pathos and Transfiguration in the Face of the Camera: A Reading of *Stella Dallas*," in Rothman, *The "I" of the Camera*. Cambridge: Cambridge University Press, 1988.

———— *The Murderous Gaze*. Cambridge, Mass.: Harvard University Press, 1982.

Sayers, Dorothy L. *Unpopular Opinions*. London: Victor Gollancz, 1946.

The Seven Year Itch, a film directed by Billy Wilder, 1955.

Shakespeare, William. *Antony and Cleopatra*. Cambridge: Cambridge University Press, 1968.

Shakespeare, William. *Pericles*. In *The Complete Pelican Shakespeare*. Baltimore: Penguin Books, 1969.

Shaw, George Bernard. *Pygmalion*. Baltimore: Penguin Books, 1951.

Simpson, Eileen. *Poets in Their Youth: A Memoir*. New York: Random House, 1982.

Snow, Edward. *A Study of Vermeer*. Berkeley: University of California Press, 1979.

———— "Theorizing the Male Gaze: Some Problems." *Representations* 25, Winter 1989.

Some Like It Hot, a film directed by Billy Wilder, 1959.

Sontag, Susan. *On Photography*. New York: Farrar, Straus & Giroux, 1977.

Spellbound, a film directed by Alfred Hitchcock, 1945.

Steinem, Gloria. *Marilyn* (with photographs by George Barris). New York: Plume Books (New American Library), 1987.

Stella Dallas, a film directed by King Vidor, 1937.

Stich, Sidra. *Made in USA* (exhibition catalogue). Berkeley: University of California Press, 1987.

Sturges, Preston. *Five Screenplays*, ed. with an introduction by Brian Henderson. Berkeley: University of California Press, 1986.

Sutton, Denys. *Edgar Degas: Life and Work*. New York: Rizzoli, 1986.

Thomson, Richard. *Degas: The Nudes*. New York: Thames and Hudson, 1988.

Vertigo, a film directed by Alfred Hitchcock, 1958.

Vidal, Gore. "Return to 'The Golden Bowl.'" *New York Review of Books* 30, nos. 21–22, January 19, 1984.

Wilde, Oscar. *The Artist as Critic: Critical Writings of Oscar Wilde*, ed. Richard Ellmann. New York: Vintage Books (Random House), 1969.

Williams, Linda. "'Something Else Besides a Mother': *Stella Dallas* and the Maternal Melodrama." *Cinema Journal* 24, no. 1, Fall 1984.

Winnicott, D. W. *Home Is Where We Start From*, ed. Clare Winnicott, Ray Shepherd, Madeleine Davis. New York: Norton, 1986.

—— *The Maturational Processes and the Facilitating Environment*. Madison: International Universities Press, 1965; rpt. 1988.

—— *Playing and Reality*. London: Tavistock, 1971; rpt. New York: Routledge, 1989.

—— *Psycho-Analytic Explorations*, ed. Clare Winnicott, Ray Shepherd, Madeleine Davis. Cambridge, Mass.: Harvard University Press, 1989.

—— *Through Paediatrics to Psycho-Analysis*. New York: Basic Books, 1958; rpt. 1975.

Zola, Emile. *Thérèse Raquin*, trans. Leonard Tancock. Harmondsworth: Penguin Books, 1962.

Notes

Notes are keyed by page number. Full citations of works listed here appear in the Bibliography.

1. Divided Selves

3 Tania Modleski, *The Women Who Knew Too Much*, p. 9.

5 Harold Brodkey, "Jane Austen vs. Henry James," p. 6.

5–6 John Berger, "Painting and the Erogenous Zone," p. 29.

9–10 Plato, *Symposium*, pp. 521–523.

12 Primo Levi, *Other People's Trades*, p. 170.

13, 14 Jacques Lacan, *The Seminar of Jacques Lacan*, Book I, pp. 73, 228, 230.

14 R. D. Laing, *The Divided Self*, p. 106.

14 Heinz Kohut, *The Kohut Seminars*, p. 64.

14, 15 D. W. Winnicott, *Playing and Reality*, pp. 117, 118, 111.

15 Lacan, Book I, p. 80.

16 Kohut, p. 39.

16 Ibid., p. 65.

16 Winnicott, *Playing and Reality*, p. 112.

17 Poe, quoted in Lacan, Book II, p. 180.

17 Kohut, p. 30.

17 Sigmund Freud, *General Psychological Theory*, p. 71.

18 Kohut, p. 41.

18 Freud, p. 69.

18 Lacan, Book I, p. 276.

18 Plato, pp. 522–523.

22 D. W. Winnicott, *Psycho-Analytic Explorations*, p. 221.

2. Mothers

25 Charles Dickens, *David Copperfield*, p. 18.

25 Ibid., p. 246.

26 George Orwell, "Charles Dickens," p. 60.

26–27 *David Copperfield*, pp. 27, 127.

27 Ibid., pp. 65, 70, 140.

27–28 Ibid., pp. 699–700.

28–29 D. W. Winnicott, *Through Paediatrics to Psycho-Analysis*, p. 155.

29 Ibid., p. 202.

30 *David Copperfield*, p. 225.

30–31 Peter Handke, *A Sorrow Beyond Dreams*, pp. 201, 235.

31 Harold Brodkey, *Stories in an Almost Classical Mode*, p. 222.

31 Brodkey, Letter to the Editor, p. 31.

32 Freud, *General Psychological Theory*, p. 213.

32 Brodkey, *Stories*, p. 236.

32 Ibid., p. 265.

33 Handke, p. 216.

33 Brodkey, *Stories*, p. 246.

33 Winnicott, *Through Paediatrics*, p. 97.

34 Brodkey, *Stories*, p. 252.

35 Ibid., p. 251.

35 Ibid., p. 231.

35–36 Handke, p. 231.

36 Ibid., pp. 226, 243.

36–37 Brodkey, *Stories*, pp. 221, 262–263.

37 Handke, p. 199.

37–38 Ibid., p. 211.

38 Brodkey, *Stories*, p. 423.

39 *David Copperfield*, p. 29.

39 Ibid., p. 18.

40 Ibid., p. 364.

40 Handke, p. 217.

40–41 John Berger, "Her Secrets," pp. 4, 5, 8.

42 Edgar Allan Poe, "The Philosophy of Composition," p. 534.

42–43 Handke, p. 240.

43 Brodkey, *Stories*, pp. 228, 257, 264.

44 Handke, p. 220.

44 Brodkey, *Stories*, pp. 224, 222.

44–45 *David Copperfield*, pp. 43, 14, 43.

46 D. H. Lawrence, "The Rocking-Horse Winner," pp. 790, 804.

46–47 D. H. Lawrence, *Studies in Classic American Literature*, pp. 89, 93, 97, 92.

47–48 D. W. Winnicott, *Home Is Where We Start From*, p. 125.

48 Lawrence, *Studies*, pp. 2, 86.

49 Brodkey, *Stories*, p. 265.

49 D. H. Lawrence, *Sons and Lovers*, p. 420.

49–50 Berger, "Her Secrets," pp. 3, 4, 6.

51 *David Copperfield*, p. 374.

3. Degas's Nudes

56 Richard Thomson, *Degas: The Nudes*, p. 145.

56 J. K. Huysmans, quoted in Edward Snow, *A Study of Vermeer*, p. 147.

56 *New York Times*, national ed., February 13, 1988, p. 12.

56 Gustave Geffroy, quoted in Thomson, p. 138.

56 George Moore, quoted in Denys Sutton, *Edgar Degas: Life and Work*, p. 235.

57 Carol Armstrong, "Edgar Degas and the Representation of the Female Body," p. 234.

57 Thomson, pp. 205, 207.

57 Snow, pp. 28, 30.

57–58 Armstrong, p. 239.

59 Thomson, p. 190.

60 Mirbeau, quoted in Thomson, p. 135.

60 Thomson, pp. 193, 51.

61 Armstrong, p. 238.

61 Sutton, p. 25.

62 Thomson, p. 36.

62 Sutton, pp. 251, 253.

62 Thomson, pp. 108, 117.

65 Emile Zola, *Thérèse Raquin*, pp. 157–158, 23.

66 Snow, p. 28.

66 Randall Jarrell, *The Complete Poems*, p. 18.

67 Thomson, p. 128.

69 Edwin Denby, *Dance Writings*, p. 565.

70 E. H. Gombrich, *The Image and the Eye*, pp. 58, 44, 59.

70 Denby, p. 497.

71, 73 Armstrong, pp. 238, 241.

74, 75 Thomson, pp. 143, 207.

77–78 Snow, pp. 28–30.

78 Degas, quoted in Snow, p. 32.

78–79 Denby, pp. 572–573.

80 D. W. Winnicott, *The Maturational Processes and the Facilitating Environment*, p. 30.

4. Gissing's Even-Handed Oddness

81 George Gissing, *The Odd Women*, p. 129.

82 Gillian Tindall, Introduction to George Gissing, *The Whirlpool*, n.p.

83 John Halperin, Introduction to George Gissing, *The Emancipated*, n.p.

83 The Emancipated, p. 330.
84 The Odd Women, p. 125.
84 Stanley Cavell, In Quest of the Ordinary, pp. 167–168.
86 The Odd Women, p. 239.
87–88 Ibid., p. 176.
88 Ibid., p. 336.
89–90 Henry James, The Bostonians, pp. 463–464.
92 The Odd Women, pp. 124, 135.
92 Ibid., p. 53.
93 Ibid.
94 Ibid., p. 52.

5. Henry James and the Battle of the Sexes

95–96 Cynthia Ozick, Metaphor & Memory, pp. 62–63.
96 Ezra Pound, Literary Essays, p. 299.
98 T. S. Eliot, Selected Prose, p. 151.
99 Henry James, Literary Criticism: Essays on Literature, American Writers, English Writers, pp. 24–25.
100 Harold Brodkey, "Jane Austen vs. Henry James," p. 6.
100 Sandra Gilbert and Susan Gubar, No Man's Land, vol. 1: The War of the Words, pp. 25–27.
102 Henry James, The Golden Bowl, pp. 253, 534.
103 Ibid., pp. 255, 68.
104 Ibid., pp. 67, 491–492.
105 Henry James, The Wings of the Dove, p. 46.
105 The Golden Bowl, pp. 519–520.
106 Henry James, The Spoils of Poynton, p. 13.
106–107 The Golden Bowl, p. 35.
107 The Wings of the Dove, p. 253.
107 The Spoils of Poynton, p. 31.
107 Brodkey, "Jane Austen vs. Henry James," p. 4.
109 Henry James, The Bostonians, pp. 78, 232, 400.
110 Ibid., pp. 193–194.
110 Gilbert and Gubar, p. 26.
111–112 The Bostonians, pp. 198, 274.
112 Ibid., p. 288.
113 Ibid., pp. 199, 86.
114 Henry James, Letters, vol. 3, pp. 69–70.
114 The Bostonians, pp. 26–27.
115 Ibid., p. 38.
116 Ibid., p. 464.
116–117 Ibid., p. 111.
117–118 Gore Vidal, "Return to 'The Golden Bowl,'" p. 9.

118 John Bayley, *The Characters of Love*, p. 235.
118 *The Bostonians*, p. 388.
119 William James, *Pragmatism*, p. 42.
120 *The Bostonians*, p. 60.

6. Hitchcock's Couples

123 T. E. Lawrence, *The Selected Letters*, p. 284.
123 Stanley Cavell, *Pursuits of Happiness*, p. 51.
124–128 William Shakespeare, *Antony and Cleopatra*, 1.1.12–13, 2.5.21–23, 3.7.16–18, 3.13.117–125, 1.1.37–40, 3.13.185–187.

7. Randall Jarrell's Sinister Beings

Throughout this chapter, extensive use is made of quotations from Randall Jarrell's poetry. The author gratefully acknowledges permission to reprint from the published poems, as follows: excerpts from *The Complete Poems* by Randall Jarrell, copyright © 1945, 1951, 1955, and renewal copyright © 1973 by Mrs. Randall Jarrell, reprinted by permission of Farrar, Straus & Giroux, Inc., and Faber & Faber Ltd; excerpts from *The Lost World* by Randall Jarrell, copyright © 1963 and 1965 by Randall Jarrell, reprinted by permission of Macmillan Publishing Company.

145 Randall Jarrell, *Poetry and the Age*, p. 26.
145 Randall Jarrell, *The Third Book of Criticism*, pp. 151, 107, 110.
145–146 *Third Book of Criticism*, pp. 109, 205, 230.
146 *Poetry and the Age*, pp. 86, 63.
146–147 James Dickey, "Randall Jarrell," pp. 34, 35, 37, 41, 44.
147 *Poetry and the Age*, p. 116.
148 *Poetry and the Age*, pp. 26, 17.
148–149 Randall Jarrell, *A Sad Heart at the Supermarket*, pp. 75, 84.
149 Ibid., p. 68.
149 Henry James, *Literary Criticism*, pp. 24–25.
149 *Sad Heart at the Supermarket*, p. 162.
150–152 Randall Jarrell, *The Complete Poems*, pp. 301, 331, 18, 17, 16.
152 John Crowe Ransom, *Poems and Essays*, p. 29.
152–154 *Complete Poems*, pp. 15–16, 18, 304.
154 *Poetry and the Age*, p. 13.
155 *Complete Poems*, p. 53.
155 *Third Book of Criticism*, p. 29.
155–156 *Sad Heart at the Supermarket*, p. 168.
156 Randall Jarrell, *Pictures from an Institution: A Comedy*, p. 152.
156 *Complete Poems*, p. 53.
156–158 Randall Jarrell, *Letters*, pp. 471, 313, 292, 23, 25, 19, 187, 119, 108.

159 Eileen Simpson, *Poets in Their Youth: A Memoir*, p. 110.
159 Robert Phelps, in *Randall Jarrell, 1914–1965*, p. 138.
159–160 Jarrell, "The Reader Replies," *The American Scholar*, p. 136.
160 *Pictures from an Institution*, p. 39.
160 Peter Taylor, in *Randall Jarrell, 1914–1965*, p. 250.
161 Conversation between the author and Edith Jenkins, San Francisco, California, November 6, 1988.
161 *Complete Poems*, pp. 23–24.
161 *Letters*, p. 285.
161 *Third Book of Criticism*, p. 39.
162 *Pictures from an Institution*, p. 63.
162–163 *Sad Heart at the Supermarket*, pp. 136–137.
163 *Complete Poems*, pp. 331, 16.

8. Beaton's Ladies

164 Janet Malcolm, "The View from Plato's Cave," p. 77.
165 David Mellor, "Beaton's Beauties: Self-Representation, Authority and British Culture," in *Cecil Beaton*, ed. Mellor, p. 9.
165 Cecil Beaton, *The Best of Beaton*, p. 17.
168 Stuart Morgan, "Open Secrets: Identity, Persona, and Cecil Beaton," in *Cecil Beaton*, ed. Mellor, p. 111.
170–171 Edward Snow, "Theorizing the Male Gaze: Some Problems," *Representations* 25 (Winter 1989), pp. 37–38, 36.
171 Baudelaire, quoted in Susan Sontag, *On Photography*, p. 190.
171 Oscar Wilde, *The Artist as Critic*, p. 236.
172 Friedrich Nietzsche, *Daybreak*, p. 141.
172 Wilde, p. 236.
172 Cecil Beaton, *Memoirs of the 40's*, pp. 297, 139.
173–174 Wilde, pp. 67, 66, 434, 433, 115, 434.
177 Philippe Garner, "An Instinct for Style," in *Cecil Beaton*, ed. Mellor, p. 78.
178 Nietzsche, p. 171.
179–180 George Bernard Shaw, *Pygmalion*, p. 112.
180 Wilde, p. 235.
180 Shaw, p. 113.
180–181 *Memoirs of the 40's*, pp. 172–173.
181 Mellor, "Beaton's Beauties," pp. 41–42.
181 *Memoirs of the 40's*, p. 108.
182 David Kalstone, *Becoming a Poet*, p. 101.
183 *Best of Beaton*, p. 78.
183 Sontag, *On Photography*, p. 15.

185 Randall Jarrell, *Complete Poems*, p. 144. Reprinted by permission of Farrar, Straus & Giroux, Inc., and Faber & Faber Ltd.

184–185 Wilde, pp. 235–236.

186 Nietzsche, p. 172.

188 Jarrell, *Complete Poems*, p. 331.

9. The Disembodied Body of Marilyn Monroe

193 Norman Mailer, *Marilyn: A Biography*, p. 177.

194 Gloria Steinem, *Marilyn*, p. 180.

194 Graham McCann, *Marilyn Monroe*, p. 214.

195 Arthur Miller, *Timebends*, p. 464.

195 Steinem, p. 2.

195 Arthur Miller, *After the Fall*, p. 32.

195 Monroe, quoted in Steinem, p. 138.

195 Lewis Carroll, *The Annotated Alice*, p. 239.

195 Randall Jarrell, *Complete Poems*, p. 16.

195 Mailer, p. 193.

196 W. S. Di Piero, "The Americans," p. 20.

197 Miller, *Timebends*, p. 369.

198 Miller, *After the Fall*, pp. 89–90.

198 Mailer, p. 17.

198–199 Ibid., pp. 157, 37.

199 Miller, *Timebends*, pp. 9, 306.

199 Mailer, p. 248.

200 Miller, *Timebends*, pp. 354, 424.

200 Monroe, quoted in Steinem, p. 92.

202 Miller, *Timebends*, p. 471.

202 Mailer, p. 21.

203n Miller, *Timebends*, p. 484.

203 Mailer, p. 106.

204 Miller, *Timebends*, pp. 370, 425.

206n Jacques Lacan, *The Seminar of Jacques Lacan*, Book I, p. 77.

209 Miller, *Timebends*, p. 303.

214 Miller, *After the Fall*, p. 55.

215 Curtis, quoted in Mailer, p. 17.

217–218 Miller, *After the Fall*, p. 77.

220 Miller, *Timebends*, p. 24.

221 Ibid., p. 474.

222 Ibid., pp. 382, 369.

223 Miller, *After the Fall*, pp. 63, 86.

223 Miller, *Timebends*, p. 532.

223–224 Mailer, pp. 17, 20, 44.

10. Stanwyck

226 Robert Lang, *American Film Melodrama: Griffith, Vidor, Minnelli*, p. 134.

226 Mary Ann Doane, *The Desire to Desire: The Woman's Film of the 1940s*, p. 75.

227 William Rothman, "In the Face of the Camera," p. 129.

229 Linda Williams, "'Something Else Besides a Mother': *Stella Dallas* and the Maternal Melodrama," p. 22.

229 E. Ann Kaplan, "The Case of the Missing Mother: Maternal Issues in Vidor's *Stella Dallas*," pp. 83–84.

230 Lang, pp. 145, 137, 151.

230–231 Ibid., p. 142.

231 Doane, p. 75.

231 Rothman, p. 120.

232 Doane, pp. 76–77.

235 Lang, p. 148.

237 Ibid., pp. 151, 149.

239 Ibid., p. 135; Williams, pp. 16, 18; Doane, p. 74.

239 Rothman, p. 128.

239 Williams, p. 20.

239 Doane, p. 75.

239–240 Edward Snow, "Theorizing the Male Gaze: Some Problems," p. 31.

240 Lang, p. 143.

240 Rothman, pp. 131–132.

241 Rothman, p. 133.

242 James M. Cain, *Double Indemnity*, pp. 51, 112, 9.

243 Ibid., p. 125.

244 Ibid., p. 42.

248 Ibid., p. 79.

249 Stanley Cavell, *Pursuits of Happiness*, p. 66.

251 James Harvey, *Romantic Comedy in Hollywood, from Lubitsch to Sturges*, p. 573.

251–252 Cavell, *Pursuits of Happiness*, p. 61.

252 Harvey, p. 580.

255 Ibid., p. 579.

255 Sturges, quoted in Sturges, *Five Screenplays*, p. 349.

256 Cavell, *Pursuits of Happiness*, pp. 62, 61.

257 Lewin, quoted in *Five Screenplays*, p. 350.

259 Henry James, *The Other House*, pp. 28–29.

260 D. W. Winnicott, *Through Paediatrics to Psycho-Analysis*, pp. 154, 202.

261 D. W. Winnicott, *Playing and Reality*, p. 13.

11. Closing the Circle

262–263 For an interesting discussion of what I've called "the Pygmalion complex" as it pertains to works of literature, see J. Hillis Miller's *Versions of Pygmalion*, a book that unfortunately appeared only as mine was going to press, and that otherwise would have been very helpful to me in formulating some of my ideas.

263–264 Dorothy L. Sayers, *Unpopular Opinions*, p. 116. I'm grateful to Thomas Laqueur not only for finding this quotation, which appears in his book *Making Sex: Body and Gender from the Greeks to Freud* (Cambridge, Mass.: Harvard University Press, 1990), but also for our many fruitful lunchtime arguments about the definitions of male and female.

264 Primo Levi, *Other People's Trades*, p. 170.

267 Rita Felski, *Beyond Feminist Aesthetics*, p. 2.

267 Barrett, quoted in Felski, p. 28.

267–268 D. W. Winnicott, *Psycho-Analytic Explorations*, pp. 190, 192, 16, 476.

Acknowledgments

For financial support, which translated directly into time, I am extremely grateful to the Guggenheim Foundation, which awarded me a fellowship to work on this book, and to San Francisco Artspace, which gave me a John McCarron Grant for New Writing in Art Criticism. I also owe thanks to the editors of *The Hudson Review* and *The Southwest Review*, who first allowed me to try out some of these ideas in print.

For excellence in all aspects of publishing, I would like to thank Harvard University Press, specifically in the persons of Lindsay Waters, Camille Smith, Claire Silvers, Marianne Perlak, and David Foss. Without them, obviously, there would be no book—or certainly not such a meticulously edited and well-produced one. I also want to thank the anonymous readers who offered Harvard their responses to the manuscript; in doing so, they gave me a great deal of useful advice for revision.

Two people are, more than anyone else, responsible for the intellectual shape of this book, though they should not be held accountable for its shortcomings. One is Edward Snow, whose book *A Study of Vermeer* made it unnecessary for me even to consider writing a Vermeer chapter, and whose example—as teacher, writer, and friend—made it possible for me to begin thinking along these lines. The other is Christopher Ricks, who kindly but rigorously edited about two-thirds of the first draft, and whose unfailingly correct editorial advice stayed with me as a voice in my mind while I was writing the rest of the book.

Further thanks are due to my sister, Janna Lesser, who discussed Winnicott with me and steered me toward the Kohut material when I was beginning to think about narcissism; Arthur Lubow, who helped me reconceive and rewrite the Cecil Beaton chapter; Katharine Ogden,

who similarly helped restructure the Mothers and Hitchcock chapters; Robert Hass, who helped me in the early phases of the Randall Jarrell chapter, and William Pritchard, who took an important final look at it; and Mindy Aloff, Gregory Farnham, James Harvey, Mark Stevens, and Daniel Wolff, whose responsive readings of various chapters led to innumerable improvements.

Finally, I want to thank "the Rizzos," who have given me a day-to-day life that makes my writing life both possible and pleasurable.

Index